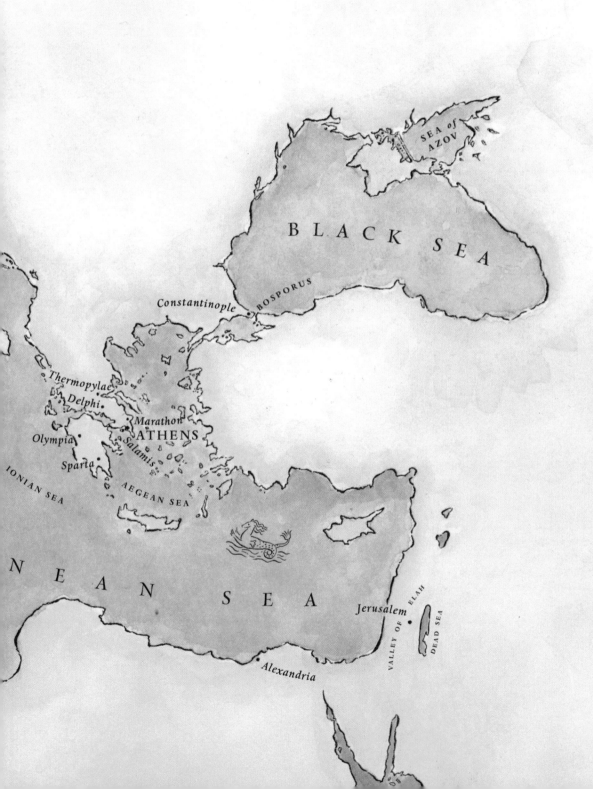

SEA of
AZOV

B L A C K S E A

Constantinople • BOSPORUS

Thermopylae
• *Delphi*
Marathon
ATHENS
Olympia •
Salamis
Sparta •
IONIAN SEA
AEGEAN SEA

N E A N S E A

Jerusalem
VALLEY OF ELAH
DEAD SEA

• *Alexandria*

David's Sling

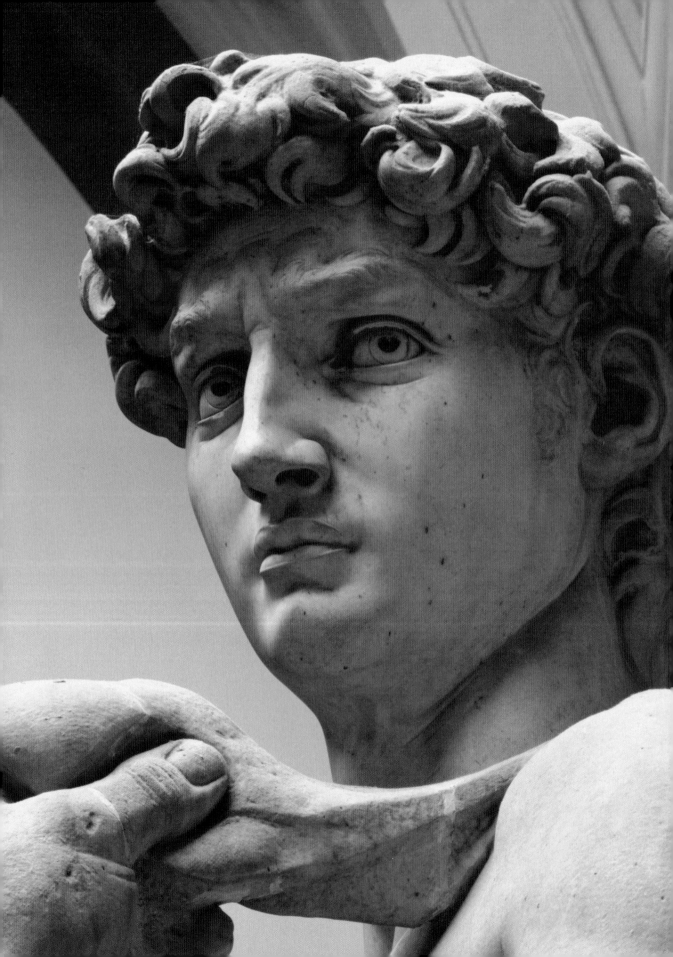

David's Sling

A History of Democracy

in Ten Works of Art

Victoria C. Gardner Coates

ENCOUNTER BOOKS

NEW YORK · LONDON

First American edition published in 2016 by Encounter Books,
an activity of Encounter for Culture and Education, Inc.,
a nonprofit, tax exempt corporation.
Encounter Books website address: www.encounterbooks.com

Manufactured in the United States and printed on
acid-free paper. The paper used in this publication meets
the minimum requirements of ANSI / NISO Z39.48–1992
(R 1997) (*Permanence of Paper*).

FIRST AMERICAN EDITION

LIBRARY OF CONGRESS CATALOGING-IN-PUBLICATION DATA

Gardner Coates, Victoria C.
David's sling : a history of democracy in ten works of art /
by Victoria C. Gardner Coates.
 pages cm
Includes bibliographical references and index.
ISBN 978-1-59403-721-4 (hardback) — ISBN 978-1-59403-722-1 (ebook)
1. Democracy—History. 2. Art—Political aspects—History.
3. Masterpiece, Artistic. I. Title.
JC423.G3545 2014
321.809—dc23
2014001929

10 9 8 7 6 5 4 3 2 1

Contents

For George, who makes everything possible,
and for Gardner and Gowen,
who make everything worthwhile.
With all my love.

Introduction

*David said to the Philistine, "You come against me with sword
and spear and javelin, but I come against you in the name
of the Lord Almighty, the God of the armies of Israel,
whom you have defied. This day the Lord will deliver you into
my hands, and I'll strike you down and cut off your head.
This very day I will give the carcasses of the Philistine army
to the birds and the wild animals, and the whole world will know
that there is a God in Israel. All those gathered here will know that
it is not by sword or spear that the Lord saves; for the battle
is the Lord's, and he will give all of you into our hands."*

I Samuel 17:45–47

The Valley of Elah is today a quiet agricultural zone southwest of Jeru-
salem, not far from the small town of Zekharia. Three thousand years
ago, however, it was the setting for an iconic battle between a young
shepherd and a giant.

The mighty Philistines had been trying to subdue the Israelites for
years when the two armies faced off across the valley. Hoping to destroy
their enemies once and for all, the Philistines proposed that the Israelites
send one champion out against their most formidable warrior, Goliath,
to resolve the war through single combat. For the Israelites, the odds
seemed hopeless. Goliath was a colossus of a man, and the Philistines'
skilled metalworkers had equipped him with bronze armor and weap-
ons that far outstripped anything the Israelites possessed. He taunted
them daily while no one volunteered to take him on.

After forty days, David stepped forward. He was a teenager who
had been tending sheep while the Israelite warriors confronted the Phi-
listines in the Valley of Elah. He had come to the camp bringing food for
his older brothers in the army – none of whom had been brave enough
to challenge Goliath. To their shame, David announced he would fight
the giant himself.

David had no armor of his own, and he felt awkward and uncom-
fortable in what the Israelite leader, Saul, offered him for the battle. He

decided to face Goliath armed only with the slingshot he used to defend his sheep from wild beasts, confident that his skill and his pure faith in God would protect him.

Those of lesser faith despaired. The best they hoped for was that it would be over quickly, at which point the Israelites would become slaves to the Philistines. But then a miracle happened. As Goliath approached his prey, the young man steadied himself, aimed his slingshot and stunned the giant with a single stone to the forehead. The enormous warrior tumbled to the ground. David took Goliath's sword and cut off his head. The Israelites were victorious.

David went on to become a great king and to found a royal house that would eventually produce Jesus Christ. But his youthful contest with the giant has long stood as a parable for the remarkable power of combining faith in the divine with human ingenuity. David's sling was more than a primitive weapon; it was the crucial advantage that enabled the shepherd to win the day.

Through history, various kinds of metaphorical slings have enabled individuals and societies to rise like David above seemingly insurmountable difficulties and reach impressive heights of achievement. One of the more consequential of these innovations was devised on a rocky outcropping on the Greek Peloponnesus some five hundred years after the famous confrontation between David and Goliath, by a group of men who had never heard of either of them. What the Athenians invented on their citadel was a new political system of free, self-governing people. They called it *demokratia*.

Although hints of political self-determination had appeared in some ancient Mesopotamian city-states, the fact remains that until the end of the sixth century BC in Athens there was no comparable, deliberate effort to institutionalize a democratic government. The Athenians were fully conscious of their system's novelty and would credit their freedom with empowering their small *polis* to lead the Greek allies in their triumph over the awesome Persian Empire. This political innovation coincided with the brilliant flowering of creativity known as the golden age of classical Greece, which set enduring standards of cultural excellence. During this period Athens's greatest statesman, Pericles, commissioned grand monuments for the Acropolis, chief among them the exquisite temple to Athena known as the Parthenon – which remains, even in its ruined condition a timeless symbol of Western democracy.

Over the next two and a half millennia in the West, the ideal of democratic self-governance took on a variety of practical manifestations,

from small city-republics to constitutional monarchies. These free societies have set a remarkable pattern of success and influence far beyond what their size or resources might have predicted. Among their accomplishments are a series of artworks that have acquired canonical status in cultural history and today stand as visible testaments to democracy.

This is not to say, of course, that no other form of government can inspire great art; any such notion is quickly dispelled by a stroll through the Pantheon in Rome, built for the emperor Hadrian, or a glance at *Las Meninas*, painted by Velázquez for King Philip IV of Spain. Indeed, a large proportion of the Western cultural patrimony was commissioned by royalty or clergy. This fact makes it all the more noteworthy that democracies have demonstrated a special capacity to inspire extraordinary works of art. The purpose of this book is to highlight the synergy between liberty and creativity, and so to bring a fresh perspective to both.

David's Sling is thus a hybrid of political history and art history. It is based as much as possible on primary sources, which have been used to inform creative but plausible reconstructions of how the historical characters might have spoken and interacted. My goal has been to highlight the very human stories behind the selected objects of art in an effort to make them vital and vibrant for a contemporary reader.

The following chapters examine ten works of art and architecture representing democratic societies from ancient Athens to twentieth-century Spain. All of them have in some way transcended their original context to acquire a universal meaning or timeless aesthetic value. But they remain tributes to the free political systems that fostered them and which they were originally designed to honor.

Michelangelo's *David*, for example, has come down to us as the quintessential image of male beauty, and as the greatest statue ever made by the greatest sculptor who ever lived. The statue has become so intertwined with the legend of Michelangelo that it is generally understood as an autobiographical statement. A great deal of scholarly attention has therefore been lavished on the figure's oversized right hand, which is read as a sort of signature for the human hand that carved the great block of marble. And so it is, but that is only one piece of a larger puzzle. There is another hand: the left hand holding the sling with which David outmatched his foe. For Michelangelo and his contemporaries, David's use of the sling was analogous to the startling achievements of the Florentine Republic. In just a few hundred years the city had transformed itself from a lackluster little market town into the first great financial hub of Europe – a success that fueled the cultural phenomenon

we call the Renaissance, which in turn produced superlative works of art such as the *David*.

In addition to the Parthenon and the *David*, this book examines eight other works of art and architecture that would be highlights in any undergraduate art history course. There is the bronze portrait bust that is traditionally believed to capture the stern features of Brutus, founding hero of the Roman Republic. St. Mark's Basilica in Venice is a splendid jewel adorning a city-republic that built its own solid ground and grew prodigiously wealty through maritime trade. Rembrandt's *Night Watch* honors the citizen militias that proudly defended the liberty of the Dutch Republic, which like Venice reclaimed land from the sea and prospered far beyond its size. In *The Last Breath of Marat*, Jacques-Louis David memorialized the tragic sacrifice of the revolutionary "Friend of the People" in the turmoil surrounding the first effort to establish a French republic. By salvaging the Elgin Marbles from the decaying Parthenon and putting them on permanent display in London, Thomas Bruce, Lord Elgin converted the work of Phidias into a proclamation that the British constitutional monarchy was the worthy heir of democratic Athens. Albert Bierstadt's *Rocky Mountains, Lander's Peak* conveys the huge potential of a young democracy in the untamed spaces of the New World, even while a brutal civil war threw the whole American project into doubt. Claude Monet offered his *Nymphéas* (Water Lilies) to the French Third Republic to commemorate its hard-won victory over imperial German aggression. Finally, Picasso's harrowing *Guernica* is a denunciation of the existential threats to democracy, such as fascism, that gathered in the twentieth century.

Each of these objects is part of an individual polity's narrative and gives us a snapshot of a point in its history. Some are prophetic of future greatness, others more retrospective. All provide tangible evidence of history that in some ways is more reliable than texts, offering powerful insight into successive efforts to establish and sustain a democracy. They are not isolated aesthetic objects; part of their value as historical evidence derives from their role in the public life of the communities that produced them.

These are not static objects that come down to us in a pristine state; indeed, only Monet's *Water Lilies* cycle is currently displayed as the artist intended. They have all continued to have eventful histories to this day, which is testimony to their powerful sway over the popular imagination. Three of them – *David*, *The Night Watch*, and *Guernica* – were physically attacked in the twentieth century by disturbed individuals who became obsessed with them. Two of them, the *Brutus* and the horses from St. Mark's, were forcibly abducted by Napoleon. And the Parthenon was

destroyed not by marauding hordes of barbarians in antiquity but in the early modern period by the Venetians and the British who claimed their own democratic roots in ancient Athens.

While these works of art represent vastly different historical circumstances, there are common themes that emerge from their stories: the moral power of a free citizenry, the responsibility of citizens to defend their liberty, the role of the statesman in commissioning works of commemorative art, the benefits of economic competition, and the increasing significance of the independent artist in honoring the polity's achievements. Moreover, there are connections between the works of art and their creators, just as there are links and echoes from one democracy to another. For example, the Roman republican tradition of portraiture exemplified by the *Brutus* inspired Rembrandt and was overtly imitated by some of the American founders. Jacques-Louis David felt a personal connection with Michelangelo because he shared the misfortune of facial disfigurement with the sculptor as well as a name with his most famous work. Great statesmen from Pericles to Georges Clemenceau understood the importance of fostering human creativity even in moments of national crisis. A resolutely undemocratic actor who well understood the power of art, Napoleon Bonaparte, appears in six of ten chapters, mostly in the context of a cautionary tale. This history is thus more than a sum of unrelated parts. Together, the stories of these works form a narrative tracing the aspirations and accomplishments of free peoples in the West.

Nevertheless, as a number of the chapters illustrate, nothing in this history was inevitable. Democracy is not preordained, nor is it guaranteed to survive. It is not a perfect form of government. Indeed, free systems have their own particular vulnerabilities, notably the lack of executive efficiency. This does not mean, however, that freedom is not worth the constant struggle to achieve and maintain. Winston Churchill famously remarked that "democracy is the worst form of Government except for all those other forms that have been tried from time to time," in an ironic reminder that the alternatives to this least worst kind of political system are not appealing.

In a coincidence, albeit a significant one, this book shares its name with the new generation of Israeli missile defense. While there are obvious differences between a missile defense program and a study in art history, both versions of David's sling demonstrate how liberty inspires human ingenuity. The exceptional works examined here serve to illustrate what is at stake as we safeguard and celebrate freedom in our own time.

A Note on Creative Reconstruction

As mentioned in the introduction, there are creatively reconstructed dialogues throughout this book. It is impossible to know exactly what Aeschylus said to Pericles, or Rembrandt to Joachim von Sandrart, or Frederick Lander to Lincoln, but there are primary documents – inscriptions, drawings, diaries – that put these individuals together at key moments of this history, inviting an educated guess as to what they may have said. Dialogue is introduced only when we have evidence that such an interaction took place.

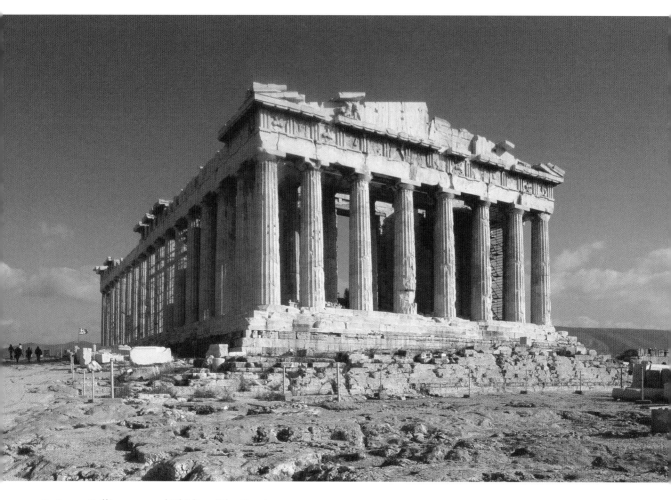

Ictinus, Callicrates and Phidias, The Parthenon, 447–32 BC.

Possessing Freedom

The Parthenon and the Birth of Democracy in Athens

Freedom is the sure possession of those alone
who have the courage to defend it.

PERICLES, "Funeral Oration"
as quoted by Thucydides in the
History of the Peloponnesian War

The Acropolis, Athens: 449 BC

Not one column remained standing, nor a single statue on its pedestal. The entire sacred precinct of Athens had been demolished with calculated thoroughness in two vindictive attacks, the first one in September of 480 BC. While most of the population had already been evacuated, a small force of temple stewards remained behind and fought valiantly, but unsuccessfully, to defend their sanctuary. Ten months later, the invaders came back to complete the destruction.

When the Persians attacked, the Athenians were in the process of rebuilding on the great rock that dominated their city. Some five hundred feet tall, with a surface area of almost eight acres, it had been inhabited for centuries and was known as the Acropolis, or "high city," which functioned as both a citadel and a sacred space. The citizens were starting to construct a grand new temple to Athena, their special protectress, on top of it in thanks for their prosperity and freedom, but the Persians put an end to that project. While they had no love for any of the Greeks, they harbored a special hatred for Athens, which had been the first to assist the Greek colonies of Asia Minor in their rebellion against Persian rule. So they ravaged the entire city – perhaps frustrated by the paucity of human victims. Their devastation of the Acropolis was especially systematic and savage, leaving only the bases of temple columns and a thick layer of dust and ash.

It turned out to be a parting shot. When the small Greek city-states – usually more inclined to attack each other than band together in com-

mon purpose – had first begun resisting the mighty Persian Empire in the 490s, the effort seemed futile. But to everyone's surprise, an unlikely alliance under the leadership of Athens defeated the Persians decisively and forced them out of Greece in 479 BC. The allies took an oath not to rebuild what the Persians had torn down, but rather to leave the ruins on their citadel as a reminder of what they had lost and of the need to remain vigilant in case the Persians returned.

Over the years, the Athenians went about fortifying and rebuilding much of their ravaged city, while the wreckage remained on top of the Acropolis. But after thirty years it was more of an eyesore than a memorial. Peace terms highly favorable to the Greeks had finally been reached with the Persians in 449 BC, and Athens had a leader who was determined to revive and expand the building projects that the Persians had derailed. He was the son of the politician Xanthippus, and his name was Pericles.

The Athenian Ecclesia – the popular assembly of male citizens who were eligible to vote in the city's democratic system – was meeting in its customary place on the Pynx, an unkempt hillock at the foot of the Acropolis. Pericles had already made the case for a magnificent new complex of buildings and monuments on the citadel, centering on a great temple to Athena. This would only be fitting for the metropolis that was now the undisputed leader of Greece, he had argued. The question before the Ecclesia that day was how to pay for it.

Originally, Pericles had reasoned that the work on his various building projects around the city would provide a way for laborers to earn a share of the public wealth, just as warriors did. It was a savvy move that brought him a well-trained, disciplined workforce and broad political support.[1] The Ecclesia had at first approved the expenditures with little question, but the staggering cost of the construction was becoming a scandal.

Pericles had enemies, particularly among the old guard – his father's friends – and they smelled weakness. The traditionalists of Athens disliked the Acropolis rebuilding plan; they thought the rubble should be left as it was. They had even less appreciation for the efforts of Pericles to shift political power from the great families to the wider citizenry. They expected to bring him down a notch or two at this year's vote over continued funding of the construction on the Acropolis.

When Pericles strolled to the center of the meeting space as if he had not a care in the world, the crowd immediately made room for him. A small man in his mid-fifties with a neatly trimmed beard, his most distinctive physical feature was his unnaturally large head. What was truly remarkable about Pericles, however, was his confidence.

1 Plutarch, *Pericles* 12.

"Friends, I have solved the problem of the building accounts," he said in a tone so engaging that even his bitter enemies – of whom there were several in the crowd – might feel that he was speaking directly to them. "Surely you can all see it as plainly as I. Why else would Athena have brought us the treasury of the Delian League if not to use it in her honor?"

The assembly was shocked into silence. The money in the Delian treasury had been deposited by the various city-states in the league – the alliance that had expelled the Persians – in return for Athenian protection. Traditionally housed on the island of Delos, this money had recently been moved to Athens, ostensibly so it could be better secured.

Pericles' enemies pounced. "Now you have gone too far!" thundered one old man, who by tradition spoke first because of his age. "They already suspect us for moving the treasury in the first place. What will they say when they learn we have used the money they have entrusted to us for waging war instead to bedeck Athens as if she were some whore, bedecked not with gems but with statues and temples?"[2] The word "whore" was a personal insult to Pericles, an intensely private man whose divorce of his wife and longstanding affair with the foreign-born Aspasia were subjects of considerable public gossip.

"You misunderstand me," replied Pericles, showing no sign of irritation. "I believe our responsibility to protect the Delian League is a sacred obligation, and I would never shirk it. But our duty is to provide protection in the form of soldiers and ships, which we have done and will do. And if we are providing it, what grounds would the league have to grumble?"

The opposition was having none of it. The crowd grew restive.

"Well then," continued Pericles, "if you are convinced we cannot use the Delian treasury, even though the city is so stocked with armaments that we will not have to purchase more for a generation, then I will pay for the rebuilding on the Acropolis myself. I rather like the idea of having the name 'Pericles' across the pediment of Athena's temple!"

At first there were some cheers. Pericles was fabulously rich; he could afford it. Then the idea sank in. The temple was still in the planning phase, but it was obviously going to be spectacular, the largest and the most elegant of its type. If Pericles got his way, rather than being a monument to Athens and her people it would be a monument to one wealthy man who might start to think of himself as a king. Suddenly, using the Delian treasury seemed like the prudent course.

It was often like that when you argued with Pericles. One of his toughest political opponents – an Olympic wrestling champion – once said that even if Pericles were wrestled to the ground he could convince

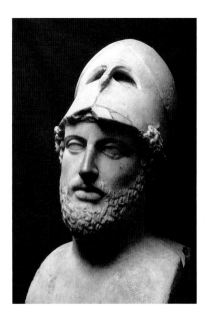

Pericles, son of Xanthippus, Athenian. Roman copy after a Greek original, c. 430 BC.

2 Plutarch, *Pericles* 12.

everyone standing around looking at him lying on his back that he had actually won the match.[3]

"Fine," spat the old man, "get on with it, and spend what you like, as long as not one piece of silver comes out of your blasted pockets."

The Acropolis: the dawn of time

"I saw it first, Athena," said Poseidon testily, "and it's mine."

It was true. As the lord of the ocean cavorted in the sea one day, a gleaming white rock about a mile ashore caught his attention. Upon further investigation, he found the site to be not only beautiful but also strategic, commanding broad views of the surrounding plain. Poseidon resolved that it should be sacred to him, and the few rude humans who had been living there would worship him.

Then Athena arrived to see what had captured her uncle's notice. As goddess of both wisdom and war, she quickly recognized the value of the Acropolis and laid claim to it as well.

Poseidon's anger at Athena's challenge set off earthquakes, and the fur-clad humans who witnessed this standoff muttered uneasily as the rock moved beneath them.

Athena was unimpressed. Instead, she gestured toward the men. "Why not let them choose? They are the ones who will be worshipping one or the other of us, so they may as well have a voice in the matter."

Poseidon thought for a moment, then grasped his trident and jabbed it deep into the rock. A spring gushed forth – salt water, the men discovered when they stuck their hands in it to be sure it was real. Poseidon folded his arms smugly as they marveled at his power.

Athena stretched out her hand. At first nothing happened, and Poseidon looked even more smug. Then a small rock tumbled over. A green shoot appeared where it had been and promptly grew into a small but sturdy tree with silvery leaves and green fruit.

Athena beckoned to the men. "This," she said, "is an olive tree."

A man picked one of the fruits and took a bite, which he quickly spit out. Rinsing his mouth with the salt water, he sputtered, "It's terrible! Must be poison."

"It is nothing of the sort. It just needs to be prepared correctly," Athena replied. Poseidon yawned. She glared at him and went on: "The fruits are hard and bitter now, but if you cure them in salt they become delicious and will last a long time. Or you can press them and they'll give

Amasis Painter, olpe with the contest between Athena and Poseidon, c. 540 BC.

3 Plutarch, *Pericles* 8. Pericles' chief political opponent was named Thucydides (possibly related to the historian of the same name).

you a wonderful oil that can be used for everything from cooking to dressing your hair. The tree itself can grow out of a rock and it takes care of itself."

Athena let the men come to the obvious conclusion. While a salt spring might be impressive, it was of little practical use since the water couldn't be drunk. This tree, on the other hand, offered shade from the sun as well as food and oil. In the end, the men voted unanimously to accept Athena's gift. Athens had her patroness.

So goes the myth of the founding of Athens, setting the stage for the great developments that took place in the city from the sixth to the fourth century BC – developments that reverberate through Western culture to the present day. The Athenians viewed themselves as being specially favored by the goddess of wisdom and war, and they believed that as long as they and their exceptional city were under her protection they would excel in both. But as legend told them, they had not passively received favors from the Olympians; they had made the crucial decision about the destiny of their city themselves.

The Theater of Dionysus: April 472 BC

"A curse is a heavy thing, Pericles," sighed Aeschylus.

"Don't I know it," Pericles replied wryly.

"It's certainly not something to joke about," the older man scolded. "I know more about curses than any other man in Athens." He was, after all, the city's foremost writer of tragedy.

The revered playwright and the young politician were sitting on wooden seats above the circular stage of the Theater of Dionysus, watching the final dress rehearsal for *The Persians*. The annual drama festival would begin the next day, and a trio of tragedies by Aeschylus were considered frontrunners for the top prize. *The Persians* in particular was attracting attention because it featured a contemporary event – the invasion of Greece by the Persian Empire – rather than a traditional subject such as the affairs of the gods or the legendary deeds of ancient heroes. Comedies, another innovation, had recently brought a lighter note to the popular theater festivals, but Athenians always preferred the tragedies, the darker and more heartrending the better. They appear to have reveled in painful topics, relishing the sight of the powerful and wellborn grappling with the same merciless fate that beset the common people.

Pericles was serving as the *choregos*, or producer, for Aeschylus at

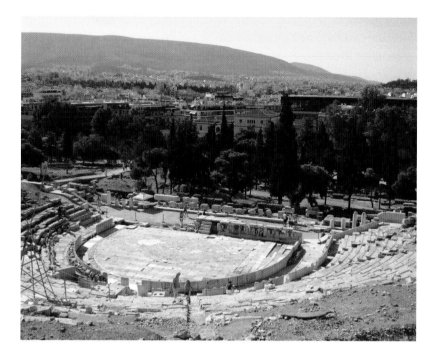

Modern remains of the Theater of Dionysus, originally constructed in the 4th century BC.

the Festival of Dionysus.[4] The Athenian governing council, the Boule, honored selected wealthy citizens by allowing them to pay for the plays. The *choregos* was also responsible for hiring the actors, training the musicians, and overseeing the sets. Pericles had recently received a substantial inheritance when his father died, and he was delighted to have been chosen as the producer for Aeschylus.

Then in his early twenties, Pericles had been considered a shy boy, hardly noticed in the shadow of his politician father and patrician mother. But in fact he had spent his time preparing, studying everything from philosophy to military tactics to human nature. He knew that some people joked about his mother's account of dreaming she had given birth to a lion the night he was born, but Pericles took the story seriously. Now he was ready to start making a name for himself.

Everything he had observed over his first two decades convinced Pericles that his city's achievements – culminating in the defeat of the Persians – were attributable to the unique form of government that had taken shape in the previous century. After the Greeks had emerged from the murky period that followed the breakup of the Mycenæan civilization around 1100 BC, Athens was ruled by a series of aristocratic clans who raised armies and dispensed justice. These families also enriched them-

4 Stephen V. Tracy, *Pericles: A Sourcebook and Reader* (University of California, 2009), 15, 22. Of the three tragedies that Aeschylus presented at this festival, only *The Persians* survives. The first play, *Phineas*, and the third, *Glaucus*, apparently both dealt with more traditional, mythological subjects.

selves by assuming the debts of the less fortunate, and eventually taking their freedom when they were unable to repay. More and more of the population lived in a condition of virtual slavery, as wealth and power were concentrated in the hands of fewer and fewer families.

At the end of the sixth century, the situation came to a head. Cleisthenes, of the powerful Alcmæonid family (from which Pericles was descended through his mother), attempted a thorough overhaul of the government to outlaw the practice of enslavement for debt and to extend voting rights to a broader base of citizens. This would effectively disenfranchise the council of nobles, who were used to a more exclusive authority. Not surprisingly, the oligarchs objected, and a few established themselves as tyrants. Cleisthenes was exiled.

Then a remarkable thing happened. The rest of the upper classes allied with the common people and rose up against the tyrants. Besieged in the old temple on the Acropolis, the former oppressors had to sue for mercy before being exiled themselves. In 505 BC, Cleisthenes made a triumphant return, after which he codified his reforms in the Athenian constitution.[5] According to this document, Athens was ruled by the Ecclesia, or people's assembly, which voted directly on legislation and was open to all male citizens with two years of military experience. A smaller group of five hundred, the Boule, was chosen from the Ecclesia to prepare and propose the laws. The Ecclesia also elected the magistrates who ran the legal system and the military, as well as a large pool of jurors to serve at trials. The entire enterprise was based on the novel premise of *isonomia*, the equality of all citizens before the law.

The result was the unprecedented participation of Athenians in their government, which became known as *demokratia* – rule by the *demos*, the free citizens in assembly. Over the centuries, critics have maintained that Athens was not a true democracy because slavery still existed and women were excluded from participating, as were those unable or unwilling to serve in the military. Even so, what was practiced in Athens became the paradigm of democracy in the West, the model that all future free systems would reference in some way. Cleisthenes' reforms, moreover, ushered in a dazzling burst of creative excellence, producing seminal achievements in art, drama and philosophy. The tragedies that Aeschylus was presenting at the Theater of Dionysus were a part of this broader cultural ferment.

The playwright kicked at the wooden theater benches. "Not so many years ago," he said, "we didn't have seats at all. We sat on the ground and that was good enough for us. Now everything is fancy."

5 Aristotle, *The Athenian Constitution* 3.17; see also Peter J. Brand, "Athens and Sparta: Democracy vs. Dictatorship," Ancient World Online, available via https://umdrive.memphis.edu/pbrand/public/.

"It can't be too fancy for me," Pericles replied. "I want to do your plays justice! They are noble things; the dignity of Darius is particularly impressive. But with all their wisdom and majesty, the Persians never understood that the root of their failure was to attack Athena's city in the first place."

"You may be an Athenian, but you should be careful assuming that you know what the gods are about, Pericles. Especially since your family . . ." Aeschylus's voice trailed off.

"Yes. The Alcmæonidæ were once under a curse. I know that is what you were hinting at."

"They murdered their enemies in Athena's temple. No matter what the reason, that is an unforgivable sacrilege, like a child killing his parent."

"But what if the parent committed a worse crime? Circumstances always matter. And our curse was lifted, so what my ancestors did couldn't have been so very bad." Pericles looked up at the ruins on the Acropolis. "Maybe one day I can wipe that slate completely clean."

"What do you think Athena would say?" Aeschylus asked. "She would want her people to avoid these crimes and honor each other as they honor her. That's more important than any passing political glory."[6]

Pericles drew the playwright's attention to the beautiful singing voice of the boy who was playing the part of Atossa, the Persian queen mother. But he could not help noting to himself that *pericles* literally meant "surrounded by glory."

When *The Persians* made its formal debut the following day, Atossa came onto the stage consumed with worry. The expedition led by her son Xerxes against the Greeks should have been an all-but-certain victory, for he took with him the cream of the military force of the mightiest empire on earth. But Atossa received the shocking news that the Persian fleet had been devastated by the Greeks at Salamis.

The queen went to the tomb of her husband, Darius, who had been defeated by the Greeks in the first Persian invasion. His ghost appeared and told her that Xerxes had brought this calamity upon himself by building an enormous pontoon bridge across the Hellespont, thus uniting Europe and Asia.[7] At some 1,350 yards wide, the bridge allowed Xerxes to move his immense army quickly from Persia into Greece; but it was an affront to the gods, who punished him for it.

Xerxes himself then appeared and walked to the center of the stage, with members of the chorus standing around him. He wore a rich, exotic robe, but it was dirty and torn, revealing wounds painted on in bright red, and his mask depicted an agonized scowl. He still could not compre-

6 This sentiment is expressed by the goddess herself when she appears in the final act of Aeschylus's *Eumenides*, the third in his trio of plays about the curse on the house of Agamemnon.

7 Herodotus, *The Histories* 7.34–36.

hend the reason for his own suffering. The audience sat spellbound as the Persian king bemoaned his lot:

> *Ah me, how sudden have the storms of Fate,*
> *Beyond all thought, all apprehension, burst*
> *On my devoted head! O Fortune, Fortune!*
> *With what relentless fury hath thy hand*
> *Hurl'd desolation on the Persian race!*
> *Wo unsupportable! The torturing thought*
> *Of our lost youth comes rushing on my mind,*
> *And sinks me to the ground. O Jove, that I*
> *Had died with those brave men that died in fight!*

The chorus asked the king over and over about the fate of the Persian heroes, with their flaming crowns and purple spears. They were all, Xerxes reported, "in the earth entomb'd." The chorus then lamented how the god of war had beaten down the Persian force:

> *Again the voice of wild despair*
> *With thrilling shrieks shall pierce the air;*
> *For high the god of war his flaming crest*
> *Raised, with the fleet of Greece surrounded,*
> *The haughty arms of Greece with conquest bless'd,*
> *And Persia's wither'd force confounded,*
> *Dash'd on the dreary beach her heroes slain,*
> *Or whelm'd them in the darken'd main.*[8]

After the play concluded with Xerxes and the chorus expressing their grief, the audience was silent for a while and then broke into thunderous applause. The decisive Battle of Salamis was only eight years in the past, and many of the audience members were veterans of the Persian Wars, including Aeschylus himself.

What Aeschylus left out of his drama is that the Persians might never have bothered to invade in the first place if the Greeks had not provoked them. Some Greek colonies in Ionia, on the Aegean coast of modern Turkey, had rebelled against the empire around 500 BC. Greeks from Athens and Eretria went to assist them, eventually sacking the city of Sardis.[9] In response, the emperor Darius I organized a force of twenty thousand men, which advanced all the way to Marathon, just a little north of Athens. It was so close that an Athenian courier sent back to

8 Aeschylus, *The Persians*, trans. Robert Potter, available at http://classics.mit.edu/Aeschylus/persians.html.

9 Herodotus, *The Histories* 5.97–105.

announce the Greek victory was able to run the 26.1 miles to Athens without stopping.[10]

The pioneering Greek historian Herodotus reports that the Persians lost 6,400 men at Marathon – more than a quarter of the force – while the Greeks lost only 192.[11] The defeat was so lopsided that Darius's son Xerxes vowed to return and destroy the Greeks as a sacred duty:

> I intend to bridge the Hellespont and lead an army through Europe to Greece, so that we can punish the Athenians for all that they did to the Persians and to my father. Now you saw how even Darius had his mind set on marching against these men, but that he died and did not have the opportunity to exact vengeance upon them. I, however, on his behalf and that of the rest of the Persians, shall not give up until I conquer Athens and set it on fire[12]

Things did not turn out as Xerxes planned. While the bridging of the Hellespont was a great achievement and the Persians did finally annihilate the Greeks at Thermopylæ in 480 BC, this was only after three hundred Spartans kept Xerxes' tens of thousands of "Immortals" at bay for seven humiliating days. The delay allowed the rest of Greece valuable time to prepare. The Athenians, in particular, were able to effect an orderly evacuation of their city, so when Xerxes arrived to put it to the sword he found only a small rearguard on the Acropolis. Meanwhile, the Athenian fleet had gone to the island of Salamis armed with a plan. The Greeks lured the Persian navy into a constricted strait near the island where their large, elaborate ships were unable to maneuver, and the swifter, more agile Greek vessels crushed them. Xerxes returned to Persia, and the war concluded the following year as an unqualified triumph for Athens and her allies.

Pericles was only a boy when these events took place, but he had witnessed enough of them to understand how remarkable the Greek victory had been – and by extension, how remarkable the Greeks must be. *The Persians* commemorated this proud achievement, and Aeschylus won first prize for tragedy at the Festival of Dionysus in 472 BC.

Athens: 461 BC*

There were a number of suspects in the murder of Ephialtes, the leading politician of Athens. One of them was Pericles, who as his deputy was

10 In his account of the Battle of Marathon, Herodotus mentions a courier going to Sparta and Athens, but not this fabled run, which first appears in Plutarch. Herodotus, *The Histories* 6.105; and Plutarch, *De gloria Atheniensium* 3 (available at the Perseus Digital Library).

11 Herodotus, *The Histories* 6.102–18.

12 Herodotus, *The Histories* 7.8.

likely to succeed him. But the more likely culprits were members of the traditionally conservative Areopagus, the council of aristocrats. Many of them believed that Cleisthenes' democratic reforms had resulted in mob rule, but Ephialtes thought the reforms had not gone far enough. In close consultation with Pericles, he stripped away most of the council's jurisdiction, a radical act that finally broke the power of the aristocracy and launched the most expansive phase of Athenian democracy.

If members of the Areopagus had indeed plotted to assassinate Ephialtes on the assumption that the reform movement would founder in his absence, they were quickly disappointed. Pericles became, in effect, the "first citizen of Athens" in 461 BC and aggressively continued the effort to transfer political power to the Ecclesia as he consolidated his own position. His main rival was ostracized, or banished, on the grounds that he was a Spartan sympathizer. Over the next decade, Pericles led Athens in an almost endless series of military adventures against the Spartans, against the Persians in Egypt, and even against the sacred city of Delphi. These expeditions had mixed results, but they nevertheless enhanced Pericles' power and burnished his prestige. For the moment, Athens was the acknowledged leader of Greece as head of the Delian League.

When a formal peace was finally settled with the Persians in 449 BC that permanently excluded them from Greece, Pericles declared it was high time for Athens to emerge from the long, self-imposed state of mourning that followed the sack of the city. A tiny olive seedling had appeared amidst the rubble left by the Persians on the Acropolis, and the citizens decided it must have sprung from Athena's legendary tree. Pericles interpreted the seedling as a sign that the sanctuary should be rebuilt (though he may well have planted it himself).

The first challenge for Pericles was financial. He was not an elected official with executive authority to dispense funds at will, but merely the most influential member of the Ecclesia. He could wield power only by calling on the support of allies and persuading his fellow citizens that his ambitious building plans were a worthy expenditure of the city's limited financial resources. But Pericles was nothing if not persuasive. When the various projects around the city were running low on funds, he convinced the Ecclesia to dip into the treasury of the Delian League – the money set aside by Athens and her allies for their common defense. The first stone for Athena's new temple was laid in 447 BC.

* * *

The Acropolis: c. 445 BC

When Pericles walked into the workshop, a scantily clad girl raced for a curtained enclosure at the back of the room. Phidias turned around with a scowl. "Impeccable timing as always," he snapped. "You've frightened my model."

"And whore?"

"Of course."

Pericles grinned. "Don't let her distract you too much – I need you to keep working."

"What else have I done these many years?" the sculptor sighed dramatically.

"Tell me about it! I've been to a banquet only once since Ephialtes died," Pericles responded.[13] "You've been well paid. Some say too well paid. And there are obvious benefits." He nodded toward the curtain. "Besides, aren't you now the most famous artist in Greece?"

The scope of Pericles' building projects, combined with his firm faith in the genius of Phidias, had given the sculptor a singular opportunity to remake the city center in his own style. Pericles had decided that the Acropolis would be completely razed, and what little the Persians left would be removed or embedded in the new foundations. Thousands of workmen, from day laborers to the most sophisticated engineers and craftsmen, were required to complete the task on the ambitious timeline Pericles had set, and only Phidias had the ability to coordinate this army so that their collective product was coherent.

His workshop was half stonemason's yard and half laboratory, with various tools for carving marble and chasing metal. The furnaces to cast bronze were nearby, on the south slope of the Acropolis. When Pericles dropped in, Phidias was working on a large clay figure of Athena holding a spear in one hand.

"I don't see why you need a nude model for this, Phidias. I've never seen a woman so covered up in all my life." Pericles gestured to the heavy, embroidered peplos that was pinned at the figure's shoulders and belted at her waist, draping all the way to the floor.

"The virgin Athena is always chaste, more's the pity," Phidias agreed. "But the important thing is to get the anatomy right beneath the drapery. Our old sculptors didn't care about such things and the bodies they carved were just blocks. But even under that shroud you can see that my Athena has the figure of a goddess. Look how gracefully she strides forward."

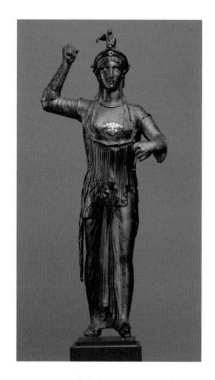

Statuette of Athena Promachos, 50 BC–25 AD.

"Her head is exquisite, but she is certainly fierce," Pericles observed.

"The goddess at war!" said Phidias, with visible satisfaction. "She is ready to lead Athenians into battle – truly *promachos* (first in war.)"

"How big will she be?" asked Pericles. He hated anything small.

"Thirty feet. Athena Promachos will tower over all the buildings. Her body will be bronze but her helmet and spear will be gold, so when they flash in the sunlight you will be able to see her all the way from the port at Pireaus."[14]

"Perfect. Then you can concentrate on finishing the temple – and the Athena Parthenos to go inside it."

The Acropolis: 432 BC

Pericles had to admit that even by his exacting standards, what Phidias and his team had accomplished was staggering. From the charred rubble there emerged a gleaming new complex that would stand as a testament to Athenian achievements in the decades since the Persians had been repelled. The ancient sacred way had zigzagged up the rock, but now visitors ascended a grand central ramp and were greeted by the Propylæa, or gatehouse, a massive structure of limestone and white marble with both Doric and Ionic columns. Inside the main space was a wall with five gates into the temple complex. On the western, outward-facing side, two wings flanked the building. Corresponding wings planned for the eastern side would never be built; reality caught up with ambition as tensions grew between Athens and Sparta, breaking into full-scale war in 431 and putting an end to the building projects.

Fortunately, the crown jewel in Pericles' complex had already been completed by this time. The space atop the Acropolis was dominated by a new temple to Athena, which came to be known as the Parthenon, taking its name from her title Athena Parthenos (virgin). Rectangular stone temples surrounded by columns standing on a platform of steps had a long tradition in the Greek world, and had been constructed as far afield as Sicily. The Parthenon had all the customary elements of this temple type, but on a larger scale and with an unprecedented quantity and quality of decoration.

Phidias had employed two engineer-architects, Ictinus and Callicrates, to oversee the building process. He planned to put a second statue of Athena even taller than the bronze Athena Promachos inside the temple, which was also to house whatever was left of the Delian treasury,

14 Pausanius, *Description of Greece* 1.28.2 (available at the Perseus Digital Library).

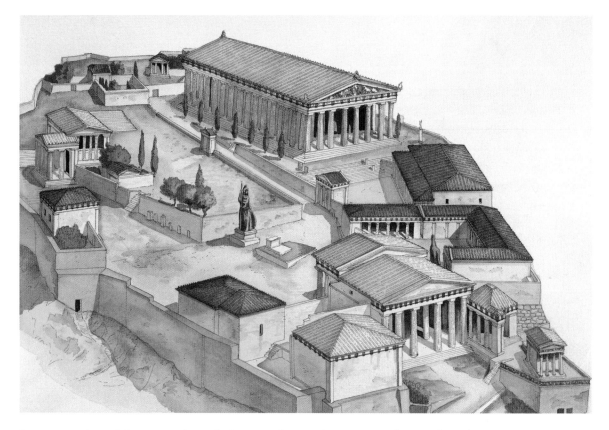

Reconstruction of the Acropolis with the Propylaea, Athena Promachos, and Parthenon.

so its proportions threatened to become bulky. Ictinus and Callicrates approached the project with surgical precision, adjusting their measurements by the millimeter to trick the eye into believing this huge masonry structure was light and elegant.[15]

Greek temples traditionally had peaked roofs, creating a triangular space known as a pediment above the horizontal shelf on top of the columns. Pediments were logical places for sculptural decoration, being highly visible. They were also awkward spaces; fitting a composition into a triangle was always a challenge. Earlier artists had simply made figures on a smaller scale in the sharp angles, but Phidias wanted to craft a design that would appear more natural, with all figures on the same scale.

The east pediment of the Parthenon, facing out toward the city, showed Athena's miraculous birth. Her mother, Metis, the primordial goddess of wisdom, had been one of Zeus's many paramours. When she became pregnant there was a dire prophecy that if the baby was a girl, she would be a goddess and a close ally of Zeus, but if a boy, he might one day dethrone his father. Zeus attempted to solve the problem by swallowing Metis whole. Nine months later, he suffered a headache so severe that he called for Hephæstus, the god of fire and the forge, and

15 The design of the Parthenon was so complex that Ictinus wrote a mathematical treatise on its intricacies, which is now lost.

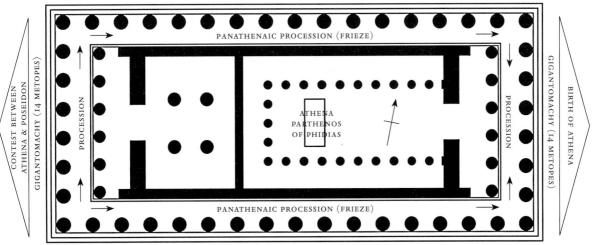

Plan of the Parthenon.

demanded that he cut open his head with an axe. Hephæstus obliged. To the amazement of all, Athena emerged full-grown and armed to the hilt. Metis was not heard from again.

This blessed event, according to legend, had occurred at dawn. Phidias envisioned it taking place in a sort of communal bedroom as the Olympian gods and goddesses were just starting up from their couches. The chariot of the sun was peeping out of the left-hand corner, while the tired horses of the moon goddess, Selene, descended into the right. The rest of the pediment was crowded with figures of the Olympians reclining in various states of undress. Dionysus, for example, was naked. For the goddesses like Hera and Aphrodite, less prudish than Athena, Phidias had been able to indulge his taste for clinging, diaphanous drapery. While they were still clothed, their voluptuous forms were so clearly revealed that everyone assumed he had used models covered in wet linen.

On the west pediment, Phidias had carved the foundation myth of Athens, the scene of the contest between Athena and Poseidon for control of the city. All Athenians coming up through the Propylæa toward the Parthenon would be reminded both of their special relationship with their protectress, and of how their ancestors had participated in deciding their city's future.[16]

Moving around the temple, visitors would have found seventy-eight rectangular stone reliefs known as metopes above the exterior colonnade. Rather like a comic strip, the metopes were individual scenes

16 This pediment was severely damaged in the seventeenth century and is almost impossible to reconstruct.

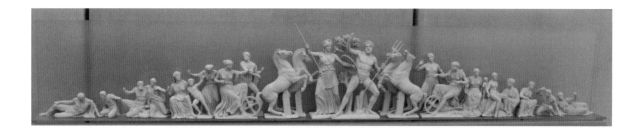

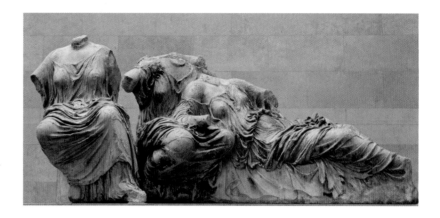

ABOVE: Reconstruction of the west pediment, Parthenon.

RIGHT: Phidias, detail of goddesses, east pediment, Parthenon.

framed by decorative moldings called triglyphs. The metopes told the story, over and over, of how very superior the Greeks were to all other peoples. Fourteen metopes under the east pediment showed the triumph of the Olympians over the giants, the original victory of reason over brute force. On the long south side of the temple, thirty-two metopes were devoted to the most ancient Greeks, known as Lapiths, beating back the half-man, half-horse centaurs. Under the west pediment, the Greeks defeated the Amazons, the race of ferocious female warriors whose queen, Antiope, married the Athenian hero Theseus – but who had also, like the Persians, attacked the Acropolis and been repulsed. On the north side, the final thirty-two metopes showed the destruction of Troy at the hands of the Greeks, the subject of the ancient poem *Iliupersis*, which picked up where Homer's *Iliad* left off. In all four of these cycles, the Greeks battled intently but impassively to dispatch the fierce and monstrous foes that threatened their civilization.

The Parthenon was surrounded by a full ring of columns, and visitors who mounted the steps of the platform could have circumnavigated the temple again in the shade and enjoyed yet more relief sculpture above the interior columns. Here there was a continuous frieze running

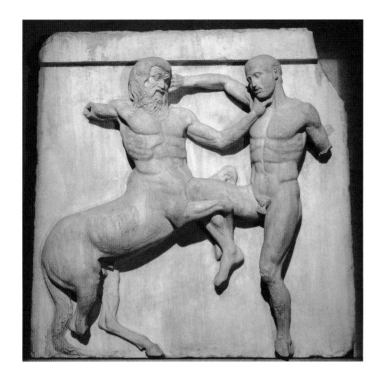

Phidias, metope with Lapith battling a centaur, Parthenon.

524 feet around the entire building. Instead of mythological scenes, like those ornamenting the exterior of the Parthenon, this frieze depicted the defining civic ritual of Athens.

The Olympic Games, founded in 776 BC and continued until 394 AD, were the most famous and long-running of the ancient Greek athletic festivals, but most cities had a local version of their own. A festival at Athens was first recorded in 566 BC (although the Athenians claimed it originated seven centuries before the Olympics). It was celebrated every year, and every four years there was a larger event, known as the Great Panathenaic Festival. This production included athletic contests, notably the mile-long dash from the port of Piraeus to the city of Athens by torchlight, as well as other traditional sports at the Panathenaic Stadium.[17] There were also music and poetry competitions. Capping off eight days of activities was the delivery of a new peplos to robe the ancient olivewood statue of Athena that was housed on the Acropolis.[18]

This procession was an exuberant affair that ran through the city and ascended the Acropolis to the sacred space outside the Parthenon. Participants included maidens carrying the peplos, a hundred oxen destined to be sacrificed to Athena, the triumphant athletes and the cream

17 The Panathenaic Stadium still exists; it hosted the 2004 Olympiad.

18 According to legend, this rather homely but extremely venerable statue had fallen out of the sky shortly after the foundation of Athens. It was evacuated from Athens during the Persian invasion, and thus survived the sack of the city.

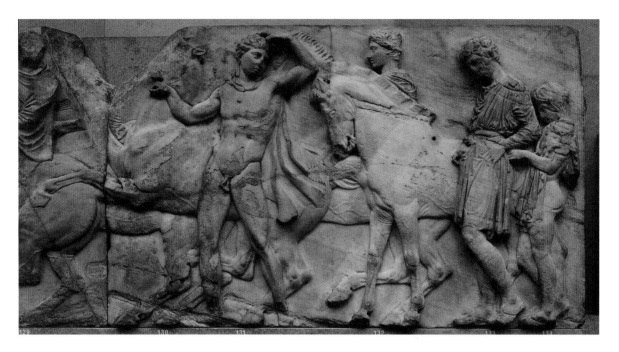

Phidias, detail of north frieze with riders preparing to form a procession, Parthenon.

of Athenian youth on horseback. Once the crowd arrived on the Acropolis there was a massive feast that went on all night.

The inner frieze of the Parthenon showed an idealized image of this procession, the bulk of which was devoted to the Athenian youths. All handsome, chiseled, and dressed only in cloaks, they handled their steeds with the same preternatural calm that characterized the heroes on the metopes. The frieze culminated on the east side of the temple with the preparation of the new peplos. Phidias's depiction of the Panathenaic procession was a timeless pæan to Athens's unique character, commemorating the city's past and affirming its future.

The line between Athenian mortal and Olympian god is blurred throughout the decoration of the Parthenon, with the humans becoming more perfect and the gods becoming more natural than they had been in any previous art. The elevation of the mortal and the humanization of the divine were achieved through careful attention to anatomy and a rigorous application of mathematical proportion to the figures. There is compelling evidence that what later came to be called "divine proportion" or the "Golden Ratio" was used throughout the Parthenon. The principle, which Euclid would describe in his *Elements*, around 300 BC involves dividing a line so that the ratio of the larger segment to the smaller

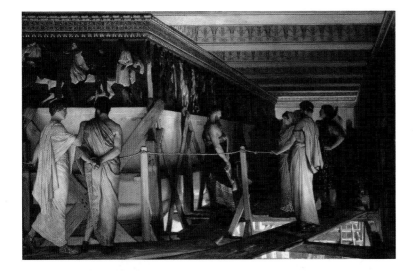

Lawrence Alma-Tadema, *Phidias Showing the Parthenon Frieze to His Friends*, 1868.

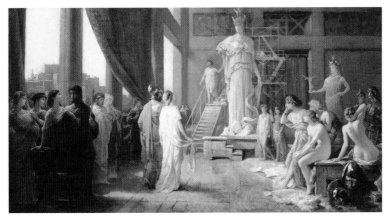

Hector Leroux, *Pericles and Aspasia Visiting Phidias' Studio*, c. 1870.

equals the ratio of the whole line to the larger segment. This ratio was considered especially pleasing to the eye, whether in the dimensions of a rectangle or the proportions of a human body. In the work that Phidias oversaw, all the figures, regardless of size, showed relative proportions consistent with the Golden Ratio, in everything from the size and shape of the head to the distance between the elbow and the tip of the middle finger. The same ratio governed the Parthenon's architecture as well, from the overall dimensions to the proportions of columns and capitals. While the effect might be subtle in the individual elements, the use of consistent mathematical proportion in both figures and architecture produced an overwhelming impression of supernatural harmony.

There are works predating the Persian sack of Athens that show

attempts to create figures that seem to respond to the same external forces that affect humans, such as gravity, but are flawlessly beautiful at the same time. This trend was still tentative when the Persians arrived, and the first victory monuments generally reflect the more traditional manner known as the archaic style.

By comparison, when Pericles launched his building program for the Acropolis, the new style of Phidias must have seemed nothing short of revolutionary. Phidias crafted an image of man not as he was, but as he could aspire to be. This style of sculpture had its critics; Aeschylus, for example, regarded the old style as closer to the gods: "Those ancient statues, though simply made, are to be considered divine, while the new kind, though elaborately worked and inducing wonder, have a less divine aspect to them."[19] But the idealized naturalism of Phidias was also widely admired. It has since become known as the classical style – the touchstone for excellence in Western art.

The pediments, metopes and frieze were all more than forty feet above visitors' heads, and were made more legible by bright paint and gilding that contrasted with the white marble – a contrast that continued into the interior of the temple. Here was Phidias's masterpiece, the colossal Athena Parthenos, towering more than forty feet. Like the bronze Athena Promachos outside, she wore a peplos and carried a shield and a spear, but she was made of materials far more precious than bronze: her skin was fashioned from thin sheets of luminescent ivory molded over wood, while her helmet, peplos and shield were gold.[20]

This technique of combining ivory with gold, known as chryselephantine, was a specialty of Phidias. Not only was it hugely expensive, it was also a technological marvel, as the ivory had to be imported and then carefully soaked to make it flexible. So much gold was required for this statue that it caused a scandal of its own. Pericles tamped down the criticism by pointing out that the gold elements were detachable and could be melted down to pay for the defense of Athens and the Delian League in future times of need, then recast from the original molds when the danger had passed.[21]

Like the Parthenon, the chryselephantine figure of Athena was covered with symbolic sculptural ornament. The griffins on her helmet were the mythological guardians of gold. The head of Medusa on her breast warded off evil. The figure of Nike in her right hand represented victory. On the outside of her shield, the Greeks battled the invading Amazons. On the inside, the Olympians defeated the giants. On her sandals, the Lapiths fought the centaurs. On the base of the statue, the gods witnessed the birth

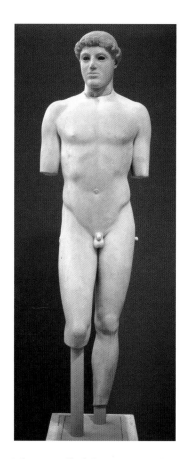

The so-called "Kritios Boy," c. 480 BC. This figure was smashed by the Persians in the sack of the Acropolis in 479 bc. It is an early example of what came to be known as the classical style.

19 As quoted in Richard Neer, *The Emergence of the Classical Style in Greek Sculpture* (University of Chicago, 2010), 103.

20 Pausanius, *Description of Greece* 1.24.5–7.

21 Thucydides, *History of the Peloponnesian War* 2.13.5. According to some

of Pandora, the first woman.[22] From her head to her toes, the Athena Parthenos reprised the larger message of the temple, visibly conveying the wealth, power, ingenuity – in a word, the superiority – of the Athenians, from the ancient days of gods and heroes to the age of Pericles.

The Sacred Way: November 431 BC

The Athena Parthenos was dedicated during the Great Panathenaic Festival of 438 BC, although work on the temple's exterior went on until 432 BC. Toward the end of the following year, the complex on the Acropolis formed the backdrop for Pericles as he climbed up on a specially constructed platform, artfully placed so his audience down on the ground would see him framed by the Parthenon and the Athena Promachos. Now in his sixties and completing his third decade as the leader of Athens, Pericles was in his thirteenth year as an elected general. He had been personally managing the conflict with Sparta, known as the Peloponnesian War, which had started in earnest that year. The early battles were going well for Athens.

Pericles remained undeniably the first citizen of Athens, but in a democracy that did not mean he was unopposed. His policies of broadening and strengthening the city's democratic system ensured that he had enemies, who were perpetually on the watch for weakness. In recent years they had been attacking him through some of his unorthodox relationships, particularly those with Phidias and Aspasia. Accusations of immorality and graft had, perhaps with some basis, dogged the sculptor throughout the Acropolis building projects. He was also accused of including portraits of himself and Pericles among the mythological Greeks fighting the Amazons on the shield of the Athena Parthenos, and was imprisoned on a charge of impiety.[23] Phidias ended up leaving Athens for Olympia, where he created a huge chryselephantine sculpture of Zeus that would be accounted one of the wonders of the ancient world.

Aspasia turned out to be a greater vulnerability for Pericles. She was his most powerful confidante and was famous for her intellect as well as her beauty. He freely acknowledged her, making no effort to mask their relationship. Her house became a regular stop on his daily walk through the city, and he would kiss his hand to her when she appeared in her window at the appointed time.[24] Besides being a mistress and so essentially an independent woman, Aspasia was also, even more dangerously, a foreigner. She hailed from Miletus, one of the Ionian colonies that had been involved in the revolt against the Persians.

sources, this ingenious plan was put into action in 300 BC when the tyrant Lachares melted down the detachable gold plates to pay his mercenary army. They were replaced with bronze replicas, rather than with the gold as Pericles specified. Pausanius, *Description of Greece* 1.25.7. The Athena Parthenos disappeared without a trace in late antiquity.

22 Pliny the Elder, *Natural History* 36.4.5 (available at the Perseus Digital Library).

23 Plutarch, *Pericles* 31.

24 Plutarch, *Pericles* 24.

Athenians nursed a deep distrust of foreigners and tried to keep them at arm's length. They had to compete in separate games during the Panathenaic Festival and had few political rights. Rumor had it that even the most quintessential of Athenians, Pericles, might be subject to their pernicious influence through Aspasia. Female, foreign and not his wife, she was an easy target and was publicly tried for lewd behavior. Pericles sprang to her defense; according to Plutarch, he made a most uncharacteristic outburst on her behalf, weeping with such emotion that the shocked jurors, accustomed to his famous poise, acquitted her on the spot.[25]

The comic playwright Aristophanes would later claim that Pericles started the Peloponnesian War either to distract from the scandals of Phidias or to avenge the abduction of two prostitutes working for Aspasia, but neither theory has been substantiated.[26] Relations between the Greek city-states were increasingly contentious as the unifying Persian threat receded into the past, though Pericles' specific rationale for leading Athens into war with Sparta remains obscure. After his long tenure as a general he had to be aware that Sparta, with its tradition of military excellence and large network of wealthy client states, would be a formidable foe. Pericles may have believed that their conflicting interests made war inevitable, and that the best chance of victory for Athens would be in a quick campaign of his own initiation.

At first, the plan went well. Pericles' strategy was to protect the city of Athens and depend heavily on the navy to harass the enemy while avoiding major engagements on land. The Athenian navy defeated Sparta's ally Corinth in an early engagement at Corfu with remarkably few Athenian casualties.

By tradition, those cut down in battle were cremated on the spot and their bones brought back to Athens for burial in a common grave just outside the city in an annual ceremony. Marathon was the only exception, the soldiers who died there being considered so heroic that they got a special monument on the field of battle.[27] The war with Sparta was not (yet) seen as unusual, so the normal protocols were followed. As the winter of 431/430 approached and the campaign season ended, Athenians prepared for a state funeral and selected Pericles to give a speech in praise of the fallen.

Since there were not (yet) many to mourn, he did not spend much time on consolation after he had climbed onto the platform in front of the new Acropolis temple complex. His theme was, rather, the glory of Athens and why it was in the best interest of all that Athens rather than Sparta prevail in this conflict. Sparta was a monarchy with a tightly regi-

25 Plutarch, *Pericles* 32.

26 Aristophanes, *Peace* 605–11; and *Acharnians* 515ff; see also Anthony J. Podlecki, *Perikles and His Circle* (Routledge, 1998), 104–5, 112–13.

27 Thucydides, *History of the Peloponnesian War* 2.34.5.

mented society that gave little value to the rights of individuals. According to Pericles, what made Athens exceptional was the city's experiment in democracy, through which free citizens could rise on their merits under the rule of law:

> Our constitution does not copy the laws of neighboring states; we are rather a pattern to others than imitators ourselves. Its administration favors the many instead of the few; this is why it is called a democracy. If we look to the laws, they afford equal justice to all in their private differences; if no social standing, advancement in public life falls to reputation for capacity, class considerations not being allowed to interfere with merit; nor again does poverty bar the way, if a man is able to serve the state, he is not hindered by the obscurity of his condition. The freedom which we enjoy in our government extends also to our ordinary life. There, far from exercising a jealous surveillance over each other, we do not feel called upon to be angry with our neighbor for doing what he likes, or even to indulge in those injurious looks which cannot fail to be offensive, although they inflict no positive penalty. But all this ease in our private relations does not make us lawless as citizens. Against this fear is our chief safeguard, teaching us to obey the magistrates and the laws, particularly such as regard the protection of the injured, whether they are actually on the statute book, or belong to that code which, although unwritten, yet cannot be broken without acknowledged disgrace.

Pericles then praised Athenian democracy for nurturing cultural excellence and personal responsibility, and for celebrating open public debate where each man could have his say:

> We cultivate refinement without extravagance and knowledge without effeminacy; wealth we employ more for use than for show, and place the real disgrace of poverty not in owning to the fact but in declining the struggle against it. Our public men have, besides politics, their private affairs to attend to, and our ordinary citizens, though occupied with the pursuits of industry, are still fair judges of public matters; for, unlike any other nation, regarding him who takes no part in these duties not as unambitious but as useless, we Athenians are able to judge at all events if we cannot originate, and, instead of looking on discussion as a stumbling-block in the way of action, we think it an indispensable preliminary to any wise action at all.

Athens presented a "singular spectacle of daring and deliberation" in which courageous men "are never tempted to shrink from danger." Moreover, said Pericles, "In generosity we are equally singular, acquiring our friends by conferring, not by receiving, favors. . . . And it is only the Athenians, who, fearless of consequences, confer their benefits not from calculations of expediency, but in the confidence of liberality."

Pericles declared Athens to be "the school of Greece," for no other people were "equal to so many emergencies, and graced by so happy a versatility, as the Athenian." Indeed, the greatness of democratic Athens needed no poet like Homer to glorify it for future generations, as it was proved in deeds – and it justified the Athenians in extending their influence widely:

> For Athens alone of her contemporaries is found when tested to be greater than her reputation, and alone gives no occasion to her assailants to blush at the antagonist by whom they have been worsted, or to her subjects to question her title by merit to rule. Rather, the admiration of the present and succeeding ages will be ours, since we have not left our power without witness, but have shown it by mighty proofs; and far from needing a Homer for our panegyrist, or other of his craft whose verses might charm for the moment only for the impression which they gave to melt at the touch of fact, we have forced every sea and land to be the highway of our daring, and everywhere, whether for evil or for good, have left imperishable monuments behind us.

Having extolled the unique character of Athens in detail, Pericles concluded that the Athenian "stake in the struggle is not the same as theirs who have no such blessings to lose," and that the fallen heroes he was honoring were "men whose fame, unlike that of most Greeks, will be found to be only commensurate with their deserts."[28]

Pericles' portrait of Athens was obviously idealized, like the beautiful figures on the Parthenon. The citizens of Athens could not all have been either so free of jealousy and anger or so law-abiding; and like other societies of the time, they accepted slavery and the disenfranchisement of women as proper and just. But the idealization was founded on a truth: the political liberty born under Cleisthenes and nurtured under Ephialtes – and Pericles himself – had created unprecedented opportunities for achievement, including the artistic excellence so clearly displayed in the gorgeous monuments behind Pericles as he spoke. Surely, the old

28 Thucydides, *History of the Peloponnesian War* 2.35–46.

statesman and general might be forgiven for assuming that even greater feats lay ahead for Athens as he prepared for the next year's military campaign.

Athens: 429 BC

A plague had arrived in Athens along with the warm spring weather of 430 BC. Generally accompanied by a violent cough, skin blisters and raging fever, it brought death in about a week. It was wildly infectious, cutting down entire families who were crowded into the city while the Spartans controlled growing portions of the countryside. The death toll was in the thousands; there were so many victims that when a pyre was lit to cremate one individual, people would creep out of the shadows with more bodies, throw them on the fire and run away.

Weakened by the disease, Athens was less successful in the second year of its war. Sparta had invaded Attica again. Pericles continued emphasizing the navy and pointed to the great strengths that Athens still possessed, but the people were demoralized. Pericles lost his generalship and was fined for fraud.

He regained his position the following year, but was now suffering from a slower but still deadly strain of the plague himself. Two of his sons had already died. When the end was near, in the autumn of 429 BC, Aspasia put a protective charm around his neck, and he observed with amusement that he must be very sick indeed to put up with such a superstition. His chamber was crowded with government officials, generals and friends, who reminisced about his great accomplishments and military victories. Pericles hushed them, saying that those things were not true victory. His life's work had been to govern by persuasion rather than force, and to honor what Athens had achieved as a democracy rather than a dictatorship. "My real triumph," he said, "was that no Athenian wore mourning because of me."[29] They were reported to be his final words.

After Pericles

The successors of Pericles, less skillful and less dedicated to democratic principles, exploited the democratic process to enhance their own power. The Peloponnesian War dragged on for many more years, punctuated by an uneasy truce, but the tide was turning against the Athenians – espe-

29 Plutarch, *Pericles* 38.

cially after a calamitous attempt to conquer Sicily in 415 BC severely debilitated the city's capacity to fight. Many allies revolted after a disastrous naval battle at Aegospotami. The Spartans besieged Athens, finally breaching the city walls in 404 BC.

Sparta imposed a new governing authority of thirty conservative aristocrats, the sort of men who had been so resistant to the democratic reforms of Ephialtes and Pericles in the 460s. The Athenians called this group "tyrants," and eventually a popular uprising restored the democratic system, but it was not long-lived. As the fourth century unfolded, new powers emerged to challenge the Greeks – first Philip of Macedon and then his son Alexander the Great, who dominated the Greek world and beyond during his brief life (356–323 BC). Farther afield, a city on the Italian peninsula was consolidating power and extending its sway. Rome would conquer Greece in 146 BC, and Athens would begin its long history of being a noted cultural center but not a political power.

There is no evidence that Pericles ever met the outstandingly curious – and ugly – young man who was born in Athens right around the time that Aeschylus introduced *The Persians*, but there are strong indications that Aspasia may have. Socrates was not a quiet, reflective sort of philosopher but rather a self-described "gadfly" who constantly asked impertinent and inconvenient questions in his pursuit of the truth.[30] Many people undoubtedly found him irritating, but Aspasia enjoyed the companionship of free spirits. Socrates was rumored to be a visitor to her house, some said for conversation, others said for different reasons.

Shortly after the Spartan-imposed tyrants had been expelled from Athens, the city's democratic government sentenced Socrates to death on charges of having corrupted the youth of Athens – those pure and perfect creatures immortalized on the Parthenon frieze. As Athens found itself in a precarious state economically and politically, the sort of questions that would previously have been tolerated were now considered seditious. Socrates accepted the death sentence on the grounds that he loved Athens and believed its government to be just, and he calmly drank the poison hemlock when it was brought to him.

His followers were less accepting. Plato, most notably, developed a skepticism of democracy after his teacher's execution. In *The Republic*, Plato ranks democracy near the bottom of his list of government types. He argues that the blind pursuit of freedom can become a kind of slavery when the city is governed by those who know how to win elections, not those with the people's best interests at heart.[31] In Plato's ideal system, government would be guided by a constitution that guarantees jus-

30 Plato, *Apology*.

31 Plato, *The Republic* VIII.555b–IX.580b.

tice for all citizens, but power would be wielded by a benign monarch with a vested interest in the long-term success and stability of the state.

Plato took up Pericles' posthumous reputation directly in his less well-known dialogue *Menexenus*. The piece is a conversation between Socrates and Menexenus, a young Athenian, about the now-annual oration for the war dead. In a none-too-gentle mockery of Pericles, Socrates delivers a speech he claims was composed by Aspasia, and even suggests that Pericles' famous funeral oration was also written by his mistress. Whereas Pericles made a bold assertion of Athenian exceptionalism in his speech, Socrates focuses on praising the deceased and suggests that Athenians, instead of trying to reshape the world, need to accept their place in it, for "[a] mortal man cannot expect to have everything in his own life turning out according to his will"[32]

Athens's greatest philosopher thus reflected on the legacy of its greatest statesman with more irony than reverence. But while Plato may well have been right in noting the flaws of Athenian democracy, fortunately for Western civilization he had a pupil of his own named Aristotle who would leave a far more favorable record of it.[33] The city's political and cultural achievements in the Periclean age remain no less impressive for having been fleeting. Indeed, what was created there during those brief decades inspired each of the following chapters of this book, and it remains a powerful – if controversial – legacy to this day.

32 Plato, *Menexenus*.

33 For the tension between the Platonic and Aristotelian schools of thought, see Arthur Herman, *The Cave and the Light: Plato vs. Aristotle, and the Struggle for the Soul of Western Civilization* (Random House, 2014).

For Liberty and Blood

Brutus and the Roman Republic

For liberty and Rome demand their blood
And he who pardons guilt like theirs takes part in it.

Voltaire, *Brutus*

Delphi: c. 540 BC

Titus and Arruns Tarquinius shared a self-satisfied smile as they passed the rows of triumphal monuments lining the road to the ancient shrine at Delphi in central Greece. The beautiful marble and bronze faces of generations of athletes stared impassively at the travelers, secure in their timeless perfection. The aristocratic brothers felt a certain kinship with them, which they did not think extended to their cousin who was traveling with them.

Appearing stupid can be a remarkably smart disguise, and Lucius Junius had it down to a science. His rough face with its heavy beard was a far cry from the polished features of the Tarquin family, let alone the superhuman Greek athletes. His cousins had nicknamed him "Brutus," or idiot. He plodded quietly behind Titus and Arruns, keeping his eyes on the ground.[1]

The three young Romans had made the long journey to Greece to find out which of them should be the next king of their city. Rome may not have seemed much to rule in those days, with about 35,000 inhabitants and a territory of some 350 square miles. The capital was a cluster of simple clay and wood structures that clung to a group of hills near the Tiber River. While strategic, the location couldn't function as a port since the river was too shallow to allow the passage of seafaring vessels. At the same time, the proximity to the river meant that floods were a constant menace, and the flatlands were a swamp where disease bred easily. Rome's neighbors, the Etruscans, considered Rome a rather crude minor power. They preferred to build their cities directly on the coast to facilitate the sea trade, or on more salubrious inland hilltops.

Brutus (so-called), c. 300 BC.

1 Dio Cassius, *Historia Romana* 11.10.

29

But the Romans were determined. A recent king had drained the swamp by constructing a great sewer, the Cloaca Maxima, to create the dry land for a proper city center. The Romans were so proud of this feat of engineering, the world's first covered sewage system, that they appointed a dedicated deity, Venus Cloacina, to protect it and built a temple in her honor. They insisted that all number of divine portents foretold a mighty future for their city, which would require a suitably strong ruler.

The obvious candidates were Titus and Arruns Tarquinius, sons of the current king, Lucius Tarquinius Superbus, or "Tarquin the Proud." He had assumed the throne after murdering his predecessor (who happened to be his father-in-law), and he wanted to institute a more orderly succession plan.[2] Tarquin was a powerful autocrat who expanded Rome's influence throughout central Italy, but he was not uniformly popular at home. His habit of ignoring the traditional cabinet of advisers to the king, known as the Senate, had provoked the most criticism. Consultation with the Senate, which included men from the most prominent clans, was not a point of law, but the Romans had become accustomed to having a say in how their monarchs governed. Tarquin responded to their grumbling by summarily executing some of the senators.

As he grew older, Tarquin had come up with a scheme to put the succession in the hands of the gods. He would send his two most promising sons to Delphi to ask Apollo's oracle which one should be king. To offset charges that the Tarquins were being too presumptuous by assuming that one of their own would be the successor, he sent along his sister's dullard son Brutus as a token outsider.[3] Apollo would know at a glance that this young man was no king.

The cousins had an arduous trip across the Italian peninsula through the lands of hostile tribes on uncertain tracks; the famous roads that would unite a vast empire were centuries in the future. But once they had sailed away from the Adriatic coast and finally reached Delphi, they received a warm welcome. They were wealthy enough to pay the tribute that would allow them to jump to the front of the long line of poor pilgrims who waited for days to consult the oracle and were mostly turned away without gaining an audience.

According to legend, in the mists of time long before the Trojan War, Delphi had been guarded by a monstrous reptile – a dragon known as the Python, with the head of a woman and a habit of eating men alive. Apollo had slain it with his arrows and taken the sanctuary as his own. His priestess, Pythia, was installed in a rocky cave where she could inhale

2 Livy's *Ab urbe condita libri* (*History of Rome*) records that Tarquin had been attracted to his predecessor's daughter Tullia, who was inconveniently married to his brother, while Tarquin was married to her sister. Tarquin and Tullia murdered their spouses so they could marry each other, then plotted to overthrow Tullia's father. When this was achieved, Tullia personally drove her chariot to the place where her father had fallen and ran over his body for good measure. *Ab urbe condita* 1.47.

3 Livy, *Ab urbe condita* 1.56.

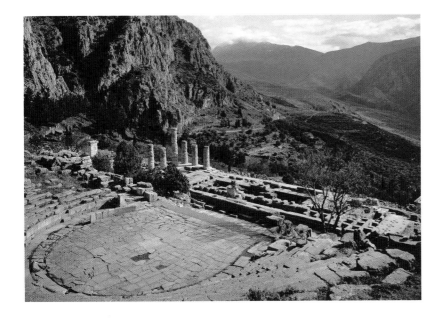

Modern remains of the theater at Delphi, originally constructed in the 4th century BC.

the gases that came up out of the earth from a crack in the floor. In a hallucinogenic trance she would mutter cryptic words that, when correctly interpreted (for another fee), foretold the future.

Titus and Arruns were unnerved by the unblinking glare of the old woman who swayed precariously on a three-legged stool. The cave reeked with the smell of subterranean gas and incense. A priest whispered their query over and over in her ear: Who would next rule Rome?

Pythia stared at the brothers for a long time, then glanced at Brutus, who as usual stood a little behind. Her eyes rolled up into her head and she emitted a stream of gibberish in which only the words "kiss" and "mother" could be understood. Finally she fell silent and slid from her stool to lie still on the floor of the cave. The priest guided the three Romans out to the antechamber, which was richly furnished thanks to the generosity of those whose questions had been answered favorably.

"She chose me!" Arruns and Titus declared simultaneously.

The priest shook his head. Once the requisite tribute had been produced, he informed them that the choice had not yet been made. They should return to their city and the first one to kiss his mother would be the next to rule over Rome.

The young men pondered the oracle's prediction on their long trip home. Arruns and Titus were focused on how to get to their mother first. As queen, she would be at the front of the party coming out from

the city to greet them. They didn't worry about Brutus, whose mother – a mere younger sister of Tarquin – would be well behind the royal couple.

The brothers raced their horses back to Rome, then sprinted to their mother, knocking her over in the process. Both brothers claimed to have reached her first.

Brutus brought up the rear. When he caught up with them, Arruns and Titus stopped arguing with each other and started laughing at him. His face was covered with mud.

"Don't tell me," Arruns jeered. "In your hurry to reach your mother, you fell off your horse! As if you were ever going to get there first."

Brutus looked down, as if ashamed. But he had not fallen. He had deliberately slipped off his mount the moment it crossed into Roman territory, and pressed his lips to the earth of his motherland long before Arruns and Titus came anywhere near the queen.[4]

Rome: c. 510 BC

Rape was not a crime per se in ancient Rome.[5] Men dominated society, and women were for the most part a cheap commodity. But the rape of a noblewoman, particularly a married noblewoman, was serious business, involving issues of bloodline and inheritance in addition to honor. It was even more serious when the man in question was a royal prince, as was the case when Lucretia, wife of Brutus's good friend Lucius Tarquinius Collatinus (a distant relative of the royal family), was raped by Tarquin the Proud's third son, Sextus.

Like his brothers, Sextus had been brought up with autocratic pretensions. He had also shown himself to be an exemplary liar. Tarquin exploited this talent when he sent Sextus as a double agent to the neighboring town of Gabii, which Rome wanted to conquer. The leading men of Gabii accepted Sextus's claim that he had betrayed his father to join them, and they made him a general in their army. Having gained their trust by fighting against the Romans, Sextus hatched a plot to murder all the noblemen who had befriended him. Tarquin then sacked the defenseless town.[6]

Sextus rejoined his father's army and they targeted another unfortunate neighbor. One evening, bored with their maneuvers, the Romans decided to go home and surprise their wives to see how they spent their time while their husbands were away. They found the Tarquinian women dressed in their finest clothes and preparing to have a lavish banquet,

4 Livy, *Ab urbe condita* 1.56; Dio Cassius, *Historia Romana* 11.11.

5 According to legend, as recounted by Livy, the Roman nation was founded on the abduction and rape of women from the neighboring Sabine clan, which was considered a heroic and patriotic act. *Ab urbe condita* 1.9.

6 Livy, *Ab urbe condita* 1.52–54.

while Collatinus's wife, Lucretia, was working quietly with her maids in her day dress.[7]

Sextus was annoyed by this display of virtue, which he believed to be just a show to make the royal ladies look bad by comparison. To prove it, he quietly returned to the house of Collatinus the next night and attempted to seduce Lucretia. When it became clear that she would not be persuaded by his promises of love, he drew his sword and threatened her with death. She was still unmoved, so Sextus told her he would kill a male servant along with her and put them naked in bed together so everyone would believe for all eternity that she had been unfaithful. Faced with the threat of perpetual dishonor, Lucretia gave in.

When Sextus was gone, Lucretia sent a message asking her father and husband to come home with one trusted companion; Collatinus chose Brutus. She told them what had happened, and showed them the despoiled marriage bed. Taking her husband by the hand, she begged him through her tears to punish Sextus for his crime.

"Of course," Collatinus responded, trying to embrace her. "You are blameless – your soul is not responsible for his crime against your body."

Lucretia pushed him away. "Don't touch me," she said. "My body is shamed beyond recovery. It can only be absolved through the proper punishment." With that, she pulled out a dagger and stabbed herself in the heart.[8]

Her father and her husband screamed in shock, but Brutus kept his head. Striding forward, he yanked the bloody dagger from the dead woman's chest. "I swear by the gods," he shouted, "to expel Superbus Tarquin, his wife, and their disgusting offspring from Rome – by fire, iron, or whatever means I have. Our city shall have no more kings!"[9]

Rome: 509 BC

The Tarquins were sent into exile in 509 BC. Contrary to expectations, Brutus did not become king of Rome, although he was certainly eligible. He was popular, and – it was quietly known – he was the one chosen by the Delphic sibyl to succeed Lucius Tarquinius Superbus. The prospect of ruling the city as it grew in power and wealth was attractive, but Brutus and his friends had another idea.

Rome was still a backwater around the time the Tarquins were expelled, but the Italian peninsula had many visitors. Rome's more prosperous neighbors were trading with the Greeks who had settled in Sicily

7 Livy, *Ab urbe condita* 1.57.

8 Livy, *Ab urbe condita* 1.58; Dio Cassius, *Historia Romana* 11.12–19.

9 Livy, *Ab urbe condita* 1.59.

and southern Italy, a region that became known as Magna Græcia, or Greater Greece. Brutus himself had visited Greece as a young man, so he would have been generally aware of what was going on there, including the fledgling development of democracy. Any Athenians the Romans subsequently encountered would have made sure of that.

The Romans were always keenly aware of the cultural superiority of the Greeks (particularly the Athenians), but their appreciation for the Greek model tended toward adaptation rather than flattering imitation. So while Brutus clearly admired a government in which citizens played an active role and no one man dominated, he did not attempt to replicate the Athenian system in Rome. Instead, he forged something specifically Roman: a republic in which citizens voted for the officials who would govern the state, rather than voting on individual pieces of legislation as they did in Athens.

The government established in Rome in 509 BC would change over time and suffer its share of crises and setbacks, but the basic elements endured for more than four centuries – significantly longer than democracy in Athens. The Roman Republic included a revitalized and expanded Senate that was no longer the council of a king, but a formal legislative body that deliberated over and then voted on the laws proposed by smaller regional assemblies of citizens.

Senators served for life and were originally drawn from the patrician class, but later included representatives from the *plebs*, or commoners, as well as the *equites*, a class of horsemen with a military origin, just below the patricians. There were between three hundred and six hundred senators, and for official and celebratory occasions they wore distinctive togas to indicate their rank: pure white for the most junior members, while the leading senators had a broad purple border on their togas and special buckles on their shoes.

The Senate was responsible for security and foreign policy, public works, and overseeing the judicial system. Elected officials led by two consuls, and later two tribunes, managed the day-to-day business of the government. In times of emergency a dictator could be appointed, but he was expected to resign voluntarily when the danger passed.

Brutus was already a senator and was a logical choice to be one of the first two consuls, who would serve for a year, alternating the primary power monthly. His partner was Collatinus, the husband of Lucretia. In short order, the new government faced a crisis that threatened to destroy it from within.

The Tarquins had not gone quietly into exile. Instead, they went to

their kinsmen in the town of Cære, northwest of Rome, and plotted a return to power. They were furious with Brutus, who they assumed would take the kingship and along with it the substantial fortune they had had to abandon when they fled. For all their bad behavior, the Tarquins were not without supporters in Rome, and they made discreet inquiries to friends in the Senate about the lay of the land. Encouraged by the response, Titus and Arruns approached relatives who were not happy to have lost their royal privileges, promising them a return to the old ways if they supported the Tarquins. A group agreed to help, among them Titus and Tiberius Junius, who were sons of Brutus.[10]

Titus and Tiberius had, like most, assumed that their father would become king – and that they would hold the same princely position that Titus, Arruns and Sextus had enjoyed. Although pleased that Brutus was the de facto ruler of Rome as consul, they had little use for the democratic system that would end his rule after a year and return him to the status of one among many in the Senate. When Titus and Arruns approached them, the Junius brothers decided they had nothing to lose. If the plot succeeded, the Tarquins would be grateful and reward them. If it failed, they could throw themselves on the mercy of their powerful father, who would be in a position to protect them.

The conspirators made the mistake of discussing their plans in front of a slave, including the fact that they had recorded the details of the plot in a contract that was going to be delivered to the Tarquins at an appointed time and place. The slave reported them to the authorities, the guilty parties were arrested at the rendezvous, and the written evidence of the conspiracy was seized. When confronted, Titus and Tiberius admitted what they had done, assuming that Brutus would put his fidelity as a father over his duty as consul. They anticipated a token period of exile in one of the nearby Etruscan cities, which might actually be enjoyable, after which they would return to their rightful places. They turned out to be poor judges of their father's character.

Brutus looked sternly at his sons. Their crime, he declared, was treason against the Roman state. He reminded them of the oath they had sworn before him to defend the new liberty of the Roman people from the bribes and promises of kings. Citizenship in the republic was not just a privilege, it was also a weighty responsibility, and true citizens would always put Rome before their personal interests. The consul's sons had betrayed that trust. The law was unequivocal, and the penalty was death. The traitors were thrown into prison with no further discussion.

On the appointed day of execution, a large crowd gathered on land

10 Livy, *Ab urbe condita* 2.3–4.

freshly drained by the Cloaca Maxima, a place that would one day become the Roman Forum. While there were a number of conspirators meeting their fate, everyone was looking at Brutus and his sons, wondering how the consul would handle the event. Many heroes had given their lives in battle for Rome as their patriotic duty; it was quite another thing to deliberately sacrifice two sons in their prime. Titus and Tiberius were stripped and brutally flogged. Some observers reported that Brutus winced and even wept as the boys cried out for him to save them. But he regained his composure, his face settling into an impassive mask. He gave the order for his sons to be decapitated. The slave who had exposed their plot was given citizenship and a rich reward.[11]

The assembled Romans were aghast, but also impressed by Brutus's self-control and willingness to sacrifice his personal happiness for the state. They started to cheer. The consul stood up and raised his hand for silence. "Do not praise me," he said, "for I am nothing now but a grieving father. Let me go and prepare my house to receive the bodies of my sons." The crowd quietly parted to let him through.

The Roman Senate confiscated the Tarquins' property in Rome, which infuriated the family, and they made an attempt to retake the city by force. They marshaled a large Etruscan army that should have outmatched any force the Romans could field.

At first, the battle appeared to be going to the Tarquins. Arruns was in charge of the cavalry, and he confidently observed the smaller force of Roman horsemen. His eye was caught by a group of lictors carrying the ceremonial fasces, the bundle of rods surrounding an axe that symbolized the authority of Roman magistrates. That could mean only one thing: a consul was present. Scanning the lines, Arruns recognized Brutus's distinctive face. He spurred his mount forward, unable to believe his luck. If he could get rid of his stupid cousin once and for all, the road to Rome would be open. Brutus recognized Arruns as well and rode out to confront him. No words were exchanged as the two cousins speared each other through the chest.[12]

Brutus's death galvanized the Romans, while the Etruscans were demoralized by the loss of Arruns. The battle ended in confusion, but the Romans quickly declared victory and returned to their city to bury their hero. The Tarquinian forces scattered. Tarquin the Proud and his sons were finished for good this time.

Brutus received a magnificent funeral and the entire city mourned him for a year, led by the women of Rome. A large bronze statue was commissioned depicting him brandishing the dagger he had pulled out

11 Livy, *Ab urbe condita* 2.4.

12 Livy, *Ab urbe condita* 2.5.

of Lucretia's chest as he swore to free Rome of tyrants. It was placed in front of a grand temple to Jupiter, which had just been completed on the sacred Capitoline Hill.

The bronze *Brutus* drew upon Greek precedents for commemorative monuments and may have been executed by Greek craftsmen who were well versed in casting metal. Still, the generations of Romans who viewed this image of Brutus would have had a very different experience from that of the Athenians who marveled at the beauty of statues such as those adorning the Parthenon. The Greeks specialized in sculpting perfect faces that showed no trace of age or strain, conveying a spiritual

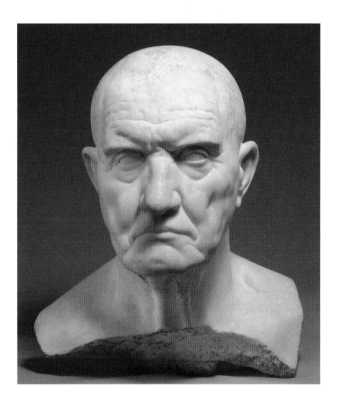

Marble bust of a man, mid 1st century AD, Roman. The Metropolitan Museum of Art.

superiority unaffected by the outside world. Judging from its art, classical Athens was exclusively populated by young and beautiful people who did not break a sweat, even if they were holding up buildings with their heads or battling monsters. The heroes of the Roman Republic, by contrast, were not transformed into the superhuman counterparts of the classical Greek heroes. Artists began showing them as they were, accentuating rather than airbrushing their individual, imperfect features.

The result was the first realistic portraits as we understand them – images that record the unique appearance and individual character of their sitters. In Roman culture, their weathered, lined faces had something higher than mere beauty; they reflected the toil and sacrifice that produced the republic. The greatest ornaments of those portrayed were their heroic deeds, such as Cincinnatus leaving his plow in the field when suddenly appointed dictator to counter an Etruscan invasion and then returning to it immediately after the threat had been repulsed, or Fabius Maximus waging a long campaign to defeat Hannibal and all his elephants in the Second Punic War. The portrait busts of early Romans were treasured by their descendants, who displayed them in their homes as reverence for the forefathers developed into a sort of patriotic religion.

The harsh features of Lucius Junius Brutus had earned him a nickname that was intended to be mocking but wound up as a badge of honor. Indeed, Romans of later generations who wanted to connect themselves to the founder of the republic would claim to resemble his portrait on the Capitoline.[13]

Rome: March 15, 44 BC

Some 450 years after the statue honoring Brutus was erected on the Capitoline Hill, one of his descendants, Marcus Junius Brutus, picked up a dagger and plunged it into the chest of the most powerful man in Rome. Julius Cæsar was the scion of the noble Julian clan claiming descent from Aeneas, who according to legend had fled Troy as the Greeks annihilated it and then made his way to the Italian peninsula. Cæsar was a brilliant politician and statesman but above all a warrior, campaigning as far afield as Britain and Egypt. The territories under the control of Rome were expanding dramatically, and this growth put a strain on the republican government while a series of civil wars was crippling it from within. When the Senate voted to make Cæsar "dictator in perpetuity" in an effort to restore order, it was a radical transformation of the office that had been devised in the early republic as a temporary expedient for crisis situations.

Most Romans believed that Cæsar was preparing to dissolve the republic once and for all. In desperation, his rivals banded together with the few stalwarts who thought the republic could be preserved, and they plotted his assassination. A key to the conspiracy was the participation of a new Brutus, who would bring the legitimacy of his ancestor's heroic tyrannicide to this rather underhanded bit of political violence.

13 Plutarch, *Brutus* 1.

Instead of confronting Cæsar in a fair fight, the assassins planned to kill him when he was unarmed at a regular meeting of the Senate on March 15, known as the Ides of March. The defenseless Cæsar was stabbed thirty-three times and bled to death. Marcus Junius Brutus then led the attackers to the Capitoline – where the bronze statue of his ancestor still stood – and declared to the Romans that they were free again.[14]

Cæsar does not seem to have been taking serious precautions to prevent this turn of events. He had dismissed his personal guards some weeks before, perhaps realizing that he would not survive the tumultuous breakdown of the republic. He had lived by the sword and was likely to die by it, but he might be able to arrange things so that his sister's grandson Octavian could assume power after him and set the Roman world to rights.

Octavian eventually did just that, but only after decades of bloody and destructive conflict to subdue rival claimants to power – beginning with the dispatching of Brutus and his co-conspirators, and culminating in the defeat of Mark Antony and Cleopatra at the Battle of Actium in 31 BC. It was becoming clear that the system fashioned for a small city-state was not equal to governing a sprawling empire. But even as Octavian restructured Rome's government – and acquired an imperial title, Augustus – he was mindful of the power of the Roman past.

The deeds of the republic's heroes had been reverently passed down, becoming more awe-inspiring with each generation. Their rigorous moral code and self-sacrifice stood in stark contrast with those who had mired Rome in civil war, from Sulla to Mark Antony. They even looked different, as their rough faces – immortalized in official portraits and innumerable private busts lining the shelves of upper-class homes – gave a mute reproach to their effete descendants who swathed themselves in luxuries imported from Egypt and Byzantium.

For Titus Livius, a scholar and distant cousin of Augustus's wife, Livia, those heroic stories were not mere legends. They were proof of Rome's early greatness, which could serve as the foundation for even greater achievements under Augustus and his successors. Following the example of the Greek historians Herodotus and Thucydides, he embarked on a sweeping study of Rome's history from its origins to his own time. In forty years of writing, he produced a massive work organized into 142 scrolls, titled *Ab urbe condita libri*, "Books from the Founding of the City," but more commonly known as *The History of Rome*.

In his introduction to the history, Livy advised his contemporaries to look back to their city's origins for the keys to their own character.

Silver denarius minted for Marcus Junius Brutus, 43–42 BC. The reverse shows the dagger that Lucius Junius Brutus pulled out of Lucretia and the dagger that Marcus used to kill Cæsar.

14 Plutarch, *Brutus* 14–18.

Despite all the recent bloodshed and upheaval, he saw a grand symmetry in Roman history, from the violence surrounding the first Brutus at the birth of the republic, to a rebirth after the equally violent killing of Julius Cæsar by the second Brutus. Even though Livy was intimate with the newly imperial Julian family, who viewed Cæsar as their divine primogenitor, he rather boldly framed the act of the second Brutus as justified by fears that Cæsar was trying to establish one-man rule.[15] Livy's narrative proved compelling, and *The History of Rome* was widely read and copied, becoming an authoritative source book for subsequent historians from Tacitus to Edward Gibbon. Though many of Livy's later chapters were lost in the eventual breakup of the Roman Empire, the early ones survived, and generations to come would be fascinated by his harsh yet heroic telling of the story of Brutus and the founding of the Roman Republic.

Palazzo Carpi, Rome: 1550 AD

The home of a member of the Roman Inquisition might not seem like a comfortable place for someone who had just been exonerated of a heresy charge, but to a man of Ulisse Aldrovandi's inclinations, Cardinal Rodolfo Pio da Carpi's palace in Rome was irresistible. It was stuffed with every manner of collectable, from gems and minerals to prized antique marbles to Renaissance canvases by masters such as Raphael, not to mention one of the finest libraries in the city.

Aldrovandi was a polymath who would later be renowned for his study of natural history and his specimen collections. During his months of house arrest in Rome waiting for his trial, he became keenly interested in the city's ancient heritage – which was only natural for someone named Ulisse after the hero of Homer's *Odyssey* (with a brother named Achilles). Cardinal Pio da Carpi was an avid collector of antiquities, and he knew that Aldrovandi was taking notes on the best collections of classical sculpture in Rome for a publication on the subject. Given how quickly great collections were generally sold after their owner died, inclusion in a catalogue to preserve at least the memory of a collection would have been highly desirable.

Aldrovandi had already visited the cardinal's exquisite villa on the Quirinal Hill and explored the exceptional array of antiquities housed there – a collection so fine in a place so beautiful that he had declared it an earthly paradise.[16] The Quirinal had been part of the city proper in ancient times (as it is today), but in 1546 it was more suburban, almost

15 Livy, *Periochæ* (fragments of *Ab urbe condita*, from Book 116, http://www.livius.org/li-in/livy/periochae 116.html.

16 Ulisse Aldrovandi, *Le antichità de la città di Roma* (1556), 299.

rural. Over the course of the thousand years since the Western Roman Empire had ceased to exist, the city had slowly contracted. With aqueducts cut off and drains clogged, Rome became marshy and unhealthy, reverting to a set of villages surrounded by the rotting remains of a glorious past. Cattle were put to pasture in the Forum, the Colosseum was used as a stone quarry, and the temple complex on the Capitoline crumbled away. Countless treasures had vanished without a trace, among them the bronze statue of Brutus, which for centuries was known only from accounts in ancient texts.

It would have taken less than an hour to walk from the cardinal's villa on the Quirinal to his palazzo in the heart of town, close to the Tiber. While the large-scale antiquities were stored at the villa, Pio da Carpi kept many smaller pieces, notably portraits, in the palazzo. He led Aldrovandi through two rooms packed with heads of emperors and their families, including Carcalla, Agrippina, Julia (daughter of Titus), and Septimus Severus, as well as several Alexander the Greats and a fine Philip of Macedon. Aldrovandi dutifully noted the identifications when known, and scribbled *"non conosciuta"* in his notebook when they were not.

Both men paused respectfully to gaze up at a marble bust with a Latin inscription that had pride of place over the door leading out of the second room.

"Not only is he beautiful, it is a most rare piece," said the cardinal. "You recognize him, of course?"

"Of course. The second Brutus. Marcus Junius. And the epitaph – is it a parent lamenting that faithfulness to the surviving offspring prevents her from sharing death with a lost child?"

"Yes indeed. I like to think that Rome felt that way about Brutus, her beloved son – that she would have liked to die with him as a republic but had to continue on as an empire for the sake of her people."[17]

They proceeded into smaller rooms with still more treasures, including busts of Hadrian and Lucius Verus as well as modern portraits of Pope Paul III and Charles V, the Holy Roman Emperor. Scattered throughout were innumerable antique fragments – hands, arms, heads, legs, feet. Finally the two men arrived in a study with no fewer than seventy-six portraits. Aldrovandi quickly fixed his attention on one that stood out from the crowd.

"That's a recent acquisition," the cardinal told him. "You might find it interesting."

In fact, Aldrovandi was stunned. Most surviving ancient statuary was marble, with the original paint and ornamentation long since worn

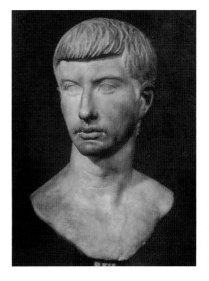

Marcus Junius Brutus (so-called, now generally identified as Agrippa Postumus), 1st century AD.

17 Aldrovandi, *Le antichità de la città di Roma*, 205–6.

away to leave a uniform whiteness and blank eyeballs that appeared blind. Here was a bust made of rich, dark bronze, with eyes of inlaid glass and ivory that gave the impression of a piercing gaze from the past directly into the present.

"That is no emperor," observed Aldrovandi as he inspected the rough hair and lined features. Images of emperors from Augustus to Constantine had been reproduced over and over again. While they depicted individual traits, they also tended to represent the subject as young and serene regardless of his age or condition when the portrait was made. In contrast, this austere face was that of a man who had been aged by hardships; yet it could be assumed that he had triumphed over them to merit the honor of such a costly portrait.

"In my opinion," Pio da Carpi said, "it can be only one man. The man who was chosen by Pythia to rule Rome. The man who pulled the dagger from Lucretia's beautiful breast. The man who swore to banish the tyrants from the city and ordered the execution of his own sons when they betrayed the republic. His harsh story is written on this face as clearly as it is in the pages of Livy."

"Where was it found?" asked Aldrovandi.

"I can't be positive," the cardinal admitted, "but I was assured it was discovered on the Capitoline."

A number of things had recently been unearthed in that location. About ten years earlier, Pope Paul III had ordered a full rebuilding of the government buildings on the Capitoline Hill. Rome's already deteriorating condition had been further degraded in 1529 when Protestant German troops commanded by Charles V – His Most Catholic Majesty – captured it after a long siege, sent Pope Clement VII fleeing for his life, and then spent months occupying and sacking the city. The once grand Capitoline was in a sad state, with the medieval palace of the senators (by then a ceremonial title) awkwardly sandwiched between the magistrates' building and the Church of Santa Maria in Aracœli (Saint Mary at the Altar of Heaven). While all these structures stood on the foundations of significant ancient Roman buildings and filled important civic and religious functions, they were architecturally undistinguished. The highlight of the complex was the equestrian statue of Marcus Aurelius standing at the center of the hilltop, but it was frequently obscured by Rome's boisterous central market.

Paul III commissioned a whole new urban space from Michelangelo Buonarroti, who had moved to Rome after the fall of the Florentine Republic in 1529. Michelangelo created a harmonious plaza by encasing

ABOVE LEFT: View of the Capitoline Hill before Michelangelo's restoration, c. 1500.

ABOVE RIGHT: The Capitoline Hill after Michelangelo's restoration in 1536–46.

LEFT: Étienne Dupérac after Michelangelo, piazza on the Capitoline Hill, 1568.

BELOW: Arial view of the Capitoline Hill after Michelangelo's restoration.

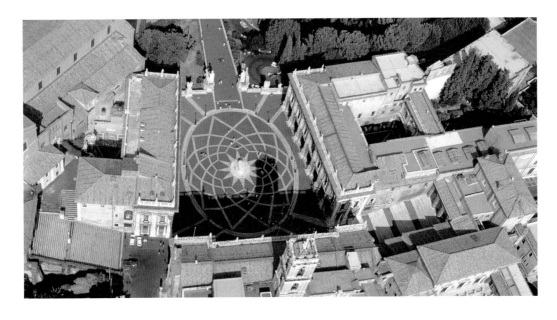

the existing buildings in elegant classical-style architecture. The scrubby ground was cleared and leveled, and a ceremonial staircase flanked by paired ancient statues created a suitable entryway. Marcus Aurelius retained his place of honor, now framed by the elaborate starlike pattern that Michelangelo designed for the plaza pavement. As Michelangelo's vision took shape, Christian Rome finally appeared to be rivaling the ancient city.

The heavy construction work unearthed an abundance of ancient artifacts, some of which found their way into the collection of their rightful owner, the pope, while many items were offered on the open market. The antiquities trade in Renaissance Rome was a brisk but shady business. Dealers and collectors alike had their favored "runners" who would alert them when a sensational find was made. Everyone knew that relics of the Roman past once considered rubbish could now fetch a handsome price. Farmers in their fields who had never heard of Julius Cæsar were on the lookout for anything from coins to statues. It paid to be deliberately vague when asked where something was found, since other treasures were likely to be lurking nearby, and there might be troubling issues of ownership. Cardinal Pio da Carpi did not ask too many questions.

"If you look closely," he said, pointing to the neck of the bust, "you can see that the head was broken off its base at some time. The man who sold it to me admitted he had attached it to a different base. It may have originally had a full body."

Aldrovandi knew his Livy well enough to understand that a realistic bronze portrait found on the Capitoline could well be – indeed, *should* be – that of the legendary founder of the Roman Republic. He quickly sketched the head in his notebook and labeled it BRUTUS.

The cardinal was gazing out a window, his head turned slightly in a pose that echoed the ancient bronze.

"I swear I see a resemblance," said Aldrovandi, trying not to sound too obsequious. Their features were remarkably similar, and Rodolfo Pio da Carpi did come from an old Roman family. Who knew how far back his lineage went in the city?

Cardinal Pio di Carpi died in 1564, and in his will he donated the bronze portrait now universally known as *Brutus* to the new museum being organized in the judiciary building on the Capitoline.[18] A century earlier, Pope Sixtus IV had assembled some important antiquities in Rome and put them on display in the building's portico – in effect creating the world's first public art museum. During Michelangelo's renovation, the collection was moved inside and displayed formally, and more

18 From this time on, the actual identification of the portrait ceased to matter until the twentieth century, when it was questioned—throwing the bust into a sudden eclipse from which it has yet to emerge. But for four hundred years it was firmly believed to be the great man celebrated by Livy, and the features were uniformly read as reflective of Brutus's unyielding dedication to republican principles.

Francesco Salviati, *Cardinal Rodolfo Pio da Carpi,*
c. 1540.

Brutus (so-called), c. 300 BC.

objects were added. Images of emperors abounded, including the colossal fragments of Constantine and the equestrian Marcus Aurelius. But there were also much older pieces, such as the Etruscan "She-Wolf," depicting the fierce beast of legend that nurtured the abandoned twins, Romulus and Remus, who went on to found Rome.

Even among such treasures, the *Brutus* was clearly iconic. Pio da Carpi thought it should be returned to the site where he believed it had originally stood, and it was joined by his marble head of Marcus Junius Brutus in a display designed to commemorate the family's heroic deeds permanently on the Capitoline.

* * *

Paris: 1798 AD

Napoleon Bonaparte found himself the undisputed ruler of Italy in 1797. Reversing the progress of Julius Cæsar, who had conquered Gaul for Rome, he had come south over the Alps and waged war in northern Italy for two years. The fiercest resistance had come from Pope Pius IX, who tried to defend the Papal States in the center of the peninsula, but capitulated after a series of decisive French victories. The seemingly immortal Venetian Republic would follow suit a few short months later. From his headquarters in Tolentino, the French general dictated his terms.

The resulting Treaty of Campo Formio shocked the civilized world. In addition to claiming territory in Italy and demanding an enormous sum of money, Napoleon required that the pope surrender the finest ancient and modern cultural treasures of Rome to be transferred to the Musée Napoléon. According to Article 8 of the treaty, a designated commission of experts would select the works and oversee their removal. That commission was given broad latitude to make its choices, as only two objects were specified: the bronze bust of Lucius Junius Brutus and the marble bust of Marcus Junius Brutus from the Capitoline Museum.

"When they arrive," Napoleon remarked to his favorite painter, Jacques-Louis David, "we can create the greatest museum in the world here in Paris, at the Louvre." It was still not entirely clear what was coming from Rome in the long convoy of carriages, but they knew the Apollo Belvedere was in the priceless cargo, as well as Raphael's great last painting, *The Transfiguration*. And Napoleon wasn't finished – he was working on a plan to detach Raphael's frescoes from the walls of the Vatican and dismantle Trajan's Column so that even these seemingly permanent denizens of Rome could be transported to Paris.

"You know your Brutus is coming?" Napoleon said to David. "I made them put that in the treaty."

David nodded, wishing as always that the general would sit still for his portrait. The artist's esteem for the founder of the Roman Republic was well known – he had been in Rome working on a painting of *The Lictors Returning to Brutus the Bodies of His Sons* for Louis XVI when the revolution broke out in France.[19] David brought it with him back to Paris, where it was a sensation at the 1789 Salon. Begun for a monarch, the picture became an icon of the revolution as Brutus's willingness to sacrifice his own family in the service of Rome was invoked to justify the Reign of Terror. David's painting was used as a backdrop for a revival of Voltaire's play *Brutus* in 1791, the staging of which also included a copy

19 See image on page 149 below.

of the Capitoline bust from David's personal collection. Now it was on public display in the Louvre.

"When the bronze arrives," continued Napoleon, "we will compare your painting to the original and see how well you captured the likeness. I expect you had an easier time with him than with me. And you will have to help me figure out where to put Brutus."

The *Brutus* had an eventful visit to Paris. Besides being displayed with David's painting, it was paraded through the streets on the anniversary of the fall of Robespierre. If David resented this celebration of the execution of his former friend and political mentor, he kept quiet about it. Shortly thereafter, at Napoleon's request, the painter selected a prime spot for the bust at the Tuileries Palace, which had been home to the kings of France but would now house Napoleon and his wife, Josephine. Napoleon was savvy enough to realize that republican eyebrows would be raised when they made this move; but who could accuse the Bonapartes of imperial tyranny, he reasoned, if they had Lucius Junius Brutus watching over them?[20]

Jean-Jérôme Baugean, *The Departure from Rome of the Third Convoy of Statues and Works of Art*, 1798.

20 Louis Antoine Fauvelet de Bourrienne, *Memoirs of Napoleon Bonaparte*, ed. R. W. Phipps (1891, 2008), vol. II, 7–8. The *Brutus* was returned to Rome after the Battle of Waterloo in 1815.

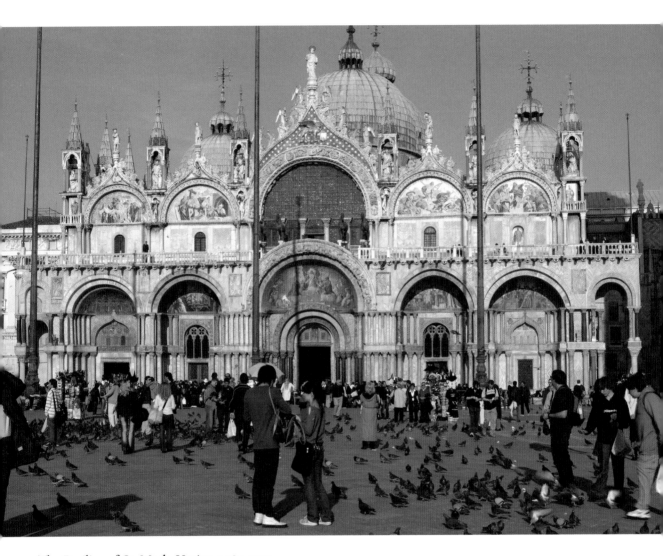

The Basilica of St. Mark, Venice, 1084–1117.

Safeguard of the West

St. Mark's Basilica and the Most Serene Republic of Venice

> *Once did She hold the gorgeous East in fee,*
> *And was the safeguard of the West: the worth*
> *Of Venice did not fall below her birth,*
> *Venice, the eldest Child of Liberty.*

<div align="right">

WILLIAM WORDSWORTH
On the Extinction of the Venetian Republic

</div>

Constantinople: April 15, 1204

The old Venetian nobleman ran his hands over the bronze horses as if he were taking the measure of living animals, something he had done innumerable times as a rider. They had been made with such skill that he seemed to feel veins and muscles under their metal skin.

"I saw them when I was here before, and I still had my vision," he said. "It must have been thirty years ago."

Enrico Dandolo remembered well his previous visit to Constantinople, the gleaming imperial city on the Bosporus with its wealth of ancient and beautiful monuments, as well as its fantastic natural port, known as the Golden Horn. The skyline was dominated by Hagia Sophia, the Church of the Holy Wisdom. Originally commissioned by Constantine in the fourth century, the building had been destroyed in a riot in 532 AD and then completely rebuilt by Justinian. The emperor had imported rich materials from all over his realm and employed a military engineer to design a gigantic dome soaring over the open central space, appearing to defy the laws of physics.

Dandolo had been in Constantinople in 1172 as a diplomatic representative of his native Venice. Relations between the maritime republic and the Byzantine Empire were severely strained at that time – a year earlier, the emperor Manuel I Comnenus had ordered that all Venetians in Constantinople be arrested and their property confiscated. Some ten thousand people would remain in prison for a decade. The Venetian mil-

49

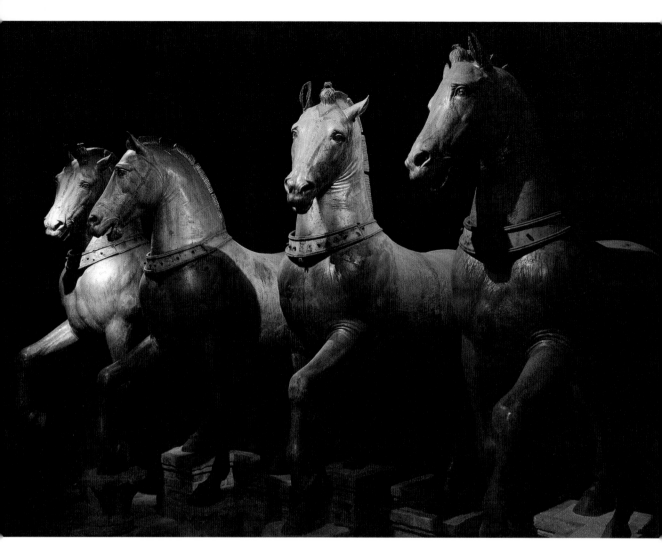

The Horses of St. Mark's.

itary response was a disaster, and Dandolo was sent to try to arrange a settlement.

It was a hopeless cause. The Byzantines had no reason to negotiate with the Venetians and treated them with a truly imperial scorn. The visit went so badly, in fact, that there was a rumor that Manuel had the Venetian envoy blinded. This was not the case; Dandolo was already beginning to lose his sight to cortical blindness. His mission to Constantinople was nonetheless a grim experience, leaving him with the unshakable impression that the Byzantines were arrogant and vicious, and that their Orthodox Christianity had the tinge of heresy.

Three decades later, the situation was dramatically different. Constantinople burned after a brutal sack at the hands of crusaders under Dandolo's command. He had been the elected doge of Venice for twelve

years, and now he was also the master of Constantinople. In his nineties and stone blind, he remained a man of tremendous energy. Dandolo quickly exerted control over the city and surrounding territories, but found time to inquire after the four horses that caught his notice so long ago. Countless other precious artworks were ruined in the mayhem. The great Byzantine historian Niketas Choniates lamented how "barbarians, haters of the beautiful" had destroyed "marvelous works of art" and converted them into "worthless copper coins."[1] The bronze horses, however, were kept safe on the doge's orders.

No one knew exactly when the horses had been made, or even where, but there was a long tradition that they had been part of a massive importation of artworks when Constantine turned the city known as Byzantium into the capital of the Eastern Roman Empire. Even in this "Queen of Cities," renowned for the beauty of her art and her women, the horses were among the choicest of treasures.

Spirited yet poised, natural yet more perfect than any earthly animal, they embodied the ideal of a horse. They also seemed interconnected, as if conversing with each other. They were covered not with the heavy gilding typical of statues from late antiquity, but with a translucent gold wash that gave their bronze surface the reflective quality of a well-groomed horse.

Dandolo rested his hand on the neck of one statue. "Morosini!" he shouted, although the man was standing right beside him.

"Yes, my lord?"

"Crate them, and get them out of this hellhole as quickly as possible. Take them safely back to Venice."

"Of course." Domenico Morosini welcomed the task. Himself the descendant of a doge, he had ambitions of his own, and carrying out Dandolo's orders was a good place to start. "If I may ask, where do you want them to go?"

"To the church of Saint Mark, of course."[2]

The Northern Adriatic: Late Antiquity

The imperial system that had spread Roman rule across the Mediterranean region was failing. Beset by economic and political dysfunction within and by aggressive Germanic tribes outside its borders, the empire could no longer defend its Italian heartland, let alone hold on to its far-flung provinces.

1 *O City of Byzantium: Annals of Niketas Choniates*, trans. Harry J. Magoulias (Wayne State University, 1984), 358.

2 Charles Freeman, *The Horses of St. Mark's: A Story of Triumph in Byzantium, Paris and Venice* (Overlook Press, 2010), 90–95.

At first, the threat had seemed manageable; after all, the Romans had been battling Germans for centuries. (A popular Augustan-era general was called "Germanicus" in honor of his victories over them.) The dynamic began to shift around 251 AD when the emperor was killed by Goths, a branch of the Germanic peoples. Isolated victories turned into a sustained campaign. By the end of the third century, the Romans were abandoning territory to Goths who were settling in large numbers within the empire's boundaries.

Facing both external and internal pressures, the Romans tried an administrative division of the empire into four parts – two eastern and two western. After Constantine gained control over the whole empire, he moved his capital east in 323 to the ancient city of Byzantium, which he rebuilt and renamed after himself. He showered treasures onto Constantinople, including artworks from all over the empire and relics of all twelve of Jesus' disciples, in keeping with his conversion to Christianity. Rome was hardly abandoned, for Constantine pursued ambitious building projects there also. He commissioned a triumphal arch beside the Colosseum, and an enormous legislative building in the Forum that housed a forty-foot statue of himself. He initiated an extensive program of church building including the original St. Peter's Basilica. But power was shifting to Constantinople, which would be the capital of the Eastern Roman Empire when the division resumed after Constantine's death and then became permanent, well before the last Western Roman emperor was deposed in 476 AD.

Twenty-four years earlier, Attila the Hun had left a trail of devastation through Italy, sacking and razing many towns. Pope Leo the Great famously led a delegation to meet with Attila and plead or negotiate for an agreement to spare Rome.[3] There had been no such reprieve for Aquileia, a once-prosperous city in what is now the Veneto region at the northern tip of the Adriatic Sea.

Survivors from the destruction of Aquileia sheltered miserably on an archipelago of small islands in a nearby lagoon. Eventually they began returning to the mainland, until a new scourge would send them fleeing back to the lagoon. City gates could not hold back barbarians, but the expanse of water separating the islands from the coast proved an effective defense. The island dwellers appear to have cultivated a distinctive kind of society. In 523, the historian Cassiodorus wrote of them that "rich and poor live together in equality. The same food and similar houses are shared by all; wherefore they cannot envy each other's hearths and so they are free from the vices that rule the world."[4]

3 Raphael would commemorate this event in a fresco. Various reasons have been given for why Attila withdrew and left Rome untouched, but the reprieve was temporary—the city was sacked by the Vandals a few years later.

4 Cassiodorus, "Senator, Praetorian Praefect, to the Tribunes of the Maritime Population," *The Letters of Cassiodorus*, trans. Thomas Hodgkin (1886), 517, quoted in Frederick C. Lane, *Venice: A Maritime Republic* (Johns Hopkins, 1973), 3–4.

The worst of the serial threats to the Veneto region came in 568, when the Lombards crossed the Alps and began conquering northern Italy (including the territory around Milan that is still known as Lombardy). Unlike the nomadic Huns, the Lombards were there to stay, and they made a name for themselves by brutalizing landowners who resisted them. To those taking refuge on the islands, it must have seemed prudent to stay there for good. They remained nominally subject to the Eastern Roman Empire until the Lombards finished off the vestiges of Byzantine power in that region in 751.

By then, the island dwellers were forming their own government. On the mainland, Lombard dukes gathered vassals around themselves and sired traditional dynasties, but something different happened out on the lagoon. The settlement that was becoming Venice had a duke, who was called the doge, but he appears to have been an elected official from early times, at least since the Byzantine overlordship came to an end.

Alexandria, Egypt: 828 AD

The Sassanid Persians had little use for the rich cultural history of Alexandria, which was founded by Alexander the Great and was his burial place. They obliterated what remained of its famous library shortly after conquering the city in 642 AD. As adherents of the rapidly spreading religion of Islam, they had an equal contempt for Alexandria's Christian tradition, inaugurated by Mark the Evangelist, who was martyred there in the first century. As far as the Persians were concerned, Alexandria was an asset to be milked for resources that would fuel additional conquests.

One day in January 828, the customs officials paid little attention to the two Venetian merchants asking permission to load a large basket onto their galley and sail out of Alexandria's spectacular natural harbor. The merchants stank and whatever they were carrying smelled even worse. When they uncovered the basket to reveal layers of rotting pork, the Muslim officials drew back in disgust, murmuring *"Kanzir, kanzir,"* their term for the unholy meat. They were not about to contaminate themselves over these infidels.

The Venetians heaved a sigh of relief as their trireme set sail north into the Mediterranean. Stowed in the barrel under the layers of pork was a religious treasure beyond price.

The veneration of relics – physical remains of Christ, his followers

and the many faithful who were martyred under Roman persecution – dated to the time of Constantine's mother, Saint Helena. She had traveled to the Holy Land and, according to legend, discovered there the True Cross and the veil that Saint Veronica used to wipe the Savior's face while he was carrying the cross to Gethsemane (both of which are still preserved at St. Peter's Basilica). Pilgrims by the millions braved arduous travel in the dangerous conditions of early medieval Europe to visit holy relics in Rome. Indeed, as the city was drained of political power and shrank to little more than a village, tourism became its main industry.

While Rome and Constantinople abounded in sacred relics, Venice had almost none. The city had been founded well after the time of the early Christian martyrs, and the first settlers had more pressing things to worry about. But the situation was changing by the ninth century; what had started as a refugee encampment was growing in stature and significance. Previously busy ports, notably the one at Ravenna (which had briefly replaced Rome as the capital of the beleaguered Western Roman Empire), silted up and became unusable. Venice was the obvious alternative, and so it prospered.

The city caught the attention of both Charlemagne, who was reviving a Western "Roman" empire at the beginning of the ninth century, and the emperor Nicephorus I in Constantinople, who considered himself the sole legitimate heir to any territories of the old Roman Empire. In the course of their wrangling, diplomatic and otherwise, Venice was not devastated by either imperial army as had seemed likely. Instead, a treaty between Charlemagne and Nicephorus in 811 established the independence of the Venetian territories between the Western and Eastern powers, a unique status that shaped its identity from that time on. For centuries, the "Holy Roman Emperor" in the West would coexist uneasily with the Byzantine emperor in the East, sparring over everything from religious dogma to dominion over old Roman imperial lands. Meanwhile, Venice was able to develop as an autonomous polity with ties to both East and West.

When Agnello Participazio was elected doge in 811 after valiantly defending Venice from a siege by Charlemagne's son Pepin, he found both an opportunity and a challenge. The city was becoming a significant power, but one that was limited by its physical plant – a series of small, scraggly islands that flooded regularly and had no level surface on which to build large structures. Fortunately, Participazio was a man of vision who had the trained engineers on staff to carry out his plans. Wood was plentiful on the mainland, and a program was devised to har-

vest trees and drive the trunks into the soft subsoil of the lagoon so close together that their level tops made a solid surface. Slowly, thousands and then millions of tree trunks were driven into the lagoon, and Venice took form.

Map of Venice, *Civitates Orbis Terrarum*, 1572.

If the terrain was a handicap, Venice's situation as a nexus between East and West was a great advantage, and the Venetians capitalized on it in trade agreements not only with Constantinople but also with Damascus and Alexandria. Venetians had to be excellent sailors to survive, so merchant vessels quickly multiplied and fanned out across the Mediterranean Sea. Goods of all sorts began to flow through the city – first salt and fish, then textiles and dyes, and finally spices, arms and slaves. Muslims from the East and Russian heathens from the north were packed into ships and brought to market on the Rialto; Christians were technically off-limits.

Advances in galley design resulted in ships that could sail year-round, not just in the summer, and the volume of trade increased accordingly.

The Venetians who sailed out of Alexandria with their precious basket filled with human remains were under the orders of Agnello Participazio's son Giustiniano, who had forcibly ousted his father, then his brother, to become the doge himself in 827. As ambitious as he was ruthless, Giustiniano was determined to make Venice into the dominant city in Italy – in short, the new Rome.

Rome was not then in much of a position to contest the rise of Venice. The Eternal City, repeatedly sacked by invading tribes, was almost derelict. But as the seat of the pope, Saint Peter's heir, Rome was still the center of Western Christendom. In this respect at least, Venice was a very poor cousin. Agnello Participazio had made a start in elevating the city's religious profile by renovating the old convent of San Zaccaria, and in honor of this project the Byzantine emperor Leo V had sent relics – some said the whole body – of Saint Zacharias to Venice from Constantinople.[5]

Giustiniano set his sights higher. According to local legend, the Evangelist Mark, after serving Peter in Rome, had come to establish the church in Aquileia. During this period he translated his Gospel from Hebrew into Greek, and it was widely distributed – marking the first time the story of Jesus was available in what was the international language of the time. In the course of his travels, Mark paused at the uninhabited islands that would one day become Venice. There he had a dream that an angel appeared to him and said, "Pax tibi, Marce, evangelista meus. Hic requiescat corpus tuum." (Peace be with you, Mark, my Evangelist. Your body will rest here.)[6]

This experience does not seem to have encouraged the Evangelist to linger. He went on to Rome, and then to Alexandria, where he was martyred and interred for some centuries. But the legend persisted connecting Saint Mark with Venice – or at least with the general region – and the plot was hatched to bring his physical remains back from Alexandria.

Giustiniano was delighted when the galley returned with its precious cargo intact. During the voyage, the very presence of the relics had reportedly healed one sailor from demonic possession and brought joy to all the faithful on board. The ship pulled up to the new quay that had been built at the head of the canal that was becoming the main waterway through Venice. Here, Giustiniano had been modifying the palace that accommodated the doges and the increasingly complex functions of Venetian governance. Behind the palace was an open plot of ground, a pretty if marshy space with a few fruit trees. What solid ground existed

5 Saint Zacharias, the father of John the Baptist, was martyred during the Massacre of the Innocents when he refused to reveal the hiding place of his young son. His remains are also rumored to be in Istanbul, Jerusalem and Azerbaijan.

6 Andrea Dandolo, *Chronica per extensum descripta*, cited in John Julius Norwich, *A History of Venice* (Knopf, 1982), 28.

there was being supplemented by ever more tree trunks hammered into the mud of the lagoon. As Giustiniano pondered where to house the body of the Evangelist, he considered the older shrines on the outlying islands – Torcello, Castello, and Murano. But more and more of Venice's activity was taking place on the new ground. He would build a home for the relics there, right by the Doge's Palace.

Giustiniano had visited Constantinople five hundred years after Constantine's transformation of the city and had seen the great Orthodox churches: Hagia Sophia as well as the Apostoleion (Church of the Holy Apostles).[7] Traditionally, Catholic churches in the West were planned as "Latin" crosses, with one long arm and a shorter crossing – an arrangement that recalls the shape of Christ's cross while providing a large space for the congregation. The "Greek" plan of the imperial churches in Constantinople was instead based on an equal-armed cross, surmounted by a dome.

The doge's concept was to bring the Greek model to Venice, where a magnificent new building would be the final resting place of the Evangelist who had been the first to translate the Gospel for a broad Roman audience. This structure would not just be a church; it would also be the chapel of the duly elected doge of Venice, adjacent to his palace, with a political as well as a religious significance. And the symbol of the city would become Saint Mark's emblem, the lion.

Mosaic detail from St. Mark's Basilica showing the arrival of the body of Saint Mark in Venice.

Venice: 976

The default building material in Venice was wood. Besides being plentifully available from the mainland, it was also lighter than stone and therefore easier on the city's fragile foundation. But wooden structures were vulnerable to fire, so Venetians took elaborate precautions to prevent fires and to contain them if they started.

That night in 976, though, the fire was set deliberately. An angry

7 Hagia Sophia has survived as a mosque, but the Apostoleion was completely destroyed in the conquest of Constantinople by the Ottoman Turks in 1453.

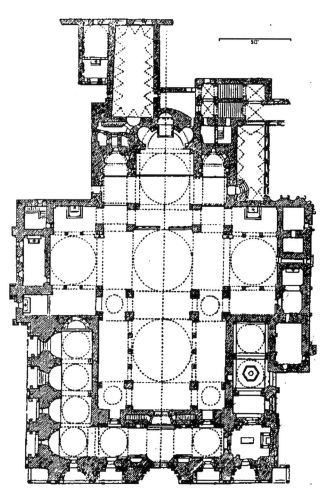

Plan of St. Mark's Basilica.

crowd barricaded the portals to the Doge's Palace and began throwing torches through the windows. The object of their rage, Doge Pietro Candiano, was locked inside with his second wife, the beautiful Lombard princess Waldrada, and their infant son. A cousin of the Holy Roman Emperor Otto I, Waldrada, as a foreigner, was only the most visible locus of Venetian dissatisfaction with Pietro. He had married her for her lavish dowry and imperial connections after packing off his first wife, a native Venetian, to the convent of San Zaccaria.

Pietro had always been something of a renegade, rebelling against his father, who had also been elected doge, and dabbling in piracy. He was charismatic and popular in certain circles, but always controversial. He had actually been exiled to Ravenna and had to be elected doge in absentia. Arriving back in Venice in great state, he made it clear he had no patience for the city's democratic system. He attempted to reign as a monarch, but in fairly short order the Venetians had had enough. When word came that Otto I had died, leaving Pietro without his most important ally, they attacked.

The doge's family attempted to escape through a passage connecting the palace directly to St. Mark's Basilica. They prayed the mob would respect this holy structure that symbolized the special relationship between the doge and the Evangelist. But when they emerged from the passageway into the church, choking in the smoke, they were surrounded by heavily armed men. Pietro pleaded for mercy, but they only laughed. The baby was quickly speared with a lance. Pietro died more slowly after being stabbed many times. In the confusion, Waldrada somehow escaped and fled the city, large parts of which were engulfed in flames.[8]

The message was clear. While the Venetians expected multiple doges to come from a group of prominent families, each of those doges needed to be properly elected and submit himself to the established protocols of the government. The citizens were not prepared for any doge to set himself up as king, no matter how wealthy or well connected.

8 Chronicle of John the Deacon, cited in Norwich, *A History of Venice*, 42.

When the fires were finally extinguished, the Doge's Palace had been completely destroyed. St. Mark's was badly damaged and its most precious relic, the body of the Evangelist, was nowhere to be found.

Efforts were made to repair the church after the great fire, and as Venice enjoyed an economic boom in the eleventh century this project grew more ambitious, culminating in a full reconstruction. While the original Greek-cross plan was retained, the new church was far more vertical, with five domes rising high above the city. The thick masonry walls required to bear their weight put a strain on the wooden supports below, but the builders persevered, convinced that the foundations would hold.

Indeed, Venetians gained confidence from their continuing good fortune. In return for the Venetian navy's support, the Byzantine emperor Alexius I Comnenus issued a decree in 1082 that Venetian merchants could travel tax-free through the empire, and that their transactions would be free of excise taxes. This "Golden Bull" was a great advantage, and it coincided with another major economic opportunity for Venice: the Crusades.

It was a nagging humiliation to Christendom that the Holy Land had remained in Muslim hands ever since the Arab conquest of Jerusalem in 638 AD. Western monarchs mounted successive military efforts to reclaim these territories ostensibly in the name of the church, but also to enrich themselves and expand their domains. The First Crusade achieved its goal by gaining control of Jerusalem in 1099, but setbacks followed. For the next two centuries, crusaders would keep launching campaigns, with diminishing success.

Most of these expeditions flowed at least in some part through Venice, where armies purchased supplies, hired expert sailors and navigators, and sometimes even ordered entire navies. Venetian merchants had to develop a whole new system of accounting, called double-entry bookkeeping, to track these complex and lucrative transactions. Venice would also play a key role in preparing for the Third Crusade, launched in 1189 in an effort to recapture Jerusalem after it fell (again) to the great sultan Saladin. And it was in Venice that Pope Alexander III reconciled with Frederick Barbarossa, the rebellious Holy Roman Emperor who went on to lead the crusade as a demonstration of his renewed piety.

* * *

Venice: July 24, 1177

When Alexander was elected pope in 1159, his first priority was to excommunicate Frederick. The preceding pope had intended to do it but died before he could get the job done. The sentence stood for seventeen years while pontiff and emperor contended for control of Italy. The pope stubbornly maintained that he was the ultimate spiritual authority in Europe and, as such, had jurisdiction even over the emperor. Frederick, an inveterate warrior who aspired to be a new Charlemagne, supported a series of anti-popes in an effort to undermine Alexander's position.

The result was a brutal power struggle that engulfed much of Europe in war. For a while it seemed the emperor would prevail as his armies pressed into Italy, but after a disastrous defeat at Legnano in 1176, and with an uprising against him back in Germany, Frederick agreed to accept Alexander's terms.

Venice had managed to alienate both sides in the conflict, but Doge Sebastiano Ziani, a brilliant administrator, aimed to repair those relationships. This effort culminated in the selection of Venice as the site for the reconciliation of Alexander and Frederick. St. Mark's Basilica was chosen as the perfect backdrop for the ceremony; although it was unfinished, the three grand portals were in place, creating a sort of triumphal arch that would frame the central figures, while the Evangelist himself would be an implied presence blessing the important event.

On a beautiful summer day at dawn, the pope arrived at the basilica and took his place on the high throne that had been constructed for him in front of the main entrance. The emperor followed. His famous red hair was going white, but he wore a brilliant cloak in his signature color, which he shed before making his final approach to the throne on his knees until, finally, he lay prostrate before Alexander, kissing his feet. The pope raised him, embraced him, and seated him on the adjoining throne.

The conflict between them had been long, bloody and personal. But in the end, the prevailing sense seems to have been relief. Later chroniclers insinuated that Alexander and Frederick had whispered insults to each other during the ritual of abasement, but contemporary records suggest this was a genuinely joyful occasion. The pontiff invoked the biblical story of the Prodigal Son, giving Frederick a fatted calf and telling him, "It is meet that we should make merry and be glad, for my son was dead, and is alive again; and was lost, and is found."[9]

The two certainly seem to have been in no hurry to get away from each other, as both remained in Venice well into the fall, along with their

9 Norwich, *A History of Venice*, 114.

noble and wealthy retinues. This extended visit was a welcome eco-
nomic windfall for the city, as was the recognition that Venice's unique
geographic and political situation made it an appropriate location for
such a delicate diplomatic mission. An eyewitness noted as much, declar-
ing that Venice was "subject to God alone . . . a place where the courage
and authority of the citizens could preserve peace between the partisans
of each side and ensure that no discord or sedition, deliberate or invol-
untary, should arise."[10]

Canaletto, *Festa della Sensa*,
c. 1729–30.

While in Venice, Alexander III gave his papal blessing to a civic ritual
that had more than a passing affiliation with the pagan past. Every year,
on the Feast of the Ascension (the Thursday after Easter), the doge would
embark from his palace in a special galley called the Bucentaur, row out
into the Grand Canal, and throw a golden ring into the water, thereby
symbolically marrying the sea. This Festa della Sensa underscored the
special maritime nature of the city, and with Alexander's blessing it
became fully legitimate in the eyes of the church. Through the centuries,
generations of splendid vessels were built for this purpose.

Doge Ziani directed the reorganization of Venice's urban fabric as
the city grew in size and beauty, concentrating on the area around St.
Mark's Basilica, which had become the undisputed heart of the city. He
moved the loud and dirty shipyards to an outlying area and cleared out the

10 *De Pace Veneta Relatio*, as translated
in Norwich, *A History of Venice*, 117.

space leading up from the Grand Canal to the church, making a suitable stage for civic ritual. He rebuilt the Doge's Palace. And he continued to refine and decorate St. Mark's.

The basic structure had been completed about a century earlier, and a program to cover the interior with mosaics had been initiated after the Evangelist's body made a dramatic reappearance in 1094. The story went that the treasured relic had been hidden away during the fire of 976 and the three people who knew the hiding place had all died before revealing it. As the renovation work was finished, the people of Venice prayed for three days for their saint to be restored to them. At last there was a rumbling in the old masonry and the Evangelist miraculously tumbled out of a column where, the experts claimed, he had been hidden for a century.

Venetians vied with each other for the honor of ornamenting the basilica, bringing home rich treasures from successful commercial voyages. Brightly colored carved marbles, gold and gemstones poured into St. Mark's, where they were incorporated into the ever more ornate interior or displayed in the treasury.

Craftsmen came on the ships too, most notably a whole school of mosaicists from Constantinople. This ancient art, originally created from naturally colored pebbles to decorate floors in Greece, had been widely popular in the Roman Empire and was used to adorn the first imperial Christian churches with glittering scenes of the celestial realm. The mosaics in St. Mark's were made of small tiles, or tesseræ, which were specially manufactured pieces of glass backed by thin layers of colored material, including gold, lapis and porphyry. The result was both brilliant and durable, albeit expensive and labor-intensive to produce. The Byzantine artists who settled in Venice established a flourishing community that would survive for centuries, creating and then extensively restoring the mosaics inch by inch.

More than an acre of decorated surface coated the interior of the church, telling the long story of Christianity from the Creation and the Garden of Eden to the lives of the saints, including the miraculous translation of Saint Mark from Alexandria to Venice. Although such representations are sometimes described as the "Bibles of the illiterate," this was not the original purpose of the mosaics. Certainly an attentive viewer who knew where to start and finish could learn a great deal from them, even if the figures high up in the domes might be obscure. But the main function of the mosaics, and the church as a whole, was to celebrate the remarkable wealth and influence that this most unlikely of cities had gained under the Evangelist's protection.

St. Mark's Basilica: September 8, 1202

Enrico Dandolo could no longer see the golden glow created by the bright sunshine reflecting from the water outside and bouncing off the polished surfaces of the mosaics. His vision was long gone. Two acolytes guided the elderly doge up the aisle of the basilica, but he still carried himself with authority in the distinctive headgear of his office: a white linen skullcap surmounted by a pointed hat known as the *corno ducale*, which made him seem even taller.

St. Mark's Basilica was packed with the usual Venetian aristocrats, supplemented by French knights who had thronged to the city anticipating an expedition to the Holy Land. Inspired by the charismatic and energetic Pope Innocent III, the Fourth Crusade had been planned as another attempt to wrest Jerusalem away from Saladin. By the time the company got to Venice, their resources were already spent and the project seemed doomed, until Dandolo offered his support. But no one anticipated what the doge would do that day.

Dandolo climbed into the elevated pulpit under the central dome and began speaking to the assembly. "My lords," he said, quietly at first, "you are joined with the finest men in the world in the most noble endeavor anyone has ever undertaken.

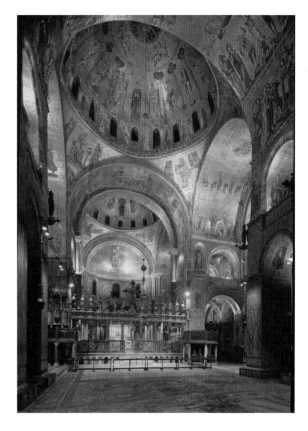

Interior, St. Mark's Basilica.

I am an old and weak man and am in need of rest – my body is failing." There was a pause. "But I see that no one knows how to lead and command you as I, your lord, can do." His voice grew louder: "If you are willing to consent to my taking the sign of the cross in order to protect and guide you, while my son stays here to defend this land in my place, I will go to live or die with you and the pilgrims!"[11]

The congregation erupted in cheers. Dandolo descended from the pulpit, weeping, and went down on his knees before the high altar, which stood over the tomb of Saint Mark. His ceremonial hat was removed and a cross was sewn onto it, where it would be easily visible.[12] A crowd of Venetians who had previously been reluctant to commit to the crusade knelt with their doge before the Evangelist. "Come with us!" the congregation shouted, as the church bells rang out.[13]

11 Geoffrey of Villehardouin, *The Conquest of Constantinople*, in Joinville and Villehardouin, *Chronicles of the Crusades*, trans. Caroline Smith (Penguin, 2008), 20.

12 Crusaders normally wore a cross on the shoulder of their cloak or tunic.

13 Geoffrey of Villehardouin, *The Conquest of Constantinople*, 20.

Enrico Dandolo had become doge in 1192 and was continuing the civic reforms of his predecessors, in which his father, Vitale, had played a major part as both counselor and diplomat. Sovereign authority was vested in the Great Council, consisting of elected representatives of the citizens. The council chose officials to serve for short periods of time advising the executive on domestic policy and overseeing diplomatic and military activities, and it appointed the committee that would elect the doge. The process for choosing a doge had evolved over centuries, and the system developed under Dandolo and codified in 1268 would remain in place until the end of the republic in 1797. It was lengthy and complex, involving ten successive votes by select groups of wellborn men over the age of thirty. The whole system appears designed to limit the power of the doge and to ensure that successful candidates had broad support among the qualified voters.[14] Venice was an oligarchy, with voting rights increasingly restricted to wealthy and noble citizens. While its government may not have been widely inclusive, it did have the virtue of concentrating power in the hands of those with the largest stake in maintaining Venice's prosperity and independence, and they tended to be highly educated.

The Venetians' decision to supply and bankroll the Fourth Crusade was not exclusively inspired by piety, and they demanded a say in the strategy in return. The existing plan to reach the Holy Land by first attacking the Muslims in Egypt did not really benefit the city. Dandolo was more interested in picking off trade competitors than in attacking trade partners in Alexandria, even if those partners were infidels. The Venetians observed that the passage to Egypt would be dangerous with winter approaching, and they recommended spending the cold months at Zara, a city on the Dalmatian coast that was once a client of Venice but had recently rebelled. Dandolo personally led the charge against Zara in a scarlet galley with gorgeous silk hangings, and with attendants who signaled his instructions to the other vessels on trumpets of solid silver. When they captured Zara in November 1202, it marked the first time that Catholic crusaders attacked people of their own faith, and it earned them excommunication by Pope Innocent III.

The company may not have been aware of this action by the pope when they sailed on to Constantinople. In any case, relations between Venice and the Byzantine Empire had been deteriorating since the Great Schism of 1054 formally divided the Eastern and Western churches, though the reasons were not all theological. Venetians continued to trade with Constantinople and resented incursions into their trade monopoly by rivals (particularly Genoa and Pisa). But they also resented

14 The doge's powers are specifically described in Dandolo's oath of office, which can be found translated in Thomas F. Madden, *Enrico Dandolo and the Rise of Venice* (Johns Hopkins, 2003), 96–98.

the high-handed treatment of their merchants by the Byzantines, who viewed foreigners as greedy upstarts.

Doge Dandolo had not forgotten the unpleasantness of his diplomatic mission to Constantinople three decades earlier, nor the death of his father there on another failed mission two years afterward. He was therefore receptive to a scheme proposed by Alexius Angelus, the exiled son of the emperor Isaac II Angelus. Isaac had been deposed and blinded by his own brother, also named Alexius. The younger Alexius claimed that he should be emperor by hereditary right, and he promised to pay the crusaders generously if they threw out his uncle, Alexius III, and installed him on the throne. And so the crusaders sailed not for Jerusalem but for the capital of the Byzantine Empire, arriving at its gates in June 1203.

Constantinople: April 12, 1204

"The Queen of Cities" made an awesome sight. It was ten times the size of Venice, which had about fifty thousand inhabitants at the time, while Constantinople had half a million. Its triangular site was bounded on two sides by water, while the third was guarded by some three and a half miles of fortified masonry walls dating back to the fifth century. The city boasted hundreds of churches, huge palaces, libraries, bath complexes, race tracks and amphitheaters that had survived for hundreds of years in proud testimony to the fact that no invader had ever breached its defenses. In Rome, such things had been reduced to rubble.

The crusaders had been in the vicinity of the imperial city for nearly a year, and their patience was wearing thin. At first, things had gone according to plan because the lazy and ineffective emperor Alexius III had not adequately prepared for their arrival. Doge Dandolo led the initial charge, roaring orders from the prow of his galley and ramming the vessel aground in front of the walls, with the banner of Saint Mark streaming over him.[15]

Dandolo had hoped the Byzantines would rise up in support of the younger Alexius and the deed would be done with little fighting. Alexius III fled in due order, but his nephew, now Alexius IV, was greeted with apathy, and the city showed no signs of producing the hefty payment that had been promised to the crusaders. As negotiations dragged on, the Venetians grew suspicious that they had been dupes in yet another Byzantine plot.

Outside the city, skirmishes began between the Byzantines and the crusaders, or Latins as they were called. Alexius IV was deposed by one

15 Madden, *Enrico Dandolo and the Rise of Venice*, 161.

of his own nobles and thrown into prison, where he was eventually strangled. The fighting escalated until Constantinople was under siege, and finally the walls were breached.

Thousands of enraged (and starving) crusaders rampaged through the city, which was quickly engulfed in flames thanks to the ceramic vessels of "Greek fire" that were delivered from the Venetian ships by catapult. This highly incendiary substance had once been a Byzantine secret,

Tintoretto, *The Conquest of Constantinople in 1204*, 1584.

but now it was turned against the empire. The Byzantines who were not cut down started to flee in large numbers as the Latins divided their time between rape, plunder and devastation. At Hagia Sophia, a prostitute was seated in the high chair of the Orthodox patriarch, where she sang a dirty song and drank wine out of a communion goblet. Anything of value disappeared into the flames, the official inventory of plunder, or the pockets of individual crusaders.

After three days, some semblance of order returned, although the city was almost unrecognizable – a burned-out shell with a shadow of its former population. The leaders of the crusade began divvying up the

spoils, with Venice receiving three-quarters of the booty by prior agreement. This massive haul justified Dandolo's support for the expedition from the Venetian perspective, even as the rest of the Latin West was shocked at the ravaging of Constantinople by fellow Christians.

Within weeks, the crusaders had chosen one of their own, Baldwin IX, Count of Flanders and Hainaut, to become Emperor Baldwin I.[16] It was rumored that Dandolo turned down the crown, and he seemed less concerned with ceremony than with governmental affairs and selecting objects to send back to Venice, particularly the four bronze horses. The doge died in May 1205 of a septic hernia sustained during a three-day ride visiting his troops outside the city, and was buried in Hagia Sophia – the only man to be so honored.

St. Mark's Basilica: February 1438

The Byzantine courtiers could not help but be impressed. They had traveled west seeking aid, and Venice was putting on a fine display of its wealth. More than two centuries had passed since the crusader sack of Constantinople, which still bore physical scars from the attack, but an even more brutal enemy was now at the gates. The Ottoman Turks had already whittled the empire down to little more than the capital city itself, and the emperor could not pick and choose his friends. John VIII Palaeologus had come personally to seek reconciliation with the West, hoping it would bring material assistance from Christian allies to keep Constantinople out of Ottoman hands. Along with the leaders of the Orthodox Church, he would be attending an ecumenical council in Ferrara (later transferred to Florence).

Pisanello, medal of John VIII on his visit to Italy, c. 1440.

The Orthodox patriarch of Constantinople, Joseph II, had expressed a special interest in visiting St. Mark's Basilica. He arrived in state at the quay beside the Doge's Palace, and the long retinue of courtiers paraded down the Piazzetta toward the basilica, pausing frequently to examine objects of interest. While relatively small in comparison with the colossal churches of the imperial city, St. Mark's made up for it in opulence. The mosaics were largely complete by this point, and the spoils from the Fourth Crusade had been carefully installed throughout the complex. Sophisticated visitors like the Byzantines would have understood the messages conveyed by the sumptuous decoration.

For example, there was the statue of the Tetrarchs at the corner where the church met the passage to the Doge's Palace. The Tetrarchs

16 The "Latin Empire" in the East would last only until 1261, when the Byzantines once again gained control of Constantinople.

had been created to represent the four rulers of the Roman Empire when it was administratively divided for a time before Constantine gained sole control. Made of the dense purple stone called porphyry, which in Roman antiquity was exclusive to the emperor, the statue had stood for more than eight hundred years at the Philadelphion, the great council hall of Constantinople, as a symbol of unity and good governance. Now the figures were embedded into the juncture of church and state in Venice, which claimed to have extended its influence into the four quadrants of the old Roman Empire.

The courtiers gazed at them dejectedly, and even more so at the gilded horses prancing over the central portal of the church. Like the Tetrarchs, this foursome had become symbolic of Venice's power, but the horses had an additional and more ancient significance. The details of their creation were obscure, but the prevailing impression was that they had originally come from Greece. Fantastic rumors said they were created by Phidias for Pericles, or by Alexander the Great's favorite sculptor, Lysippus, as the *quadriga*, or four-horse team drawing the chariot of the sun. While neither attractive attribution could be proved, the horses were undeniably of the highest quality.

When the horses first arrived in Venice, they were stored for a time at the fortress known as the Arsenale. Representatives of Florence, whose rising republic was beginning to rival Venice, circulated a spiteful story that they were saved from being melted down only by the intervention of some Florentines who truly understood art (although it would have been easier to do the melting in Constantinople had that indeed been the intent). But even if the Venetians had been incapable of recognizing the horses as great works of art, their connection with the revered Enrico Dandolo would have protected them.

In any event, their period in storage was brief. By 1267 they had been hoisted up over the main entrance to St. Mark's onto a marble platform where the doge customarily addressed the Venetian people after his election. From here on out, he would deliver his oration flanked by a pair of horses. But they were not there solely as an accessory for the doge, although they remained closely linked with the office.

According to Saint Jerome, the four Evangelists – Matthew, Mark, Luke and John – were the *quadriga* of Christ, who drew his light into the world through the Gospel.[17] So while the mosaics on the lower walls of the church focused on the story of Mark and his miraculous transfer to Venice, here at the base of the dome he took his place as one of a sacred foursome that transcended the earthly realm. It would not have escaped the notice

The Tetrarchs, c. 300 AD.

17 Freeman, *The Horses of St. Mark's*, 100.

Detail of the façade of St. Mark's Basilica.

of the visiting Byzantines that the position of the horses over the five entrances to St. Mark's also echoed the traditional arrangement of a Roman triumphal arch, thus not only filling a sacred function but also commemorating in perpetuity the Venetian-led capture of Constantinople.

The Byzantine retinue moved on into the church and were shepherded up to the main altar. While many churches had large, elaborate altarpieces, the one in St. Mark's was unique: it was solid gold, glimmering in the light of the hundreds of candles that had been lit for these special visitors. (The winter weather had been miserable, depriving them of the famous reflecting sunlight of Venice.)[18] The doge led the way into the apse so they could walk all the way around the altar, known as the Pala d'Oro (or Golden Altar), and see the brilliant gems and exquisite enamels embedded in the gold. The main dignitaries then gathered symbolically under the great central dome for a staged display of unity, while a smaller group of courtiers lingered by the Pala d'Oro to examine it more closely.

"It is something of a hybrid," one of the Venetians explained. "The main body was made for us in your city many years ago, with the story of Saint Mark across the bottom. Then the top part, with the icons, came

18 *The Memoirs of Sylvester Syropoulos* IV.21, available at the Syropoulos Project, www.syropoulos.co.uk.

ABOVE LEFT: Pala d'Oro, 976 and 1342–45. ABOVE RIGHT: Detail of the Pala d'Oro with Empress Irene.

after the Latins took Constantinople." He paused awkwardly before adding, "It was all legal, of course, as captured enemy property."

"We understand these things," replied George of Trebizond, a classical philosopher who was a close aide to the emperor. "But how did they become a single object?"

"Andrea Dandolo – descendant of our great doge Enrico Dandolo – was the procurator of this church before his own election as doge, and he is responsible for much of what you see here. It was his idea to unite the old and the new, and make the most beautiful altar in Christendom. There are thousands of jewels and pearls – so many that it is impossible to count them all. The enamels came from your own Hagia Sophia – and as you know, Doge Enrico has the honor of being the only man buried there."

The Byzantine philosopher was quiet for a moment, and then he remarked, "Is it not curious, my friend, how the sight of these beautiful things fills you with pride and delectation, while for us they are objects of sorrow and dejection?" As the Venetians nodded sympathetically, he continued: "But are you certain the panels came from Hagia Sophia? What do you think, Sylvester?"

One of his companions, Sylvester Syropoulos, happened to be a high official at Hagia Sophia. "According to my reading," he replied, "they are actually from the Pantocrator monastery. There can be no doubt – the inscription around the image of Empress Irene, who was a great patroness of the monastery, proves it." His satisfaction was obvi-

ous. "This is undisputedly a glorious and most artful object, but imagine how much more impressive it would be if the panels had indeed come from the great church!"[19]

"Such a pity you were mistaken," said George coolly. "Perhaps the Greek inscription was too difficult to read?"

The Byzantines felt they had gotten back a little of their own as the group exited the church. But for all its pomp and circumstance, their visit was ultimately a failure. At the Council of Florence the following year, John VIII and his delegation agreed to a reunification of the Orthodox and Roman Catholic churches under the pope, but no significant help against the Ottomans arrived from the West. John's brother, Constantine XI, was the last Byzantine emperor. He died when Constantinople was captured by Sultan Mehmet II on May 29, 1453, and sacked with such brutality it made the 1204 crusade pale in comparison.[20] And so the Roman Empire finally ended.

Venice: May 12, 1797

General Napoleon Bonaparte was too busy to visit Venice himself, so he sent his trusted lieutenant, General Louis Baraguey d'Hilliers, to accept the surrender of the Venetian Republic. The Great Council had voted this action the previous day. When it was done, the 120th and final doge, Lodovico Manin, left the council's elegant chamber in the Doge's Palace. The gorgeous ceiling depicting the triumph of Venice now seemed a mockery, like innumerable other images throughout the city created by generations of brilliant Venetian artists – Bellini, Titian, Tintoretto, Veronese, Tiepolo – that celebrated the special character of the divinely protected Republic of Venice.

Manin went to his private chamber in the palace, and took off his *corno ducale* and white linen skullcap. "Take these," he said to his attendant. "I will not need them anymore."[21] The end had come not with a roar of the Venetian lion, but with a whimper.

The Sack of Constantinople in 1204 had been a high-water mark for Venice, but the victory came at a price. By devastating the Byzantine Empire, the Venetians enabled the rise of the Ottomans, who conquered the Eastern Roman Empire and then turned their attention to Venice's holdings throughout the Mediterranean. The city also had the dubious distinction of being the gateway to Europe for the Black Death, which was first carried to Venice by rats in trading ships in 1348 and made a devastating return in 1630. Meanwhile, new trade routes were being

19 *The Memoirs of Sylvester Syropoulos* IV.25.

20 According to legend, the Turks broke open Enrico Dandolo's tomb in Hagia Sophia and threw his bones to their dogs.

21 John Julius Norwich, *Paradise of Cities: Venice in the Nineteenth Century* (Doubleday, 2003), 9.

Paolo Veronese, *The Triumph of Venice*,
c. 1585.

established, gradually diminishing the status of Venice as a commercial center. But the city remained wealthy due to its growing popularity as a tourist destination and its expanding territories on the mainland.

The Venetians hoped that Napoleon might leave their city alone out of respect for its status as a cultural center and a republic. Instead, the general informed Venetian diplomats that he intended to do to Venice what Attila the Hun had done to Aquileia in the fifth century. Surrender was the only option.

The French moved quickly to dismantle the ceremonial remnants of the Most Serene Republic. The lion of Saint Mark was no longer the emblem of the city. "It is not appropriate that the gentle and pacific character of the people of Venice should be represented by a wild beast whose dripping fangs threaten only massacre and ruin," declared the new authorities.[22] The last and grandest Bucentaur, the galley used by the doge for the Festa della Sensa, was ritually demolished – although it was so large and solid that this took several attempts and eventually it had to be burned. The French, always strapped for cash, also confiscated Venice's wealth, ransacking the treasury of St. Mark's Basilica for precious metals and gems. The Pala d'Oro survived only because of the mistaken assumption that something so large must be plate rather than solid gold.[23]

Napoleon also demanded works of art. Twenty canvases by Venetian masters were to be selected by commissioners specially appointed by the general. The settlement did not mention sculpture, but on December 13, 1797, a crane was erected on the platform over the entry to St. Mark's, and the four horses were slowly lowered to the ground, rolled across the Piazzetta on carts, crated, and placed on a ship bound for France. There, Napoleon had them installed on top of his new Arc de Triomphe du Carrousel near the Tuileries Palace.

After Napoleon's final defeat at Waterloo in 1815, the Treaty of Paris dictated that the horses be returned to Venice. The French people protested against their removal from Paris as they did for no other object, but the horses would be restored to their place over the portal of St. Mark's.[24]

The Venetian Republic, however, was not restored. The city and its

22 Norwich, *Paradise of Cities*, 11.

23 Norwich, *Paradise of Cities*, 15.

24 They are now located inside the church, while replicas stand on the platform.

former territories were now the possessions of the Austrian crown, and would remain so until 1866 when Venice became part of the newly formed state of modern Italy. The subjugation of this once-proud republic became a fascinatingly melancholy topic for the Romantic poets, the most famous of whom, Lord Byron, wrote in 1817:

> *Before St. Mark still glow his Steeds of Brass,*
> *Their gilded Collars glittering in the sun;*
> *But is not Doria's menace come to pass?*
> *Are they not bridled? – Venice, lost and won,*
> *Her thirteen hundred years of freedom done,*
> *Sinks, like a sea-weed, into whence She rose!*
> *Better be whelmed beneath the waves, and shun,*
> *Even in Destruction's depth, her foreign foes,*
> *From whom Submission wrings an infamous repose.*[25]

ENTRÉE TRIOMPHALE DES MONUMENTS DES SCIENCES ET ARTS EN FRANCE; FÊTE À CE SUJET.

Abraham Girardet after Pierre-Gabriel Berthault, *The Triumphal Entry of Scientific and Artistic Monuments,* 1802.

25 Lord Byron, *Childe Harold's Pilgrimage,* Canto IV.13.

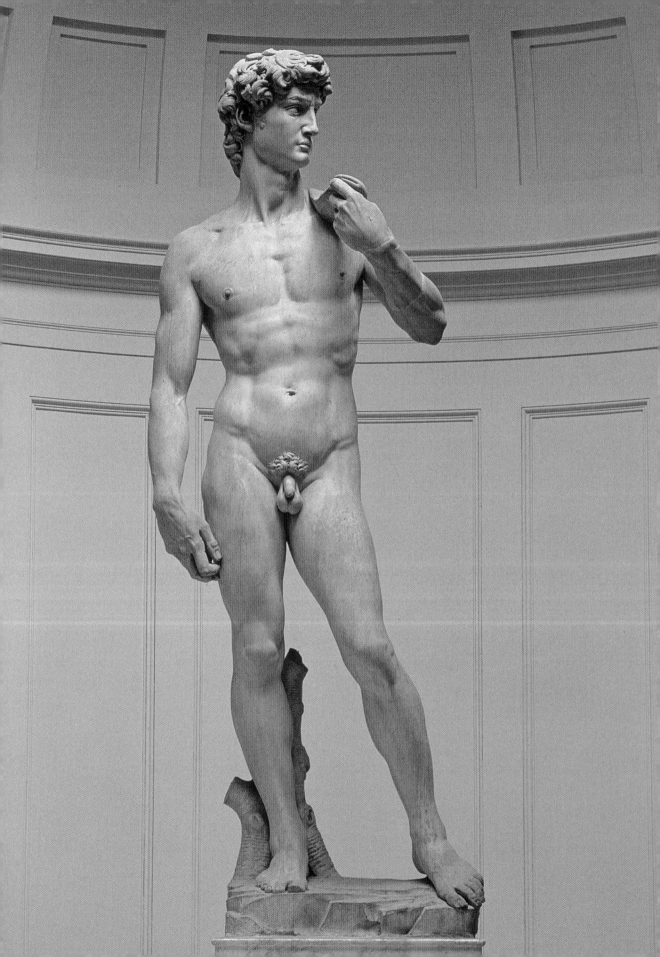

In the Company of Giants

Michelangelo's David and Renaissance Florence

As David did with his sling, so I do with my drill.

MICHELANGELO BUONARROTI

inscription on a drawing for the *David*, 1502

Florence: 1482

The marble block commanded attention by its sheer size. No other piece of stone this large had been quarried for hundreds of years, if not thousands. Visitors to the busy work yard behind the cathedral of Florence would whistle in awe when they spotted it, and they would pace heel to toe down its side to take its measure. The block was fifteen feet long and weighed more than six tons. But it was lying in disuse, covered with vines, while activity hummed all around it. The air rang with axes, chisels and hammers. Workers were casting metal, chopping wood, carving stone, carrying on the decades-long work of finishing a cathedral worthy of the Florentine Republic.

In its early days, the town of Florence did not seem destined for greatness. There were ambitious claims that Julius Cæsar had founded it, but that story is more likely to explain the origin of Fiesole, with its strategic position high on a nearby hill that would have attracted a Roman general. Florence's main feature was its situation on the Arno River in relatively flat countryside, so it was easy to reach and therefore well suited to be a market town. But the city had managed to capitalize on this prosaic attraction and had evolved into the first financial hub of Renaissance Europe.

Florence's chief commercial assets were luxury textile manufacturing and banking. Both industries generated substantial wealth, which was then multiplied by the establishment of the florin, Europe's first hard currency, in 1252. Consistent in weight, hard to counterfeit, and easy to recognize, the florin quickly became the international coin of choice, allowing this small city-state to exert astonishing influence far beyond its borders.

Michelangelo, *David*, 1501–4.

The Florentine florin, 1252.
TOP: Obverse with a fleur-de-lys.
BOTTOM: Reverse depicting
St. John the Baptist.

1 At least seven artists produced sam-
ple panels in the competition, and
those of the finalists, Brunelleschi and
Ghiberti, are preserved. The more
graceful design by Ghiberti prevailed,
and his work was so successful that
he was commissioned to create a
second set of doors for the Baptistery
in 1425. After twenty-seven years of
labor, Ghiberti completed doors so
spectacular that Michelangelo pro-
nounced them worthy of being the
Gates of Paradise.

The boom of economic activity in the thirteenth century inspired
Florence's leaders to rebuild the city's cathedral, which had originally
honored the early Christian martyr Saint Reparata. The new designs called
for a Latin cruciform plan with a massive vault over the crossing, although
no one had attempted anything like it since the fall of the Western Roman
Empire. The Romans' engineering secrets had followed the ancients
into the darkness. Still, the Florentines proceeded with the plan, starting
at the east end in 1296 and working their way down the nave, assuming
that by the time they got to the crossing someone would have figured
out the dome.

Eventually someone did. The young sculptor Filippo Brunelleschi
had been studying architecture in Rome, where he had gone to nurse his
disappointment over losing out to Lorenzo Ghiberti in a bid for the com-
mission to cast bronze doors for the Florentine Baptistery in 1400.[1] He
embarked on an intensive examination of the ancient Roman ruins, not
only for aesthetic inspiration but also as a tutorial in engineering. During
this study, Brunelleschi developed one-point perspective, the geometric
system for projecting the illusion of a coherent three-dimensional space
onto a flat surface. It involved using a grid to calculate the relative size of
figures so that the eye reads the smaller figures as being situated farther
distant in space. Originally used by Brunelleschi to record the precise
proportions of buildings in a simulated three-dimensional space on the
pages of his sketchbook, this technique would radically change the
course of painting in the fifteenth century.

For Brunelleschi, one-point perspective meant that he was able to
study and record the structure, not just the ornament, of monumental
classical architecture. Back in Florence, he used his new knowledge to
win another competition with Ghiberti, this one for the structural design
and engineering of the cathedral dome. It took sixteen years to build the
octagonal vault that soars above the city, which was completed in 1436.
Brunelleschi's achievement in erecting the immense dome without a
supporting frame seemed nothing short of miraculous, and it gave Flor-
ence the landmark that defines the urban landscape to this day.

In the following decades, work continued on ornamentation befit-
ting this architectural triumph. The affluent Arte della Lana (the guild of
wool merchants), which had been supervising the cathedral's construc-
tion since 1331, was commissioning a series of sculptures representing
Old Testament figures for the exterior. When the huge marble block was
quarried in 1464, the wool guild planned that it would become a figure
of David. As with the dome, the Florentines were confident that some-

Basilica of Santa Maria del Fiore
(the Duomo), Florence,
1294–1436.

Plan for the Duomo.

one would be able to meet the technical and artistic challenges of the
block, even if no one had created a figure of this size for centuries. The
first aspirants chipped tentatively at the marble, but found they could not
confidently project a figure onto it. Because the stone was very tall but
narrow, a human form in this brittle material would be susceptible to
breaking at the ankles. Eventually it was abandoned to lie in the yard,
little more than a curiosity piece. Some observers described it as "some-
thing that had been left for dead" and wondered if the best thing wouldn't
be to break it up into more manageable portions.[2]

2 Giorgio Vasari, *Lives of the Artists*
(Volume I), trans. George Bull (Pen-
guin, 1987), 338.

One young man was quietly pleased that nobody was trying to carve the block anymore. Solitary and somewhat unpleasant, he had few friends, and no one minded that he spent his free time with a piece of marble. For his part, he found the block a good companion that held limitless secrets. He knew it wasn't dead.

Nothing about this boy foretold a great future. Michelangelo Buonarroti's father, after failing at the family business of banking, had held positions as a minor bureaucrat in the Florentine government. His mother died when he was a small child. During her illness, he was placed in the care of a stonecutter's family in Settignano, until his father brought him to Florence for schooling. The intent was to make a bureaucrat of him as well. The city had an insatiable need for civil servants with a basic knowledge of mathematics and the law, who could read Latin and write a legible hand, to keep track of contracts and financial transactions as well as lawsuits.

From his father's perspective, it would have been a comfortable career for Michelangelo, especially if he could attach himself to one of the fabulously wealthy banking families, such as the Medici (to whom the Buonarroti were related by marriage). They had been one among a number of successful clans in the fourteenth century, but around the time Brunelleschi completed his dome the Medici were exerting a disproportionate influence in republican Florence. Their efforts to consolidate both political and financial power were, however, met with considerable resistance from a city that was determined to maintain its freedom.

The Florence that young Michelangelo encountered in the 1480s was a synergistic hive of economic, political and cultural activity that produced a singular result. The city's status as a republic made it a worthy rival to Venice, which (correctly) viewed Florence's expanding influence as a challenge to the Most Serene Republic's claim to be the preeminent free state in Italy. This rivalry played out in counting houses, in the occasional military skirmish, and in artistic endeavors. But it was Florence that emerged as the epicenter of Renaissance culture. When Michelangelo arrived, the roll call of genius inspired by the city's freedom and prosperity was already legendary: Dante, Boccaccio, Masaccio, Brunelleschi, Ghiberti, Pico della Mirandola, Poliziano, Donatello, Botticelli and, most recently, Leonardo da Vinci. But the greatest was yet to make his mark – and create the defining icon of Florence at a critical moment for the republic.

* * *

Brancacci Chapel, Santa Maria del Carmine: 1491

When the Brancacci family renovated their chapel in the Church of Santa Maria del Carmine during the 1420s, they were at the height of their power. Their wealth derived from the silk trade, and in alliance with some of the other influential families they were able to stage-manage the exile of Cosimo de' Medici from Florence in 1434. But Cosimo returned less than a year later more powerful than ever, and the Brancacci were in turn exiled. Before this disastrous turn of events, however, they commissioned a fresco cycle in their chapel as a public manifestation of the family's piety. Several artists participated, the most prominent of whom was the famous Masaccio ("Fat Tom"). He painted in a new style that would reflect not only the magnificence of the Brancacci, but also their sophistication.

On the walls of the Brancacci Chapel, Masaccio created a simple but profound rhythm out of shapes that fit together like a three-dimensional geometric puzzle. Christ produced the tax coin from the mouth of a fish and Saint Peter raised the dead in an atmosphere of timeless harmony enhanced by the use of one-point perspective, which the painter had learned directly from Brunelleschi. This technique made his pictorial space seem to be an extension of the chapel's three-dimensional space, in which the figures stood solidly as if anchored by gravity and lit by the same sunlight that came streaming in from the solitary window.

Masaccio's preternaturally calm figures made a curious contrast with a violent struggle that broke out on the chapel floor some sixty years after he painted his frescoes on the walls. A group of students were there to sketch Masaccio's work that afternoon in 1491, but two of them instead wrestled about in a most undignified fashion, rolling over and over on the cold pavement, each demanding that the other admit his rival was the better artist. Then the bigger boy got on top and started punching the face of his adversary until there was a crunch and a spurt of blood that drenched them both. The younger boy went limp.

Pietro Torrigiano stood up, his expression defiant if also a little scared. He wasn't sorry he had done it. Michelangelo had become insufferable, constantly criticizing Pietro's drawings with a smug insistence on his own superiority. But he was also the favorite young artist of Lorenzo de' Medici, who would be displeased to learn he was injured. The best bet was to get out of there quickly. Pietro was followed by the other boys; they had also had enough of Michelangelo.

The only one who seemed concerned was one of Masaccio's figures on the wall, a nude Adam who clutched his face in sorrow as he was

The Brancacci Chapel, Santa Maria del Carmine.

Masaccio, *Adam and Eve Expelled from Eden*, 1423.

Masaccio, *The Tribute Money*, 1423.

banished from the Garden of Eden. Adam had been of particular interest to Michelangelo, but was of no assistance to him as he lay unconscious on the floor.

Michelangelo had to be carried home and be revived by his family. The bones of his nose were shattered. He hadn't been handsome to begin with, and now he would be disfigured for life. His broken nose would serve as a permanent reminder that the gift of genius was not an easy one to bear, and he would be sensitive all his life to the irony that he who would create so much beauty was himself so ugly.[3]

Florence: March 1492

All Christendom was making nervous preparations for the approaching year 1500. This date had a solid claim to be the "time and a half" that Saint John had prophesied for the Second Coming of Christ in the Book of Revelation, when the living and the dead would be judged for eternity. As it would turn out, however, 1492 was far more momentous in historical terms. Columbus reached the New World, the Moors were expelled from Spain, and most importantly for Michelangelo, Lorenzo de' Medici died at the age of forty-three.

Lorenzo was a new breed of Medici. The family's fortunes had been consolidated by his grandfather Cosimo, who became known as the Florentine *pater patriæ*. A man of immense political and financial acumen, Cosimo outwitted the machinations of his rivals, even enduring two periods of exile while plotting his triumphant return. On his watch the Medici bank became the de facto counting house of Europe, with offices as far afield as London and Bruges.

Cosimo had lived to see his family host no less than the Byzantine emperor, John VIII Palaeologus, and the large delegation that came with him to attend the ecumenical Council of Florence in 1439. For many Florentines, the presence of the man understood to be the living, breathing descendant of the Roman emperors of old seemed to confirm the growing sense of a paradigm shift away from the medieval and toward a revival of the classical legacy. Latin and then Greek were eagerly studied so that surviving ancient texts could be rescued from dusty library shelves and probed for the knowledge and culture that had been obscured by the intervening centuries.

Florence claimed an especially profound connection with the classical past, as Florentines understood their republic as the modern embod-

3 The story is recounted in Vasari, *Lives*, 332; and in Ascanio Condivi, *Life of Michelangelo*, trans. Alice Sedgwick Wohl, ed. Hellmut Wohl (Penn State, 1999), 108.

iment of the ancient democracies of Athens and Rome. There had been
fitful efforts at self-government in the city following the death in 1115 of
the somewhat scandalous Matilda, Countess of Tuscany, whose close
relationship with Pope Gregory VII had dragged Florence into his epic
struggle with Henry IV, the Holy Roman Emperor, for political domi-
nance in Europe.[4] When her domains were divided up between church
and empire, Florence became an independent entity. A republic was for-
mally established in 1293 with the Ordinances of Justice, which declared
that all males who had reached maturity and joined a guild – in other
words, men who participated in the economic life of the city – were eligi-
ble to serve in the government. Indeed, they were frequently obligated to
do so, since officials were selected, theoretically at random, from bags
containing the names of all eligible voters. It was not a long commit-
ment – a term measured in months or even weeks – and most served
without complaint. In times of crisis, Florentine citizens participated in
a communal parliament to make important decisions.

Florentines were proud of the fact that their city remained a repub-
lic while many of the other free communes (self-governing republican
city-states) established in the medieval period had fallen under the con-
trol of despots by the year 1400. Maintaining independence was no small
achievement. Foreign powers, attracted by Florence's wealth, had attacked
more than once. The relationship between the elite and the workers was
uneasy, and tensions flared periodically into savage violence. Competition
between the leading families could all too often become – literally – cut-
throat, making Florence a dangerous place. Furthermore, Florence's com-
plex and unwieldy political system, designed to prevent any one individual
from amassing too much power, had been effective in thwarting dictators
but had also frequently rendered the government incapable of decisive
action. Still, the city's legislature, the Signoria, was freely elected, and the
trade guilds as well as the nobility had a say in how Florence was run.

Direct participation in the government was understood as a sacred
trust for citizens, and the Signoria on the whole pursued policies that
fostered the city's prosperity. They saw to it that businesses were encour-
aged to employ good practices that would minimize defaults (and so
increase confidence in Florence's banks), and generally pursued a fair tax
code that was conducive to commerce. The result was the astonishing
burst of wealth that fueled what we call the Renaissance.

While the word "renaissance" was not used until the nineteenth
century, Florentines were well aware that something noteworthy was
occurring within the city walls. They were convinced that their republic

4 Matilda of Tuscany (1046–1115) was
renowned as comely, pious and fabu-
lously wealthy. Even though Florence
was destabilized when her connec-
tions pulled the city into the bitter
conflict between Gregory VII and
Henry IV, she remained popular
locally—so much so that the
staunchly republican Michelangelo
would claim to be descended from
Matilda's family in order to enhance
his humble pedigree. Florence is still
marked by her bountiful patronage,
notably in the Church of San Miniato,
perched on a hilltop.

was morally superior to neighboring despotic regimes, and that the city's remarkable prosperity was a sign of providential approval. To celebrate this divine favor, increasing sums were spent on projects that beautified the decidedly dark and unlovely medieval urban fabric. In addition to the new Basilica of Santa Maria del Fiore (commonly called the Duomo, or cathedral), a number of sumptuous parish churches were either established or rebuilt throughout the city. An imposing new town hall, the Palazzo Vecchio, was constructed between the Duomo and the river, flanked by a graceful colonnade in the classical style. The great families began to dismantle their ungainly defensive towers and build more luxurious town houses. And the guilds, made more powerful by the Ordinances of Justice, spent their growing profits on artistic programs to glorify Florence.

The proliferating cultural treasures of the city, including Masaccio's frescoes and Brunelleschi's architecture among many others, were inspired by the legacy of classical antiquity and looked very different from their medieval predecessors. But they also looked

Michelozzo, Palazzo Medici, 1445–60.

different from actual antiquities. Despite the visceral sense of connection between early modern Florence and the ancient past, this thing we call the Renaissance was not really a rebirth. It was a distinct cultural era that transformed the past to suit the needs of the present. When, for example, Cosimo de' Medici built his new palace, he had the exterior ornamented with arcades that recalled those of the Colosseum in Rome, but in a way that would never be mistaken for the original.

It was telling that the Palazzo Medici reflected an imperial rather than a republican Roman model, for this building – and the family who lived there – posed a serious threat to the Florentine Republic. Unlike the traditional homes of the Florentine nobility, which hid their riches behind plain façades, this ornate structure took up an entire city block and proudly declared the family's success. It became a financial and social hub for the city as those who wanted to do business with the Medici – or to

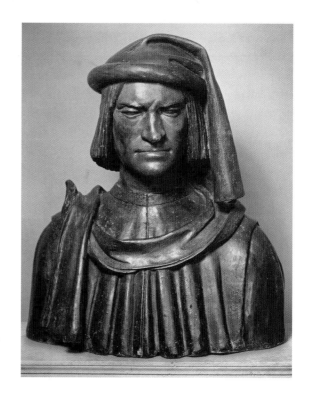

Andrea del Verrocchio (after), *Lorenzo de' Medici*, 15th or 16th century.

5 Machiavelli describes the conspiracy in detail in his *History of Florence*. A few years before Michelangelo came to Florence, members of the Pazzi family, who were resentful of the growing Medici power, plotted along with Pope Sixtus IV to assassinate Cosimo's two eldest grandsons. They planned to stab the boys to death during Sunday services in the great cathedral, when the ringing of the church bells would drown out the victims' cries. On April 26, 1478, they killed Giuliano and wounded Lorenzo, who was able to barricade himself in the sacristy until help arrived. Niccolò Machiavelli, *History of Florence and of the Affairs of Italy*, trans. Christian E. Detmold (1882), VIII.1–8, available at http://oll.libertyfund.org/titles/774.

admire their ever-growing collection of ancient and contemporary art – passed through its portal. When he arrived in Florence, Michelangelo wanted to do both.

The new head of the family that welcomed him, Lorenzo de' Medici, was, like the young artist, so outstandingly ugly that there was no point in portraying him any other way. His portraits reveal his sallow complexion and strangely deformed nose, which managed to be both flat across the bridge and prominent at the tip. Perhaps because of this, or because his neck had been wounded in an assassination attempt by the powerful Pazzi family (which left his brother Giuliano dead), Lorenzo had a thin, nasal voice. In a society that prized beauty and music, both imperfections should have been serious impediments, but such was the force of Lorenzo's personality that no one seemed to notice. Moreover, the Pazzi conspiracy against the Medici backfired. The people of Florence rallied around Lorenzo, who proved brave and decisive in the crisis, and the conspirators were summarily executed. Rather than restore the republic, the episode laid the foundation of Lorenzo's power.[5]

Building on his grandfather's success, Lorenzo proposed a set of

reforms to Florence's cumbersome political system in the 1480s. While these measures purportedly were designed for efficiency, in actuality they made it easier for the Medici to control the government by concentrating power in the hands of their allies and dependents. Lorenzo was remarkably adept at increasing his political sway and personal influence. Although Florence was nominally a republic, he was determined to present himself as a prince. Surrounded by scholars, exquisite luxury, and even exotic animals, he earned the nickname *Il Magnifico*, the Magnificent.

During the years that Lorenzo was consolidating his control over the city, Michelangelo turned out to be a less than ideal candidate for the civil service as his father had wished. Instead, he managed to get himself apprenticed to a major artist. Domenico Ghirlandaio happened to be painting a chapel for the family of Lorenzo's mother, the Tornabuoni, who were only slightly less fabulously wealthy than their Medici cousins. The thirteen-year-old quickly distinguished himself: on seeing what Michelangelo had painted in the Tornabuoni Chapel, Ghirlandaio declared that the student was now the master.[6] Thus Michelangelo came to the attention of the Medici, who brought him into their busy palazzo in 1490 to continue his studies.

Lorenzo received interesting if decidedly mixed reports about the artist. On the one hand, there was the bickering and brawling with his fellow students, none of whom had a nice word to say about him. On the other, all the masters, including the philosophers and poets as well as the artists, believed he was something out of the ordinary. Surly, yes, but exceptional. He could carve as well as paint, and he was also starting to write poetry that wasn't all bad.

Michelangelo's youthful encounters with Lorenzo were staged in the pleasant garden up the street from the family's palace where Il Magnifico had informal gatherings of the artists and intellectuals on his payroll. Although the Florentine weather was changeable, they could at least pretend that they enjoyed the same idyllic experience as the ancient Athenians who had gathered in olive groves to debate the origins of philosophy. The artists, especially the sculptors, may not have been enthusiastic about lugging heavy and fragile works out to a garden, but if it was what Lorenzo wanted, they did it.

In March 1492, Michelangelo brought a particularly interesting piece of marble to the garden. Lorenzo had been ill, and everyone was eager to please him – including a self-consciously dignified man in a scarlet robe with a maroon cap pulled over his dark hair who hovered close to him. Angelo Ambrogini, known as "Poliziano" after his hometown of

6 Vasari, *Lives*, 329.

Montepulciano, was among a growing group of men who made a liveli-hood from their encyclopedic knowledge of classical culture. Proficient in both Latin and Greek, Poliziano examined ancient texts for secrets of grammar and composition as well as philosophical insights that had been lost over the centuries. He had shared his knowledge with Lorenzo and his brothers when he served as their tutor, before taking charge of the lavish library the family was assembling.

Poliziano had taken an active interest in Michelangelo after the young man moved into the Palazzo Medici under Lorenzo's protection.[7] He had encouraged the artist to explore not just the forms of ancient art but also its themes – for instance, he suggested that Michelangelo meditate on the story of the Lapiths (a legendary tribe of ancient Greeks) and the centaurs (half-man and half-horse creatures). Poliziano knew from his study of ancient texts that the battle between Lapiths and centaurs was depicted by Phidias on the metopes of the Parthenon and on the sandals of the Athena Parthenos inside, as part of his program celebrating the triumph of the Athenians over more bestial forces.[8]

The myth had been taken up by the Roman poet Ovid, whose *Metamorphoses* was a key text for the Renaissance understanding of antiquity. Ovid told a long and bloody story of a wedding reception gone wrong, in the course of which the centaur guests, inflamed with lust and wine, attempted to abscond with the bride and her attendants.[9] A war ensued between the Lapith groom and his companions on the one side and the centaurs on the other. In the mayhem, one Lapith was struck in the face and died as his nose was pushed all the way through his palate so that his eyes burst out of their sockets – an experience with which Michelangelo must have felt a certain empathy. Scholars understood Ovid's story as an allegory of the conflict between intellect and nature, with victory for the intellect leading to civilization but victory for nature resulting in chaos. At seventeen, Michelangelo may not have grasped this larger concept on his own, but Poliziano, the most learned man in Florence, could surely have illuminated it.

For his part, Lorenzo liked the idea of being a modern Pericles with his own Phidias, and he had a small block of marble given to Michelangelo so he could explore this theme. It was a significant vote of confidence, as the physical materials required to produce a work of art were generally considered more valuable than the creative act of the artist. These assets – from precious metals and stones down to scraps of paper – were jealously guarded.

Lorenzo's confidence turned out to be well placed, for the boy had

7 Both Vasari and Condivi describe the role of Poliziano in Michelangelo's education—and particularly in the creation of the *Lapiths and Centaurs*—suggesting that Michelangelo wanted to emphasize his early connection with an intellectual celebrity. Vasari, *Lives*, 331; Condivi, *Life of Michelangelo*, 14–15.

8 Pliny the Elder, *Natural History* 36.4.5 (available at the Perseus Digital Library).

9 Ovid, *Metamorphoses* XII.210–535, particularly 245–60.

packed a great deal into his chunk of marble. The surface was covered with writhing figures that were not delicately incised like a drawing on stone, but deeply carved so they stood out in three dimensions. Michelangelo had spent many days over the past few years dissecting corpses in the local hospital – a rare chance to learn about the inner workings of human anatomy. His forms suggested muscles and sinews straining under the skin. He could portray the nude in a remarkable number of different poses – twisting, crouching, even leaping – that would have defeated many older artists. And Michelangelo's figures were not just static hunks of stone. He had imbued them with a striking range of emotion, from the despair of the form huddled in a lower corner, head in hands, to the serenity of the figure in the center who exudes a godlike calm even as the fighting rages around him.

Taking Poliziano's lessons to heart, Michelangelo identified the conflict between the Lapiths and centaurs with the creative struggle to take a base natural material and transform it through his intellect into a great work of art. He included several figures who prepared to hurl stones of about the same scale as his marble block, the implication being that after the triumph of the Greeks, they would be transformed from blunt weapons into vehicles for human creativity.

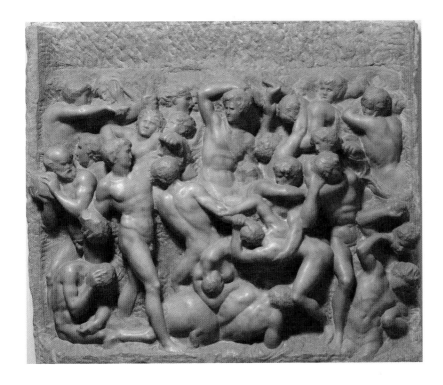

Michelangelo, *Battle of Lapiths and Centaurs*, 1492.

Lorenzo studied the relief for a while, and then turned to Poliziano. "So, do you think your pupil has bested Phidias?"

Poliziano had no way of truly knowing – and neither did Lorenzo or Michelangelo. None of them could hope to see Athens, let alone a work by Phidias, since Greece was now a domain of the Ottoman Empire and the Parthenon had been converted into a mosque. They could only imagine the great antiquities that survived on the Acropolis, aided by Roman copies of Greek sculpture and the texts that described lost masterpieces.

Michelangelo's attempt at an esoteric subject known to have been favored by Phidias was a daring gambit. As a rule, Lorenzo preferred collecting antiquities, and if he strayed into the modern, he favored illuminated manuscripts or more intrinsically valuable objects such as carved gems – the latter in particular being considered more precious than paintings or large-scale sculptures. Michelangelo knew he needed to catch his patron's attention with something extraordinary if he wanted to win further commissions in his chosen media. But by attempting a work so ambitious in composition and subject, he might have been setting himself up for failure, and the title of "the new Phidias" could have been one of mockery rather than praise.

Fortunately, he was more than up to the task. The scholars and the other artists, and most importantly Lorenzo himself, were duly impressed as they worked their way through the figures, remarking on their strange fusion of violence and grace as well as their cleverly interlocking forms. Lorenzo noted that Michelangelo's skill was such that had he not known better, he would have thought he was looking at the work of a much older master.

Poliziano tapped the marble with his finger. "Imagine if you gave him something larger than a loaf of bread to work on!" The whole group laughed. Lorenzo and Poliziano, trailed by the rest of the courtiers, took their leave and moved off down the Via Larga toward the Palazzo Medici. Lorenzo, still weak from his recent illness, was carried this short distance in a litter. But he seemed to be on the mend, and Michelangelo was hopeful.

Given Lorenzo's enthusiasm for the relief, the young artist might well be on the edge of great new projects that would transform Florence. Michelangelo was finished with being a student; after all, he had already been paid as an assistant to Ghirlandaio, an unprecedented honor for one so young. (Most apprentices paid for the opportunity to work under a master.) Grateful though he was for the practice on scraps of marble

from the Medici workshops, he was ready for something more challeng-ing. In a word, something bigger.

Lorenzo's recovery proved illusory; just a few weeks later he was on his deathbed at his villa near Careggi. The normal bevy of courtiers and relatives attended him, but his focus was entirely on the dark-robed Dominican friar who sat near the head of his bed.

Some of Lorenzo's companions had tried to keep Girolamo Savon-arola out of the chamber. Heaven only knew what the fiery preacher might say; his distaste for pagan antiquity and his disapproval of all those who admired it were well known. Savonarola was striking a chord with people who worried about the looming year 1500, and he had to give his brimstone-filled sermons in the Duomo because of the enormous crowds he attracted. He had not been shy about criticizing the Medici as excep-tionally sinful, but the family, mindful of the calendar, went out of their way to be conciliatory. Lorenzo had taken a personal interest in the friar, and while not ready to renounce his beloved ancient sculptures and texts, he started thinking much more about the state of his soul, especially after he fell ill. And so it was that Savonarola was sitting by his bedside, hearing his affirmation of faith and granting him his blessing.

Lorenzo the Magnificent was at peace when he died on April 9. A rumor went around that the dome of the cathedral was struck by lightning just before his last breath. Whether the story was true or not didn't matter; clearly, an era had ended.

Under Lorenzo's weak and sickly son Piero, Medici power quickly waned while Savonarola's waxed. When Piero made a bad deal with the approaching French army of Charles VIII in 1494, public anger exploded, and Piero had to flee the city with his brothers. The family that had seemed invincible just two years before was exiled once again. By popu-lar demand, Savonarola assumed the powers of a dictator, charged with preparing the Florentines to meet their maker when the century ended.

The promise of secure patronage for Michelangelo died along with Lorenzo. As Florence fell into chaos under the French threat, the young sculptor left the city in search of other opportunities, spending a year in Bologna.

Upon returning to Florence in late 1495, he produced a figure of a sleeping Cupid, likely inspired by a late Roman piece he would have seen in the Medici gardens. Michelangelo's *Sleeping Cupid* was buried in the ground for a period of time so it would appear to be an authentic antique, and a Florentine merchant took it to Rome. There he sold it to a cardinal as an ancient Roman treasure for a much higher price than a work

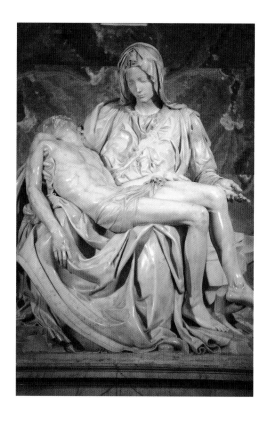

Michelangelo, *Pietà*, 1499.

10 Who initiated the deception is not certain, though both Vasari and Condivi unsurprisingly present Michelangelo as an innocent in this episode. Vasari, *Lives*, 333–34; Condivi, *Life of Michelangelo*, 19–20. The *Sleeping Cupid* was acquired by Cesare Borgia, who gave it first to the Duke of Urbino and then (after conquering Urbino) to Isabella D'Este of Mantua. The marble was eventually purchased by the great collector Charles I of England, and it appears to have perished in the Whitehall fire of 1698.

attributed to Michelangelo Buonarroti would have commanded. It was a risky move for the sculptor, since being a known forger could have ended his career before it began. But when the ruse was discovered, the cardinal blamed the dealer and wanted to meet the artist. Michelangelo claimed it was all a joke. He emerged with his reputation burnished, and his *Sleeping Cupid* became a celebrity object.[10]

The *Sleeping Cupid* affair soon brought Michelangelo himself to Rome at age twenty-one, introductory letters in hand. He got a critical opportunity to demonstrate his abilities in 1498 when the French cardinal Jean de Bilhères-Lagraulas commissioned him to create a sculpture of the dead Christ cradled in Mary's lap for St. Peter's Basilica – the very heart of the Roman Catholic Church. Ironically, Michelangelo's *Pietà* turned out to be so moving in its pathos and accomplished in its technique that many doubted so young a man could have created it. In order to silence the skeptics, Michelangelo reportedly stole into the church at night and signed the marble in large capital letters on the strap across the Virgin's chest: MICHAEL A[N]GELUS BONAROTUS FLORENT[INUS]

FACIEBA[T]. It would be the only work he ever signed. A few years earlier, he had tried to pass off his sculpture as someone else's; now he boldly claimed his own work.

While Michelangelo matured in Rome, Savonarola became more radical in Florence. During Carnival in 1497 he organized a "Bonfire of the Vanities," in which pious citizens brought their texts by pagan authors and other worldly goods to the cathedral to be tossed into a fire. Even the great Sandro Botticelli, one of Savonarola's most devout followers, threw some of his own mythological paintings onto the flames.

That same year, the friar was excommunicated by the pope for his scathing criticism of the church. He remained defiant, but Florentines were tiring of his strict demands; they were ready to return to politics and culture, not to mention commerce. A mob attack on the convent of San Marco in April 1498 led to Savonarola's surrender and trial for heresy and sedition. The next thing thrown into the flames was his lifeless body. The city would face 1500 on its own.

Florence, the epicenter of Renaissance culture just six years before, was now in a sorry state. Savonarola's regime had not been kind to artists and intellectuals. As the republican government began to reassemble itself, the authorities decided that major new projects were needed to draw back the talent that had been such a rich source of civic pride. At that point, someone noticed the neglected piece of marble in the cathedral work yard.

"Friends" wrote to Michelangelo in Rome to tell him that the city was seriously considering reviving the project to carve a single figure out of the tall, narrow block. Whatever those letters said was enough to bring the artist racing home to declare his allegiance to the Florentine Republic.

Florence: July 1501

The two men regarded each other with frank dislike. Leonardo da Vinci was approaching fifty, but he still had the arresting beauty that had made him famous as a young man. An elegant figure, he favored the gorgeous textiles produced in Florence, particularly the pale silks. Michelangelo Buonarroti was half his age, dark and muscular, with his twisted nose. He was wearing a dusty leather smock and an untidy turban on his head, making him look like a stoneworker who had run out for supplies. Which, after all, he was.

Both Leonardo and Michelangelo had returned to Florence in the

hope of landing the commission to fashion a figure of the biblical David from the colossal block of marble. Leonardo had been working at the court of Milan before joining the mercenary Cesare Borgia as his traveling military engineer. Given Borgia's none-too-friendly interest in Florence, it must have seemed only prudent to the Florentines to tempt Leonardo out of his service with the promise of a substantial commission. Leonardo was eager for the challenge and considered the block his by rights because of his reputation as a genius and his recent effort to cast a bronze equestrian monument to Ludovico Sforza, Duke of Milan. He dismissed Michelangelo as disrespectful and unpleasant, and certainly not worthy of this marvelous piece of marble.

Michelangelo saw things differently. He had grown up hearing tales of the great Leonardo and had been encouraged as a boy to study his cartoon for *The Adoration of the Magi*, a work the master had begun in 1481 but abandoned when he left Florence for Milan the following year. Now Leonardo was consumed with painting the portrait of a local merchant's wife. Madonna ("My Lady," or Mona for short) Lisa was lovely enough, though hardly a goddess – yet Leonardo had been obsessing for months over the shading of her eyes and the form of her smile. He showed no signs of getting close to completing the commission. Michelangelo understood the creative brilliance of Leonardo's compositions and the expressiveness of his figures, but what good was being a genius if you never finished your work?

For a period they had tried to avoid each other, but in a town the size of Florence an encounter was inevitable. It happened one afternoon in front of the Palazzo Spini, one of the most imposing of the surviving medieval urban fortresses. Leonardo was traveling grandly down the street, surrounded as always by a cadre of well-dressed assistants. A group of men chatting in front of the palazzo asked him how he interpreted a certain passage of Dante's *Divine Comedy*, which was the sort of small talk enjoyed by Renaissance Florentines. As he pondered the question, Leonardo's eye lit on the solitary figure approaching them.

"Look," Leonardo observed loudly, "you might think that man is a baker. He is covered with flour! I bet when he stands by his ovens it melts into sweaty mud. But he claims to be a sculptor and a great genius, so ask him what he thinks of Dante." His acolytes sniggered; they too recognized the man.

Michelangelo retorted, "If you have any hope of carving that great block, Leonardo, you'd better get used to a little marble dust. But don't worry – you would never make it beyond the drawing board anyway.

Everyone knows how you couldn't manage to cast your Sforza horse in bronze."

"Ugh, can you imagine the house of such a creature!" Leonardo went on as if his rival had not spoken. "He must have chips of stone everywhere, covering the ground like hay in a horse's stall. In fact, he has a face like a horse, only not so noble!"[11] The sniggering intensified.

Michelangelo's face darkened. "You," he spat, "are the son of a whore!"[12] He darted away. Leonardo tried to laugh it off, but he was stung. He disliked references to his illegitimate birth. And he despised Michelangelo.

When a report of the quarrel reached the new head of the republic, Piero Soderini, he was dismayed. The idea had been for Leonardo and Michelangelo to spur each other on to greater heights of artistic achievement through lofty competition, not to trade squalid slurs in the streets.

Soderini had been the ambassador to France. Returning to Florence shortly after Savonarola's execution in 1498, he became a key figure in the re-establishment of the republic. It was a precarious moment, as the Medici were eager to end their exile and they smelled opportunity. This created an awkward situation for Soderini, who had been a close Medici associate and was originally named ambassador by Lorenzo's son. But he knew that if the Medici came back to Florence now it would be the death knell for democracy, and he was determined to stop them. Soderini had become *gonfaloniere*, a key post in the Florentine government that had traditionally been a two-month appointment filled at random from among the elected members of the Signoria. But given the city's difficult financial and diplomatic circumstances, Soderini was named *gonfaloniere* for life in 1502. The maneuver seemed self-defeating, an invitation for Soderini to become a despot. Luckily for Florence, however, Soderini was committed to preserving the republic.

He was assisted by a brilliant civil servant who had observed both the ascendancy of the Medici and the rule of Savonarola with disquiet. Niccolò Machiavelli was thirty-two when Soderini took power. While best remembered today as the author of *The Prince*, that notorious handbook for aspiring tyrants, he was a fervent republican at heart and his most profound writings deal with the history of the Florentine Republic and its parallels with republican Rome.[13] Machiavelli served as Soderini's secretary of the chancery, a powerful administrative post.

Soderini was a shrewd administrator and diplomat, with the calm competence that Florence needed after the drama of Savonarola. He reconstituted the city's defenses by establishing a standing militia under

11 Leonardo da Vinci, *Treatise on Painting,* fragment 51.

12 This scene is recounted by the so-called "Anonimo Magliabechiano," who wrote a series of gossipy anecdotes about Michelangelo's life in the 1540s.

13 Later in life, reflecting back on this period from his enforced retirement after the return of the Medici, Machiavelli would assert that Soderini had not been ruthless enough to save the republic—suggesting that he should have taken the ancient Roman hero Brutus as his model and executed the surviving Medici and their supporters, even if they were personal friends. Book 3, Chapter 3 of Machiavelli's *Discourses on Livy* is titled "Why It Is Necessary to Kill the Sons of Brutus If One Wishes to Maintain a Newly Found Freedom."

Machiavelli's leadership, and he ended a protracted war with Pisa by bru-
tally annexing that old rival (and its leaning tower) in 1509. His decade of
sustained success as *gonfaloniere* was the equivalent of several lifetimes in
Florentine politics.

Soderini was also a discerning man of culture, and he knew how
useful artists could be in burnishing and perpetuating the city's glory. He
had gotten to know the young Michelangelo before Lorenzo's death and
may have been responsible for sparking the artist's patriotic commit-
ment to the Florentine Republic. He took a personal interest in the plans
for the gigantic marble block, especially after both Leonardo and Michel-
angelo arrived in Florence to compete for the David project in 1501.

In the end, Michelangelo's youth – in addition to his friendship with
Soderini – seems to have tipped the balance in his favor. He was officially
granted the commission by the Arte della Lana in August 1501, just
weeks after Soderini unveiled the new constitution that officially restored
the Republic of Florence.[14] Leonardo, whom Machiavelli had favored,
was put to work frescoing the main hall of the Palazzo Vecchio with
battle scenes from Florentine history.

Michelangelo's workshop: January 1504

14 Michelangelo's contract for the
David, dated August 16, 1501, survives
in the Florentine archives.

15 Giorgio Vasari, who wrote his
biography of Michelangelo years
later at the Medici court, tells this
story in a way that makes Soderini
out to be a bumbler incapable of
understanding the sculptor's art.
When Michelangelo reviewed the
draft, he sent Vasari a curt note ask-
ing him to take the story out, as it
was not accurate. But the old sculptor
died, and Vasari left it in, no doubt to
curry favor with the triumphant
Medici, who had a vested interest in
denigrating Soderini's connection to
the great statue. Vasari, *Lives*, 338–39.
(Condivi omits this story in his
account of the *David*.)

"Don't you think the nose is too big?" Soderini was gaping wide-eyed at
the huge marble figure, and in his amazement he said the first thing that
came into his head.

"I know a thing or two about noses," Michelangelo replied. "But if it
makes you feel better ... "

Seeing that his friend was mesmerized by the sculpture, he surrep-
titiously reached down and grabbed a handful of marble dust off the
floor. He climbed up the scaffolding alongside the statue and pretended
to drill at its nose, releasing the powder slowly from his hand for dra-
matic effect.

Soderini either didn't notice he was being tricked or didn't care. He
was still trying to absorb the magnitude of Michelangelo's achievement.
"Yes, that's it, he's perfect now," the *gonfaloniere* said absently. "Truly
perfect."

"He already was," the sculptor retorted as he jumped off the scaf-
fold. "He's the perfect Florentine warrior."[15]

The biblical David was a loaded subject in Renaissance Florence. He
was a popular hero for underdogs in the Christian tradition, having

started life as a lowly shepherd. While still a teenager, according to the Book of Samuel, he grew ashamed of the Israelites' inability to muster a champion to face the Philistine brute Goliath, so he volunteered to do it himself, armed only with a slingshot. David was confident that his skill with the humble weapon, and more importantly his faith in God, would gain him victory. His faith was rewarded: after stunning Goliath with a well-placed shot to the forehead, David decapitated him, and so delivered the Israelites from the Philistines.

The Florentines identified with this biblical story because they had played David to numerous Goliaths over the years. In 1402, for example, the republic that didn't even keep a standing army was menaced by Giangaleazzo Visconti, Duke of Milan, who was scheming to become the first ruler of all Italy since the end of the Roman Empire. The powerful despot systematically choked off Florence's trade and thwarted the city's attempts to enlist foreign assistance. Giangaleazzo's army seemed poised to conquer Florence when the duke contracted one of the many strains of plague that were then active. His sudden death demoralized his forces, which had not been paid in some time, and they retreated. The Florentines greeted the news as a mark of divine favor: just as God had granted David an improbable victory over Goliath, now their republic had been delivered from imperial Milan.

In the following decades, a number of David images were produced to reinforce the notion that free Florence enjoyed special protection because of her righteousness. These ranged from paintings on ceremonial shields that could be borne through the streets in civic festivals, to major sculptures by the great Donatello. His first recorded commission from the years just after Visconti's death was a somewhat unremarkable marble version of David triumphant, dressed in a jerkin and cape, his sling elegantly dangling from his left hand, with a foot on Goliath's severed head. Although originally intended for the Duomo, the figure was claimed by the government of Florence. It was placed in the town hall as an appropriate symbol for the republic, and duly inscribed "To those who fight bravely for the nation, God grants aid even against the most fearsome enemies."

Donatello returned to the theme decades later under very different circumstances. He was then the most famous sculptor in Italy, and his close confidant and patron Cosimo de' Medici had commissioned a bronze David for the family's new palace. Donatello produced a far more subtle and enigmatic interpretation of the theme the second time around. This David was nude – the first nude cast since antiquity – and

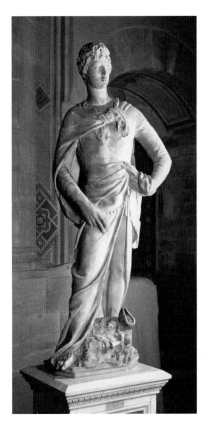

Donatello, *David*, 1409.

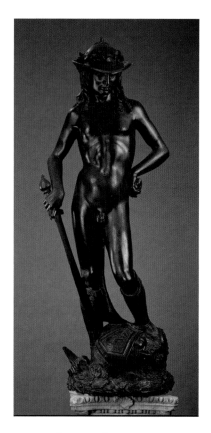

Donatello, *David*, c. 1445.

while he was once again shown at the moment of triumph, he looked down at Goliath's head with sympathy, even sorrow. The undeniably beautiful but curious figure would have greeted visitors as they entered the courtyard of the Medici palace, and would even have been glimpsed by passersby on the street during business hours when the great doors were open. Michelangelo would have had many opportunities to study the famous statue; indeed, he was probably encouraged to do so by Lorenzo and Poliziano.

After the exile of the Medici in 1492, their elegant palace was sacked and on Soderini's orders the second David by Donatello joined his marble version at the town hall, rechristened as an emblem of the republic. But for all its symbolism, the bronze remained difficult for the broader populace to understand, and the newly revived republic needed emphatic, not enigmatic, defenders. It was Michelangelo's job to produce one.

When, later in life, Michelangelo described his early projects in marble, he insisted that his role was to liberate the figures that already existed in the stone, which he could glimpse in his mind's eye. His productions were thus presented as an intuitive process, guided by pure – and divine – genius. But in the case of the *David*, he had already been meditating on the block for years. Who knows how many tentative early drawings were consigned to the flames in the purge he made of his papers late in life? Almost nothing survives, so we are left with the impression of an artist struck by a thunderbolt of inspiration rather than carrying out a cautious and laborious technical process.

At any rate, Michelangelo was sufficiently prepared to attack the block in public view within days of taking possession of it: his first action was to hack off an element on what would become the figure's chest (possibly the knot of a cloak) left from an earlier attempt to carve the marble. After this opening blow, he surrounded the block with a temporary shed so he could labor in solitude. When he was about halfway done, he allowed a few officials in to see what he was creating, and they increased his commission on the spot. But he kept everyone else out. The secrecy stood in contrast with the more performative working method of Leonardo, who allowed crowds of spectators in to observe while he painted. Sometimes they would gasp with amazement when he added a brushstroke; other times they would just watch him staring at the blank wall or canvas for hours.[16]

The sculptor's technique would have been more labor-intensive by its very nature, as it is more physically demanding to carve than to paint. Michelangelo claimed to glory in the physical act of creation as evidence

of his *fortezza*, a word conveying both "force" and "power," which happened to be one of the key civic ideals of republican Florence. Even so, he preferred not to perform this work in public. Admirers and critics alike, along with the merely curious, would have to content themselves for the time being with the incessant din from hammer, drill and chisel, punctuated by outbursts of colorful language that occasionally emerged from the shed.

It was, once again, a high-risk strategy. Michelangelo knew he was raising expectations for the statue by this staged secrecy. Anything short of a masterpiece would come as a letdown. He had to pull off something unprecedented or else face mockery and derision from his rivals. He was also personally invested in this commission, his first public work in his hometown. Michelangelo came from a family with a history of participation in the Florentine government, and notwithstanding his connections to the Medici, he had developed a profound allegiance to the restored republic.

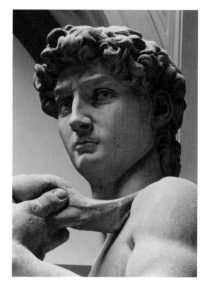

Detail of Michelangelo's *David.*

Soderini was among the first to see the completed *David* when he visited Michelangelo's studio near the end of March 1504. He had a great deal riding on the statue as well. The significance of this commission, coming as it had so close to the establishment of the new constitution, had not been lost on the city. The attempt to revive the republic and the attempt to revive the marble block were understood as parallel efforts, and if the sculpture was a failure it would sap the public's confidence in their government.

The *gonfaloniere* was not disappointed. The sculptor had overcome the daunting narrowness of the block by turning the figure so his body faced the viewer but his head was in profile. The figure seemed almost to quiver with physical and psychological tension, as if the stone had really been brought to life. Michelangelo had used his unusual knowledge of anatomy to show a physique that might be still for the moment, but whose muscles were tensing for a fight. For he had chosen not the traditional moment of triumph for David, but an earlier point in the story when the shepherd watches the approaching giant, waiting for him to get into slingshot range.

In the confines of Michelangelo's work shed, the statue's size was overwhelming. "He is a veritable giant," Soderini remarked, using the nickname of the block, *Il Gigante*, which had become so familiar it appeared in Michelangelo's contract. "It makes you think, doesn't it, about how big the real giant he's supposed to fight would be?"

Michelangelo concurred, since this after all was the point: the

Michelangelo, study for the *David*, 1502.

17 One of the few surviving draw-
ings for the *David*, reproduced above,
includes a couplet in the artist's hand:
"Davicte cholla fromba e io chollar-
cho—Michelagniolo" (As David did
with his sling, so I do with my drill).
Michelangelo took care to save this
drawing, which is the vital document
for understanding his conception of
the *David* as his personal contribution
to the preservation of the Florentine
Republic.

moment to rest on your laurels was never. There would always be another enemy for the republic to confront, either within or outside the city walls, and some of them would be formidable. As big and powerful as the *David* might be, he would still need God's help, and he would serve as a constant reminder to the Florentines to be on their guard against losing the freedoms they had just reinstated. In fact, Michelangelo explicitly tied his creation of the sculpture with the act of confronting threats.

"What David did with his sling, I now do with my drill," he declared.[17]

"Your drill is every bit as mighty as David's sling," Soderini replied. "Even the ancients never created the likes of this statue."

Michelangelo, never a victim of false modesty, did not bother to demur. It had become a cliché to suggest that the product of the modern era, blessed as it was by Christianity, was superior even to the revered ancient models. But it took on special resonance in this case. A few monumental examples of classical sculpture had survived intact, notably the Dioscuri, or twins Castor and Pollux, who then as now stood on Rome's Quirinal Hill. Michelangelo had studied them closely and even taken detailed measurements. But for him, the antique was now a point of departure, not a master. The graceful pose and psychological intensity of his *David* made the twins seem stiff and bland by comparison.

When the concealing shed was finally broken away and the statue revealed to the Florentine people, they agreed with Soderini. There was a palpable sense that a new generation of artists, even greater than their distinguished predecessors, would produce works of unparalleled genius to glorify the city.

Soderini, intent on confirming this expectation, encouraged Michelangelo to go straight to work on his next task: a large painting on the wall of the grand meeting room in the Palazzo Vecchio where Leonardo was already at work. His subject would be the Battle of Cascina, a historic

The Dioscuri, 4th century AD.

military victory for the republic, and his rival would be frescoing the facing wall with the Battle of Anghiari. The results of their competition would be the wonder of the world – powerful paintings seventy feet long, showcasing the greatest artists of the age in the service of Florence, while officials of the republic carried out their duties below.

Palazzo Vecchio: September 8, 1504

While Michelangelo and Leonardo prepared designs for their frescoes in the Palazzo Vecchio, debate raged over where to put the *David*, and, more practically, how to get him there. The sculpture had been intended to be installed at the base of the cathedral dome. Michelangelo had proportioned the figure for an elevated placement, exaggerating the head and hands so they would be legible to distant viewers. But it now seemed a pity to put this compelling icon of Florence so far away. Alternative locations were proposed, including the piazza in front of the cathedral, or somewhere near the town hall. The new *David* might, for example, echo the original placement of Donatello's bronze *David* in the Medici palace by standing in the middle of the Palazzo Vecchio courtyard, where it would serve as a stern, republican rebuke to Medici extravagance.

Detail of Michelangelo's *David*.

18 The *David*'s view to the river
would later be obstructed by addi-
tional administrative space attached
to the Palazzo Vecchio by Vasari for
Duke Cosimo I de' Medici in the
1560s. This space now houses the
Uffizi Gallery.

19 The detailed notes from this meet-
ing, dated January 25, 1504, survive in
the Florentine archives.

Michelangelo and Soderini appear to have favored a position out-side the main door to the Palazzo Vecchio, with the *David* looking south across the river toward encroaching dangers from Rome, where the Medici had established themselves.[18] This placement would have emphasized the political as opposed to religious nature of the statue, enlisting him as a soldier in the defense of the republic. The politicization of the image had not escaped anyone. While it was still in the work yard, it was attacked one night by stone-throwing vandals; rumor had it they were Medici supporters. No damage was done, but it seemed prudent to get the *David* up on a high pedestal.

It was no small proposition to move a statue more than thirteen feet high and weighing six tons, especially since the marble was susceptible to cracking. Borrowing a device from classical sculpture, Michelangelo had added a buttress in the form of a diminutive tree trunk to the fig-ure's lower right leg, but there was still a real danger the statue could break in transit.

Happily, the heirs to Brunelleschi's engineering knowhow were up to the challenge. They fashioned a sort of hammock for the figure so it was suspended over a cart that was moved by forty men, who kept a series of fourteen greased rollers in constant motion underneath it – the same basic technique that had been used to move the gigantic stones of the Egyptian Pyramids thousands of years before. It was a laborious process. While a brisk walk through Florence from the Duomo to the Palazzo Vecchio takes about five minutes, this apparatus took four days to make the journey.

The statue arrived safely at its destination for a public unveiling on September 8, 1504, festooned for the occasion with gilded hair, a garland of flowers, and even a bronze diaper to shield the more delicate eyes. It was Leonardo who recommended this *ornamente decente* at a meeting in which a group of artists discussed possible placements for the sculpture. While it is tempting to interpret this gesture as a rival's effort to under-mine Michelangelo's achievement, there is no record of the sculptor objecting.[19] Leonardo may well have had a valid concern. It is not that artistic male nudity was anathema in Renaissance Florence. After all, one of the city's historic emblems had been an ancient nude statue of Hercu-les (now lost); Masaccio had painted the nude Adam and Eve in the Bran-cacci Chapel; and Donatello had cast his nude bronze *David*. But Hercules was a pagan hero; Adam was a secondary figure in a much larger cycle; and the bronze *David* was originally designed for private consumption. Michelangelo's very large and very public nude of a biblical hero might

Palazzo Vecchio, Florence, with the modern copy of Michelangelo's *David*.

take some getting used to, and so it was modestly draped for its debut.

Concerns over outraged decency turned out to be overblown, how-ever, and the bronze diaper was quickly discarded. There will always be some who titter at the statue or buy boxer shorts or cooking aprons adorned with its genitals, but the vast majority of viewers have under-stood the *David*'s nudity as an expression of excellence, not one of lewd-ness. Following the ancient Greek model established by Phidias, Michelangelo presented David as flawless, the ideal to which mortal humans might aspire. This David had no need for earthly garments: he was perfect as God (or Michelangelo) made him.

Inspired by this prodigious achievement, Soderini began to talk of a second giant as a companion to the *David* – a Hercules who would stand on the other side of the Palazzo Vecchio doorway. Rather than a single warrior, Michelangelo might provide an entire army for the republic. Meanwhile, however, the *David* had caught the attention of a more pow-erful patron. Pope Julius II cared little for Florence's republic and was determined to lure this remarkable artist to Rome and into his service.

The Vatican: October 1504

"I have read in Pliny about an ancient tomb that was a hundred feet high and ornamented with dozens of marble statues. Do you think such a thing existed?"

"I can't see why it could not," Michelangelo replied. "Right now we are practically in the shadow of Castel Sant'Angelo, which was Hadri-an's tomb, and it has to be at least that tall. Maybe it was once orna-mented with great statues too."

It somewhat strained the sculptor's credulity to imagine the new pope spending his time reading Pliny the Elder. Unlike his corpulent pre-decessor Alexander VI (a Borgia pontiff), Julius II bristled with physical energy and had chosen his name in an unsubtle reference to Julius Cæsar. But Michelangelo was fascinated by accounts of the legendary Mauso-leum of Halicarnassus, one of the Seven Wonders of the ancient world – and he was happy that Julius was finally talking about the plans for his own tomb. For months after the pope had invited him to Rome, the sub-ject had been avoided even though the artist was busily preparing designs.[20]

"Shouldn't the heir of Saint Peter have a monument no less magnif-icent than Hadrian's?" Michelangelo suggested.

"The heir of Saint Peter leaves no son to rule after him, and he can

20 The best records of the plans for the tomb of Julius II are the accounts by Vasari, *Lives*, 342–50; and Condivi, *Life of Michelangelo*, 28–38.

hardly control the selection of his successor. If he could, would Alexander ever have allowed us to be elected?" the pope remarked with a dry chuckle. "But one thing we can do is leave a fitting monument so that men will remember our glory forever."

Michelangelo nodded. This was music to his ears.

"Everyone is talking about your Florentine giant," said Julius, "and we have your *Pietà* in our own basilica. Now you propose to create a freestanding tomb in marble with no fewer than thirty-six figures on it to perpetuate the memory of our accomplishments. How long would it take you?"

Thirty-six figures. The *David* had taken him three years. Three times thirty-six was . . . well, these were to be only life-sized figures, not giants.

"Ten years," Michelangelo said firmly.

"Excellent. Let us hope God grants us health for that long. Come and see us when you have more designs." Michelangelo was overjoyed – this would be the greatest commission in more than a thousand years. Thoughts of Florence left him as he knelt to kiss the pope's ring.

When Julius died in 1513, however, little progress had been made on his tomb. The pope had instead set Michelangelo to work frescoing the ceiling of the Sistine Chapel with scenes from Genesis. It is somewhat ironic that this project became one of the artist's most famous works, since he resented having to spend his time painting while the promise of a great sculptural monument, for which he had left Florence, remained unfulfilled. He had meditated and brooded over the papal tomb, producing multiple designs and even purchasing marble.

The sculptor and the pope had repeatedly clashed over the project, although they managed to patch things up at the end. But once Julius was dead, Michelangelo knew his heirs would not have much interest in spending the family fortune on a wonder of the modern world. He started on a set of twelve figures, but finally the design shrank to seven figures. The central figure of Moses is undoubtedly a masterwork, but the tomb is far from Michelangelo's original vision, which was probably too grandiose to have been realized in his lifetime, let alone the pope's. More than thirty years after Julius died, his tomb was installed in a small church in an obscure Roman neighborhood.

The successor of Julius was hardly a stranger to Michelangelo. Leo X was born Giovanni de' Medici, the second son of Lorenzo the Magnificent. He was just nine months younger than Michelangelo and had likewise benefited from Poliziano's tutelage during the years they lived together in the Palazzo Medici. Giovanni had become a cardinal at the

Michelangelo, first design for the Tomb of Julius II, 1505.

age of sixteen. After the family's exile in 1494, he traveled through north-
ern Europe for several years before settling in Rome – until Julius sent
him to Florence in 1512 at the head of a papal army.

As Giovanni worked to re-exert Medici control over the city, Soder-
ini was deposed and exiled to the Dalmatian coast. Machiavelli was not
so lucky: he was imprisoned and tortured for conspiracy in early 1513. In
the general amnesty that followed Giovanni's election to the papacy in
March of that year, he was allowed to return to his country estate but
excluded from Florentine politics. Soderini was eventually permitted to
settle in Rome, though he was forbidden to return to Florence.

"God has given us the papacy – now let us enjoy it!" Giovanni
declared joyfully on his elevation. For most of the next fifteen years, he
and his cousin Giulio de' Medici (Clement VII), ruled as pontiffs, and

Michelangelo, Tomb of Pope Julius II, 1505–45.

Florence functioned as a satellite of Rome.[21] While still nominally a republic, the city was controlled in reality by the powerful popes.

There was one last attempt to restore the republic when Clement VII appeared to be weakened after the violent sack of Rome by Charles V, the Holy Roman Emperor, in 1527. The pope fled Rome and the Medici were ousted from Florence yet again. Michelangelo, who had been working in Rome for the Medici popes, raced home to join the patriotic effort. In Florence he revived the project for a Hercules to accompany the *David*. He also designed innovative (and beautiful) new fortifications for the city in advance of a siege by imperial troops, who were now allied with Clement VII.

In the course of the conflict, the forces opposing the Medici broke into the Palazzo Vecchio and started hurling furniture out the windows. Something heavy dropped onto Michelangelo's *David* in the piazza below, shattering the arm that held the sling. The damage was unintentional; the pieces were carefully gathered up and the statue repaired.[22] But as with the lightning strike on the Duomo when Lorenzo died, the incident proved prophetic. The republic fell to the besiegers on August 12, 1530 – almost exactly twenty-nine years after Michelangelo received the commission for the *David*. Clement VII was now the undisputed master of the city. The republic was dead, and Michelangelo went into hiding.

Shortly thereafter, the Medici officially established themselves as the dukes of Florence on their way to becoming the grand dukes of Tuscany in 1569. The family found their palace on the Via Larga no longer sufficient for their purposes, so they moved into the Palazzo Vecchio. The seat of the republic became, in effect, the Medici home. The unfinished designs for the frescoes that Soderini had commissioned from Michelangelo and Leonardo were covered over with scenes of great Medicean military victories, painted by their court artist Giorgio Vasari, who would shortly begin work on his biography of Michelangelo. And the *David* began more than two centuries of standing guard over – rather than against – the Medici family.[23]

Michelangelo was quickly forgiven for his participation in the uprising, as the Medici were keen to welcome him back into their fold. But after a brief visit to Florence in 1534, he stubbornly refused to return again, despite repeated invitations. Instead, he spent the last thirty years of his life in Rome, focused mainly on spiritual themes. During this time he created *The Last Judgment*, his apocalyptic fresco on the altar wall of the Sistine Chapel, and acted as architect for the new Basilica of St. Peter during the construction of its enormous dome, which dwarfed the one

21 The ascetic Pope Adrian VI held the papacy for an interval of twenty months between the Medici popes.

22 The *David* was damaged again in 1991 when a mentally disturbed man broke the second toe of the left foot with a hammer.

23 The original *David* was moved to the Galleria dell'Accademia in 1873 and a replica was placed in front of the Palazzo Vecchio in 1910.

Michelangelo, design for the
fortification of Florence,
1529.

that Brunelleschi built in Florence. But he never forgot his love for the
Republic of Florence. After a decade of self-imposed exile he wrote a
series of mournful poems about the city, including one in which he lik-
ens Florence to a lovely woman who should have many admirers but is
now the exclusive trophy of a tyrant too insecure to enjoy his treasure:

> *"Your beauty an angel's, Lady, you were meant*
> *for many a lover, yes, for hundreds even.*
> *Now all's a-drowse in heaven*
> *if it let one steal from many what's heaven-sent.*
> *Restore, as we lament,*
> *the sunlight of your eyes, that seem to shun*
> *poor wretches born without a gift so great."*
> *"No, never let troubles cloud your pure intent;*
> *the ravisher robbing you of me, that one,*
> *terrified, can't enjoy his heinous state.*
> *Even so with lovers: they're less fortunate*
> *whenever great surfeit curbs their great desire.*
> *Far better wretchedness with live hope afire."*[24]

After his death in 1564, Michelangelo was finally brought back to the city
he loved and buried with great honors, paid for by the Medici.

24 Michelangelo, madrigal no. 249
(1544), in *The Complete Poems of
Michelangelo,* trans. John Frederick
Nims (University of Chicago, 1998),
125.

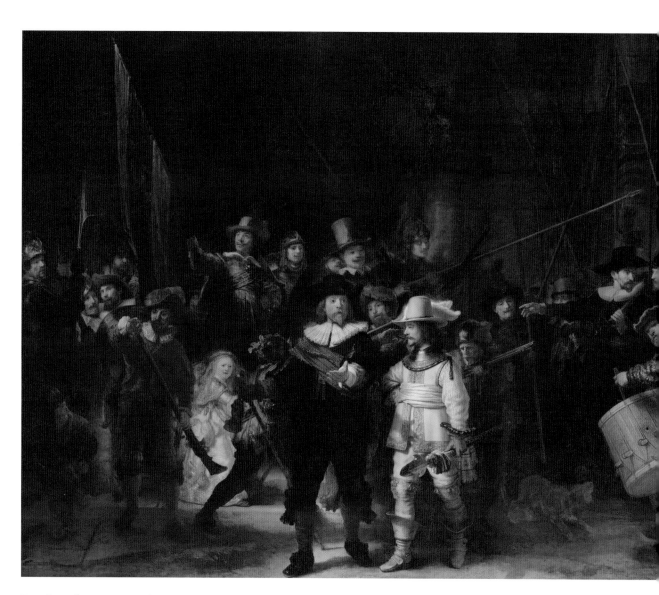

Rembrandt van Rijn, *The Night Watch*, 1643.

"A Prodigious Growth in Riches"

Rembrandt's Night Watch and the Dutch Golden Age

Having lately seen the State of the United Provinces, after a prodigious growth in Riches, Beauty, extent of Commerce, and number of Inhabitants, arrived at length to such a height (by the strength of their Navies, their fortified Towns and standing-Forces, with a constant Revenue proportion'd to the support of all this Greatness), as made them the Envy of some, the Fear of others, and the Wonder of all their Neighbours.

SIR WILLIAM TEMPLE
Observations Upon the United Provinces of the Netherlands (1673)

Amsterdam: September 1, 1638

Huge tapestries adorned the great hall of the Kloveniersdoelen, the newly renovated headquarters of the musketeers' guild. This building was intended to compete with London's Whitehall as an elegant space for banquets and entertainment. But while Whitehall had been designed by Inigo Jones in the Renaissance-inspired classical style that would quickly come to dominate English architecture, the Kloveniersdoelen in Amsterdam was typically Dutch, built on an irregular lot into which the architect had ingeniously fit rooms of regular shapes. The smaller rooms were decorated with portraits of the Kloveniers companies through the generations.

The Kloveniers – named after the *klover*, a forerunner to the musket – proudly claimed descent from the civic guards that were first created by leading townsmen in the Middle Ages to protect the growing urban populations of the Netherlands. These militias, generally called *schutters* ("guardians"), formed the backbone of the Dutch rebellion against Spanish Hapsburg rule in the sixteenth century. Following the twelve-year peace with Spain declared in 1609, the Netherlands developed a more

Kloveniersdoelen, 1627.

professional military, and the *schutters* became largely ceremonial; but they still played a role in the security of towns and provinces, as wealthy citizens volunteered to participate in civic life. The Kloveniers maintained a strict discipline and held regular drills at their *doelen*, a meeting hall with an adjacent shooting range; sometimes they wore the costumes of their forebears. With their elaborate garb and handsome mounts, they could contribute to the pageantry of important events and also perform crowd control in a pinch.

On a rainy September day in 1638, the Kloveniers and their meeting hall figured prominently in a memorable event for Amsterdam and for the newly formed Dutch Republic. The city was rolling out the red carpet for Marie de' Medici, the queen mother of France.

Marie was the daughter of Francesco I de' Medici, Grand Duke of Tuscany, and granddaughter, through her mother, of Ferdinand I, the Holy Roman Emperor. She had been reared in the sumptuous Palazzo Pitti, surrounded by her family's unparalleled collections of ancient and modern art, including superb paintings by Botticelli, Raphael, Leonardo, Vasari and many others.[1] Marie made a great match when she married Henry of Navarre, the former Huguenot who was designated by Henry III as his successor to the French throne. He had to fight to secure his claim when the king was assassinated in 1589 during the religious wars that convulsed the country, and was finally crowned Henry IV in 1594 after

1 Eleonora, the wife of Cosimo I, the first Medici duke, had found the Palazzo Vecchio not especially pleasant as a house and had purchased the more luxurious Palazzo Pitti across the river. Giorgio Vasari connected the two with a series of structures and corridors that housed administrative offices, or *uffizi*, which is how Florence's great art museum got its name.

pragmatically converting to Catholicism. Decades of war had drained the royal treasury, but his marriage to Marie in 1600 brought him an enviable dowry from the Medici fortune.[2] While frequently tumultuous on account of Henry's serial infidelities and Marie's imperious and suspicious nature, the marriage was a fruitful one. The couple had six children, on whom Henry doted.

On May 14, 1610, Henry's carriage got stuck between two vehicles on a narrow Paris street. The king was trapped, making an easy target for the assassin who had followed the carriage from the Louvre. François Ravaillac drew a sturdy knife and stabbed Henry in the ribs, severing his aorta. Blood poured out of the king's mouth, and he died in the carriage. A few weeks later, Ravaillac was pulled apart by a team of horses after enduring a host of gruesome tortures reserved for those guilty of regicide.

Marie became queen regent for her son Louis, then eight years old, but she had little interest in the difficult work of governance. As a teenager, Louis was appalled by her mismanagement and resentful of her overbearing advisers, so he staged a coup d'état in 1617 and sent his mother into exile. She returned to court in the late 1620s but was banished for good in 1631 by her son, now King Louis XIII, and his very capable chief minister Armand-Jean du Plessis, Cardinal Richelieu (who had originally been loyal to Marie but switched allegiance when he saw which way the wind was blowing). The dowager queen would spend the last years of her life impoverished, wandering Europe from London to Cologne in search of support.

Amsterdam, the Protestant capital of a proud republic, might not seem a likely source of aid for a Catholic queen of France. She had earlier been received with full honors in the southern Netherlands, where the Hapsburgs still ruled, but she had not lingered there. The northern provinces were eager to flaunt their growing wealth and political independence, so they offered their welcome to Marie. Exile or not, she was still royalty and had connections to some of Europe's most important families. Her presence would be an excuse for a major civic event to show the world that Amsterdam was now quite the equal of Brussels and might even vie with London or Paris.

The ceremonies that greeted Marie de' Medici were more than a simple parade. They were a multiday extravaganza including a mock naval battle in the harbor, speeches by dignitaries, lavish feasts and a procession that began at a heavily ornamented – though temporary – triumphal arch. The route wound through the city with frequent pauses for spectators to admire the *tableaux vivants* featuring elaborate sets and wild ani-

2 Henry, who was twenty years Marie's senior, had had his first marriage, to the childless Margaret of Valois, annulled in 1599. Through her mother, Catherine de' Medici, Margaret was Marie's cousin and a great-granddaughter of Lorenzo the Magnificent.

Salomon Savery after Jan Martsen the Younger, *The Procession of Marie de' Medici through Amsterdam*, 1638.

mals that represented Marie's heritage and virtues. The populace was treated to theatrical re-enactments of her parents' marriage (which had occasioned one of the most famous ceremonial processions in Renaissance Florence) and the history of France under Henry III and Henry IV.

The festivities culminated in the queen's arrival with her retinue in the main hall of the Kloveniersdoelen for her official reception. By all accounts, the occasion ended on a high note, and the wandering queen may have hoped that she had found a new home. But once again, her triumph was fleeting. Louis XIII and Richelieu were firmly in control of France; they looked with displeasure on any nation that assisted the queen mother; and they had agents working in Amsterdam. Just weeks after her ceremonious entry, Marie made a quiet exit.

The memory of her extravagant reception lingered on, however. A luxury book called *Medicea Hospes* was printed with elaborate engraved illustrations. The Kloveniers were pleased with how well their new hall had worked for the ceremonies, but decided that rented tapestries on the walls were not up to their standards. It was time for a more permanent set of decorations to proclaim the virtue of the Kloveniers.

Six large-scale group portraits of the militia companies that had participated in the event were proposed, to be painted by the best contemporary Dutch masters. In the hands of lesser artists, this type of portrait could result in stiff rows of heads, but a great painter could produce

a complex, theatrical composition that conveyed energy and purpose while recording the individual features of the subjects.

One such artist was in the crowd when Amsterdam welcomed Marie de' Medici. With his taste for sumptuous display and his flair for drama, Rembrandt van Rijn had thoroughly enjoyed the festivities. Then in his early thirties, he had moved to Amsterdam in 1631 and had made a name for himself with his unusually fluid style and uncanny ability to capture his sitters' personalities.

Rembrandt would receive a prestigious commission from the Kloveniers to paint the group portrait of the Militia Company of District II, whose leadership passed to the young captain (and aspiring politician) Frans Banning Cocq shortly after Marie left Amsterdam. Formally titled *The Company of Captain Frans Banning Cocq and Lieutenant Willem van Ruytenburch Preparing to March Out*, this canvas would later become universally known as *The Night Watch*. While the painting is technically neither a night scene nor a watch, this more generic title may well be closer to Rembrandt's concept. For rather than simply documenting a particular militia company, this image captures the unique character and self-confidence of the tiny Dutch Republic – as well as representing the vigilance required to defend its hard-won independence.

Leiden: August 1574

The mayor of Leiden was as emaciated and filthy as all the other citizens of his town, which was on the brink of capitulation. It had been besieged by the troops of the Spanish general Francisco de Valdés since May. Food supplies had run out long ago, pets had been consumed, and there was nothing left. Disease had followed starvation as an epidemic swept over the exhausted population.

Most of them wanted to give up, but Pieter van der Werf refused to let them. He had been elected to defend Leiden, and he knew that surrender would mean the annihilation of his town. Striding to the center of the main square, he ripped the sleeve off his shirt, revealing a muscular right arm, which he extended to the wretched crowd. "Here," he declared, "here, take my arm. Eat it. I would rather give it to you than let the damned Spanish cut it off."

Inspired by their mayor's determination, the Leideners decided to hold out a little longer in the hope that the help promised by the leader of the rebellion, William of Orange, would materialize.

The situation verged on the grimly ridiculous. On one side were the Hapsburgs, the Most Holy Majesties of a vast empire stretching from the Old World to the New. On the other were the Seventeen Provinces of the Netherlands, a marshy territory hardly big enough to be a country. The area had once been a possession of the Duchy of Burgundy, which became defunct in 1477 and was folded into the Hapsburg domains. Philip II, the Hapsburg king of Spain, took control in 1555 and set about trying to eradicate the Protestant heresy that was particularly stubborn in the region, thus triggering a revolt against Spanish rule. By 1572, the southern provinces had given up and sued for peace, leaving only the seven northern provinces still defiant. Philip resolved to end the matter once and for all. His orders were to use any means necessary, and General Valdés had been ruthless. Haarlem to the north had already surrendered; Leiden was next. Once that city fell, the Spanish would be well on their way to complete victory.

It should have been easy. Leiden did not have a standing army. What defense there was consisted mostly of a volunteer civilian militia – the *schutters*. They had behaved heroically, but they desperately needed reinforcements.

William of Orange (also called William the Silent) was an unlikely source of assistance. Born to a noble German family, he married an aristocratic wife before joining the court of Margaret of Parma, who had become the ruler of the Netherlands through her relationship with the Hapsburgs. In 1559, he was appointed by Philip to be the *stadtholder*, or governor, of three northern provinces (and later a fourth). William became openly critical of Philip's crackdown on Protestants, but he was also horrified by the iconoclastic rampages of the Calvinist rebels. For months in 1566, mobs of ostensible religious purists – also containing a sizeable percentage of pure hooligans – swept through the countryside breaking into religious institutions and destroying works of art. William was an art lover like most of the Dutch, so it took a considerable degree of brutality on the part of the Spanish to get him to join these radicals.

Finally, whether because he felt a moral imperative to aid the persecuted Protestants or because he sensed an opportunity for autonomous rule, William decided to assist the rebellion. He acknowledged that if successful he would not rule the Netherlands by divine right, but rather at the grace of the people, and that he would need to respect – indeed, obey – the elected assemblies of the individual Dutch provinces.

William provided the rebellion with coherent leadership and military strategy that proved a match to the Hapsburg armies, beginning at

Frans Hogenberg, *The Siege of Leiden*, 1574.

Leiden. He knew he could not defeat Valdés in direct battle, so he had to figure out a way to neutralize the Spanish military superiority. Thus he devised a plan to turn what was generally considered a disadvantage to the Netherlands into an advantage.

As the name suggests, the Netherlands, or Low Countries, are made up of an alluvial plane largely at or below sea level. This marshy territory is heavily prone to flooding. Around the year 1000, the inhabitants started trying to control the waters through an ever more expansive system of dikes and drains. The invention of the windmill in the fourteenth century greatly enhanced these efforts by providing energy for a perpetual hydraulic pumping mechanism. Understandably, the Dutch were fiercely proud of this achievement, as is illustrated by legends such as the story of the little boy who found a crack in a dike and filled it with his

hand – only to die of exposure because he refused to leave his post and allow the water to flood in.

William's brilliant idea was to reverse the centuries of determined effort to hold back the sea. He would instigate a flood to immobilize the Spanish army while allowing the Dutch navy to sweep in and liberate Leiden.

The first part of the plan went reasonably well. The dikes containing the rivers surrounding Leiden were broken in August and the ground around the city was inundated, to the great discomfort of the Spanish. But the water was not deep enough to accommodate the ships of the "Sea Beggars," as the Spanish had derisively nicknamed the Dutch rebels (who embraced the term). Then a great storm passed through in late September, dumping so much water that the Sea Beggars could sail in and defeat the Spanish decisively on October 3 – a day that remains a major national holiday in the Netherlands.

Dutch independence would not be formally recognized until the Treaty of Münster in 1648, but the liberation of Leiden was a turning point. Like the Greeks defeating the Persians at Marathon and Salamis, a small group of ragtag rebels had vanquished a mighty empire, a victory they attributed to their freedom and to a moral superiority that brought divine protection. William and then his sons exercised a moderate executive authority as *stadtholders* – an office that came to be elective – but the Dutch increasingly understood themselves as the inhabitants of a free republic ultimately governed by the will of its citizens.

William rewarded Leiden by founding a new university there, an institution that contributed greatly to the thriving town's growth in the early seventeenth century. A twelve-year truce was reached with the Spanish in 1609. Three years earlier, in a prosperous miller's home, a baby was born who would grow to be Leiden's greatest son – an event that would certainly not have taken place had the city not been miraculously saved from annihilation in 1574.

Leiden: c. 1623

One hundred guilders was a great deal of money for an unproven young artist. Rembrandt van Rijn was amazed to have earned so much from his first public sale. It all came about quite suddenly, when a friend told him that a nobleman living in The Hague about ten miles from Rembrandt's home in Leiden was interested in buying one of his works. The painter,

who was still a teenager, selected what he considered his best effort and walked to The Hague carrying the canvas on his back. The nobleman was impressed, and the transaction was easy. The hard thing now was getting back home.[3]

Rembrandt weighed the heavy sack of coins in his hands. Surely, he thought, it would be unwise to trudge home on the open road with such a treasure. He considered the barge that would go by sea, but it was potentially even more dangerous than the road. Finally, he concluded that he would take the coach. This means of conveyance had not been within his means before, but now he had money to spend.

The young artist huddled in the corner of the carriage, still not quite believing his good fortune. When the horses stopped at a roadside inn, all the other passengers got out to stretch their legs and get something to eat while the coachman fed and watered the horses. But Rembrandt stayed inside, clutching the bag of guilders.

Suddenly the coach gave a great jolt and started speeding out of the inn's yard. The horses had bolted, and Rembrandt had no way to stop them. He was frightened for a moment, but then he realized that the team was galloping straight along the road to Leiden. Sure enough, they entered the main town gate and pulled up at the customary inn, just as they always did.

The innkeeper was startled to see the coach arrive with neither coachman nor groom in sight. The door opened and Rembrandt got out. He refused to answer any questions and walked straight home, where he put the unopened bag of money into his mother's hands.

"It was actually quite a fine thing," he told her. "I got to Leiden faster than I could have imagined – and I didn't even have to pay for my ride!"

Rembrandt's success led him to redouble his training. He had always loved to draw, and he was undeniably talented and vivacious, but there was no escaping the fact that he was not very good at school. This was a big disappointment to his parents, who had recognized something special in their sixth child. While his siblings would be content to remain in Leiden and pursue trades related to their father's business as a miller (one brother was a baker, for example), it seemed clear that Rembrandt was destined for greater things. His parents thought he could even become a lawyer, if only he would apply himself to his studies. He attended the local Latin school and enrolled in Leiden's prestigious university, but it became obvious that his main interest was art.

He drew constantly, training himself to capture fleeting gestures and expressions by studying his siblings, his mother, and his own face in

3 Arnold Houbraken, in *Lives of Rembrandt*, ed. Charles Ford (Pallas Athene, 2007), 52–53. The biographer specifies neither the subject of the painting nor the purchaser.

the mirror. He collected castoff theatrical costumes and drew those as well. In 1620, at age fourteen, he was apprenticed to a local painter; then in 1624 he traveled to Amsterdam to study art for six months. When he returned to Leiden, it was to set up his own studio.

While art was Rembrandt's passion, it was also very much his business. He was thoroughly Dutch in his desire for commercial success. Rembrandt was in fact so fond of money that later in life, when he was an established master, his students amused themselves by painting trompe l'œil coins on the floor of the studio and then watching him reflexively reach down for them.[4]

Rembrandt had a powerful role model for the upward social mobility that was possible for a painter. The best-known artist of the time was Sir Peter Paul Rubens, born in Germany but raised in the prosperous Flemish city of Antwerp. Almost thirty years Rembrandt's senior, Rubens had received a rigorous classical education, trained in Italy, and painted for all the crowned heads of Europe – some of whom employed him as a diplomat or spy. He lived in a grand house in Antwerp – the sort of residence that would have been unthinkable for an artist of previous generations – where he entertained nobility and housed the many assistants required to keep up with the great demand for his work. It was a state to which Rembrandt aspired from the moment he arrived in Amsterdam to stay in 1631.

Amsterdam: 1632

Despite the long war with Spain, Amsterdam in the seventeenth century was well on its way to becoming the economic heart of Europe, if not the world. The city's origins were admittedly humble, although the Dutch pointed with pride to a passage in Tacitus, the great historian of the Roman Empire, describing the ancient Batavians who lived in the region and were part of the empire but had a special exemption from imperial taxes (thus suggesting they were independent by nature).[5] The post-Roman story went that some local folk floating down the river Amstel in hollowed-out logs had recognized the site as a natural port and set up shop there sometime in the ninth century.

It proved to be an excellent choice. The shipping lanes of the Baltic Sea were booming in the Middle Ages, and by offering merchants free passage through the port, thus allowing them to sell beer and salted fish at reduced prices, Amsterdam began to thrive. It made gains on the

4 Houbraken, in *Lives of Rembrandt*, 91.

5 Tacitus, *Germania* 29.

prominent older Netherlandish cities in the south such as Bruges, which was home to a branch of the Medici bank in the early fifteenth century. Although Amsterdam was still considered an uncultured, ugly place, there was no denying the ability of its citizens to make money.

As the northern Netherlands acquired more autonomy in the sixteenth century, Amsterdam matured as an urban center and poured resources into civic improvements. The canals that provided the easiest way to get around the city were deepened and the networks regularized; new houses were built out of stone rather than wood. The city grew to more than a hundred thousand people, drawn from all corners of Europe. Amsterdam was tolerant of foreigners of various ethnicities and faiths – especially if they were wealthy and came to do business.

While the southern Netherlands retained the basic ruling apparatus imposed by the Duchy of Burgundy, though now under the control of a Hapsburg-appointed autocrat, the United Provinces in the north developed an eccentric but effective republican system. The population of some one and a half million souls was heavily concentrated in towns. There were States General in each of the provinces to vote on national issues (primarily diplomacy and war), but the country was for the most part governed from independent urban centers. Each town had a council of important citizens known as regents, and although they were elected by the other members of the council, there was a clear understanding that their policies would reflect the will of the citizenry as a whole, or else there was the possibility of violent upheaval.

Town councils aimed to foster the conditions for successful commerce. One result of great consequence was the founding of the Dutch East India Company in 1602, just four years before Rembrandt was born. International trade had changed since the days of Venetian domination of the east-west channels that ran through Constantinople, as explorers opened up new routes around the globe. In particular, the Portuguese discovered the passage around Africa, sailing past the Cape of Good Hope into the Indian Ocean. The intrepid Dutch Sea Beggars were eager to exploit the new opportunities for trade on these routes. In addition, the Dutch government wanted to harness some of the profits to finance the ongoing war against Spain.

Staples like beer, herring, grain and lumber continued to flow through Amsterdam, while new and more exotic wares began to arrive from the Far East: spices, porcelains, tea, cotton, carpets, opium. But expeditions routinely took two years or more, and as many as half the ships did not return, so the old model of an individual investment vehi-

cle that was limited to the duration of a single voyage no longer sufficed. The investment required to get a critical mass of goods safely to Amsterdam, and the hefty profits they produced when they arrived, called for an entirely new financial institution.

The solution was the Dutch East India Company, often known as the VOC after the initials of its Dutch name, Verenigde (United) Oostindische Compagnie. The English had attempted something similar a few years earlier, but the VOC was about ten times larger, with 1,143 subscribers ranging from manual laborers to wealthy merchants. Although it was an enterprise of the Dutch government, investment was not limited to Dutch citizens but open to anyone who could pay for a share. It was, in effect, the first joint-stock company.[6]

The VOC had a monopoly on trade with the East, which reduced counterproductive squabbling among Dutch merchants and thus increased profits. It was run by seventeen directors drawn from the six cities that invested in the company, of which Amsterdam was the largest (and had eight directors). It was originally supposed to exist for a decade, after which investors would be able to withdraw their money along with any profits that had accrued. But the early growth of the VOC was slow, and the directors decided to start paying dividends rather than dissolve the company. Those who needed their money back at that point would sell their shares to other investors, in what were the first stock trades. This activity was institutionalized and the stock market was born. The VOC turned out to be a good investment: from 1602 to 1650 it averaged a 16.5 percent dividend, sometimes paid in spices or gold.[7]

The Dutch East India Company quickly grew into something much larger than a financial institution. Because the sea routes were treacherous not only from the weather but also from a range of hostile forces, the company developed a military component. Few of the indigenous people the Dutch encountered were Christian, so there was a missionary element as well. The VOC became virtually a sovereign entity in that it controlled large swaths of territory for which it administered justice and conducted diplomacy as well as war. Eventually it extended from the Cape of Good Hope and Madagascar, to southern India, to much of modern Indonesia – a merchant empire that dwarfed the United Provinces.

The extraordinary wealth amassed through the VOC created tension with the austere, predominantly Calvinist national character of the Dutch. John Calvin, after all, had preached that conspicuous consumption was sinful. But at the same time, Calvin had encouraged hard work, which naturally led to profits. As long as some of the money was used

6 Niall Ferguson, *The Ascent of Money: A Financial History of the World* (Penguin, 2008), 129–30.

7 William N. Goetzmann and K. Geert Rouwenhorst, *The Origins of Value: The Financial Innovations That Created Modern Capital Markets* (Oxford, 2005), 171.

for charitable works or for the glory of the Netherlands, the Dutch did not have too much trouble reconciling themselves to their prosperity.

Rembrandt certainly enjoyed the material rewards that began to follow the success of his first major commission after he moved to Amsterdam. He was tasked with creating a portrait of the surgeon's guild, then led by the famous physician Nicolaes Tulp. (His surname was actually Pieterszoon, but he was nicknamed after the tulip on his door sign.)[8] The decision was made to show Dr. Tulp in action dissecting a cadaver.

Dissections, however necessary they were judged to be by the medical profession, were controversial, involving as they did the deliberate destruction of God's work. The subjects were generally the indigent and unknown or, more commonly, executed criminals. Earlier artists who were interested in learning the details of human anatomy, notably Leonardo da Vinci and Michelangelo, generally participated in dissections secretly. Dr. Tulp, however, regarded dissections as unparalleled opportunities to teach about the intricacies of the human body and reveal the glory of God's creation in all its minute detail. Accordingly, he considered these events worthy of public performance, typically staging them in a large theater packed with students peering down at the operation in the center.

Rembrandt's challenge was to turn an inherently unpleasant subject and awkward composition into something heroic and monumental. He achieved this in *The Anatomy Lesson of Dr. Tulp* by depicting the doctor explaining the interconnected muscles and tendon's of the cadaver's exposed arm. His seven fellow surgeons gather around in wonderment rather than disgust. The body is treated respectfully and there is no trace of blood. Everyone's hands are clean. Overall, the impression is of scientific solemnity and engagement with the task at hand, but at the same time the likenesses of the sitters are all captured, whether in full-face, three-quarter, or profile views.

The painting garnered considerable attention, and the Dutch poet Caspar Barlaeus wrote of it:

> *Dumb instruments teach. Cuts of flesh, though dead,*
> *For that very reason forbid us to die.*
>
> *Here, while with artful hand he slits the pallid limbs,*
> *Speaks to us the eloquence of the learned Tulp:*
>
> *"Listener, learn yourself! And while you proceed through the parts,*
> *Believe that, even in the smallest, God lies hid."*[9]

8 Simon Schama, *Rembrandt's Eyes* (Knopf, 1999), 345.

9 Schama, *Rembrandt's Eyes*, 353.

Rembrandt, *The Anatomy Lesson of Dr. Tulp*, 1632.

The Anatomy Lesson of Dr. Tulp established Rembrandt as a major figure in the competitive art world of seventeenth-century Amsterdam, a success he consolidated with additional major commissions and an advantageous marriage to Saskia van Uylenburgh, a woman far above his station. He bought a stately brick house in the city with stone ornament and tall chimneys, and he enthusiastically purchased objects that would mark it as the home of a gentleman. Saskia's family complained that he was squandering her fortune on assorted "rarities": natural curiosities such as exotic shells, all manner of weaponry including specimens from the New World, antiquities, paintings, books of engravings from which he

could learn about the works of Renaissance masters such as Leonardo, Michelangelo and Raphael. These luxuries packed the new couple's substantial home and proclaimed their prosperity.

Keizersgracht, Amsterdam: April 9, 1639

Rembrandt took his seat beside the German painter Joachim von Sandrart in a crowded drawing room. The house on the Keizersgracht (Emperor's Canal) was one of the most elegant in the city; it had belonged to Lucas van Uffel, a hugely successful shipping merchant who traveled widely and lived in Venice for a number of years. Van Uffel had died the previous year, and now his home was crammed with people anticipating the greatest art auction ever seen in Amsterdam.

Amsterdammers loved to bid on almost anything. Their *beurs*, or stock market, was a sort of institutionalized auction where all sorts of commodities went to the highest bidder, and it was housed in one of the grandest buildings in Amsterdam. The tulip craze of 1637 was only the most famous of the many financial bubbles that ballooned and then burst when the prices soared beyond reason.

Art also brought out the bidders. The early denizens of Amsterdam may have had little time for luxuries, but by 1639 there were many citizens eager to showcase their cultural sensibility and their wealth through the display of paintings. This was not a practice exclusive to the rich; a British traveler marveled that almost every house, even those of simple craftsmen, had a picture of some sort.[10] As a Protestant country without a strong classical tradition, the Netherlands had a limited appetite for the religious and historical pictures that were regarded as the apex of art in Rome or Paris or Madrid. The general preference was for other types of images on a more domestic scale, including still lives, scenes of everyday activities, and especially portraits that honored the virtues most prized by the Dutch, such as prudence and perseverance.

The ancient Roman fascination with realistic portraiture had largely vanished during the medieval period but was revived in the Renaissance, notably in Florence but also in northern Europe, where artists from Jan van Eyck to Albrecht Dürer painstakingly created realistic images of their contemporaries and sometimes themselves. The taste for lifelike portraits became a mania among the Dutch, as they avidly recorded the features of the sternly virtuous individuals who had fostered the political and economic miracle of their republic. Any occasion could be an oppor-

10 Simon Schama, *The Embarrassment of Riches: An Interpretation of Dutch Culture in the Golden Age* (University of California, 1988), 318.

tunity to commission a portrait. All phases of life – birth, travel, marriage, professional advancement, civic activity, old age – were considered worthy of commemoration.

Anthony van Dyck, *Lucas van Uffel*, 1621–27.

Lucas van Uffel's likeness painted by Rubens's pupil, the courtly Anthony van Dyck, was a somewhat more luxurious product than the typical Dutch portrait. More consequentially, the merchant had managed to acquire one of the most renowned portraits from the Italian Renaissance, which would be the object of intense bidding in the auction that Rembrandt was attending on the Keizersgracht. Van Uffel had some (possibly shady) personal dealings with the agent who handled the sale of the extensive art collection amassed by six generations of the Gonzaga family, who ruled the city of Mantua from 1433 until their financial situation collapsed in the early seventeenth century. Most of their paint-

ings, more than two thousand in total, were purchased by King Charles I of England in 1627. A few treasures escaped his hands, including one of the most prized works: a portrait of Baldassare Castiglione by Raphael,

Raphael, *Baldassare Castiglione,* 1515.

who was regarded as the greatest painter of the Renaissance – renowned for the harmonious grace of his early compositions and the dramatic spirituality of his later works, before his early death at age thirty-seven.

Castiglione was a diplomat and scholar as well as a patron of art, but he is best known for writing *The Courtier* (1517), a handbook for molding one's self into the ideal courtier without seeming to try – a cultivated nonchalance known as *sprezzatura*. The book had captured the imagination of a society just beginning to explore the concept of self-presentation through autobiography and self-portraiture, neither of which had been of much interest to the ancient world. The idea was so foreign to the

classical Greeks that the mere rumor that Phidias had included an image of himself on the shield of the Athena Parthenos got him into trouble with the authorities. But the Renaissance, with its new emphasis on the limitless potential of the individual, broadened the Roman tradition of realistic portraiture to include self-portraits and, in a step beyond that, self-presentation through a calculated refashioning of one's public persona.

As a distinguished diplomat who served Mantua and Urbino as well as the Papal See, Castiglione traveled a great deal. He had a young wife and child at home, so he commissioned Raphael to paint a portrait of him that might comfort her during the solitary weeks and months when he was away. The two men were good friends, and Raphael was able to capture not only Castiglione's likeness but also a sense of the man: accessible and engaged, yet poised and self-possessed, not to mention elegant in subdued but costly clothing of velvet and fur. The composition with the figure forming a pyramid shape, slightly turning with hands clasped, was a subtle homage to Leonardo's already iconic *Mona Lisa*, which Raphael had seen in Rome.

The result, bringing together a brilliant artist and a compelling subject, was to become iconic in its turn. Raphael's workshop executed numerous copies for collectors who admired *The Courtier* or the painter or both. Castiglione was so pleased that he wrote a poem to his wife describing how she must love the picture so much as to consider it almost an improvement on the original.

"What do you think?" Sandrart asked Rembrandt, who was intently studying the portrait on its easel in the Van Uffel house. "Is it superior to Rubens?"

Rembrandt did not immediately answer; he was studying how Raphael's almost imperceptibly small brushstrokes captured form and texture.

"So you have no opinion then," Sandart said brusquely. "That's because you've never seen real art before. You've been stuck here in Amsterdam and Leiden your whole life, and you've never studied at the foot of the masters."

"I paint what I see," Rembrandt replied somewhat defensively, "and I don't need to learn how to see."

"I'll admit you have a prodigious talent for painting what you see, but that's almost like an ape imitating nature. A real artist transforms nature into something greater. If you don't bother to train yourself seriously in real art, you'll never amount to anything."[11]

Rembrandt already knew Sandrart's views on the subject, since the

11 Joachim von Sandrart, in *Lives of Rembrandt*, ed. Ford, 29–30.

German painter had made a career of studying other people's work. He had traveled to Paris to assist Rubens in his Marie de' Medici cycle in the early 1620s. Then he had gone to Italy in 1629 and spent some years in Venice and Rome, where he specialized in engravings after well-known antiquities (including the famous *Brutus* in the Capitoline Museum). After moving to Amsterdam in 1638, he had watched the French queen's entry into the city and received a commission for one of the militia portraits to be displayed in the Kloveniersdoelen. Sandrart's painting of Captain Bicker's company gathered reverently around a bust of Marie de' Medici would be completed the following year. He fervently believed that the art of the north could be every bit the equal of the south if northern artists would only educate themselves properly.

Joachim von Sandrart, *Captain Bicker's Company Waiting to Greet Marie de' Medici*, 1638–40.

Rembrandt was not sure he disagreed. He admired the achievements of the Italian Renaissance, and he studied Italian prints and even some originals in major collections in Amsterdam and The Hague. Most of his friends had gone to Italy, returning with tantalizing stories about the weather and the women as well as the art. He had often thought about making the journey himself, but he did not enjoy travel, and now that he was married he liked being away from home even less.

Ultimately, Rembrandt was a man of the north who loved his country and the opportunity it gave him. Too many chances for major commissions could be missed if he traveled south. Would a young Dutch painter be allowed into a nobleman's art auction in Italy? He doubted it. And at this point he didn't need to bolster his credentials to gain more business at home.

"I'm going to buy the Raphael," declared Sandrart, his eyes shining with anticipation. But within moments his face had fallen. "Or maybe not," he sighed. "I probably have no chance of getting it now that The Sun is here."

Rembrandt turned to see the crowd part for a diminutive man in black who was being escorted to the front of the room. Alfonso López might not have looked very much like the sun, but his spectacular wealth created an aura that earned him his nickname. A lapsed Jew of Portu-

guese descent, he was a diamond merchant who had come to Amsterdam a few years earlier. Whatever he wanted from the Van Uffel collection, he would be able to buy.

At first there were a number of bidders on the *Castiglione*, including Rembrandt, who quickly dropped out. In the end, it came down to Sandrart and López. Sandrart inwardly groaned as the price reached his drop-dead limit of 3,400 guilders. If he went above this amount, it could ruin him. He shook his head. López nodded. The *Castiglione* was his for 3,500 guilders.

There were audible gasps of amazement around the room, and Rembrandt noted the fantastic sum on his sketch of the portrait. Five hundred guilders was considered a good price for a portrait, and not so very long ago he had been elated to get one hundred for a painting. Now this portrait of a long-dead Italian author was going for thirty-five times as much.

It was not widely known at the time that Alfonso López was acting as an agent for Louis XIII and was receiving instruction from Cardinal Richelieu. His activity in the Netherlands was mostly political, as the French crown wanted to monitor any lingering support for the queen mother after her visit. But Louis also had artistic interests, and the *Castiglione* was destined for the royal collection; it remains in the Louvre to

Rembrandt, sketch after Raphael's *Baldassare Castiglione*, 1639.

this day. For the next few years, however, the portrait was displayed in López's Amsterdam home, a dwelling so palatial it was known as the "Golden Sun." Since López was also a patron of Rembrandt – and owned his early work *Balaam and the Ass* – the artist would have opportunity to study it more deeply.

At the same time, Rembrandt could compare it with another exceptional portrait that López had in his possession, the *Ludovico Ariosto* by Titian, the greatest Venetian master of his time.[12] Like the *Castiglione*, it had been painted in the second decade of the sixteenth century. And like Baldassare Castiglione, Ariosto was one of the foremost Italian men of letters of the day, the author of *Orlando Furioso*, an epic poem that reimagines medieval battles between Charlemagne and the Saracens (Muslims).

Titian, in contrast with Raphael, employed a bravura technique to build up his image with loose, easily visible brushstrokes. Like Raphael in the *Castiglione*, he borrowed the pyramid composition from Leonardo, but his vision was grander, focusing on the sitter's bright, elaborate sleeve. The subject in *Ludovico Ariosto* also seems more wary and reserved, as if he is challenging the viewer. The proximity of these two images would have prompted endless debate over the differing techniques of the two artists, both of whom had been called "divine" and "prince of painters," and over the relative merits of the two authors portrayed.[13]

Evidence that Rembrandt studied both may be seen in a series of self-portraits he executed shortly after the Van Uffel auction. He had already made a habit of recording his own features as training in portraiture, but in the late 1630s the practice grew into something larger. Rembrandt was clearly fascinated by his own psychology, and his unprecedented series of self-portraits offer penetrating insight into the workings of his mind, as many admirers have noted. But for the artist, they were not merely an exercise in introspection. They were an important tool of self-promotion that helped him establish himself as the preeminent artist in Amsterdam. After all, what better advertisement could there be for his skills as a portraitist than one for which the sitter would always be close to hand for prospective clients to compare with the painted image?

Whereas Rembrandt's earlier self-portraits tended to be working studies, the ones he produced after 1640 became more substantive – still demonstrating his skill, but also declaring his character. He fused the elegant sophistication of the *Castiglione* with the majesty of the *Ariosto*, and he made his homage to the old masters overt by dressing in a costume from the sixteenth century, but without the image becoming

Titian, *Ludovico Ariosto* (so-called), 1510.

12 The identification of Ariosto has been questioned, and the portrait is now generally known as *The Man with a Blue Sleeve* (possibly a self-portrait by Titian or a portrait of Gerolamo Barbarigo, which was described by Giorgio Vasari in his biography of the painter). But in the seventeenth century it was universally accepted as Ariosto.

13 Eric Jan Sluijter, *Rembrandt and the Female Nude* (Amsterdam University, 2006), 265, quoting Roger de Piles on how Lucas van Uffel liked to put various painters to work simultaneously and then compare the results side by side.

Rembrandt, *Self-Portrait at Age 34*, 1640.

derivative or archaic. Rembrandt did not try to idealize his small eyes, scraggly beard or bulbous nose, as he remained true to painting what he saw, yet the overall impression conveyed is of a refined and intensely observant individual.

Jodenbreestraat, Amsterdam: 1642

Saskia kept insisting that she was getting better, but the constant coughing told its own story. Rembrandt's wife was very sick. Although she was still young, the repeated pregnancies year after year had taken their toll.

Three infants – a boy named Rombertus and two girls both named Cornelia – died shortly after birth. Finally, in 1641, she gave birth to a son who survived, named Titus. But as the baby grew, Saskia weakened, beset by an ailment of the lungs.[14]

Saskia and Rembrandt's marriage had begun, like most did at the time, as a practical arrangement. The daughter of a substantial Amsterdam family with a hand in the art market, Saskia van Uylenburgh was a significant step up for a relatively unknown son of a miller who aspired to be a painter. At the same time, Rembrandt was an obvious talent who would likely prosper and be able to provide comfortably for his family.

Practicality did not preclude happiness, and all evidence points to a happy union. Certainly Rembrandt delighted in painting Saskia's pretty, delicate features and dressing her up as everything from a barmaid to Flora, the ancient Roman goddess of springtime and fertility. He also delighted in the luxuries her dowry brought him – something she seems to have had in mind when she made her will, leaving the bulk of her fortune in trust for Titus.

We do not know what Saskia made of the huge canvas that consumed so much of her husband's time and energy during the final months of her life. The portrait of the Militia Company of District II that he was painting to hang in the Kloveniersdoelen dwarfed anything Rembrandt had previously attempted. At close to twelve feet high and fifteen feet wide, it was an enormous undertaking not just in its dimensions, but in terms of organizing all the figures on this vast expanse of canvas into a coherent composition, let alone an exciting and innovative one.

The shadow of Peter Paul Rubens, who had died the previous year, must have hung heavily over the project. Rubens was famous for creating grand-scale princely decorations. For example, King James II of England had commissioned a massive cycle of paintings extolling his reign to adorn Whitehall. Marie de' Medici, when she returned to Paris in 1621 after her first exile, celebrated in truly Medicean fashion by commissioning from Rubens a cycle of two dozen large-scale pictures of her life and achievements to adorn the Luxembourg Palace. The scenes included Marie's arrival in France on a barge worthy of Cleopatra, her assumption of the regency as the murdered Henry IV ascends into heaven, and her tutelage of her young son while he learns to steer a symbolic ship of state.

Rembrandt would almost certainly have seen prints and drawings of these monumental works, and of course he knew Sandrart, who had assisted Rubens on the Marie de' Medici cycle. The challenge for him was to demonstrate that, as the representative of the next generation of

14 The consensus is that Saskia died of tuberculosis, which was also known as consumption.

ABOVE LEFT: Peter Paul Rubens, The Marie de' Medici Cycle, 1622–25.

ABOVE RIGHT: Peter Paul Rubens, *Louis XIII Comes of Age*, 1622.

Netherlandish artists, he was fully capable of producing something comparable, but in his own distinctively Dutch fashion.

Rembrandt was fortunate in his chief patron for the Kloveniersdoelen project, Frans Banning Cocq, who had recently taken over the Militia Company of District II. Banning Cocq was a successful and ambitious man who wanted this picture to represent, above all, his leadership of his new command. He had not actually been captain when the French queen made her entry into Amsterdam, but he remembered well that glorious day.

One standard theme for such portraits was to depict the company at a banquet, the sort of activity for which the Kloveniersdoelen had been renovated; it was a choice that allowed the composition to be loosely modeled on images of the Last Supper. Rembrandt decided instead to show the militiamen in action.

Although the civic guards played an increasingly ceremonial function, they understood that the United Provinces were still officially at war with Spain. Each of the Dutch provinces was responsible for supplying its own defense in case another event like the siege of Leiden should occur. Ongoing militia training was more than a formality. It was a serious business, for these volunteers needed to remain vigilant against

Frans Hals, *The Meagre Company*, 1637.

threats to their nation. In addition, it was a patriotic duty, an expression of a love of country and a commitment to its defense.

Some confusion has arisen over what precisely is depicted in *The Night Watch*. The elaborate costumes and the architectural setting – which looks more like the temporary triumphal arch erected in honor of Marie de' Medici than any actual monument in Amsterdam – suggest the scene is related to the French queen's entry, but Banning Cocq did not become the captain of the District II militia until the following year, when Rembrandt received the commission for the portrait. If, however, this is an image of a more general patriotic activity, associated with but not limited to Marie's arrival, it hardly matters when he became captain.

The Night Watch is also not actually a nocturnal picture representing a "watch." It is an early-morning scene of the company preparing to march out to perform military drills, and Captain Banning Cocq is giving the command to assemble. The picture may at first appear to show a casual gathering, but the people in it are preparing to be organized into disciplined ranks.

And is the picture really so casual – is Rembrandt just painting what he saw one morning, as Sandrart claimed was his practice? Closer inspection suggests not. Banning Cocq and his lieutenant, Willem van Ruytenburch, stand firmly in the middle of the picture, gracefully linked by gesture and gaze. Rembrandt's study of Italian Renaissance art had

served him well. The examples of the *Baldassare Castiglione* and the *Ludovico Ariosto* had taught him that portraits could be not only realistic likenesses but also expressions of character. Echoes of both the Raphael and the Titian appear in the dignified central figures of *The Night Watch*.

Rembrandt also drew inspiration from an even more famous model, which he would have expected well-educated viewers to recognize and appreciate. Around the time that Julius II lured Michelangelo away from the Florentine Republic to work on his tomb and then the Sistine Chapel

Raphael, Stanza della Segnatura, 1508–11.

ceiling, he also hired the young Raphael to paint his private apartments in the Vatican. Raphael started on the pope's private library (now known as the Stanza della Segnatura) with representations of a different art on each of the four walls: philosophy, jurisprudence, theology and poetry. This project was among Raphael's most celebrated; it received a lengthy description in Giorgio Vasari's biography of the artist and was widely copied in drawings and prints that quickly traveled throughout Europe. Rembrandt himself owned several volumes of prints after Raphael, so even though he never visited Rome to see the originals, he would have understood the substance and the composition of the master's art.

Rembrandt chose to invoke Raphael's representation of philosophy, known as *The School of Athens*; it was a daring move that established his painting as heir to the legacies of both classical antiquity and the Renaissance. Raphael's conceit had been to assemble all the renowned sages of

the classical world and group them around the two greatest sages of them all, Plato (pointing up to the sky) and Aristotle (pointing to the earth). A host of brilliance surrounds them, from Epicurus to Diogenes. But rather than try to conjure up the visages of the ancients, Raphael used those of his contemporaries, so the gloomy Heraclitus seated on the bottom step has the face of Michelangelo, while the geographer Strabo holding a globe to the right is a portrait of Baldassare Castiglione. Raphael thus suggested that the genius of ancient Greece had its equal –

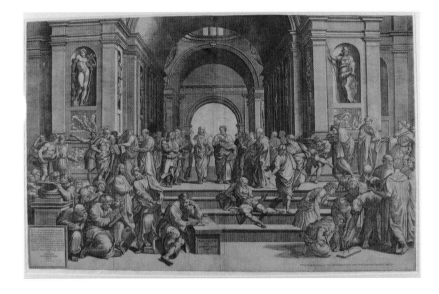

Giorgio Ghisi, engraving after *The School of Athens*, c. 1550.

if not its superior – in Renaissance Rome. Rembrandt took this concept a step further. By overtly modeling his two central figures on Raphael's composition, he claimed this mantle of greatness for the Dutch.

Captain Banning Cocq and his lieutenant take on a timeless quality as they carry out their duty, one that transcends any individual day's events – even a day as important as the grand entrance of Marie de' Medici. Thus the everyday activities of the Dutch civic militias are invested with the same solemnity as the reflections of the greatest philosophers. It was an audacious statement from a society that a century earlier had been considered singularly lacking in culture, and one with no discernible roots in the classical tradition. But now the Dutch Republic, solely through the virtue and industry of its citizens, had attained prosperity on such a scale that the country could play an international role hugely disproportionate to its size or its history.

For all Sandrart's criticism of his artlessness, Rembrandt had created a highly artful painting organized around a complex system of interlocking geometric forms. In doing so, he played fast and loose with concrete details, including the way the men held their muskets and the length of their pikes, both of which deviate from the standard recorded in contemporary military handbooks.[15] Such details were secondary to the drama of his composition, which leads the eye of the viewer around the vast canvas and then back to the central pair.

But central though Banning Cocq and Van Ruytenburch may be, they have competition from a somewhat unlikely source: a richly dressed little girl standing behind them. While she gazes intently at the militia leaders, no one in the group seems to notice her.

Various attempts have been made to identify this girl as either a young Saskia or the ghost of one of the two stillborn Cornelias, but it is more likely that she is neither – and both. However personally invested Rembrandt may have been in this painting, it would not have occurred to him to make it a vehicle to record his family sorrows, though he might well have merged the women of his family into a larger concept. Representing what his wife once had been, what his daughters might have been, what all the virtuously Protestant Dutch maidens were, this girl is not a specific individual but rather the personification of an ideal that the men of this small republic volunteered to defend. Whereas Sandrart's painting for the Kloveniersdoelen gave the place of honor to Marie de' Medici, Rembrandt answered with what is, in many ways, the antithesis of the Catholic French queen born of Italian aristocracy.

This girl's specialized status is confirmed by her unusual manner of dress. First and foremost, she is simply too finely outfitted to be a random street urchin, even in a city as rich as Amsterdam. Her luminous yellow and blue gown, which echoes the garments worn by Van Ruytenburch, displays the colors of the Kloveniers, marking her as one of the company. (Banning Cocq wears the colors of Amsterdam: black, white and red.) The bird tied to her belt is more than just a dead fowl; it speaks to the dual nature of *The Night Watch* as both specific and general, as it could be both a pun on the current captain's name, Cocq, and a reference to the company's nickname, *klauweniers* or claws, which was itself a play on "Kloveniers."

The presence of this girl, who serves simultaneously as muse, ward and mascot of the company, transforms the painting from portrait to allegory. Fusing the idea of the country's defense with a display of the prosperity it had come to enjoy, the image symbolizes what it meant to

Detail of Rembrandt's *Night Watch*.

15 Harry Berger Jr., *Manhood, Marriage, Mischief: Rembrandt's 'Night Watch' and Other Dutch Group Portraits* (Fordham, 2007), 195–200.

be Dutch. *The Night Watch* turned out to be not only a record of the Militia Company of District II, as represented by its current members, but also a statement about a larger history in which the company played a vital part.

The central figures, perhaps not surprisingly, were pleased with the result. Banning Cocq had a detailed watercolor copy made and pasted into a family album, along with a note explaining that the captain is giv-

Watercolor copy of Rembrandt's *Night Watch*, c. 1665.

ing the order to march out. There was some grumbling from supporting players whose faces were not as prominently featured. Rembrandt tried to appease them by inscribing all their names on a shield affixed to the background architecture. In any event, he was handsomely compensated for the picture: the sixteen official sitters all paid an average of one hundred guilders apiece. While it was not quite in the realm of the winning bid for the *Castiglione*, 1,600 guilders was a fine price.

In the final days of his work on *The Night Watch*, Saskia was failing rapidly. Doctors were a constant presence in the house, but Rembrandt painted on, determined that this project would secure his reputation as the Netherlands' pre-eminent portrait painter. He certainly achieved his

objective. *The Night Watch* immediately attracted so much attention that the artist felt confident a flourishing career stretched out before him, even as the death of his wife brought personal sorrow.

The Westerkerk, Amsterdam: October 1669

Six drunken gravediggers clumsily lowered a simple wooden casket into an unmarked, rented grave near Amsterdam's Westerkerk, complaining about the weight of the corpse.[16] It was not an unusual event. Given the mortality rates at the time, only a tiny fraction of the deceased got individual memorials. Most, like this man, a bankrupt painter, were disposed of as quickly and cheaply as possible in graves that were reused when their inhabitant's survivors could no longer pay the rent.

The twenty-seven years since the completion of *The Night Watch* had in many ways not been kind to Rembrandt. He had endured considerable disappointment in his personal life, including an ugly legal fight between the two successive housekeepers he had hired after Saskia's death, both of whom appear to have been his mistresses. He had chosen one of them, Hendrickje Stoffels, as his common-law wife, and had the other woman locked up in a "house of correction." Hendrickje died in 1662, and then his beloved son, Titus, died in 1668.

There had been financial disappointments too. Despite his prodigious creative output, Rembrandt's income could never sustain his style of living. Titus and Hendrickje took formal legal control over his estate in 1660 to avoid complete ruin, and much of his prized collections was sold.

These hardships notwithstanding, Rembrandt was hardly a forgotten man in Amsterdam. He worked consistently up to the end of his life on portraits, history paintings, and his lucrative print business. His studio remained a regular stop for wellborn visitors to Amsterdam. On December 29, 1667, a particularly impressive-looking party arrived. They wore no emblems, as this was a private journey. The principal was traveling incognito, but his distinctive facial features would have identified him readily as a Medici.

Cosimo de' Medici, who would soon become Cosimo III, Grand Duke of Tuscany, had been encouraged by his father to go abroad to take his mind off his wretched marriage to the French princess Marguerite-Louise d'Orléans, who happened to be Marie de' Medici's granddaughter (and Cosimo was Marie's great-great nephew).[17] Cosimo left Florence for more than two years, during which time he would visit

16 Van Loon, *The Life and Times of Rembrandt*, Foreword, xiii–xv.

17 Generations of aristocratic inbreeding had taken their toll on the Medici line. Cosimo III and his children were increasingly unbalanced and ineffectual. His younger son, Gian Gastone, was the last Medici grand duke of Tuscany, and his surviving sister, Anna Maria, bequeathed the family's magnificent art collection to the city of Florence before her death in 1743.

Amsterdam twice. The young man seems to have been pleased to meet Rembrandt, who is described in his journal as "the most famous painter."[18]

Rembrandt did not have any finished pictures in stock at the first visit, so no sale was made, but when Cosimo returned to Amsterdam about eighteen months later he appears to have bought one of the artist's final self-portraits, a picture that clearly reveals the subject's age but still reflects the lessons of Raphael's *Baldassare Castiglione* in composition and tone. What had begun as a teaching tool and then a means of self-promotion had become a habit, as Rembrandt recorded his own features some ninety times. This phenomenon was noted by his contemporaries, and the self-portraits were sufficiently well known that Cosimo, who usually collected exotic dogs and pictures of pretty noblewomen, stepped outside his custom to acquire this painting. And so one of Rembrandt's self-portraits entered the princely Medici collection, and the supposedly untutored Dutch artist would rub shoulders with the Italian masters he had neglected to visit during his lifetime.

Rembrandt, *Self-Portrait as an Old Man*, c. 1669.

The Night Watch would remain in the Kloveniersdoelen until 1808, when it was made the centerpiece of a new national collection highlighting the masterworks of the Dutch school, which became known as the Rijksmuseum.[19] Rembrandt's masterpiece was now a beloved emblem of Amsterdam, and of the remarkable, unlikely achievements of the Dutch Republic in its golden age.

18 Ernst van de Wetering, *Rembrandt: The Painter at Work* (University of California, 2000), 266.

19 *The Night Watch*'s status as a charged national icon was demonstrated when it was physically attacked by unbalanced individuals with grievances against the government in 1911, 1975 and 1990.

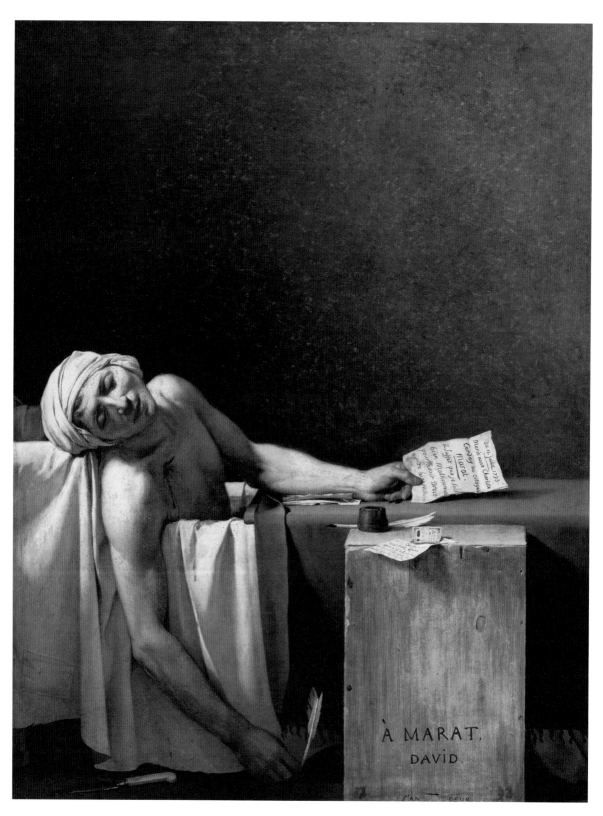

Jacques-Louis David, *The Last Breath of Marat*, 1793.

The Best and the Worst

David's *Marat* and Revolutionary France

It was the best of times, it was the worst of times, it was the age of wisdom, it was the age of foolishness, it was the epoch of belief, it was the epoch of incredulity, it was the season of Light, it was the season of Darkness, it was the spring of hope, it was the winter of despair, we had everything before us, we had nothing before us, we were all going direct to heaven, we were all going direct the other way

Charles Dickens, *A Tale of Two Cities*

25 Vendémiaire, Année II (October 16, 1793), Morning[1]

The roar of the crowd brought the painter to the window of his room in the Louvre. Passing slowly along the boulevard below was a woman who sat ramrod straight in a wooden cart. Her composure made a stark contrast to the chaos around her, and Jacques-Louis David was impressed. The luxurious trappings of royalty had surrounded Marie Antoinette like a cocoon the few times he had seen her at court. Now she was being conveyed to the guillotine like a common criminal, with her hands bound behind her, yet she was calm and dignified. Perhaps, he reflected, she understood that her death was necessary, a sacrifice demanded by the new state to make a clean break with what the revolutionaries labeled the *ancien régime*. It had to be made certain that the royal family would not return to the throne. With Louis XVI and Marie Antoinette alive, providing hope to the many expatriates who were agitating in capitals around Europe for their restoration, the security of the fledgling French Republic was in doubt.

That had been David's logic when, as a member of the Revolutionary Council, he voted for the deaths of both king and queen. He bore them no particular animus – after all, they had been patrons of his early work – but he loathed the oppressive system they represented. It had to be rooted out, which meant they had to die.

[1] To demonstrate how the French Revolution was the dawn of a new era, the authorities instituted a new calendar. Initially they began a year count with the revolution in 1789, but then started again with year 1 being 1792, when the republic was established. The calendar featured twelve 30-day months, each divided into three *decades* (10 days). The system proved hopelessly confusing and Napoleon abolished it in 1805.

Jacques-Louis David, *Marie Antoinette*, 1793.

The king had not been content with the original postrevolutionary arrangement, which would have left him the constitutional monarch of France with reduced authority. So in the turbulent summer of 1792, Louis tried to escape from Paris and mount a counterrevolution that would return him to absolute power. The plot was uncovered and the royal family captured. The monarchy was officially abolished, a republic was declared, and citizen Louis Capet (as the king became known) was tried for treason and executed in January 1793. Now the widow Capet was headed for the same fate.

Executions had increased dramatically in the second year of the revolution. There were whispers that terror, not democracy, ruled in Paris. David's political mentor, Maximilien Robespierre, had explained to him that terror was a legitimate – indeed, a necessary – tool of democracy. The republic had to be cleansed of the old order, he said, and fear would lead to virtue. So the occasional procession of a condemned captive to a public execution had grown to a steady stream. Enemies of the state in their hundreds, and then thousands, made their way to the guillotine, or "national razor" as it was known, which efficiently cut away the rot of the past. David had little sympathy for anyone who threatened the republic, so he barely bothered to glance out the window at them anymore; but today's event was different.

The artist grabbed a pen and quickly captured the angular outlines of Marie Antoinette's figure, her lined face, her thin hair and her simple cap. There was a spare, geometric harmony to her form. This body that had been so pampered and bedecked was now shorn of every earthly comfort – even her false teeth – and brought as a sacrifice to the altar of liberty.

The death of the last queen of France could then come to symbolize the birth of democracy in a country that had been ruled by monarchs for a thousand years. David wondered if the scene in the street below might be the seed of a great painting, one modeled on the classics that depicted ancient despots killed in acts of heroic tyrannicide.

After the upheaval of 1789, the aspiring First Painter to the King had quickly turned into an active participant in the effort to overthrow him. Politics consumed David, which explains the lack of finished paintings from this period. But the assassination of Jean-Paul Marat, a hero of the French Republic and a personal friend, had shaken him, and in the three months since then he had worked feverishly to create a fitting tribute to the beloved "Friend of the People." It was now finished, and David was confident it was a masterpiece that gave visual form to the ideals of the

revolution. *The Last Breath of Marat* would be carried in a procession through Paris later on the same day that Marie Antoinette made her final journey.

June 5, 1772

"You are going to have to eat something sometime, Jacques," the older man said. "You may as well give in now before you make yourself sick."

"I will not," was the snarled reply. David glared at his teacher, his dark eyes burning in the face that was already a little thinner after his brief hunger strike. The tumor in his left cheek was more noticeable than usual. He claimed not to care about the disfigurement, declaring that if Michelangelo could get through life with a broken, twisted nose, then he would do fine with a lump on his face.[2] What mattered was how he painted, not how he looked.

The comparison to the great Michelangelo, even for so young a man, was not casual braggadocio. Everyone in the Académie Royale de Peinture et de Sculpture was impressed by his talent. His manners were another matter. As the Académie's name implied, it was a courtly institution, but David was no courtier.

His teacher, on the other hand, was. Joseph-Marie Vien was favored by Louis XV's final mistress and was one of the most powerful figures in the Académie Royale. The institution was charged with providing suitably trained artists to serve the king – visual art being a potent tool to enhance and amplify his majesty. For the students, one of the most-sought awards was the Prix de Rome, a multiyear residency for study at the Académie de France à Rome. It was then located in the luxurious Palazzo Mancini, where the students reproduced Raphael's Vatican frescoes on the walls of the reception rooms.[3] Awarded each year to the most promising young painter, the Prix de Rome was a critical step up in the rigid hierarchy of the French art world.

David had already entered the competition three years in a row, beginning in 1770. He had arguably offered the superior submission each time, but other considerations had trumped his talent. Older painters who had put in the requisite work and showed reasonable promise were given priority. In addition, David was still developing as an artist. It was the judgment of the committee that he needed time to learn all the subtleties of oil painting, which could easily be done in Paris.

The young painter resented the system that rewarded mediocrity in

2 David's tumor was a benign one that grew in a wound he had sustained in a swordfight as a young man. Perhaps not coincidentally, his father had been killed in a duel in 1757.

3 The Académie de France would be moved to its current home, the Villa Medici, by Napoleon in 1803.

the name of protocol. He knew he was the best, and he was desperate to go to Rome and see for himself the remnants of the brilliant civilization he had read about in school. While it was true that he had spent more time drawing in his copybooks than paying attention to his teachers, he had in fact absorbed the Roman histories of Livy, Tacitus and Plutarch. He knew he needed more technical training, but in his opinion the place to acquire it was Rome, not Paris. The fact that the prize had been awarded that year to his main rival, whom David considered hopelessly inept, made the insult worse.

"It's no good," David grumbled to Vien. "I can't sit here in Paris painting gods and goddesses for the queen's boudoir. If you are going to starve my genius, I am going to starve my body."

Vien sighed. David was passionate; you had to give him that. He was also a melodramatic juvenile and would need to learn patience. After all, his eventual role as First Painter to the King appeared inevitable. The future King Louis XVI had been raised on the same ancient histories as David and was intrigued by the artist's serious, classicizing style, which might come to define his court in the same way the sensuous rococo canvases of Boucher and Fragonard had defined his grandfather's. Vien believed his student was destined to take his place in the long line of distinguished artists who had shaped the glorious image of the Bourbon monarchs, stretching back more than a century to Nicolas Poussin. That is why he had accepted the difficult young man into his busy studio in the first place.

"No, you will not starve yourself," Vien responded firmly. "You are going to eat lunch, and then you are going to apply again for the Prix de Rome next year."

It took another day of persuasion but David gave in, as Vien knew he would. His intense passions had a way of suddenly dissipating into pragmatism when the chips were down. David would be passed over once again in 1773, but he finally won the coveted prize in 1774. He departed for Rome in 1775 along with Vien, who became director of the Académie de France.

As the cultural hub of Europe at the time, Rome hosted a constant stream of international visitors. It was an exciting cosmopolitan environment for the young painter, who closely studied not only the plentiful antiquities but also modern painters and sculptors such as Raphael, Michelangelo, Caravaggio and Poussin (who had left more works in Rome than in France). He worked his way through their compositions inch by inch, frequently dissecting their figures in his sketches to get into

the secrets of their anatomy. The voluptuous curves of his early style gave way to harder edges, strongly influenced by his study of sculpture as models for his paintings.

David returned to Paris in 1780, and by the middle of the decade he was an established master. He began executing major canvases in a stricter style that eliminated extraneous detail to focus the viewer's attention on the heroic ancient themes he favored. These paintings were startlingly different from the more decorative and elegant interpretations of the antique that were in vogue. But they had their own austere beauty and undeniable power, expressing an intellectual curiosity that bordered on the scholarly. David found enthusiastic patrons among fellow antiquarians who had no way of knowing that his radical new artistic style would eventually seem a foreshadowing of an even more radical political change.

The Louvre: August 25, 1787

"Now this is a superb painting," drawled Thomas Jefferson in his oddly accented French. The American "minister plenipotentiary" to France was enjoying his tour of the 1787 Salon de Paris, a public exhibition of the best products of the Académie Royale.[4] A Salon was held each August in the Louvre, where enthusiastic hoards, then as now, swarmed the great public rooms, craning around each other to catch a glimpse of the paintings crowded onto the walls. But unlike modern museum visitors who arrive expecting to see acknowledged masterpieces, viewers in 1787 were there to evaluate new works for their compositional beauty and for the artists' skill in interpreting their subjects. Judgments could be harsh, and spectators were not shy about voicing critical opinions.

Jefferson was examining one of the two works that were generating the most comment at that year's Salon. The canvas had an excellent position low on the wall so it could easily be seen, although the strikingly simple composition was legible even from a distance. Its severity made it stand out from the gaily ornamental images surrounding it, and was well suited to the subject David had selected: *The Death of Socrates*.

Jefferson considered Socrates a hero of the first democracy for his willingness to sacrifice himself so that the free system of Athens might survive. Socrates' assertion that the laws passed by the people carried more weight than the will of any one citizen was a powerful lesson for Jefferson, a devoted student of ancient philosophy, as were the other founders of the new republic in America. Their pioneering effort to

4 Thomas Jefferson, letter to John Trumbull, August 30, 1787.

Pietro Antonio Martini, *The Salon of* 1787, 1787. David's *Death of Socrates* is in the lower left center of the back wall, and Vigée-Lebrun's *Marie Antoinette* is one painting to the right.

establish a free system of government in the New World had elicited a sympathetic response in France, which was facing its own political crisis over issues of taxation and representation. High-minded French reformers understood classical democracies through the lens of Voltaire and Rousseau, who advocated for freedom and social equality. But as these reformers included many of the hereditary nobility, their plans for imitating the American experiment tended toward the establishment of a constitutional monarchy rather than an actual revolution.

David's admirers described his paintings as windows onto the antique, but he never intended merely to replicate the past. The ancient world, as admirable as it may have been, must serve the needs of the present, and so the painter deviated freely from known historical facts in order to enhance the contemporary relevance of his subjects. In the *Socrates*, for example, the philosopher's muscular torso was not that of a squat seventy-year-old, but of a heroic young man, modeled on an idealized classical statue. The painter thus transformed Socrates' physical body into an emblem of the transcendent democratic ideals for which he sacrificed his earthly life. Critics understood this kind of artistic license, and they praised the painting for its beauty and its moralizing rigor. David's patron, the liberal intellectual Charles-Michel Trudaine de la Sablière, was so pleased that he raised the artist's payment from 6,000 to 10,000 livres in recognition of how well David had captured this seminal moment in the history of democracy and made it a vivid lesson for the troubled present.

Jacques-Louis David, *The Death of Socrates*, 1787.

Aside from the enthusiastic reception that *The Death of Socrates* met, 1787 was a disappointing year for David. He tried mightily to become the next director of the Académie de France à Rome, but was rebuffed on the grounds that, at age thirty-nine, he was too young. He made a socially advantageous marriage to Marguerite-Charlotte Pécoul, a vivacious and intelligent – if unbeautiful – daughter of a well-connected builder. But Mme. David was by her nature a member of the establishment that her husband increasingly opposed, and their relationship was stormy.

David was experiencing in microcosm the fatal disconnect between the traditional authorities in France and the people they governed – a disconnect also apparent in the other painting at the 1787 Salon to attract a similar level of interest as *The Death of Socrates*. Élisabeth Vigée-Lebrun's *Marie Antoinette and Her Children* had a very different but no less political purpose than David's painting: it was designed to rehabilitate the queen's reputation as a virtuous mother, rather than the vicious, extravagant, depraved monster she was popularly believed to be.

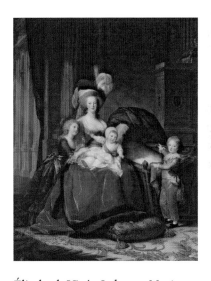

Élisabeth Vigée-Lebrun, *Marie Antoinette and Her Children*, 1787.

The effort was not a success. There was a great hue and cry that public money would be lavished on such an image, with its elaborate gilded frame, in such difficult economic times. (The queen's favorite artist was paid the enormous sum of 18,000 livres for the work.) Protests grew so heated that the painting had to be withdrawn from the Salon after two days.

* * *

The Comédie-Française: November 1790

David was sitting in the great public theater, the Comédie-Française, watching the gripping conclusion of Voltaire's *Brutus*. Composed in 1730, the play told the story of Lucius Junius Brutus, the ancient hero who expelled the Tarquinian tyrants from Rome and established the Roman Republic. As the first executive head of this new government, Brutus had to preside over the trial of his own sons after they joined a plot to return the kings to power. Being both a dedicated republican and a devoted father, he ordered them to be executed for treason – and then gave them a proper burial.

Voltaire's tribute to the Roman struggle for freedom had been considered close to subversive in Louis XV's Paris. For all the reverence that Voltaire enjoyed as the nation's preeminent man of letters, his *Brutus* was rarely performed in his lifetime, although it was widely read in pro-reform circles. Toward the end of the century, however, Lucius Junius Brutus was revived as a prototype of a French republican hero, a man of the old order who presided over a fundamental political shift in his country, in the course of which he faced an excruciating choice between his personal loyalties and public duty.

Oddly enough, one admirer of Brutus was Louis XVI, who was willing to countenance the need for reform as long as the monarchy remained essentially intact. He commissioned David to create a monumental painting of the ancient Roman's patriotic sacrifice for the republic, which was to be a centerpiece of the 1789 Salon. Louis hoped it would signal to a restive population that their king understood the need for change.

This was David's first official royal commission and he began the project with enthusiasm, digging through his notebooks for sketches of the bronze portrait of Brutus he had made in Rome. The resulting canvas, *The Lictors Returning to Brutus the Bodies of His Sons*, seemed destined to enter the royal collection alongside the prized Leonardos, Raphaels and Poussins, and in its triumphal wake David would be a frontrunner to become First Painter to the King.

By the time of the August 1789 Salon, the world had changed. In a cascade of events culminating in the fall of the Bastille on July 14, Louis XVI had lost control of the country. While he remained king, a new legislative body had been formed, and it planned to draft a constitution guaranteeing basic rights to all French citizens and outlining their responsibility to participate in their own government. David's *Brutus* was displayed at an exhibition that was no longer a demonstration of munificent royal

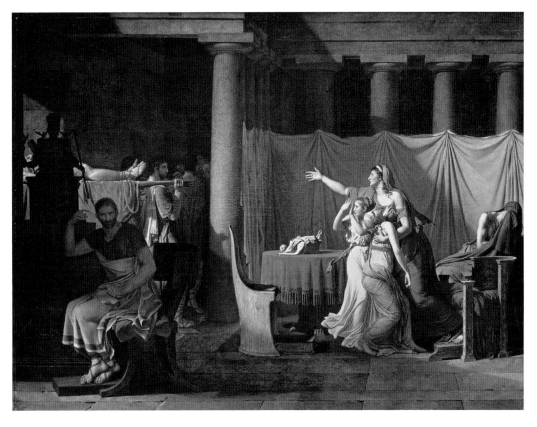

Jacques-Louis David, *The Lictors Returning to Brutus the Bodies of His Sons*, 1789.

patronage, but rather a celebration of the newly free French nation.

However fortuitously, the painting captured the electric moment of potential at the beginning of the revolution, when France seemed to be, like republican Rome, on the threshold of a mighty new phase in its history. David's *Brutus* was described as both "touching" and "terrifying," and the painter was praised for his "noble, severe, energetic" style.[5] He was present when his canvas was brought to the Comédie to serve as a backdrop for a revival of Voltaire's play in November 1790. When the actor playing Brutus came to the climactic line, "By the gods give us death before slavery!" he pointed to David's canvas. The audience, including the painter himself, rose to their feet and roared with approval.

* * *

5 Quoted in Robert L. Herbert, *David, Voltaire, 'Brutus' and the French Revolution: An Essay in Art and Politics* (Viking, 1973), 126.

September 22, 1792

In the heady months after the performance of Voltaire's *Brutus*, David became more politically active in the circle of high-born, idealistic reformers who were also his fellow Freemasons, and in some instances his patrons. What needed to happen seemed so clear. The French were well aware of what had recently transpired in the British colonies of North America. Surely France, with its far more sophisticated history and culture, could do as well, if not better. The country would emerge as Voltaire and his younger contemporary Jean-Jacques Rousseau had imagined it: a nation directed for and by the people, the most noble modern flowering of the ancient seed of democracy.

Rousseau, in particular, had argued fervently that direct democracy was the only virtuous form of government, and that all others were inherently wicked. Rousseau's political philosophy had a strong overlay of moral judgment that was inherited by the politicians who tried to put it into practice. Those who disagreed with Rousseau's assertion that the will of the people must directly guide the government were not merely viewed as the opposition; they were branded as traitors. But these "traitors," including many of the original supporters of the revolution, believed that embracing Rousseau's ideals would mean capitulating to mob rule and would be the ruin of France.

Rousseau's disciples won out. Organized around the Jacobin Club, a political association of which the philosopher had been a member before his death in 1779, they consolidated power in 1791 and dominated the government until 1794. The principal leaders of this movement were two of the philosopher's most ardent disciples: Maximilien Robespierre and Jean-Paul Marat. Both men became close friends of David's and brought him into the vortex of the revolution in 1790. Under their influence, the painter, who was rebellious by nature, grew more radical in renouncing the old order – even divorcing his wife, Marguerite-Charlotte, out of abhorrence for the courtly connections for which he had married her.

Robespierre, a talented provincial lawyer, had been elected to the Estates-General for the emergency session that Louis XVI called in May 1789. Representing the three "estates" of clergy, nobility, and everyone else, the Estates-General had traditionally advised the French monarchs but had been marginalized since the early seventeenth century. Now the king called on this institution in a last-ditch effort to resolve the political crisis. Robespierre, for his part, believed that the government of France needed to be drastically remade, not just reformed. He masterminded

the dissolution of the Estates-General and its eventual replacement by a National Convention on September 22, 1792, which became day one in year one of the new revolutionary calendar.

The Convention's main purpose was to draft a constitution, but the task was repeatedly delayed because of a war with Prussia and the ongoing domestic crisis. The body consisted of 749 deputies of the people, and all French males over the age of twenty-one could vote for them. Although the deputies elected an administrative president every two weeks, the real power resided in the hands of Robespierre, the first deputy for Paris, through his control of important committees, particularly the Committee of Public Safety. Robespierre's popular appeal rested on his reputation for uncompromising moral rectitude – hence his nickname, "the Incorruptible." Unmarried and childless, he cultivated the image of a tireless worker for the new order with no thought for himself.

Marat was more flamboyant and overtly zealous. He wrote the eighteenth-century equivalent of the modern political blog: a broadsheet called *L'Ami du peuple* ("The Friend of the People," which was Marat's nickname); it was printed nightly on cheap paper in his basement and handed out on street corners the next morning. These short, incendiary statements were designed to draw attention to the grievances of the dispossessed. The charismatic Marat became the focus of a collective outrage among the lower classes at what they considered to be their ongoing oppression even after the revolution.

Their sharp differences in character sometimes brought Robespierre and Marat into conflict, but they were united in their drive to implement a revolutionary new order. This process, they believed, would require the ruthless eradication of the old authorities, including the church along with the nobility. The more moderate political rivals of the Jacobins, known as the Girondists, were lumped in with the *ancien régime* and suffered accordingly.

Violence formed an uneasy subtext to French political activity through this period. It was present from the beginning of the revolution, with the mob lynching of the governor of the Bastille in July 1789. Such behavior should have been treated as antithetical to the ideals of democracy – especially after the Declaration of the Rights of Man and of the Citizen was adopted by the National Constituent Assembly in 1790, setting forth civilized principles starting with the premise that all men are created equal and including freedom of speech, the rule of law, property rights and equitable taxation. But the revolution was not a purely intellectual exercise in Enlightenment ideals. More primal urges, including

vengeance, lay just below the surface. Violence periodically flared up, sometimes dramatically, as in the September Massacres of 1792 during which thousands of defenseless prisoners, many of them Catholic priests, were slaughtered by the mob on Marat's orders.

The aspirations that launched the French Revolution were of the highest order: the belief that France needed to remake itself in a democratic mold by transferring power from the monarchy and aristocracy to the common people, and to establish legal equality for all citizens. But the human beings implementing the lofty plan were fatally flawed. Rather than leading France in an orderly march to freedom, they set the nation on a downward spiral into chaos, resulting in tens of thousands of civilian deaths and delaying the establishment of a functioning republic by almost a century.

Despite this tragic failure, one of the great republican icons in the Western tradition resulted from the intersecting lives of three principal players in these tumultuous events: Robespierre, Marat and David. Their paths crossed in the summer of 1793 to produce a stunning portrait of a martyr who died not for religion or monarch, but in the service of the revolution's democratic ideals.

July 12, 1793

"What do you want me to do, David – execute the entire Académie?" Robespierre asked. He looked tired, which he had every reason to be. As the virtual dictator of the republic, he had altogether too many things to worry about and might not be expected to care much about a bunch of painters and sculptors. But he had little sympathy for the old academic system, another obnoxious leftover of the monarchy.[6]

"It would serve them right," David fumed, all the pent-up grievances of the past twenty years in his voice. "I've tried and tried to show them the flaws in their miserable system and they just won't change."

David had been elected to the National Convention, along with Marat, at the same meeting in September 1792 that chose Robespierre to be the first deputy for Paris. The artist embraced his new political role. As a member of both the Committee of General Security and the Committee of Public Instruction, David essentially became the propaganda minister for the French Republic. He envisioned an entirely new and democratic structure for the art world, one based on merit rather than tenure. It would result in art to educate and elevate the people, not

6 Warren Roberts, *Jacques-Louis David, Revolutionary Artist: Art, Politics, and the French Revolution* (University of North Carolina, 1989), 49–50.

oppress or overawe them. He began by establishing a new "commune" of artists that opened instruction to all, not just the chosen few.

The Académie Royale should have been a distant memory by the summer of 1793, but the academicians had stubbornly clung to their privileges, so David wanted Robespierre to abolish the institution altogether. When there was no longer a king, what need was there for an academy in his name? The artist had come to regard its very existence as an insult and a threat to everything they had been fighting for.

"All right then," said Robespierre. "Draw up your plan for the Académie and we'll see if we can get to it next month. But in the meantime, why don't you go see Marat? You can inquire after his health for me. He'll like that."

In Robespierre's judgment David was a true revolutionary, able to keep his head and work toward their larger goals – unlike the mercurial Marat, who had become almost unhinged. Marat was increasingly obsessed with his role as the Friend of the People, and by "the people" he meant the unruly mob who idolized him. Robespierre considered this cult of personality distasteful and inappropriate; the people should be trained to revere the abstract ideals of liberty and virtue, not the actions of one citizen, however personally compelling he might be.

But Robespierre was not in a position to cast aside a valuable ally because he did not like his methods. The first deputy knew better than anyone else that the republic balanced on a razor's edge, teetering between aggression from abroad and dissatisfaction at home. The execution of the king had removed one evil, but others remained. Foreign despots were intent on toppling the republic for fear that the infection of freedom would spread. The tools of the *ancien régime* – the nobility and the church – still plotted to reinstate the old order. The people themselves were beginning to think that progress was not coming quickly enough, which for them boiled down to the fact that the price of bread was still too high.

Robespierre became convinced that the death of Louis XVI was only the beginning, and that a deeper purge would be necessary to cleanse France of tyranny once and for all. This would not be an easy task, and Robespierre knew he would need all his allies for the work ahead. Marat might be a nuisance, but his pen was a mighty weapon.

"Tell Marat we all hope he will grace us with his presence at the glorious anniversary of the fall of the Bastille this week," Robespierre said to David. "And maybe you can get him to understand that helping the people sometimes means rationally explaining to them what is in their best interests, not just whipping them into a frenzy."

The painter snorted. It wasn't likely. Whipping people into a frenzy was pretty much all that was keeping Marat's body and soul together.

Walking down the rue des Cordeliers toward Marat's residence later that afternoon, David had trouble believing it had been four years since the revolution began. Sometimes it seemed they had little to show for their efforts. There had been terrible disappointments, but he continued to regard the revolution as a seminal event in French history. Surely some birthing pains were to be expected, as in any fundamental change. But the basic premise, that the old authorities were moribund and that the only just form of government was one controlled by the people, remained incorruptibly true. In time, the people would come to understand. His job was to provide suitable examples to guide and inspire them to work together for the common good. The old idols like Socrates, for all their sterling qualities, were too distant and esoteric. The people needed modern heroes who shared their own experience, presented in such a way that they could instantly grasp the lesson.

The artist was so caught up in his reflections that he did not notice the horse-drawn cab clopping away from the unassuming house as he arrived. Had he seen it, he might have been surprised – cabs were unusual in this neighborhood, as it was notorious for political zealots who regularly engaged in violent street fighting that could engulf passersby. But David felt perfectly at home. He rapped on the door, which was soon opened by a pretty but slovenly young woman. Most would assume she was a scullery maid who had no business questioning visitors to the great Marat.

"I told you he's seeing no one. Now go away!" she snapped rudely before recognizing her visitor. "Oh, David, forgive me, I didn't realize it was you. A stranger was just here, a lady from the country who wanted to get in to see the Friend of the People. Said she had information on the traitors trying to undermine the revolution. But I didn't like her. She was pushy – seemed to think she could walk right over me. I sent her packing."

The woman's face brightened with a self-satisfied smile, and David grasped her hand warmly. Twenty years Marat's junior, Simonne Evrard was now his common-law wife, an arrangement they had formalized a few years ago in a suitably revolutionary ceremony from which the church – and the bride's horrified family – had been banished.

"You are fighting his battles for him now?" David kidded her as he stepped inside. But this was not a topic on which Simonne could joke. "He is still the heart and the mind," she responded. "I am only the hands."[7]

7 William Vaughan and Helen Weston, Introduction to *David's 'The Death of Marat,'* ed. Vaughan and Weston (Cambridge, 1999), 4.

"How goes it with the heart and the mind today?" David asked. Marat's health, never robust, had been in steady decline over the past months. Simonne didn't answer as she led the way up the narrow staircase. There were no frills or niceties about the Marat apartment. Everything revolved around the shrunken man in the leather bathtub whose pen scratched relentlessly through the terrible heat in Paris that summer.

Marat's room was, like the rest of their abode, deliberately simple and spare. It was a fitting home for the man who insisted that his only concern was his beloved *sans-culottes*, the common people who rejected the trappings of the upper classes, such as their tailor-made silk knee-breeches, opting for plain, loose trousers instead.

Marat couldn't wear pants of any kind for very long at this point. For the past three years he had been suffering from a skin disease that erupted in painful, itchy boils. It had begun on his backside and had now spread over most of his body. There was no cure; he could only find relief in a medicated bath that cooled the rash. A cocoon-shaped tub had been devised to cover him so he could receive visitors wearing only a shirt, with a vinegar-soaked cloth wrapped around his head to reduce the itching on his scalp.[8]

Marat was writing when David walked in, and the artist stood watching him in silence so he could finish his sentence. In his best days, Marat had been famous for his small stature, dark skin and a face so ugly that a later biographer would describe him as a "shocking creature" who must have crawled out of a swamp.[9] The man really was downright repugnant, David thought – until you looked into his eyes.

For Jacques-Louis David, Marat's eyes held all the ardent conviction that had fueled the revolution, above all a commitment to the principles of freedom and equality. He was a fascinating man, a scientist as well as a medical doctor and a radical political journalist who had studied the growth of democracy in Great Britain. David had a particular sympathy for Marat's struggles against the scientific establishment that had rejected his research, provoking his furious pamphlet "Modern Charlatans, or Letters on Academic Charlatanism."[10]

Through the power of his writing, Marat had become the de facto leader of the most radical revolutionaries. He had refused to give an inch during the difficulties of the last four years, but continued arguing passionately – some said hysterically – for the rights of the poor and dispossessed.

"So Robespierre sent you to check up on me, did he?" Marat's voice cracked like a whip as he fixed his gaze on the artist.

8 Judging from Marat's recorded symptoms, it has been proposed that he suffered from *dermatitis herpetiformis*, so called because the open blisters resemble herpes sores. Now known as Duhring's disease, the condition can easily be managed with a combination of diet and antibiotics. J. E. Jelinek, "Jean-Paul Marat: The differential diagnosis of his skin disease," *American Journal of Dermatopathology* 1:3 (Fall 1979), 251–52.

9 Vaughan and Weston, Introduction to *David's 'The Death of Marat,'* 18.

10 Marat directed his most venomous criticism at the distinguished chemist Antoine Lavoisier, whom he accused of plagiarism in his most famous discoveries. Lavoisier was also an early patron of David, who gave his wife drawing lessons so she could record her husband's experiments. David painted a double portrait of them in 1788. Elegant and affectionate, surrounded by scientific equipment, they appear to be the ideal Enlightenment couple. Lavoisier was guillotined on Robespierre's orders for embezzlement in 1794, but the charges against him were later shown to be false.

"He sent me to see how you are feeling," David responded.

"Liar. He sent you to get me to see what he calls 'reason.' Tell him I wouldn't."

David moved a mess of papers and quills off a wooden crate – chairs apparently being considered an indulgence in this home – and sat down on it. "Would it be so terrible to get along with him?"

"Yes."

"You're making a lot of enemies."

"Freedom has many enemies," Marat retorted. "Benjamin Franklin told me so. I think he stole it from Thomas Paine, but he was right. And I am proud to make enemies in the cause of the republic. Robespierre should be careful not to become one of them."[11]

"Ah well, I knew it was a fool's errand, but I wanted to see you. What are you working on?"

Marat scowled. "Treason. Treason in the provinces. Those miserable Girondists are trying to build bases of power outside Paris to overthrow us. They will drag us back into tyranny if they get their way. But I am going to expose them. If we don't kill them, they will kill the republic." He paused for a moment, and his face softened. "Then once they are gone, I am going to write the full story of my life, my journey, and it will give Rousseau a run for his money!"

It should have been absurd to imagine this weakened man, immobile in his bath, exposing subversive plots hundreds of miles away or composing a tome to rival Rousseau's epic *Confessions*, but David had no doubt he meant it. As his body wasted, Marat's spirit seemed to burn ever more fiercely with a fanatical zeal. No cause was too small – or too great – for his attention. His admirers considered him a visionary; his detractors thought him a demon.

David had always been an admirer, and was perhaps even more so when they parted that afternoon. Certainly Marat was a difficult ally, as he put principles above friendship. He would turn instantly on anyone who did not live up to his ideals. David understood Robespierre's frustration with him, but Robespierre was equally uncompromising in his own way. Given Marat's state of health, however, it seemed unlikely that he would be an issue for all that much longer.

David reported back to Robespierre that Marat was too ill to attend the anniversary celebration and might never appear at the National Convention again.

11 Franklin and Marat became friendly in London in 1779.

* * *

July 14, 1793

Two days later, David sat in stunned silence as the details of Marat's violent death were read out to the Convention. The previous evening, a young female Girondist had, on her second try, gotten past Simonne Evrard to see Marat on the pretext that she had information about anti-revolutionary activities in the provinces. She gave him a list of names, and Marat declared that they would be summarily executed. Charlotte Corday then pulled out the butcher knife she had purchased for the occasion and buried it in his chest. It was such a deep blow that Marat barely had time to cry out to Simonne before he died. Corday was apprehended and was being questioned by the authorities. She would no doubt make her journey to the guillotine in short order.

David's mind was already busy with the procession he would mount in Marat's honor. He imagined a cortege bearing the martyr's body in a reconstruction of his humble chamber. The people would see him as he had been up to the end, working tirelessly for them.

The deputy sitting beside David gripped his arm. "There is still one more painting for you to do, David," he said urgently.[12]

The artist nodded solemnly. Marat's legacy was a sacred trust, and he would do his duty by portraying his friend as a new Socrates who would serve as the embodiment of revolutionary virtue. David left the Convention and made his way to Marat's apartment.

The body was still in the bedroom next to the small chamber he had visited two days before. David's stomach gave a lurch. All the perfume in Paris couldn't drown out that smell. Death had come to Marat when he was already in a severely weakened state, and on a hot summer evening. Decomposition had begun immediately. Just a day later he was nearly unrecognizable. His skin had turned green; his bulging eyes wouldn't close; his swollen tongue wouldn't stay in his mouth. David had come to plan a grand ceremony in Marat's honor, but he would have to work rapidly or there wouldn't be much left for the procession.

Pity overtook David's revulsion. Poor Marat. The artist quickly sketched his friend's face, remembering how he had looked at their last meeting. He discreetly closed the eyes and mouth in the drawing. He also noted the details of the main room – the ungainly tub, the wooden crate he had sat on during their last visit, the endless papers, the quills. There were old sheets of *L'Ami du peuple* lying in pools of drying blood. Marat's stained shirt and Corday's black-handled knife were still on the floor. They were relics now.

Jacques-Louis David, study for *The Last Breath of Marat*, 1793.

12 Vaughan and Weston, Introduction to David's 'The Death of Marat,' 6.

Over the next few weeks, two major ceremonies marked Marat's interment. The first, just two days after the murder, featured what was left of the cadaver but with Marat lying prone rather than sitting up as if still at work, as David had first imagined. Marat's supporters had attached a prosthetic right arm when the original rotted off. Then the body was mercifully buried. A fortnight later there was a more formal ceremony to enshrine Marat's heart, which had been placed in a jewel-encrusted alabaster container expropriated from the royal collection.

Once these ceremonies were over, David got to work on the more lasting memorial to his friend. It was his responsibility to create an image of Marat that would eclipse the ugly physical reality of his death and properly immortalize him for the ages. The challenge was to capture the spirit of the great Friend of the People, which so clearly transcended the shackles of his body, in a way that was still recognizably the man Jean-Paul Marat.

David searched for a model that would instantly associate his painting of Marat in viewers' minds with a historical masterpiece. For his other images of contemporary political martyrs he had looked almost automatically to the conventions of traditional religious art, which, when converted to a revolutionary context, lent these images gravitas. Such a model would not do for Marat, who hated the church as vehemently as he hated the monarchy.

It was true that a number of fine orations had equated Marat with Christ at the second and more elaborate ceremony in his honor in the weeks after his death, held at the radical Club des Cordeliers. But there was a more striking speech when a member of the *sans-culottes* stood up, a simple man named Brochet in shabby clothes. At first he seemed unassuming, as he announced that he was no orator and praised the skill of the previous speakers. Then his voice rose angrily:

> I must take issue, however, with the fine comparisons between Marat and Jesus. Marat is not to be compared to Jesus, that man made God by priests, who sowed the seeds of superstition on earth and defended Kings. Marat battled against fanaticism and declared war on the throne! Let us hear no more foolish talk of Jesus. The seeds of fanaticism and such fiddle-faddle have disfigured Liberty ever since it was born – we true Republicans have no god but Liberty and philosophy must be our only guide![13]

Brochet's voice echoed around the former convent, sending a thrill of excitement through David. Of course he was correct: there should be no

13 M. Charles d'Héricault, "A God of the Year II," *Art and Letters* 3:3 (September 1889), 284.

equation between Marat and Christ. Marat would have found it revolting. But if not Christ, who would be the appropriate model?

One of the revolutionary tasks that had given David the most satisfaction was the reorganization of art from royal and noble collections into a public museum that could be enjoyed by all the people. An abandoned Augustinian convent in Paris was serving as a sort of holding pen for confiscated art, and there he came across Michelangelo's *Slaves.* These two statues were the most finished of the figures intended to be in a set of twelve on the tomb of Pope Julius II before the design was scaled down. Michelangelo eventually sent them to Roberto Strozzi, a fellow Florentine patriot living as an exile in France, who gave them to the art-loving French king Francis I in an unsuccessful effort to get his help in ousting the Medici from Florence. Soon the *Slaves* were given to the noble Montmorency family, and in 1632 they passed to Cardinal Richelieu, in whose family they remained.

It was remarkable that they survived the revolution, given that they were found adorning an aristocratic home. In the periodic rioting and looting of the past years, palaces and churches alike had been stripped of their treasures, which all too frequently were destroyed. Perhaps because they didn't have an obviously royal or religious subject, these statues were spared; the crowd that pillaged them from the Richelieu collection would not have known they were originally designed to honor a pope. Now the *Slaves* were liberated from their long servitude to the nobility, which made them a profoundly appropriate model for the painting of Marat.

The psychologically charged *Slaves* fascinated David. One figure struggled against his bonds, the so-called *Rebellious Slave.* The other's strength was spent as he sank toward death, the *Dying Slave.* David turned to the latter figure, which he had sketched from behind in 1790 as a model for a figure in a revolutionary painting.[14] Now he examined it from the front, absorbing Michelangelo's graceful, languid forms and transforming them for his purpose. He would turn the figure on its side and straighten the right arm, but keep the distinctive posture of the head and chest.

David attacked the project, painting furiously through August and September. Usually a meticulous worker who developed his complex compositions through detailed preparatory drawings, in this case he created directly on the canvas, making adjustments as he went along. Once he had his core idea, remarkably few revisions were necessary. By early October he had something to show.

* * *

Michelangelo Buonarroti, *Dying Slave,* 1513.

14 David's drawing, now in the Louvre, completes the powerful musculature that Michelangelo had left unfinished. As with the *Marat,* the artist took so much license with his model that he inscribed the drawing "after Michelangelo" in case viewers missed the reference.

25 Vendémiaire, Année II (October 16, 1793), Afternoon

Robespierre and David had decided to unveil the painting to the public later on the same day that Marie Antoinette was executed. There were still far too many royalists lurking among the population, so they thought it might be wise to have a powerful reminder of revolutionary virtue at the ready.

After her cart had arrived at the Place de la Révolution (now the Place de la Concorde) that morning, Marie Antoinette tripped on her way up the steps to the guillotine and inadvertently stepped on the foot of her executioner. Her last words were a gracious apology to him, her apology was accepted, and it was all over in a moment. The queen's dignity quieted the crowd, who left her remains unmolested. (High-profile executions were sometimes followed by riots in which the bodies were ripped to shreds in a revolutionary frenzy.)

Robespierre was relieved that another major spectacle was planned for later in the day, to refocus the people's attention on heroes of the republic. On the one hand, he disapproved of the fanatical cult that was developing around Marat's memory. The revolution was about principles, not personalities, and he found the worship of Marat too much like the religious and royal cults of the past. But he also understood that David's painting had transfigured Marat into an icon of the republic, so he readily agreed when the artist asked for a ceremonial procession to carry the image from Marat's home district to the Louvre.

David's painting was startling in its tranquil simplicity. Although later critics would praise it as an almost journalistic re-creation of the death scene, it was really nothing of the sort. The artist eliminated the bedlam surrounding the murder – the fatally wounded Marat spewing blood everywhere and screaming for his wife, Simonne breaking through the door trying to get to him, and one of the servants hitting Charlotte Corday over the head with a chair to subdue her. He instead presented the Friend of the People alone, leaning out toward the viewer. His assassin is conspicuous by her absence. The young and pretty Charlotte had become a figure of intense public interest as either a heroine or a villainess, but David banished her from the scene; she was represented only by her signature on the false and perfidious letter she had used to gain entrance to the great man's chamber. In addition, David transformed her black-handled kitchen knife into a more elegant white-handled version that looks like an instrument of ritual sacrifice.

David converted Marat's tub into a hybrid of sarcophagus and altar,

at once containing and presenting his body. Marat himself is cleansed of all his earthly ugliness and even stripped of the shirt that helped conceal it. His skin is gleaming white, unblemished and smooth like Michelangelo's marble. His face, while still recognizable as Marat and clearly based on David's postmortem drawing, has shed its harsh lines. The gaping wound directly over his heart, so deep the doctor could almost fit his hand into it, was reduced to a discreet slit.

Yet even in its quietness the painting has a thrilling tension, for David's Marat, like Michelangelo's slave, is not quite dead. His hands still grasp the paper and quill, and the proper title of the painting is *The Last Breath of Marat*, not *The Death of Marat* as it is often called. The artist captured the moment when Marat's mighty spirit was passing from this world to the next – a cause for lamentation and regret on this side of the veil, but for Marat a release from the torments of earthly existence. The dark upper half of the canvas, which is beginning to be invaded by a shimmering light, contains all the mysterious promise of the unknown realm that Marat is entering. Out of a violent and squalid event, David created a poignant but tranquil image, as if Marat went to his death with the philosophical resignation of Socrates, content to be the sacrifice on which the new republic would be founded.

As his finishing touch, David signed the painting on the wooden crate that served Marat as a desk, and rather than simply write his name, as he had on other images, he inscribed it "À Marat, David" (To Marat, from David), to mark it permanently as a personal tribute from one French patriot to another.

Marat's *sans-culottes* cried openly in the streets as the painting passed by, and women fainted dead away with sorrow. Even the notoriously coldhearted Robespierre was touched. "This is just the thing to make them understand how to be true citizens," he remarked to David. "The real lesson of Marat is that we must all be prepared, every moment of every day, to give everything for the republic."

"We must also be prepared to do whatever is necessary to defend it," the artist replied.[15]

David had been present at the fateful meeting of the National Convention a few weeks earlier, to which Robespierre had invited a large delegation of the people. They had presented their request that all citizens be armed and capable of defending the republic from enemies within. Robespierre announced that the full power of the state would be used to punish anyone who menaced the republican government. Terror was now the official order of France.

15 Roberts, *Jacques Louis David, Revolutionary Artist*, 95.

One month into this policy, Robespierre was reasonably optimistic that it would succeed. The rapturous reception of David's *Marat* confirmed his belief that the people were learning the necessity of guarding the republic from subversion. The painting would hang in the National Convention's meeting hall in the Tuileries Palace as a perpetual reminder of the sacrifice the French Republic demanded even of its greatest citizens.

8 Thermidor, Année II (July 26, 1794)

"I think the die is cast, David," said Robespierre, calm as ever in a crisis. "I don't know what else we can possibly do now."

It had been a grim few weeks. The terror that Robespierre unleashed the previous fall to cleanse the republic of its enemies was backfiring. The relentless executions were sweeping up his former colleagues and allies in ever-growing numbers. So many deputies to the National Convention had been guillotined that the remaining members hardly bothered to look for replacements anymore. Many innocents had died, as Robespierre knew perfectly well.[16] He still believed in the principle – that the enemies of the republic had to be relentlessly rooted out or liberty would be lost. The first deputy understood that some of the not-guilty would have to die if all the guilty were to be snared, but this logic was lost on the families of his victims.

Robespierre had made an impassioned speech defending his actions at the Convention that day, but now the opposition forces he had tried to eradicate were instead gathering power. He was not sure he still had the energy to fight them, or even try to escape them.

David grasped his friend by the hand. "If it really is all over, let us drink the hemlock together!" he declared, pledging that they would serve liberty by their deaths.[17] He assured Robespierre that they had done what was necessary to preserve the republic and that history would judge them accordingly.

The next day, there was an uproar in the National Convention over Robespierre's renewed warnings of a conspiracy against the republic. He was declared an outlaw, and the day after that he was brought to the guillotine. The cool, dapper Robespierre was now bloodied and disfigured, howling with agony when the executioner ripped the bandage off the self-inflicted gunshot wound on his jaw – the result of a suicide attempt during his one night in prison – until the "national razor" hit his

16 There are no reliable records of the number of people guillotined in France during the Terror; estimates range from 16,000 to 40,000.

17 *The Human Tradition in Modern France*, ed. K. S. Vincent and A. Klairmont-Lingo (Rowman & Littlefield, 2000), 41.

neck. Twenty-one of his fellow Jacobins met the guillotine with him. But Jacques-Louis David was not among them. He had not gone to the Convention on that dramatic day, saying he was indisposed.

There are several plausible explanations for David's absence, one of which is that he truly was sick. Another is that Robespierre, trying to protect him, discouraged him from coming. And, finally, there is the very real possibility that in the moment of truth, the artist decided that democratic ideals were not worth dying for. Unlike Robespierre, he had children to consider. So despite his brave offer to share Socrates' fate with his fellow revolutionary, David stayed home and saved his own skin.

November 15, 1797

The small man in the elaborate military uniform simply could not sit still. He kept breaking his pose and shifting his legs or fiddling with his medals, getting up occasionally to leaf through the dispatches that his aides constantly brought to him, even in an artist's studio. It was maddening, David thought, but also compelling – a testimony to the man's irrepressible energy. The question was how to capture that electric spirit in the formal portraits that Napoleon wanted.

The general was just back from his successful campaign through Italy and Austria. He had finally subdued the peninsula, including Rome and even the Republic of Venice, that last bastion of independence, which had succumbed after more than a thousand years of self-governance. He had then made it all the way to the gates of Vienna, where he dictated peace terms to the terrified Hapsburg monarch. All France resounded with his praise, and there were growing calls for him to take executive control of the government in perpetuity. The people were tired of the turmoil and violence that followed the revolution. Napoleon Bonaparte had restored French national pride – and provided a steady stream of largesse from the booty he captured, along with jobs in the armies he commanded.

David knew this sitting was a major opportunity for him. The three years since Robespierre's death had been perilous, and he spent two unpleasant terms in prison. But he survived. He recanted his support for Robespierre and renounced his revolutionary activities. *The Last Breath of Marat* had been removed from the National Convention's meeting place, and although the artist saved it from destruction, it was now crated and hidden away.

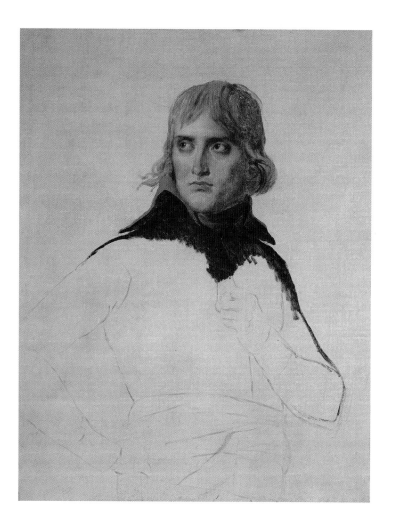

Jacques-Louis David, *Portrait of General Bonaparte* (unfinished), 1797.

While he was in prison, David's former wife, Marguerite-Charlotte, had re-emerged and served as his primary advocate; her ties to the establishment proved useful after all. Through her intervention he was released, and they remarried. Then fifty years old, David faced a largely hostile community of younger artists. In search of a patron, he came into contact with this up-and-coming military officer with an unusually keen interest in the arts.

David and Napoleon hit it off immediately. They might differ on the details of how the nation would best be governed, but they were both fervently committed to France. Royalists had warned that Napoleon might make himself a dictator, and the general responded by supporting a coup within the Directory, the executive body established by

the new constitution in 1795. But David still hoped that Napoleon, as a man of the people, would be responsive to their rights and needs. Indeed, the general was meditating on an entirely new legal code that would protect the rights of all citizens. Perhaps, David reflected, Robespierre had moved too quickly and had been too confident in the ability of the people to govern themselves. It could be that an additional period of transition was needed, with a strong guiding hand like Napoleon's, so that France could regain her rightful place on the international stage.

The fact of the matter was that Napoleon was David's best chance of patronage. The artist glanced down at his sketch, satisfied that he had captured the elegant features, the unusual proportions and the perpetually disheveled hair. "It's enough for now," he said. "I can fill in the rest later."

"Thank God," Napoleon exhaled with relief. "I don't think I could stand another moment. You have no idea how much I have to do. Egypt isn't going to surrender on its own initiative. But you should come along with us. Imagine the paintings you could do of the campaign!"

David shook his head. "My traveling days are behind me, and there are other painters who can go. But I'll have plenty to show you when you get back."

He spoke to Napoleon's departing back. The general was out the door without another word.

David would go on to execute a number of major canvases for Napoleon, including *Napoleon Crossing the Alps* (1800) and the enormous *Coronation of Josephine* (1807). After Napoleon's fall in 1815, the artist went into voluntary exile in Belgium, where he elected to stay even after he was invited back to France by the Restoration monarchy. Shortly after his death in 1825, his widow exhibited a number of portraits in Paris, hoping to sell them. Among them was *The Last Breath of Marat*, which had remained hidden away since 1795. It did not attract a buyer, however, and it remained obscure until a small exhibition of David's work was held in Paris in 1846.[18] The great poet and critic Charles Baudelaire saw it there and composed a famous encomium to it, in which he described the painting as one that transcended the political crisis that inspired it:

> There is in this work something both tender and poignant, a soul hovers in the chilled air of this room, on these cold walls, around the cold and funereal bath. May we have your permission, politicians of all parties, even you, ferocious liberals of 1845, to give way to emotion before David's masterpiece? This painting was a gift to a tearful nation, and our own tears are not dangerous.[19]

18 After the exhibit, the governments of both France and Belgium were interested in purchasing the canvas; the artist's estate elected to sell it to Belgium, where it remains.

19 Vaughan and Weston, Introduction to *David's 'The Death of Marat,'* 1–2, 19.

The Elgin Marbles in the Duveen Gallery, British Museum.

A New Athens on the Thames

The Elgin Marbles and Great Britain

If it be true, as we learn from history and experience, that free governments afford a soil most suitable to the production of native talent, to the maturing of the talents of the human mind, and to the growth of every species of excellence, by opening to merit the prospect of reward and distinction, no country can be better adapted than our own to offer an honorable asylum to these monuments of the school of Phidias, and of the admiration of Pericles, where secure from further injury and degradation, they may receive that admiration and homage to which they are entitled, and serve in return as models and examples to those, who by knowing how to revere and appreciate them, may learn first to imitate, and ultimately to rival them.

Report from the Select Committee
of the House of Commons
on the Earl of Elgin's Collection
of Sculpted Marbles, March 25, 1816

London: 1806

A congenial London dinner party should have been a relief for Lord Elgin after nearly three years as a prisoner of Napoleon in France. His host, the Duke of Sutherland, was one of the wealthiest men in Europe and famous for his brilliant entertainments. Since Elgin had left on his diplomatic mission to Constantinople in 1799, late-day meals of many courses had become increasingly fashionable in Britain. They generally started with oysters and moved on through a range of soups, meats and pastries, accompanied by champagne and claret. Amusing conversation was a central feature of these affairs, and the twenty noblemen gathered that evening included some of the most erudite in London.

Many of the diners were members of the exclusive Society of Dilettanti, founded in the 1730s. The Dilettanti were upper-class men who

had gone on the Grand Tour, the extended travel through Italy that was the capstone of an elite education heavily informed by classical antiquity. The original destination of the Grand Tour had been Rome, but it quickly extended farther south to Naples after Herculaneum and then Pompeii were excavated in the mid-eighteenth century.

An integral part of the journey was the purchase of souvenirs, and so thousands of antiquities – or objects believed to be antiquities – were crated up to make the long journey back to England. There they would line hallways and galleries in the stately abodes of the British upper classes, whose ranks were expanding to include successful officers from the almost perpetual British military campaigns around the globe, along with the merchants and financiers who were making London the economic capital of the world, surpassing Amsterdam.

The Dilettanti were regarded as England's foremost experts on antiquities. The crowning achievement of the society was *The Antiquities of Athens*, a spectacular illustrated publication by James Stuart and Nicholas Revett that appeared in 1762. The authors were both painters who traveled to Greece to make careful measurements of the surviving antiquities, and their work provided a detailed view of the fabled Acropolis ruins, long obscured by the Ottoman domination of Greece.

With their vast experience studying and collecting antiquities, the Dilettanti claimed the ability to judge on sight the excellence of any given classical object. Such assessments were highly subjective, however, and could lead to acrimonious arguments. The ostensible purpose of the society was to promote disinterested knowledge of the ancient world in a convivial setting, but its activities descended all too often into cultural snobbery and intellectual one-upmanship.

Richard Payne Knight, one of the guests at the Sutherland party, was the leader of the connoisseurs and undeniably an expert. He had made the Grand Tour in the 1770s and had amassed a significant collection of ancient bronzes and vases, which he housed in Downton Castle in Herefordshire.[1] Having sketched out a study of the Greek ruins in Sicily that was intended as a continuation of Stuart and Revett's work, he was considered especially knowledgeable about Greek antiquities.

Another dinner guest was Thomas Bruce, the seventh Earl of Elgin. He came from a long line of Scottish noblemen including Robert the Bruce, the hero who joined William Wallace's revolt against England in 1297 and continued to fight tirelessly for Scottish independence, becoming the king of Scotland after defeating the English at the Battle of Bannockburn in 1314.

Sir Thomas Lawrence, *Sir Richard Payne Knight*, 1794.

1 Bruce Redford, *Dilettanti: The Antic and the Antique in Eighteenth-Century England* (J. Paul Getty Museum, 2008), 85.

Thomas Bruce was exceptionally well edu-
cated, although somewhat anxious by nature. He
had served in the army before entering politics as a
member of Parliament and joining the diplomatic
corps. When Elgin, as he was exclusively known,
became ambassador to Constantinople, it was
assumed that he would find ample opportunity to
purchase choice objects for his Scottish castle,
Broomhall House in Kincardine. But no one,
including the earl himself, could have foreseen the
magnitude of what he was to bring back. While in
the East, Lord Elgin embarked on one of the most
ambitious and controversial acts of cultural appro-
priation in history: removing the bulk of the
now-ruined Parthenon's surviving sculptural orna-
mentation from Athens.

George Perfect Harding after Anton Graff, *The
Seventh Earl of Elgin*, c. 1787.

Elgin began his Athenian project soon after
taking up his diplomatic post, and the marbles were
still in the process of being shipped to Great Britain
when he returned home in 1806. Expert opinion
on the endeavor was mixed. Whether through gen-
uine concern about its appropriateness or sheer
jealousy that Elgin was bringing the Parthenon to
England, Richard Payne Knight had made debunk-
ing the Greek treasures his personal crusade. Lord
Elgin was an easy target. For one thing, his once-
handsome face had been permanently disfigured
when doctors in Constantinople amputated half his nose to remove sep-
tic lesions that would not heal. He was exhausted from his long captivity
in France, and shattered to discover that his lovely wife was in a relation-
ship with another man when he finally arrived back in England. He was
also piling up debt. Although noble, Elgin was not wealthy, and the cost
of the work in Athens was astounding.

Fortified by the prodigious quantities of wine for which Dilettanti
dinners were infamous, Knight brought up the topic of the Parthenon
marbles. When Lord Elgin made a comment about their beauty, he
pounced.

"You have lost your labour, my lord Elgin," he said smoothly. "Your
marbles are overrated – they are not Greek, they are Roman, of the time
of Hadrian, when he restored the Parthenon, and even if Greek, they are

by Ictinus and Callicrates, and not by Phidias, who never worked in marble at all; they are perhaps executed by their workmen, hardly higher than journeymen, and throw no light on the details and construction of the body."[2]

It was a devastating assessment. Lord Elgin had been told from childhood that the Parthenon was the apex of creative achievement in the ancient world, conceived by the great statesman Pericles and executed by the genius Phidias. He had sacrificed his personal, professional and financial well-being to bring these marbles to England in the belief that they would inspire a new generation of greatness to rival the golden age of Athens. Now he was being told that it had all been a waste. Elgin was speechless, his return to London society ruined. Knight believed he had carried the day.

As it turned out, this was only the first salvo in a long battle over Lord Elgin's trove of Greek sculptures. The sands would shift again and again. A decade after the Sutherland dinner party, Knight would be completely discredited and Elgin's collection would be purchased by the nation. Renamed the "Elgin Marbles" and enshrined in the British Museum, these treasures proclaimed that Great Britain was now the appropriate steward for the greatest artistic monument to classical democracy.

Athens: September 30, 1687

No weapon of the ancient Persians could have matched the devastating force of gunpowder. Discovered sometime around the year 1000 in China, the explosive substance changed the nature of warfare around the globe. Possession of this new technology greatly multiplied the power of a single man, who could now easily eliminate large numbers of traditionally armed opponents. Gunpowder also enabled a few men to demolish buildings in a matter of moments, whereas large armies of the past would have taken days. Given the inherent instability of the substance, however, accidents were a constant menace.

The Venetians had not come to Athens with any particular animus toward the relics of classical civilization that survived there. But they did have a boundless hatred for the Turks, who had held the city for more than two centuries. Led by the brilliant naval commander Francesco Morosini, their invasion of Greece was the sixth time that Venice had clashed with the Ottoman Empire since the fall of Constantinople in 1453.

The capital of the Byzantine Empire had never fully recovered from

2 Redford, *Dilettanti*, 178.

the sacking by the armies of the Fourth Crusade, led by Doge Enrico Dandolo, in 1204. But under Ottoman rule, Constantinople became the hub of a vast Islamic empire stretching from modern Turkey and Greece to Egypt and across North Africa. The Ottomans existed in a more or less constant state of conflict with the West, as successive emperors aimed to fold additional European territory into their domain. Venice had been particularly inconvenienced by the rise of the Turks in the eastern Mediterranean. Shipping routes became increasingly dangerous. A series of wars generally ended with Venetians the losers. It had been galling when, in 1669, they were forced out of Crete, which they had gained in the spoils of the Fourth Crusade. Francesco Morosini had overseen the final surrender.

While the Ottomans focused on attacking Vienna, Morosini's navy arrived at Piraeus, the port of Athens, on September 21, 1687. They found that the Turks had not evacuated the city as had the ancient Athenians

Francesco Fanelli, The Destruction of the Parthenon in 1687, 1707.

before the Persians arrived more than two thousand years previously. Instead, they had retreated to the Acropolis, where the great marble buildings promised some protection. Women and children were packed into the interior of the Parthenon, and so was an abundance of gunpowder.

Morosini lined up a battery of cannon to bombard the Acropolis with two-handled mortar bombs. In the early evening of September 27, one of the bombs struck the Parthenon. The gunpowder stored inside exploded, creating a massive conflagration that raged for two days. When it was finally extinguished, Morosini was the master of Athens and the Parthenon was in ruins.

As they had after the sack of Constantinople, the Venetians went hunting for treasures to ornament their city. Morosini tried to detach the horses of Selene's chariot from the west pediment of the Parthenon in the hope that the work of Phidias would join the bronze horses on the façade of St. Mark's Basilica, but the blocks of marble crashed to the ground and sustained further damage. Eventually the Venetians sailed off with some antiquities that were more portable, including a stone lion from Piraeus that would now honor the patron saint of Venice. Morosini and his fleet received a hero's welcome in Venice, and he was quickly elected doge.

The Ottomans retook Athens the next year, but the Parthenon was decisively changed – for the worse – by the Venetians' brief stay. Over the centuries, the temple had survived numerous calamities including a series of disastrous earthquakes, as well as the repeated interventions of the Romans, notably emperors such as Augustus and Hadrian who contributed their own monuments and inscriptions to the Acropolis complex. The ivory and gold Athena Parthenos vanished sometime around 435 AD, which is when the Eastern Roman emperor Theodosius II officially closed all the pagan temples, and the Parthenon was made into a Christian church dedicated to the Virgin Mary. A millennium later it was converted into a mosque after the Ottoman conquest. But through it all, the structure had continued to function as a coherent architectural space. That was no longer possible after September 1687, though even in its ruined state the Parthenon loomed ever larger in the modern imagination as the embodiment of classical Greece. Especially after the American and French revolutions, Athens would become more deeply appreciated as the point of origin for democracy.

Some of the most ardent admirers of the ancient Greeks came from a country that had had no contact with them in antiquity. Indeed, while Pericles and Phidias were collaborating on the Acropolis, the islands that constitute Great Britain and Ireland were a wilderness. The Romans established a significant presence in Britain, starting with Julius Cæsar's efforts to conquer territory there. Eight decades later, the emperor Hadrian built his renowned seventy-three-mile wall to defend the northern border of Roman Britain. Although the Roman legions left for good

in the early fifth century, Britain remained proud of its Roman heritage.

By the eighteenth century – after many more classical infusions through interactions with the European continent – Britain had become a leading light in science and arts, as well as a major power with an expanding colonial and commercial empire. At the same time, the British understood their country as fundamentally different from the absolutist monarchies of Europe. It had been gradually developing a constitutional monarchy since that fateful June day in 1215 when King John affixed his seal to the Magna Carta, thereby accepting the proposition that all the king's subjects merit protection under the law – a law that even the king himself would be bound to obey. During the reign of Edward I, the British Parliament, which like the Roman Senate had started as an advisory board to the monarch, took an increasingly active role in levying taxes when the costs of war overwhelmed the king's personal wealth. Under Edward II, Parliament included representatives of the people (commons) as well as the lords.

The development of the British parliamentary monarchy was not a straightforward process. When Henry VIII wished to divorce his first wife against the express orders of the pope (who governed marriage law), he invoked the authority of Parliament. In the seventeenth century, however – with the English church now under royal control – James asserted the "divine right" of kings to rule at will. The conflict between king and Parliament grew more bitter in the reign of Charles I, who refused to call Parliament for eleven years. Britain was plunged into civil war, Charles lost his head in 1649, and the Commonwealth of England emerged. It proved untenably chaotic, so Parliament chose to restore the Stuart monarchy, although with some limitations. The Restoration monarchy, and particularly the Catholic-friendly actions of James II, provoked fears of "popery and arbitrary government" that intensified after his Catholic second wife gave birth to a son. So in 1688, a number of English peers invited the forceful intervention of the Dutch leader William of Orange (William III, grandson of William the Silent, the liberator of Leiden), who would presumably have more democratic inclinations. William was a logical candidate because his wife, Mary, was the Protestant daughter of James II, and he reigned first as her consort and then as a co-equal monarch.

The constitutional monarchy was formalized in 1689 when William and Mary agreed to a formal "Bill of Rights" that established the fundamentally republican principles of Great Britain. These included the need for Parliament to consent to the suspension or execution of laws, the guarantee that Parliament be freely elected, the right to free speech, and

protection against cruel or unusual punishment. Grafting a democratic constitution onto a hereditary monarchy was a remarkable achievement. In doing so, the British claimed an ever-closer kinship with the ancient democracies of Greece and Rome, believing that their own free society would be the modern reincarnation of that vanished glory.

Palermo: October 2, 1799

Although well over thirty and rapidly growing plump, Emma Hamilton was still arrestingly beautiful. She was also secure in the admiration of her husband, Sir William Hamilton, the British ambassador to the Kingdom of the Two Sicilies since 1764, and of her lover, Admiral Horatio Nelson, who was basking in the glory of his victory over Napoleon in the Battle of the Nile the previous year. Their *ménage à trois* was highly irregular, but then again the Hamiltons' marriage already was before Nelson's arrival on the scene.

Emma (originally Amy Lyon, then known as Emily Hart) had been an artist's model and actress, and also the mistress of Sir William's nephew Charles Greville. But Charles desperately needed money and wanted to marry a woman of means, so he needed to get rid of Emma. He persuaded his uncle, who was lonely in Naples after the death of his beloved wife, to take Emma as a mistress – although that was not her understanding when she traveled there in 1786. Hamilton married her five years later, when she was twenty-six and he was sixty. The ambassador was certainly fond of Emma, but he was also realistic. He reacted with surprising equanimity to the mutual infatuation that struck when his wife met Lord Nelson, whom he also admired, and who happened to have a wife back in England. The three lived in a large house in Palermo, where the royal court had fled in late 1789 when Naples was threatened by the French, and all of them participated in court life.

The Hamiltons met Lord Elgin and his wellborn young wife when they passed through Palermo on their way to his new post in Constantinople. By all accounts, Mary Nisbet was a Scottish version of Jane Austen's heroine Elizabeth Bennett: strikingly pretty with dark curling hair and bright hazel eyes, though her greatest attraction was a combination of high spirits and an occasionally saucy humor. Unlike Miss Bennett, however, Miss Nisbet was distinguished by her large personal fortune. As one of the greatest heiresses in Scotland, she had been pursued by a number of suitors.

Gérard François, *Mary Nisbet Bruce, Countess of Elgin*, 1804.

One of them was Lord Elgin, who had been encouraged by no less than King George III to make a solid match before he departed for the East. The Ottoman court was famous for its luxury, and the British ambassador would have to keep himself in high style. For many decades, the embassy in Constantinople had been financed by the Levant Company, which was based in London and enjoyed a trade monopoly with the empire. But the company's fortunes declined after the monopoly was broken in 1754, so the ambassador would need to pay more of his own expenses.[3] Elgin was not in a position to do this on his own, but it would be a different story with Mary Nisbet as his wife. He courted her assiduously in the early days of 1799, and by the end of March they were married. Six months later, they were on board the HMS *Phæton* en route to Constantinople via Sicily, and Mary was already pregnant.

The culmination of the Elgins' visit to Palermo was an evening at the royal palace, where they were entertained by Lady Hamilton. Mary avoided a personal visit but had no objection to a more formal meeting. She found Emma to be "vulgar" and poked fun at her weight, but was impressed by her beautiful singing voice and couldn't help but notice that Lord Nelson was much taken by her. The countess wrote home to her parents that although Nelson was still recovering from his battle injuries (he had lost his right arm and the sight in his right eye, and then had been struck on the forehead by a projectile during the Battle of the Nile), "he had no other thought than of her."[4] Lady Hamilton may have performed her famous "attitudes," which had been a regular feature of entertainments at their villa in Naples. Sir William had ordered a special black box, somewhat larger than a coffin and open on one side, in which Emma would strike a rapid series of poses. Using only a set of diaphanous scarves and her own expressive face, she would turn into a living version of the classical statues her audience would have admired in the royal museum.

The two ambassadors had common interests to discuss. Sir William was an avid volcanologist and had carefully studied the still-active Mount Vesuvius. But his main passion was for the archaeological sites being excavated in southern Italy, containing not only Roman objects but also a wealth of Greek statues and vases that proved the Greeks had maintained substantial colonies in the region. Hamilton sent a first lot of artifacts back to England in 1771, and the items were sold to the British Museum. The expensive illustrated catalogue of that collection also sold briskly. Benjamin Franklin, then serving as a representative from the colonies to the Court of St. James's, personally ordered a copy for the

Élisabeth-Louise Vigée-Lebrun, *Lady Hamilton as a Bacchante,* c. 1790.

3 The Levant Company was established under Elizabeth I in 1581 and continued to function until 1825.

4 Susan Nagel, *Mistress of the Elgin Marbles: A Biography of Mary Nisbet, Countess of Elgin* (William Morrow, 2004), 41.

Library Company of Philadelphia so that the inhabitants of the New World could learn about these ancient treasures.

Hamilton's second shipment of antiquities had recently been dispatched to England when the Elgins visited, and plans for an auction at Christie's were in the works (although this turned out to be unnecessary, since the vases were quickly snapped up on the private market). Lord Elgin confided his own antiquarian ambitions to Sir William, telling him that he wanted to explore beyond Constantinople into the Ottoman territories of Greece and bring artists along to record the ruins. Happily, Hamilton had a likely candidate in the Italian painter Giovanni Battista Lusieri, and the plan for an archaeological expedition to Athens under the auspices of Lord Elgin was born.

Constantinople: November 26, 1799

Konstantin Kapidagli, *Selim III*, c. 1803–4.

Lady Elgin's disguise was hardly convincing, as she was very obviously pregnant, but the extraordinary layers of protocol surrounding Sultan Selim III demanded that she be dressed as a man for their formal reception. She would in fact be the first woman to participate in such a ceremony. The unusual invitation was extended because she had made such a charming impression on the grand vizier, the chief adviser to the sultan.

Mary had been brought up with considerable wealth and was no enemy of luxury, but what they found in Selim's inner chamber startled her nonetheless:

> It was a small room, and dark, but of all the magnificent places in the world I suppose it was the first. His throne was like a good, honest English bed, the counterpane on which the Monster sat was embroidered all over with immense large pearls. Beside him was an inkstand of one mass of large Diamonds, on his other side lay his saber studded all over with thumping Brilliants. In his turban he wore the famous Aigrette, his robe was of yellow satin with black sable, and in a window there were two turbans covered with diamonds. You can conceive nothing in *The Arabian Nights* equal to that room.[5]

Selim III had a reputation for being exceptionally cultured and interested in relations with the West. Certainly Mary's inclusion in the official reception for her husband suggested as much. But as sultan he still held absolute power of life and death over his subjects, who had none of the

5 Philip Mansel, *Constantinople: City of the World's Desire, 1453–1924* (John Murray, 1995), 63.

constitutional protections afforded to British citizens. That she was in the presence of a man who could have her executed at a whim was a reality not lost on Mary. She wrote to her mother-in-law that when he looked at her she felt so frightened that she had to put her hand on her head "to feel whether it was on or off."[6]

There was no escaping the fact that the earl and countess were a long way from home. The capital of the Ottoman Empire, a city of half a million people, was dirty, crowded and conducive to fever; both the Elgins were frequently ill. As the capital of an Islamic empire it was culturally foreign, although the city bore vestiges of its Roman past. The huge dome of Justinian's Hagia Sophia still dominated the skyline, but now it was flanked by the minarets that marked it as mosque rather than church. Constantinople was a crossroads of ancient and modern, Christian and Muslim, East and West, and as such it allowed for all manner of unusual encounters.

Most importantly for Lord Elgin, Constantinople was a hub of diplomatic activity, especially given the rapidly moving political events across Europe at the turn of the century. Napoleon had retrenched after his defeat in Egypt at the hands of Lord Nelson and was plotting revenge against the alliance that was arrayed against him: Britain, Austria, Russia and the Turks. He had consolidated his political power at home through a new constitution that ostensibly enshrined France's status as a republic but in reality established Napoleon as a dictator. Although some legal and religious freedoms would be guaranteed by the Napoleonic Code enacted in 1804, the radical democratic dreams of 1789 were on hold, if not ended.

Lord Elgin's energies would mainly be devoted to thwarting Napoleon's agents in the East. But the ambassador also found time to apply to the grand vizier for a *firman*, or legal order, to the Ottoman governor of Athens for his team to have access to the Acropolis, first to sketch and take molds of the surviving statuary, and later to start removing anything that was not integral to the surviving military fortifications. Athens was then a small town of about ten thousand people, but it had become an attractive destination for British antiquarian tourists as Napoleon's activity made visits to Italy increasingly perilous.

Some visitors had started to carry away small pieces of statuary, so Elgin redoubled his efforts and even resorted to bribery or outright force to make sure the best pieces went into his crates. His team got off to a slow start because of uncooperative local officials who were not inclined to let anything progress unless they were satisfactorily compensated

6 Nagel, *Mistress of the Elgin Marbles*, 68.

William Gell, Lusieri at work on the Parthenon, 1801.

(which necessitated another *firman* from the grand vizier). Soon they were making good progress – even if Lusieri, the painter, was at times "obliged to be a little barbarous," as he put it, in order to pry the sculptures off the crumbling structure.[7] Neither the Ottoman officials nor the Greeks seemed to care much what was taken or who took it, beyond making sure they profited from it.

Some fifty crates had been shipped to England and there were still as many left to go when the Elgins prepared to return home themselves in 1803. The project had become more urgent when Napoleon made clear that he was interested in adding the Parthenon marbles to the massive haul of art from Italy that was going to Paris, which included the bronze *Brutus* from the Capitoline Museum as well as the four bronze horses from St. Mark's Basilica. There was no guarantee that the diplomatic winds would not shift again and permit the French to start work on the Acropolis.

Napoleon's interest in the Parthenon sculptures unfortunately converged with a personal antipathy for Lord Elgin, whom he blamed for everything from diplomatic setbacks with the Ottomans to the mistreatment of French prisoners of war in Constantinople. He even held Elgin responsible for his defeat in the Battle of the Nile, although it happened well over a year before the earl came east. But after peace was declared

7 William St. Clair, *Lord Elgin and the Marbles: The Controversial History of the Parthenon Sculptures*, 3rd ed. (Oxford, 1998), 110.

by the Treaty of Amiens in March 1802, Lord and Lady Elgin thought it would be safe to travel through France back to England. Just as they reached Paris in May 1803, however, hostilities broke out again and Napoleon took advantage of the situation to declare Lord Elgin a prisoner of war. The earl was detained for almost three years, during which time he steadfastly refused to cede the Parthenon marbles to Napoleon even though it would have gained him an earlier release.[8] He finally arrived home in June 1806.

Back in Britain, Elgin found a large number of unopened crates that had been deposited by his mother at various friends' homes. His hope was to install the marbles at Broomhall, his castle in Scotland, and then resume his diplomatic career. But the new reality was that no major nation was willing to accept Napoleon's marked enemy as an emissary, so further diplomatic posts were unlikely. He also found that Mary had taken up with another man and would not rejoin her husband. They were quickly and very publicly immersed in a scandalous divorce, from which Lord Elgin never fully recovered (although he would remarry and have eight more children).

Then there was the matter of Elgin's debts. He estimated that his work on the Acropolis had cost £27,500 to date, and his annual income was only £2,000. (The expenses of the project would eventually grow to £62,440.)[9] He might claim that his intervention had saved the Parthenon marbles from inevitable plunder or destruction, but it ruined him, especially when he could no longer hope to inherit any more of the Nisbet fortune after his divorce.

Meanwhile, the crates would keep arriving from Athens until 1811. The shipments included seventeen figures from the east and west pediments, with Athena's birth shown in fragmentary form and the better-preserved contest between Athena and Poseidon; sixteen metopes representing the battles between Lapiths and centaurs; and 247 feet of the frieze depicting the Panathenaic procession. All in all, about 75 tons of marble made the journey to London.

The fabric of the British capital, home to a million people, had changed markedly since the great fire of 1666 destroyed much of the medieval city. There were many new churches, most notably Christopher Wren's majestic St. Paul's Cathedral, and new types of public institutions, from coffee houses to museums. Even greater changes were to follow over the course of the nineteenth century. London's population would increase almost sevenfold as railways provided easy access to the city, which was made infinitely more livable by an extensive sewer and plumbing system.

8 St. Clair, *Lord Elgin and the Marbles*, 129.

9 St. Clair, *Lord Elgin and the Marbles*, 143–44, 177.

Politically, the Great Reform Act of 1832 altered how the House of Commons was elected so it would be more representative of the population. The presence of the Parthenon sculptures confirmed that London was culturally as well as politically and economically the worthy heir to ancient Athens and Rome.

The British Museum: March 1817

Benjamin Robert Haydon could not suppress a thrill of proprietary pride as he approached the new Elgin room at the British Museum. After all, the Parthenon marbles had entered the collection in no small part because of his intervention.

Haydon had first encountered the marbles while he was studying to be a painter in London a decade earlier. Lord Elgin, unable to pay the cost of getting the sculptures north to Broomhall, had arranged them in a large, open shed at his rented home on Park Lane along the east edge of Hyde Park. Haydon got permission to sketch them as long as he promised not to publish his drawings, since the earl was still hoping to make a profit from a publication on his treasures. The artist, by his own account, became so obsessed with the sculptures that he would remain at the shed as long as fifteen hours at a time, leaving only when the porter kicked him out at midnight.[10]

Haydon's experience represents the enthusiasm that the Elgin marbles attracted when they were first exhibited, an enthusiasm Lord Elgin stoked by having famous boxers pose and even fight among the statues so viewers could compare the physiques of contemporary Britons with those of ancient Athenians.[11] But the marbles were also controversial, primarily for those who thought removing them from the Parthenon was an intolerable act of violence against the patrimony of antiquity.

The tension between wanting to have these treasures in England and wanting to keep the Parthenon intact was captured by the response of Robert Smirke, an architect who witnessed some of the first removal activity during his visit to Athens in 1801:

> Though I was at first pleased with the Idea of our Country coming in possession of such valuable remains, particularly as I have heard much of the French trying to procure them and of their already having made application to the [Ottoman] Porte for that purpose; yet I could not but feel a strong regret when I considered their being

10 Benjamin Robert Haydon, "First Encounters with the Elgin Marbles," *New England Review* 19:3 (1998), 115. This is an excerpt from Haydon's *Autobiography* (1853).

11 Fiona Rose-Greenland, "The Parthenon Marbles and British National Identity," *openDemocracy*, October 25, 2013.

Benjamin Robert Haydon,
Selene's Horse, 1809.

taken a sort of signal for the annihilation of such interesting monu-
ments. It particularly effected me when I saw the demolition made
to get down the basso-relievos [the frieze] on the wall of the Cella.
The men employed were laboring long ineffectually with iron
Crows to move the stones of these firm built walls. Each stone as it
fell shook the ground with a deep hollow noise; it seemed like a
convulsive groan of the injured spirit of the Temple.[12]

Smirke's melancholy imagining of the Parthenon as a wounded animate
being paled alongside the invective that poured from a fellow Scotsman
of Elgin's, a poet who happened to be the greatest philhellene of the age.
Even as a young man, George Gordon Byron had achieved celebrity
through his evocative literary style, in addition to his many inappropri-
ate romantic entanglements with both men and women – most sensa-
tionally his own half sister. His passionate commitment to the legacy of
ancient Greece was certainly genuine, and he was utterly opposed to the
removal of the marbles from the Parthenon.

Lord Byron had already disparaged the early shipments of marbles
he had seen in London in 1807 as "Phidian freaks" because of their ruined
state.[13] He then saw the results of Elgin's activity firsthand when he visited
Athens. In fact, he sailed from Piraeus with Lusieri and the last shipment
of antiquities on April 22, 1811, but his friendship with Elgin's agent did

12 Vincent J. Bruno, ed., *The Parthe-
non* (Norton, 1996), 150.

13 Lord Byron, *English Bards and
Scottish Reviewers* (1809).

not prevent him from launching a savage attack against Lusieri's master.

While on board, Byron was already hard at work on *The Curse of Minerva* (the Roman name for Athena), in which the goddess, bedraggled but still clutching an olive branch, visits the poet in a dream to protest the despoiling of the Parthenon:

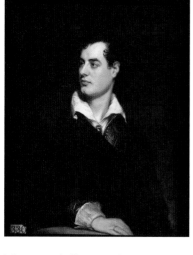

Thomas Phillips, *Lord Byron*, 1824.

> "Mortal!" – 'twas thus she spake – "that blush of shame
> Proclaims thee Briton, once a noble name;
> First of the mighty, foremost of the free,
> Now honour'd less by all, and least by me;
> Chief of thy foes shall Pallas still be found.
> Seek'st thou the cause of loathing? – look around.
> Lo! here, despite of war and wasting fire,
> I saw successive tyrannies expire.
> 'Scaped from the ravage of the Turk and Goth,
> Thy country sends a spoiler worse than both.
> Survey this vacant, violated fane;
> Recount the relics torn that yet remain:
> These *Cecrops* placed, this *Pericles* adorn'd,
> That *Adrian* rear'd when drooping Science mourn'd.
> What more I owe let gratitude attest –
> Know, Alaric and Elgin did the rest.
> That all may learn from whence the plunderer came,
> The insulted wall sustains his hated name:
> For Elgin's fame thus grateful Pallas pleads,
> Below, his name – above, behold his deeds!
> Be ever hailed with equal honour here
> The Gothic monarch and the Pictish peer:
> Arms gave the first his right, the last had none,
> But basely stole what less barbarians won.
> So when the lion quits his fell repast,
> Next prowls the wolf, the filthy jackal last;
> Flesh, limbs, and blood the former make their own,
> The last poor brute securely gnaws the bone.
> Yet still the gods are just, and crimes are cross'd:
> See here what Elgin won, and what he lost!
> Another name with his pollutes my shrine:
> Behold where Dian's beams disdain to shine!
> Some retribution still might Pallas claim,
> When Venus half avenged Minerva's shame."

In Byron's conception, Elgin was morally inferior to both the barbarians and the infidels who had conquered Athens in centuries past because he should have known better, and through his removal of the marbles he had not preserved this testament to democracy but rather betrayed the inheritance of freedom that Britain had received from the Athenians. The poet renewed his criticism in *Childe Harold's Pilgrimage*, the epic work describing the hero's journey of self-discovery through ancient ruins, in which he refers to the removal of the Elgin marbles as "dastardly devastation."[14]

Lord Byron's high-profile attack was direct and personal, and it was at first effective. The resulting impression that the removal of the marbles was dishonorable and reprehensible threatened to undermine Elgin's efforts to sell his collection to the British nation. Byron's campaign was joined by his friend Richard Payne Knight, who insinuated that besides being in terrible condition they were not even Phidian originals and so they had no place in the national collection.

At this point, the painter Benjamin Robert Haydon, grateful to Lord Elgin for allowing him to sketch the marbles and convinced of their excellence and authenticity, stepped in. Elgin was no connoisseur and could not directly rebut Knight's slander, but Haydon argued that the judgment of the connoisseurs was flawed and had no value compared with the judgment of those who actually practiced the fine arts.[15] He mounted a vigorous defense in the press, lauding the Elgin Marbles and mocking those who denigrated them, asking, "Shall the idle, superficial, conceited, vain glance of a dilettante be of more value than the deep investigating principles & practiced search of the Artist?"[16] Haydon's words struck a chord, and the artistic community rallied around the marbles.

On February 26, 1816, a select committee of Parliament began deliberations over Lord Elgin's petition that his collection be purchased for the British Museum on the grounds that if these masterworks were made generally accessible, they would inspire an artistic renaissance comparable to what had happened in Italy after the "rebirth" of antique culture in the fifteenth century. The president of the Royal Academy, the American expatriate Benjamin West, made this point in a letter to Elgin:

> Let us suppose a young man of this time in London, endowed with powers such as enabled Michael Angelo to advance the arts, as he did, by the aid of one mutilated specimen of Grecian excellence [the *Belvedere Torso* in the Vatican]; to what eminence might not such a genius carry art, by the opportunity of studying those sculptures in aggregate, which adorned the temple of Minerva at Athens?[17]

14 See note 6 to Canto II of *Childe Harold's Pilgrimage*, commenting on stanza 12, line 2, "To Rive what Goths, and Turks, and Time hath spared," in *The Works of Lord Byron, Volume 2*, ed. Ernest Hartley Coleridge (1899; Nabu Press, 2010), 168–71.

15 Haydon never enjoyed much success as a painter; he appears to have been more popular as a writer. Deeply disappointed and just as deeply in debt, he committed suicide in 1846.

16 Benjamin Robert Haydon, *On the Judgement of Connoisseurs being preferred to that of Professional Men*, quoted in Redford, *Dilettanti*, 11–12.

17 Quoted in *The Poetical Works of Mrs. Felicia Hemans* (Thomas T. Ash, 1936), 107 n.43.

The question was becoming urgent, as it was known that Prince Ludwig of Bavaria was ready to buy the marbles if the British government did not – and Elgin would have to sell. If the committee rejected Elgin's request, the marbles would almost certainly be lost to England.[18]

The parliamentary committee had four main goals. The first was to ascertain if the removal of the sculptures from the Acropolis had been legal; the second was to establish whether Elgin had properly received the authority to remove them. If these queries were satisfied, the committee would then investigate the quality of the marbles, and finally determine the appropriate price to be paid for them.[19] Over several days, numerous witnesses were questioned, beginning with Lord Elgin himself. Then came a number of prominent artists and critics of the marbles, including Richard Payne Knight, who put in a very poor performance and had to admit he had no substantive grounds for his assertion that the sculptures were not the work of Phidias.[20]

After extensive inquiry and the collection of additional documentation from witnesses who could not testify in person, the committee recommended the purchase of the marbles. The government requested the sum of £35,000 (about half what Elgin wanted) and Parliament approved the expenditure by a vote of 80 to 32. The marbles were officially the property of Great Britain – not of its monarch, but of the nation. Robert Smirke, who fifteen years earlier had sadly watched the removal of sculptures from the Parthenon, was now the architect of the British Museum and he designed a room for them at Montagu House in Bloomsbury, the museum's home.

Enthusiastic crowds numbering as many as a thousand people a day thronged to see the Parthenon sculptures when the exhibit opened to the public in early 1817. Haydon was a regular visitor, and in March he invited his friend John Keats to join him. Keats was then only twenty-one years of age. He had trained in medicine and showed promise of becoming a gifted surgeon, but had suddenly and recently announced his intent to become a poet instead. He then agonized over his decision, worrying endlessly if he would ever be able to create anything worthwhile.

The two friends paused at the entry to the Elgin room, where Haydon enthusiastically declared, "I always think when I see the marbles that I am contemplating what Socrates looked at and Plato saw!"[21] For Keats, the thought that he was about to encounter some of the greatest works of art in human history was an almost unbearable pleasure.

Smirke's hastily arranged room for the marbles was large but simple, with gray walls and a timbered ceiling. The frieze hung at eye level,

Benjamin Robert Haydon, *John Keats*, 1816.

18 St. Clair, *Lord Elgin and the Marbles*, 225.

19 *Report from the Select Committee of the House of Commons on the Earl of Elgin's Collection of Sculptured Marbles*, 1816, 1, http://catalog.hathitrust.org/Record/009711369.

20 *Report from the Select Committee of the House of Commons*, 97–98.

21 *The Autobiography and Memoirs of Benjamin Robert Haydon*, ed. Tom Taylor (Harcourt, Brace & Co., 1926), vol. II, 115.

Archibald Archer, *The Temporary Elgin Room at the British Museum*, 1819.

while the metopes rested on a cornice above. The figures from the pediments mostly stood on low platforms, although some of them, notably Selene's horse, rested directly on the floor. Visitors mingled freely with the marbles, examining them from a distance of inches and even touching them in a way that would have been impossible in their placement on the Parthenon. This installation was designed to facilitate the study of the marbles rather than mimic their original presentation.

As the painter and the poet toured around the room, Keats was so overwhelmed that he could barely speak. Finding a place to sit down, he gazed in rapture at the marbles, as he would do time and time again for the next three years until he departed England for Italy.[22] The next day, the poet found his voice and wrote two sonnets, which he sent to Haydon:

22 St. Clair, *Lord Elgin and the Marbles*, 269. Keats died in Rome of tuberculosis in 1821.

TO HAYDON, WITH A SONNET WRITTEN ON SEEING THE ELGIN MARBLES

Haydon! Forgive me that I cannot speak
 Definitively on these mighty things;
 Forgive me that I have not Eagle's wings –
That what I want I know not where to seek:
 And think that I would not be over meek
 In rolling out upfollow'd thunderings,
Even to the steep of Heliconian springs,
 Were I of ample strength for such a freak –
Think, too, that all those numbers should be thine;
 Whose else? In this who touch thy vesture's hem?
For when men star'd at what was most divine
 With browless idiotism – o'erwise phlegm –
Thou hadst beheld the Hesperean shrine
 Of their star in the East, and gone to worship them.

ON SEEING THE ELGIN MARBLES

My spirit is too weak – mortality
 Weighs heavily on me like unwilling sleep,
 And each imagined pinnacle and steep
Of godlike hardship tells me I must die
 Like a sick eagle looking at the sky.
 Yet 'tis a gentle luxury to weep
That I have not the cloudy winds to keep
 Fresh for the opening of the morning's eye.
Such dim-conceived glories of the brain
 Bring round the heart an undescribable feud;
So do these wonders a most dizzy pain,
 That mingles Grecian grandeur with the rude
Wasting of old time – with a billowy main –
 A sun – a shadow of a magnitude.

Lord Elgin, whether he knew it or not, had achieved his goal in record time. The marbles inspired a new burst of British creative excellence – not in sculpture, as the earl had envisioned, but in Romantic poetry.

For many, among them Keats and the essayist William Hazlitt, the experience of the Parthenon sculptures was primarily aesthetic: an

opportunity to admire their timeless beauty, and simultaneously to reflect on the inexorable passage of time represented by their broken condition. But there were others – beginning with the select committee of Parliament charged with evaluating the marbles – who also understood them in a political context and suggested that they had found their true philosophical home in democratic Great Britain. This idea was highlighted after the final defeat of Napoleon at Waterloo, led by the British under the Duke of Wellington, which was understood as a victory for liberty over tyranny. William Wordsworth equated Waterloo with the Battle of Marathon and claimed it confirmed England as the appropriate custodian for the Athenian marbles:

> *Victorious England! bid the silent Art*
> *Reflect, in glowing hues that shall not fade,*
> *Those high achievements; even as she arrayed*
> *With second life the deed of Marathon*
> > *Upon Athenian walls;*
> *So may she labour for thy civic halls:*
> > *And be the guardian spaces*
> > *Of consecrated places,*
> *As nobly graced by Sculpture's patient toil;*
> *And let imperishable Columns rise*
> *Fixed in the depths of this courageous soil;*
> *Expressive signals of a glorious strife,*
> *And competent to shed a spark divine*
> *Into the torpid breast of daily life; –*
> *Records on which, for pleasure of all eyes,*
> > *The morning sun may shine*
> *With gratulation thoroughly benign!*[23]

There was even a project to erect a full-scale replica of the Parthenon on Trafalgar Square as a monument to the victory over Napoleon, although in the end a column was placed there instead.

The enthusiasm for Athens as the model for Great Britain would reach a fever pitch when the modern Greeks rebelled against their Ottoman overlords in the early 1820s. The Greek struggle for independence had its origins in a secretive and subversive reading of Aeschylus's *The Persians* in Constantinople in 1820 – more than two millennia after it had first been produced in Athens under Pericles' sponsorship.[24] Fighting began in earnest on the Peloponnesus on March 25, 1821, and the British

23 From stanza 4 of William Wordsworth, "When the soft hand of sleep had closed the latch," http://www.bartleby.com/145/ww431.html.

24 Gonda Van Steen, *Liberating Hellenism from the Ottoman Empire* (Palgrave Macmillan, 2010), 66.

Romantic poets quickly sprang into action. "We are all Greeks!" declared Percy Bysshe Shelley in his lyrical drama *Hellas*, which he began writing in August that year and proudly modeled on *The Persians*. (Shelley had visited the Elgin Marbles with his wife, Mary, just two weeks before Haydon and Keats.) Byron went much further by returning to Greece to participate in the battle personally, on the grounds that this was nothing less than a fight for the survival of Western civilization.

What Byron actually found in Greece was a far cry from the idealized descendants of Pericles he had imagined. The unfortunate reality of the Greek War of Independence was a savage and mismanaged affair that dragged on for over a decade. Disillusioned, Byron languished in besieged Missolonghi for months before succumbing to a fever in 1824.

Duveen Gallery, The British Museum

When the Elgin Marbles were unveiled at the British Museum in 1817, their installation was generally understood to be temporary; Smirke was already planning a monumental expansion of the museum to accommodate its ever-growing collections. The purpose of the British Museum – particularly after the National Gallery was founded in 1824 as the repository for old-master paintings – was to showcase the culture of ancient civilizations and to house the national library. In Smirke's new building, inspired by his firsthand experience of the Parthenon, the marbles were installed in a series of exhibits displaying artifacts from the classical world.

That arrangement was ultimately judged too distracting from the pure glory of the Phidian treasures, but the museum did not have the funds to remodel until the successful but unscrupulous art dealer Sir Joseph Duveen offered to pay for a new space for them in 1928. In Duveen's opinion, the marbles should be isolated both from lesser antiquities and from modern contextualizing objects such as plaster casts. He also believed they should be subjected to an aggressive cleaning so they would be more gleamingly white, the way the public expected classical sculpture to look – not with the traces of original paint that disappointed some viewers.[25]

Duveen was not the only culprit in such cleaning efforts; as early as 1834, the Parthenon sculptures had been bathed in nitric acid with the misguided aim of "presenting the marbles in the British Museum in that state of purity and whiteness which they originally possessed."[26] But

25 The brightly painted plaster reconstruction of the Parthenon in the Great Exhibition of 1851 caused such an uproar that the designer, Owen Jones, published a book-length explanation for the paint: *An Apology for the Colouring of the Greek Court in the Crystal Palace* (1854).

26 Letter of Michael Faraday to Henry Milman, as quoted in Andrew W. Oddy, "The Conservation of Marble Sculptures in the British Museum before 1975," *Studies in Conservation* 47:3 (2002), 146.

Duveen's method was even more brutal. He employed a private team that used sharp copper scrapers and picks, on his instructions, to remove any traces of color from the sculptures, a process which must have removed a considerable amount of marble from the surfaces along with the paint.

When this activity was discovered and stopped by the director of the British Museum, it caused something of a scandal. Experts accused Duveen of reducing the marbles to little more than replicas: "The lumps of stone remain, robbed of life, dead as casts."[27] The celebratory opening of the new gallery, which was to be attended by King George V, was abruptly canceled. Duveen died in 1939 with the situation unresolved. Then World War II intervened and the marbles were packed away in safe storage. The British Museum was heavily bombed in the Blitz, and only in 1962 were the marbles finally reinstalled in the Duveen Gallery.

To some extent Duveen got his wish: the marbles now gleam white against the walls of darker stone, and they are easy to see, with all superfluous materials banished from the main hall and unobstructed sight lines established from the east to the west pediment. But as with the early display in Smirke's temporary room, there is precious little indication of how the sculptures had been positioned on the Parthenon. The frieze, which should be running around the exterior of a building, is turned inside out. The pediments would have been facing away from each other; now they are essentially backward. The metopes hang in splendid isolation on side walls, like panel paintings, instead of alternating with triglyphs in a coherent line. It is an arrangement that neither Pericles nor Phidias would have imagined, but it has been highly effective in allowing modern museum visitors to inspect the sculptures closely.

As they are now presented in the British Museum, physically altered and dramatically rearranged, the Parthenon sculptures should not be viewed simply as part of a global cultural patrimony, but also as a reflection of the historical context in which they were brought to Britain and immortalized by English poets. Their purpose in the museum is to instruct and inspire the British people through the legacy of classical Athens. While the ownership of the sculptures has been hotly contested by the Greek government for more than a century, their enshrinement in the British Museum is a testament to the nationalism of nineteenth-century Britain and to its admiration for ancient Greek democracy.

After defeating Napoleon in 1815, Great Britain was clearly the dominant power in Europe, and indeed around the world (despite the embarrassing loss of the American colonies). The British were on the

The copper scrapers used for cleaning the Elgin Marbles in 1937–38.

27 Meryle Secrest, *Duveen: A Life in Art* (Knopf, 2004), 377.

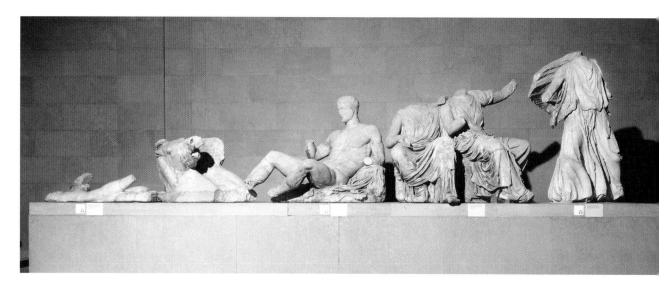

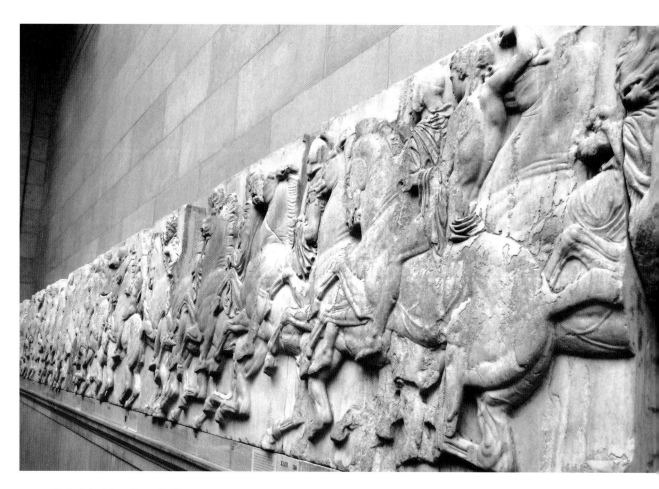

TOP: Elgin Marbles, East Pediment.

ABOVE: Elgin Marbles, Frieze.

way to establishing an empire so vast that the sun never set on it. They insisted that their remarkable success in turning an island backwater into a global superpower rested on the superiority of their parliamentary government – a view that had inspired the plan to bring the physical remnants of ancient Athens to England. Winston Churchill would summarize it best in his description of Britain's ascendancy after the Battle of Waterloo:

> This divergence between the Great Powers was in part due to the fact that Britain had a Parliamentary Government which represented, however imperfectly, a nation. Castlereagh's [the British foreign minister's] European colleagues were the servants of absolute monarchs. Britain was a world-Power whose strength lay in her ranging commerce and in her command of the seas. Her trade flourished and multiplied independently of the reigning ideas in Europe. Moreover, her governing classes, long accustomed to public debate, did not share the absolutist dreams that inspired, and deluded, the Courts of the autocrats.[28]

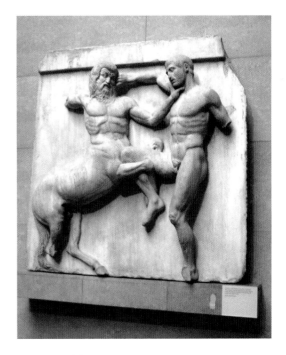

Elgin Marbles, Metope.

Churchill regarded the parliamentary system of Great Britain as key to the nation's preeminence in the nineteenth century. However imperfect its form of government, it allowed Britain to prosper beyond those European countries that were still shackled by the delusions of autocrats. Looking back on this period of history, Churchill could also see another power rising across the Atlantic Ocean, one that was linked to Britain by culture and language, and also, most powerfully, by a shared tradition of democracy: the United States of America.

28 Winston S. Churchill, *A History of the English-Speaking Peoples*, vol. 4, *The Great Democracies* (Dodd, Mead & Co., 1958), 9.

Albert Bierstadt, *Rocky Mountains, Lander's Peak*, 1862.

Manifest Destiny

Bierstadt's Rocky Mountains, Lander's Peak
and the United States of America

*What a prodigious growth this English race, especially the
American branch of it, is having! How soon will it subdue and
occupy all the wild parts of this continent and of the islands
adjacent. No prophecy, however seemingly extravagant, as to
future achievements in this way [is] likely to equal the reality.*

RUTHERFORD B. HAYES
diary entry, January 1, 1857

Wyoming Territory: July 3, 1859

Both men wore the uniform of the United States Army, but they could
hardly have looked more different in it. Colonel Frederick W. Lander, a
tall and imposing New Englander, had been accustomed to the uniform
since he entered a military academy at the age of sixteen. For Chief
Washakie of the Shoshone, on the other hand, it was a novel experience.
Normally he wore the standard garb of the western Indians in the nine-
teenth century: cotton shirt and buffalo-hide trousers, with the tradi-
tional feathered headdress appropriate to his rank. But when his friend
Colonel Lander offered him the army uniform for this special occasion,
Washakie graciously accepted it.

Eight hundred Shoshone had gathered on the banks of the Green
River near the foot of the Wind River Range in Wyoming Territory on
July 3, 1859. They mingled with the members of Colonel Lander's expe-
dition, who had traveled west by covered wagon from Missouri. Since
coming within sight of the Rocky Mountains a few weeks earlier, the
party had passed through an ever more dramatic landscape unlike any-
thing they had previously seen. But it was all surpassed by the vista
spread out before them now: massive, sheer mountains of rock that
sprang directly from the grassy plains.

The expedition's purpose was to survey a new road that would facil-itate the westward travel of pioneers intent on cultivating the Nebraska and Wyoming territories. Lewis and Clark were only the most famous in the first wave of explorers who ventured into this uncharted realm at the beginning of the nineteenth century. Now their tracks were being fol-lowed by entrepreneurs who realized that most settlers would need some basic amenities, starting with roads. Surveying expeditions were a risky business, but the rewards could be substantial. The young federal government of the United States had no illusions that it was up to the task of building an infrastructure in the western territories, so Congress routinely awarded contracts to private individuals to map the region and cut roads through it. One of the biggest hurdles these contractors faced was the increasingly suspicious Indian tribes, especially the Shoshone.

The summer of 1859 would be Lander's third surveying season, and he had learned a great deal on his previous excursions. He had estab-lished relationships with significant local leaders, such as Brigham Young in Salt Lake City as well as Chief Washakie. Overall, Lander was in an excellent position to complete his project, but he knew he needed more than technicians who could assist him in mapping the territory. He needed guides who could help him communicate his purposes to the Shoshone and the other tribes, and he needed help crafting an image of the West that would appeal to people who might come out and settle it.

Lander thus took the unusual step of recruiting several artists for his 1859 expedition. One of them was Albert Bierstadt, a twenty-nine-year-old painter who had spent the last decade developing his technique in the United States and Europe. Back east, his canvases depicting the landscapes of Switzerland and Italy commanded respectable prices from wealthy urbanites who wanted to display their European sophistication. Lander thought the artist's talents could be put to better use, and Bierstadt was keen to join the expedition. He recognized a kindred spirit in Lander – someone who was happiest on the move, exploring new places and opportunities. Bierstadt was also aware of the potential market for the pictures he might produce after the trip. The public was hungry for infor-mation about the West, but had little besides verbal descriptions and sum-mary sketches. With his well-honed skill and relatively unknown name, Bierstadt was a good candidate to be the new artist of the American West.

The party had jolted over rough roads in covered wagons, which were not known for their creature comforts. Some nights it rained so hard that the travelers feared they would drown in their sleep. Enor-mous clouds of mosquitos tormented man and beast. But as the great

mountains came into view, Bierstadt knew the journey was worth the trouble.

Working out large landscape compositions was a laborious technical and creative process that would best be done in the quiet comfort of his studio back east. On site, his main task was to record as precisely as possible the details of the scene – the small things that would make his images authentic. When darkness fell on July 3, he had to suspend his work, and the evening's entertainment began.

The Shoshone at first watched in silent amazement as members of Lander's party began dancing by the campfires. Then they joined in the impromptu celebration of the eighty-third anniversary of American independence. The western reaches of the United States would see plenty of violence and cruelty over the ensuing decades, as Lander's hope for a peaceful settling of white man alongside Indian turned into a far harsher reality. But on that night, it seemed that America was on the threshold of a great future filled with promise for one and all.

The first four score and three years of American history had been eventful, including as they did the War of Independence, the factious Constitutional Convention, and the War of 1812, among other challenges. As they headed farther west, Bierstadt and the Lander party had no way of knowing that an even greater test for the young republic lay just four years ahead. The artist and the officer would both experience the horrors of the Civil War firsthand. Both would nevertheless remain confident that America's destiny lay in the untold potential of the western territories – a vision embodied in Bierstadt's first great painting based on his travels, *The Rocky Mountains, Lander's Peak*.

The Swiss Alps: September 1856

Climbing in the Alps was not for the faint of heart. Once basically unheard-of, hiking for pleasure had became a Romantic obsession, but the reality was often uncomfortable and dangerous. Accounts abound of trekkers crawling along on hands and knees, speechless with terror.[1] "I don't really like mountains," Worthington Whittredge said miserably as he contemplated a narrow stone bridge ahead, twenty feet above a gorge, "and that looks like a devilish thing to cross."[2] His companion kept walking toward the bridge.

Albert Bierstadt was an intrepid adventurer. Then in his mid-twenties, he was eager to see everything Switzerland had to offer, from the tran-

1 One nineteenth-century traveler to the Alps recounted descending on a daunting narrow path across a rock face: "Walking first, I found in the middle of it an unfortunate American gentleman, positively on all fours, wriggling down like a worm, covered with dirt, and speechless with fear of falling on the glacier some 100 feet below." Thomas Hinchcliff, *Summer Months Among the Alps* (1857; Nabu Press, 2010), 255–56.

2 *The Autobiography of Worthington Whittredge, 1820–1910*, ed. John I. H. Baur (Brooklyn Museum, 1942), 32.

quil shores of Lake Lucerne (where Whittredge, a decade older, had been much happier) to the rugged peaks of the Matterhorn and the Wetterhorn. The drama of the Alpine landscape was so very different from what he had experienced growing up in New Bedford, Massachusetts, or even in Düsseldorf, where he had been studying. It was a point of pride with him that he had not yet been turned back by a steep incline or foul weather, and had doggedly hiked and sketched for weeks on end.

"You know this is gold, don't you?" Bierstadt mused, gazing up at the rocky cliffs above them from the middle of the bridge, which he determined was the ideal viewpoint for this particular vista. "There are plenty of people in the States who would pay good money for a glimpse of these mountains, and that is what I am going to give them."

"The only thing I am interested in paying good money for is a warm, safe bed in Meiringen," Whittredge retorted. "And you'd better come with me or you will break your damned neck."

Bierstadt finally completed his sketches and scribbled a few last notes, then reluctantly followed Whittredge back down the slope. At the inn, they joined a congenial group of fellow artists who had also spent the day exploring and sketching. Mostly American expatriates, they were enjoying their months in Switzerland and looking forward to a winter in southern Italy. But in the end, this was business. There was broad interest on both sides of the Atlantic in places from the Matterhorn to Mount Vesuvius, which few people in 1856 would see in person, so pictures of them would sell. Bierstadt had figured that out when he first decided to be an artist.

His parents had emigrated from Prussia in 1832, when Albert was two years old, in the hope that their six children would have more opportunity in the New World. His father, a skilled barrel maker, had found employment in the lively Massachusetts shipping community, and the sons appeared set to follow him in skilled crafts. But while the young Albert showed an admirable willingness to work, he also displayed a confounding determination to pursue a life in art.

There wasn't much interest in the arts in New Bedford, and Albert did not seem to have any particular talent to match his conviction that painting was his calling. But he worked assiduously to develop his technical skill, training his eye and hand as best he could to record the world around him accurately. In 1853 he traveled to his native Prussia to study at the renowned Düsseldorf Art Academy. There he met established painters in a thriving artistic community, including Worthington Whittredge and Emanuel Leutze, whose *Washington Crossing the Delaware* had recently caused a sensation in New York.

manuel Leutze, *Washington Crossing the Delaware*, 1852.

Leutze's huge painting ostensibly documented a crucial moment in the Revolutionary War. On Christmas night in 1776, General Washington and his army had surprised the Hessian allies of the British who were camped at Trenton by crossing the frozen and presumably uncrossable Delaware River through sleet and snow. His victory there on December 26 and a subsequent victory at Princeton on January 3 turned the tide in the Americans' favor, and the crossing came to emblemize Washington's ingenuity and tenacity as a military commander.

When a wave of popular revolution swept over Europe in 1848, Leutze, who was born in Germany but grew up in America, turned to this subject to encourage the spread of freedom and democracy in the Old World. He reflected that "how glorious had been the course of freedom from those small, isolated manifestations of the love of liberty to where it has unfolded all its splendor in the institutions in our own country," and these thoughts inspired subjects for monumental paintings.[3] Leutze corralled prominent American travelers to pose as George Washington's

3 As quoted in John K. Howat, "Washington Crossing the Delaware," *Metropolitan Museum of Art Bulletin* 26:7 (March 1968), pg. 295.

soldiers, while Whittredge stood in for the general himself (although he had shown little of Washington's spirit in the Alps). Newspapers on both sides of the Atlantic carefully followed the artist's progress. The project attracted even more attention when a fire damaged the original painting and he set to work on a second version, which would be considered even more excellent than the first.[4]

Completed more than seventy-five years after Washington's icy night journey, the painting is not an attempt to re-create the historical reality of the event. In the artist's vision, this damp and miserable military subterfuge became a bold and glorious enterprise. The weather, the time of day, even the laws of physics have been revised (with boats far too small to carry their burdens) in order to craft an image of destiny unfolding in an inevitable victory over the forces of tyranny. Rather than documenting history, Leutze interpreted it in a way that was highly appealing and deeply meaningful to nineteenth-century viewers. The painting, as one admirer explained it,

> gives body and soul to our ideas; and hereafter, when we think of Washington, in connection with the passage of the Delaware, the image in our minds will be complete and glowing, and not that vague and confused one, which is all we should have gained from books. Who can doubt, in this view of the case, the momentous importance of providing a nation with great works of art, simply as a means of teaching its own history?[5]

Small children were brought to learn about General Washington from Leutze's painting. Henry James later recalled his excitement in taking the stagecoach as an eight-year-old to see it in the evening, when he should have been in bed. The picture had a lasting effect on him:

> No impression here . . . was half so momentous as that of the epoch-making masterpiece of Mr. Leutze, which showed us Washington crossing the Delaware in a wondrous flare of projected gaslight and with the effect of a revelation to my young sight. . . . We gaped responsive to every item, lost in the marvel of the wintry light, of the sharpness of the ice-blocks, of the sickness of the sick soldier, of the protrusion of the minor objects, that of the strands of the rope and the nails of the boots, that, I say, on the part of everything, of its determined purpose of standing out; but that, above all, of the profiled national hero's purpose, as might be said, of standing

4 Leutze wound up finishing both versions and sold the first one to the city of Düsseldorf, where it would hang in the town hall. It was finally destroyed in the Allied bombing during World War II.

5 From the *Bulletin of the American Art-Union*, November 1851, reprinted in *American Art to 1900: A Documentary History*, ed. Sarah Burns and John Davis (University of California, 2009), 436.

up, as much as possible, even indeed of doing it almost on one leg, in such difficulties, and successfully balancing.[6]

It did not escape the attention of the aspiring young artist in New Bedford that *Washington Crossing the Delaware* was a smashing success when it was exhibited in New York in 1851, and in the United States Capitol in Washington the next year. Its carefully stage-managed unveiling was declared to be "one of the greatest productions of the age."[7] As was widely reported in the press, a record audience of more than fifty thousand people bought tickets to see the painting. In 1853, the picture was purchased for the enormous sum of $10,000, and a large, high-quality engraving of it sold briskly, ensuring the artist an ongoing stream of income from his creation.

Perhaps not coincidentally, around this time Bierstadt set sail for Düsseldorf, where Leutze had set up his studio. There he began remaking himself from a "most timid, awkward, unpolished specimen of a Yankee," as an acquaintance described him, into the most celebrated American artist of his time.[8] And he also discovered a spectacular landscape that would motivate him to search for its equal in the New World.

Washington, D.C.: March 22, 1857

Standing behind the lectern at the Washington Art Association, Colonel Frederick Lander cut a dashing figure. He was six feet two inches tall, with all the poise and polish of his privileged New England upbringing, as well as a compelling physical energy that manifested itself in almost constant motion. He declared frequently that the worst fate for him was being forced to sit still.[9]

Evening lectures by notable personages were a popular amusement for upper-class Washingtonians in the nineteenth century, and attendees expected a stylish performance in addition to interesting content. Lander was not yet well known in the capital as an orator, so the Art Association had been concerned about filling the room. But they need not have worried; there was a large crowd. The audience may have anticipated hearing stories about Lander's exciting adventures in the western territories. There had been newspaper accounts of his confrontation with a grizzly bear in 1854, which left the 1,200-pound beast riddled with musket shots and earned Lander the lifelong nickname "Old Grizzly."[10]

The colonel had other ideas, however. His goal that evening was not

6 Henry James, *A Small Boy and Others* (Charles Scribner's Sons, 1913), 266–67.

7 Abraham M. Cozzens, toast to Emanuel Leutze, September 1851, as quoted in Howat, "Washington Crossing the Delaware," 289.

8 Henry Lewis, as quoted in Nancy K. Anderson and Linda S. Ferber, *Albert Bierstadt: Art and Enterprise* (Hudson Hills Press, 1991), 23.

9 Gary L. Ecelbarger, *Frederick W. Lander: The Great Natural American Soldier* (Louisiana State University, 2000), 2.

10 Ecelbarger, *Frederick W. Lander*, 18–19.

to entertain his audience with wild frontier tales, but rather to propose that Americans had the potential to answer a higher calling than wrestling bears. In particular, he wanted to argue that the freedom and opportunity offered by the United States uniquely prepared the country to become what no one had yet suspected it might be: an incubator of human creativity. The title of his lecture was "The Aptitude of the American Mind for the Cultivation of the Fine Arts."

For Americans, Lander noted, poetry had been something "acted, rather than written." But if the nation's poets could find their voice, they would "stand on the sea of glass mingled with fire ... having the harps of God," he said, quoting the Book of Revelation. Theirs would be a distinctively American art, one that spoke to "the patriotic sentiments of the people" and focused on "productions of the natural history and elaborations of the themes of the soil" of the country.[11] In other words, the special national character of the United States – of the land and the people – should result in a corresponding cultural excellence.

Lander received a standing ovation.

In contrast to the obscure immigrant Albert Bierstadt, Frederick Lander seemed destined for greatness from birth. He came from a well-to-do family with deep roots in the nation's history. His mother's people, the Wests, had lived since the 1600s in Salem, Massachusetts, where they witnessed the witch trials and participated in the Revolutionary War. Frederick's grandfather Nathaniel West was a successful privateer who harassed the British as captain of the *Black Prince* until the ship was blown up beneath him in Penobscot Bay.

The West family also produced the most notable eighteenth-century American artist, Benjamin West. A native Philadelphian, the handsome and charming West had trained in Europe, where he pioneered the use of New World subjects for traditional history paintings. His most popular work, *The Death of General Wolfe* (1771), depicts the heroic demise of one of the great British generals of the Seven Years' War. Mortally wounded in the Battle of Quebec in 1759, James Wolfe famously refused medical treatment and calmly continued to direct military operations until the end. West treated the subject with the seriousness traditionally brought to subjects from ancient or biblical history. He also paid special attention to Wolfe's Indian allies, who would be of particular interest to a European audience, while the scenery plays only a minor role. The work was a sensational success, and tens of thousands of engraved replicas were sold internationally.[12]

Nathaniel West's wife, Elizabeth Derby, was the daughter of the

J. C. Buttre after Matthew Brady, *Frederick Lander*, c. 1860.

11 As quoted in *American Paradise: The World of the Hudson River School* (Metropolitan Museum of Art, 1988), 286.

12 Benjamin West settled in Great Britain in 1763 and became the second president of the Royal Academy in London (1792–1805 and 1806–20). In the course of this work he weighed in favorably on the national purchase of the Elgin Marbles.

Benjamin West, *The Death of General Wolfe*, 1771.

wealthiest man in Massachusetts, if not all the colonies, with a fortune of over one million dollars. Nathaniel's taste for wine and women doomed their union, but before their divorce in 1806 they managed to produce four children. Their daughter Eliza married Edward Lander, who also came from an established Salem family with a distinguished military tradition. His father, Peter Lander, commanded the *Sturdy Beggar* in the Revolutionary War, and Edward served in the War of 1812.

Between them, the West, Derby and Lander families had played a substantial part in the turbulent growth of America from a group of British colonies to a sovereign nation that embraced democratic principles. The new nation relied heavily on the British tradition of constitutional law, as well as the ancient Greek and Roman examples that had such a powerful influence on Great Britain. At the time of Eliza and Edward's marriage, the United States was beginning a massive expansion that would double its size and population during the nineteenth century.

The Landers' fourth child, Frederick William, was a worthy heir to a heritage that was the colonial equivalent of aristocracy. Attractive and affable, he excelled at both academics and sport, first at the Phillips Academy in Andover, then at the Governor Dummer Academy (now called the Governor's Academy), and finally at the American Literary, Scientific

and Military Academy in Norwich, Vermont (now Norwich University). At school, Frederick would have been steeped in the classical texts that had informed the English secondary school tradition and were now the basis of the American curriculum.

The Founding Fathers of the United States made no secret of their admiration for ancient democracy, which they learned about in the histories of Thucydides and Livy. It was their fervent belief that the free systems pioneered in Greece and Rome, which had been corrupted or lost over the centuries, could finally achieve their full potential in the New World. Indeed, the constitution they established drew elements from the Roman Republic, notably the provision for citizens to elect legislators who would pass laws, rather than vote directly on legislation as citizens had done in ancient Athens. They also made important revisions to the Roman model, such as establishing a federal system of semi-autonomous states, which allowed for an orderly process of expansion. In addition, the executive branch was significantly stronger, reducing the temptation to establish a dictatorship, and the judiciary was made independent. The founders did not seek to mimic Athens or Rome uncritically, but rather to create their own, more perfect form of government that would ensure citizens' right to life, liberty and the pursuit of happiness.

Jean-Antoine Houdon, *Benjamin Franklin*, 1779.

The founders sincerely believed they had revivified and improved upon the ancient roots of democracy in the New World, and they presented themselves as the worthy heirs of the Greeks and Romans. On March 6, 1775, for example, Dr. Joseph Collins Warren donned a toga in imitation of Cicero to deliver an oration commemorating the Boston Massacre five years earlier. Benjamin Franklin, George Washington and Thomas Jefferson were all immortalized in realistic portrait busts fashioned after classical Roman examples such as the *Brutus*, which remained one of the most popular attractions in the Capitoline Museum in Rome. Their chosen portraitist was the French sculptor Jean-Antoine Houdon, who had closely studied Roman republican portraiture after winning the Prix de Rome. Franklin sat for Houdon in 1778 while he was in Paris as ambassador to France; Houdon traveled to America in 1785 to sculpt Washington, and later Jefferson.

The founders' reverence for the ancient heroes of democracy was passed along to the next generations of Americans, who spent countless hours memorizing long passages of ancient texts. Among those who absorbed the classical tradition in their youth was Frederick Lander.

While his academic achievements were considerable, Lander was

always a man of action. He left Norwich just weeks before graduation in 1842 and then was constantly on the move, first helping his brothers with an ice business but soon becoming a consulting engineer for the growing railway companies. Making his way to the western frontier for the first time in 1853, Lander was in his element. He spent the next five years exploring the logistical challenges – and the entrepreneurial potential – of moving settlers through these vast new territories.

Lander understood that the first need was for decent roads, and then the wagon trains would follow. Of course, figuring out the best places for the roads to go was a difficult business and the consequences of a poor road for emigrants could be disastrous. The tragic Donner party became snowbound in the Sierra Nevada during the winter of 1846 after their progress was slowed by an inadequate trail. Half the party died and their flesh was cannibalized by the desperate survivors.

Absent a sustained, directed public works program to develop an efficient westward conduit, the trails would devolve into a confused network of dead ends masquerading as shortcuts. Some people favored a northern route, others a southern way that would pass closer to their existing interests. But Lander insisted that the best road to the Pacific would chart a middle course through the Platte River Valley – a position that would be adopted by an aspiring politician from Illinois who was particularly interested in issues of western expansion named Abraham Lincoln.

Lander's proposed central route won the day. Supported by a resolution of Congress, he planned to spend the summer of 1859 turning the portion of the so-called Honey Lake Wagon Trail that ran through what is today Wyoming to California into a proper road for emigrants. As he assembled his team in the winter of 1858, he was looking for sturdy, resourceful men who could break a mule and fight off an Indian raiding party as well as build a bridge.

Lander was also looking for artists because he reasoned there was not much point in building his road if no one wanted to travel on it. Some easterners might be attracted by exciting stories of life on the frontier (and even more by the promise of material gain through farming or mining), but Lander knew that words could not capture the magnificence of the West. When he spoke at the Washington Art Association in 1857, he had stressed how this landscape could inspire a great flowering of art in America. In another address given early in 1859, he talked of how artists could also record the courage and fortitude of the emigrants who braved the western wilderness:

Often on the prairies, where the setting sun shone upon the cheerful campfires of a train of emigrants, the morrow showed no trace to mark their resting-place save, perhaps, the gravestone of some way-worn woman buried in the night. And so it was with Art. The nations of the earth as they passed away, too often left no worthy relic to tell the tale of their existence, except the monuments of their art. We are too prone to forget the Past, to discourage sentiments of reverence for those who have gone before us; and hence the need of Art to quicken those sentiments and give them worthy expression.[13]

With these ideas in mind, Lander set about to recruit what he called his "full corps of artists" to accompany his new expedition.

One eager candidate was Albert Bierstadt, who had returned from his studies in Europe in 1857. His artistic skill had improved so strikingly while he was away that at first there were suspicions he had not really done the paintings he sent back. He had changed in other ways too. The same acquaintance who had once called him timid and awkward now remarked in amazement that this "son of a *Cooper* in New Bedford" who had been "totally ignorant of manners or polite society or literature; and almost equally so of Art," was being "admitted into the best society, everyone seems proud to patronize him, and since his return, some eighteen months ago, he writes me he has sold near four thousand dollars worth of pictures."[14]

It was a remarkable transformation. Yet Bierstadt knew that if he wanted to get into Emanuel Leutze's league, he would need something besides technical skill and social graces. He needed to set himself apart from other society artists producing attractive but unremarkable pictures. The Lander expedition would give him the chance to offer art collectors a new and arrestingly beautiful subject.

Napoleon Sarony, *Albert Bierstadt,* c. 1865.

The Boston Athenæum: Autumn 1858

The Boston Athenæum had a dignified if rather self-conscious air of venerability about it, which was somewhat unusual for an institution barely fifty years old. Named to evoke the legacy of classical Greece, it was born in 1807 when a group of literary-minded Bostonians banded together to remedy – at least in their own city – the image of New World culture as barbarous in comparison with the Old World. The Athenæum quickly grew in membership and status, establishing a sizeable library and even-

13 Washington D.C. *Daily Union,* January 15, 1859, as quoted in Alan Fraser Houston and Jourdan Moore Houston, "The 1859 Lander Expedition Revisited: 'Worthy Relics' Tell New Tales of a Wind River Wagon Road," *Montana: The Magazine of Western History* 49:2 (Summer 1999).

14 Anderson and Ferber, *Albert Bierstadt: Art and Enterprise,* 124.

tually acquiring an impressive new residence at 10½ Beacon Street, with architectural ornament inspired by the great Italian Renaissance architect Palladio. The first-floor reading room became a regular meeting place for Boston's Brahmins, including Ralph Waldo Emerson, Henry Wadsworth Longfellow and Oliver Wendell Holmes.

The polymath Holmes started out using the Athenæum as a resource for his medical studies, but soon he was voraciously ransacking the library shelves for books on an astonishing range of subjects. In addition to being a professor and practitioner of medicine at Harvard, Holmes was an inventor as well as a poet and novelist with a keen appreciation for the fine arts. It would have been almost unthinkable for him to miss a noted exhibition at the Athenæum, and almost equally unthinkable that he would not attend one of the receptions for Albert Bierstadt in Boston during the fall of 1858.

The Boston Athenæum picture gallery, 1855.

The walls of the Athenæum's picture gallery on the third floor were lined with dark fabric that set off the paintings like jewels. Visitors would not have been expected to view the paintings in awed silence; the exhibitions were social occasions where the images were sparks to conversation. Oliver Wendell Holmes was nothing if not a conversationalist. Earlier that year he had published *The Autocrat of the Breakfast Table*, a popular collection of essays (to be followed by two sequels) styled as conversations in a Boston boarding house on various topics, including the art of conversation itself.

Holmes would have been further attracted to the Bierstadt exhibition by his interest in methods of seeing. As a physician, he understood that Brunelleschi's technique of one-point perspective had a fundamental flaw: it derived from a single viewpoint. Human sight involves two

Albert Bierstadt, *Lake Lucerne*, 1858.

proximate but distinct viewpoints, which are combined to produce the single image processed in the brain. In the fall of 1858, Holmes believed he had a solution to this artistic problem.

"Do you remember the story from *Arabian Nights*?" he asked the painter. "The story of the tube that could let you see what a distant friend was doing? The princess turned it down in favor of a magic carpet, but I think she made a mistake."[15]

Bierstadt didn't want Holmes to know he had not read *Arabian Nights*. "Go on," he said noncommittally.

"If you think about it," Holmes continued, "the three treasures from *Arabian Nights* have all been realized in our modern marvels. What use is a magic carpet when you have a locomotive? And what is chloroform but the fruit that was supposed to take away suffering through its very scent? But the best yet is the stereograph. It enables you to see things that are very far away, and to see them exactly as if you were gazing at them with your own eyes!"

Holmes gestured to Bierstadt's painting of Lake Lucerne, a product of his Alpine journey. It was his most successful work so far; the press

15 Holmes dialogue based on Oliver Wendell Holmes, "The Stereoscope and the Stereograph," *Atlantic Monthly*, June 1859.

hailed it as a "magnificent" effort that would satisfy "lovers of natural scenery who cannot visit the Alps."[16]

"Take your picture here, this glorious Alpine landscape. Your many admirers swoon in front of it and declare that it is actually better than going there themselves. They can see from the valley floor to the mountain peaks without risking life and limb; they can even visit a gypsy camp without having to look to their purses. And do you know why they have this sensation?"

Bierstadt shook his head.

"Because you were there! You spent weeks and months toiling around the mountains, sketching the vistas and noting down all the details. Then you spent more weeks and more months back here in your studio, putting them all together into this masterful image that makes us feel like we are on the shores of Lake Lucerne ourselves. But what if I told you that you could capture the same effect with even greater precision in a matter of moments?"

"I would ask you to tell me more."

Holmes led the way into a smaller side room, where a table held various pieces of equipment. He picked up a strange object that looked like a metal mask attached to a stick. "Look at this," he said proudly. "It's my most recent invention: the hand-held stereoscope."

"How much does it cost?" Bierstadt immediately asked. A large version of the stereoscope had been invented around the beginning of the century and caused a sensation in scientific circles, but the bulky equipment was too expensive for all but the very wealthiest to afford.

"Not too much," Holmes assured him. "In fact, I think we might sell it for even less than it costs to manufacture. People will purchase only one stereoscope, so the money is to be made in the plates, which they will buy up like biscuits." Holmes picked up a piece of paper bearing a double image of the same street scene but viewed from two different points about four inches apart. He fitted it into the end of the stereoscope and handed the instrument to Bierstadt, who put it up to his face. The artist was astounded by what he saw. It wasn't just a streetscape with the sort of fidelity to detail you might find in a painting by a Dutch master; it also appeared to be in three dimensions. His eyes seemed to perceive depth as well as shapes.

"Amazing, isn't it?" Holmes said. "Now your two eyes can grasp the forms reproduced in the stereoscope the way you could grasp them between your thumb and forefinger. And without even leaving your living room, you can climb the Alps and walk the streets of Pompeii!"

Advertisement for the Holmes stereoscope, c. 1860.

16 Anderson and Ferber, *Albert Bierstadt: Art and Enterprise*, 130.

Strohmeyer and Wyman, stereoscopic view of Ludgate Hill, 1896.

"Or explore the American West," said Bierstadt.

"Exactly," Holmes replied with satisfaction.

Washington, D.C.: March 4, 1859

Emanuel Leutze brought about the first connection between Bierstadt and Frederick Lander in the spring of 1859 when all three men were living in Washington and active in the Art Association. Leutze had recently arrived back in America, hoping that the success of his *Washington Crossing the Delaware* would lead to a major commission in the expansion of the Capitol.

Lander's business in Washington was not all about high culture and principles. His activities in the western territories were ruffling some influential feathers, ironically because of his success. In his 1858 season, Lander had achieved the remarkable feat of finishing the designated section of road well ahead of schedule (taking eight months instead of the allotted eighteen) and coming in under budget (spending only $40,260 of the $75,000 appropriated by Congress for his work). The press trum-

peted Colonel Lander's "miracle" of efficiency and proposed that "his name should be emblazoned in gold and put up in the Halls of Congress as an example to all generations."[17]

This praise elicited strong personal enmity from William Magraw, the less successful superintendent of the western road project whom Lander had replaced, especially since the colonel was outspoken in his criticism of Magraw's poor engineering, his drunkenness and his inability to get along with either Mormons or Indians. Magraw began stirring up covert opposition to Lander in Congress, aiming to delay his funding and focus the project on rail lines rather than wagon roads. Lander was justifiably outraged by this underhanded behavior.

The quarrel reached the boiling point and nearly turned lethal at the Willard Hotel, just two blocks from the White House, on March 4, 1859.[18] Magraw had recently declined a challenge to a duel, knowing that Lander was an excellent fighter.[19] Instead, Magraw plotted to ambush Lander in the hotel lobby with a weight attached to a cord, a weapon known as a slung shot. He landed three blows to his enemy's head, but rather than incapacitating Lander, the attack enraged him. Lander was in the process of beating Magraw to death when the hotel staff intervened.[20]

"Cowards!" Lander thundered at the waiters who were trying to restrain him. "Is this the way you treat a man? I have challenged the scoundrel, and he refused to fight me, and now he assails me with a slung shot!" Blood streamed down the colonel's face from his lacerated scalp, while Magraw cowered a few feet away, looking for an escape.

A few weeks afterward, Lander recalled the episode with grim satisfaction: "I was knocked to my knees and lost about a quart of blood, but got to the man after a while and cleaned him out." Lander may have won that round, but he had had enough of Washington. He was ready to go out west again.

St. Joseph, Missouri: May 3, 1859

"Will you look at all the crazy get-ups in this block alone?" asked Bierstadt in bemusement. He was walking down Francis Street in St. Joseph, Missouri, which was teeming with all manner of mule-drawn conveyances. "I doubt that many of those contraptions are going to make it very far west."

A wide variety of human specimens were also on display as emigrants crowded into the town, preparing for everything from fur trapping along the Missouri River, to mining on Pike's Peak, where gold had

17 Ecelbarger, *Frederick W. Lander*, 46.

18 The building that Lander and Bierstadt would have known was far more modest than the current Willard Hotel, an imposing Beaux-Arts structure completed in 1901.

19 Lander's preferred weapon was the Bowie knife, which Oliver Wendell Holmes equated with the Roman centurion's sword, noting that "the race that shortens its weapons lengthens its boundaries." Holmes, *The Autocrat of the Breakfast Table* (Echo Library, 2006), 14.

20 Ecelbarger, *Frederick W. Lander*, 47–48.

been discovered the previous year, to farming the Nebraska Territory. Bierstadt's companion and fellow artist Francis Seth Frost pointed out an especially picturesque character – a trapper in a buckskin coat with voluminous fringes of fur trailing from the sleeves and hem, which he wore with a white cap topped by a red pompom and sizeable fur boots.

"I haven't seen costumes like this since Capri," Bierstadt mused. "In six months we are going to have enough material to paint for a lifetime."[21]

On February 13, 1859, the frontier town had become the western terminus of the railway line when the Hannibal–St. Joseph route was opened, and just months later the Lander party agreed to meet there before heading west. "St. Joe's" was booming, located as it was at an intersection of road, rail and river. It would become the eastern end of the Pony Express the following year. The town was a rough-and-tumble place that saw its share of outlaws (it was where Jesse James met his end in 1882), but it was also the last taste of civilization for what was now known as Colonel Lander's Honey Lake Road expedition.

The eight-wagon train that moved out of St. Joseph the first week in May was a ponderous affair. While Lander's party would not have needed all the heavy gear that homesteaders transported, it did require supplies for a force that would grow to some 150 men later in the summer. In addition, several wagons were laden with gifts for the Indian tribes, since one of Lander's specified duties was to improve relations with the Indians who were taking a dim view of the settlers. Other "prairie schooners" were packed with salt pork, crackers and dried fruit. Flexible five-gallon bottles made of India rubber were used for water. Fresh milk could be expected from the accompanying cows, and vegetation would be foraged along the way.

Pony Express poster advertising for young riders, c. 1860.

A mule laden with photographic equipment was an unusual feature of Lander's train. Bierstadt planned to take a number of stereoscopic pictures to record their journey, and the equipment was so large it required its own beast of burden. Operating the camera was a two-man job, which Bierstadt and Frost would share. Bierstadt's enthusiasm for photography was well known, leading to criticism that his paintings were basically efforts to mimic photography – merely mechanical reproductions of the natural world rather than intellectual creations. But this

21 Bierstadt, letter home to friends from St. Joseph, in Anderson and Ferber, *Albert Bierstadt: Art and Enterprise*, 143.

carping was far outweighed by his reputation for achieving the most pre-
cise representation of his subjects through his use of modern technol-
ogy. He attempted his first stereographs in the rough eastern territory
of Nebraska shortly after the wagon train left St. Joseph.

The early going was difficult. Colonel Lander was famous for run-
ning a tight ship, and under normal conditions his team could go thir-
ty-five miles in a day. But it was an exceptionally wet spring, and the
torrential rain slowed them to a snail's pace of less than ten miles a day.

A PIKE'S PEAKER.

After Albert Bierstadt, "A Pike's
Peaker," *Harper's Weekly*, August
13, 1859.

One of Lander's trusted hands – many of whom were veterans of the
New Mexico mail route – observed that a key to the colonel's leadership
was the wisdom to slow down or stop when necessary.[22] Lander partici-
pated in every task on the journey – even helping dig the wagons out of
the mud, which seemed a never-ending job in the early weeks.

One day, the colonel sat on the bank of the Platte River dressed in a
long canvas duster coat and boots, with a broad-brimmed hat to keep
the sun off his balding head and an ever-bushier beard on his chin. He
looked perfectly at home smoking a peace pipe with a group of Sioux
Indians who had approached the party for help. There had been a late
snowfall and the runoff had swollen the Platte. The riverbanks were
now crowded with Indians and the many miners who were impatient to

22 Houston and Houston, "The 1859
Lander Expedition Revisited," 60–61.

get to the gold at Pike's Peak but too frightened to brave the rushing waters. Lander instructed his party to help them.

The Sioux chief, named Dog Belly, took a deep breath of smoke and then pointed to the long line of covered wagons that were now making their laborious way across the river, occasionally slowed down by thrashing mules or even tipping over. "What do they expect to find?" he asked.

"Almost all of them think they're going to strike it rich with gold," Lander replied. "It's sad, really – the ones from last year are lining the road on the way home, starving and disappointed, yet this year's crowd can't wait to take their shot. If this isn't the most unmitigated humbug, I don't know what is. They would be much better off to wait until we get the road established, then make their way farther out west to homestead. But it's a hard thing to dissuade a man from the promise of easy money."[23]

None of this made sense to Dog Belly, who had little use for gold. He handed the pipe to Lander.

Bierstadt did not care much about mining one way or the other. He was sitting on the tongue of a wagon, sketching the scene, in which he found an interesting contrast between the calm of the Indians sitting on the bank and the frantic activity of the settlers toiling to cross the river.

By the end of May, the party had traversed what is now the state of Nebraska, and left the rain and mud behind them. They had picked up to Lander's normal pace of thirty-five miles a day. But even as the wagons gained speed, the landscape remained disappointing: dull, flat prairies, apparently without end. Finally they arrived at South Pass in Wyoming, where Lander promised things would become more exciting. While the pass itself was hardly as spectacular as what Bierstadt had seen in Europe, it was a major milestone – the passageway that would take them through the Rocky Mountains, from the known territories onto the new road that Lander had been forging.

South Pass may have been the gentlest place to cross the Continental Divide in terms of geography, but it was still dangerous. There were unscrupulous operators in the region hoping to fleece the greenhorns in the wagon trains, which could be quite lucrative. Earlier in the spring, Lander's good friend and associate Charles Miller had been shot dead there by a perfidious blacksmith who was collecting fees from the gullible travelers he was directing onto the old route, rather than Lander's newer, better road.[24] Undeterred, Lander appointed a new agent and wrote a guide for settlers telling them what they should pack, what they could expect along the road, and what they should do when they finally

23 Joy Leland, ed., *Frederick West Lander: A Biographical Sketch* (Desert Research Institute, 1993), 125.

24 Jermy Benton Wight, *Frederick W. Lander and the Lander Trail* (Star Valley Llama, 1993), 54–55.

reached their destination. When the guidebook failed to come back from the printer before the expedition left town, Lander set his entire company to copying it by hand, and by the time they reached South Pass they had a thousand copies ready to distribute free of charge.

There were other dangers lurking around South Pass too. Emigrants who traveled through it were encroaching on Shoshone territory, arousing some suspicion and ill will. Bloodcurdling tales of Indian abductions, scalping and even worse – from Texas to the great Northwest – were filling the newspapers back east, which certainly did nothing to encourage settlers to venture into the western territories. Lander had been deputized to negotiate a new agreement with the Shoshone in the hope of placating them.

He had first met Chief Washakie near South Pass during the previous season, when his party had come across the Shoshone engaged in their annual antelope hunt – a practice which, like so many others, was threatened by the streams of white settlers. Lander described Washakie as "very light colored, remarkably tall and well formed, even majestic in appearance," and noted his "superior knowledge and accomplishments," which he attributed to extensive dealings with white explorers. He also praised the chief for his renowned ferocity in battle.[25] Lander was impressed by Washakie's declaration that he would not attack the whites, but instead would help them, even if it meant more hardship for his own people. The two struck a bargain for the chief's continued assistance in return for recompense from the United States government.

When Lander and Washakie met again in July 1859, this time on the banks of the Green River, the colonel made the first payment of the agreed compensation. He added the honorary U.S. Army uniform that Washakie would wear for the Lander party's Independence Day celebration.

Bierstadt spent these early July days in a frenzy of activity. Finally, at the foot of the Rocky Mountains, he had something even more awesome than the Alps. The snowcapped peaks reminded him of the Matterhorn and the Wetterhorn, except that the surrounding landscape, rather than being dotted by inns and villages, was completely pristine. And when he paused to take a visual measure of the peaks jutting thousands of feet above the plains, he noted that they appeared to be "in a different class of mountain altogether."[26]

His attempts to make clear stereographs of the mountains were disappointing, so he focused instead on documenting the Shoshone culture. He was delighted that so many allowed him to sketch them and even overcame their wariness of his camera so he could photograph them up close. Bierstadt and Frost wandered for hours through their

Chief Washakie, c. 1880.

25 Grace Raymond Hebard, *Washakie: Chief of the Shoshones* (University of Nebraska, 1930, 1995), 96.

26 Anderson and Ferber, *Albert Bierstadt: Art and Enterprise*, 145.

camp, observing life in the teepees with their brightly colored rugs and blankets. Children seemed to run wild with the dogs and ponies, though in fact each family unit was closely knit. Most of the day revolved around hunting everything from prairie dogs to grizzly bears, and then harvesting each useful element from the animals.

At night the Indians provided music by pounding on what Lander called a "tum-tum," and the entire company would dance, trying to impress each other with their different steps. More amazing to the Indians were the fireworks that Lander's men set off to celebrate the anniversary of American independence – the brilliant flashes of light exploding in the clear mountain air and reflected on the glassy river surface below. For Bierstadt, those idyllic days in the Wyoming Territory with the Shoshone came to symbolize the untapped potential of the American West that he was recording for the first time.

Late Summer, 1859

Bierstadt groped his way out of a deep sleep, surprised to feel water dripping off his face since it had not been raining. Slowly he realized it was the same dew that coated the prairie grass around the campsite. Laughing, he shook Frost awake. "What would the folks back home say about this?" Bierstadt said.

"They might be shocked that we're still alive," Frost replied, mopping the dew off his own face.[27] Exposure to night air or any form of dampness was commonly considered a deadly health risk.

Shortly after the Lander party had reached the western boundary of the Wyoming Territory and started into Oregon in late July, the artists had received permission from the colonel to break away from the main group. They were given a wagon with supplies and one attendant to take care of the animals. They spent their days sketching in the wild, occasionally surprised by an Indian who was equally startled to find a solitary white man drawing a picture of the antelope he was hunting for dinner. But they hadn't come to any harm, and they led a carefree existence. Now thoroughly filthy, they ate what they caught and slept in their corduroy suits. Bierstadt declared in a letter home that he had never had a more wonderful time.

Around the middle of August, the little party began to grow concerned about the likelihood of heavy rain coming in the early autumn, so they turned east. Working their way back across Nebraska and Kan-

27 Anderson and Ferber, *Albert Bierstadt: Art and Enterprise*, 157.

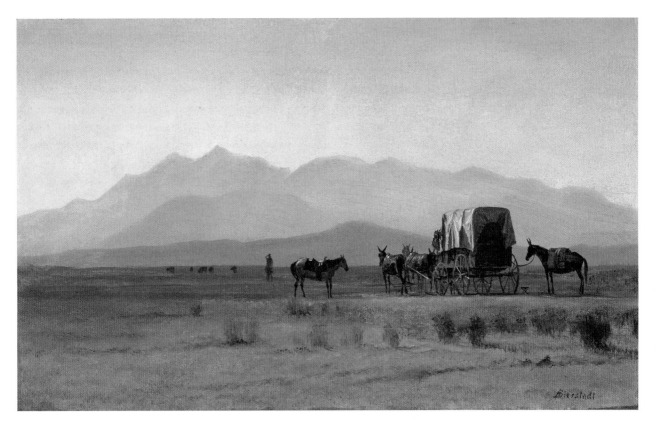

Albert Bierstadt, *Surveyor's Wagon in the Rockies*, 1859.

sas, the artists spent a fortnight sketching along the Wolf River. Bierstadt had originally proposed to spend more than a year traveling the West, but disturbing news from home hastened their eastward progress. On August 24, his hometown of New Bedford, Massachusetts, experienced the worst fire in its history.

The *New York Times* reported that the conflagration started at a sawmill and spread rapidly through the seafront, damaging ships and valuable cargo from the whaling industry, including massive stores of oil and bone. Bierstadt's brothers, Charles and Edward, who had a woodworking business in town, were named by the *Times* in a list of citizens who had "lost all or nearly all" in the fire.[28] News of the disaster seems to have reached Albert in the first week of September. He hurried home, arriving in New Bedford on September 18.

A report in the *New Bedford Standard* noted that Albert Bierstadt brought back some "fine" stereographs, although fewer than he had

28 "The Great Fire at New Bedford: Loss over $300,000, eight to ten thousand barrels of oil destroyed," *New York Times,* August 27, 1859.

29 Anderson and Ferber, *Albert Bierstadt: Art and Enterprise,* 145–46.

hoped to make.[29] It was enough, however, to persuade his brothers to set up a photographic business instead of rebuilding their woodworking shop. (They too had been experimenting with photography for a few years.) In 1860, Albert traveled with Charles and Edward to the White Mountains of New Hampshire and taught them the technique of stereoscopic photography. That same year they opened a studio in New York, offering a catalogue that included fifty-eight stereographs from the Lander expedition to the American West, along with images of New York, Washington, Niagara Falls, Egypt, Palestine, Africa, ancient statuary and "miscellaneous subjects." Edward would later obtain a patent for his modification on Holmes's stereoscope design.

While his brothers launched their careers in photography, Albert set up shop in New York's Tenth Street Studio Building, a prestigious address for artists where Leutze and Whittredge also had their studios. He went to work on paintings inspired by his travels. The first of these, *The Base of the Rocky Mountains, Laramie Peak* (now lost), was displayed at the 1860 National Academy of Design exhibition. It was widely considered the most successful landscape in the show, but as with the other pictures reflecting his western journey that Bierstadt exhibited that year, it did not fully convey the majesty of what he had seen. From the example of Leutze's *Washington Crossing the Delaware*, which measured in at a colossal twelve by twenty-one feet, Bierstadt learned that if he wanted to paint a picture that would be considered truly "great," it would have to be larger – his biggest canvases so far were four feet across, but most were closer to a foot and a half – and it would have to be more complex. That would require more time and reflection, but events were now forcing everyone's attention away from the West and back closer to the nation's capital.

Washington, D.C.: October 10, 1861

A tall man in uniform approached President Lincoln as he walked down Pennsylvania Avenue with his close aide John Hay and the secretary of state, William Seward. The three distinguished men greeted General Frederick Lander, and the president inquired why he had left his command at Camp Benton in Virginia, where he had been training the Army of the Potomac.

There had been occasional gripes around the camp about Lander's zeal for discipline and drilling, and especially for night patrols in chilly weather.[30] But the general knew that inadequate training had contrib-

30 Ecelbarger, *Frederick W. Lander*, 129.

uted to the calamity at Bull Run the previous July and he didn't want to see it repeated. Since that disaster, things had improved somewhat for the Union side in the Civil War. The capital no longer appeared to be under imminent threat of siege, and Lander was able to bring his new bride to Washington.[31] But the war was still uncomfortably close – so close, in fact, that President Lincoln was getting reconnaissance reports from hot-air balloons tethered near the city.

"Frankly, I can't stand to see another cowardly shame like Bull Run happen on my watch," Lander explained as the four proceeded along the avenue. "I am doing what I can but would rather find a good place to die with my men if by dying we set the nation on the right course." He had become convinced that he could do more for the Union cause somewhere other than Camp Benton. "I couldn't stand it anymore, hanging around in that farmyard with nothing to do but run drills. I'm sensible of the honor of the command, but can't bear to sit still. I've been thinking about what I could accomplish with a small group of men, properly trained. We could go up into the mountains and harass the enemy. We could disrupt their rail lines. I know quite a lot about railways and mountains." Lincoln and Seward looked surprised. It was unusual for a brigadier general to request what was technically a demotion.

The small group soon arrived at the plain three-story building that served as headquarters for General George McClellan, who a month later would be appointed general-in-chief of the Union Army. Lander declined to come inside, and instead walked off toward the Willard Hotel.

The secretary of state was rather skeptical of what he considered to be Lander's bravado, but the president was intrigued. "If he really wants a job like that," Lincoln remarked to Seward, "I could give it to him."[32]

Two days later, Lander received a new command from Winfield Scott, the legendary general who had first commanded troops in the War of 1812. To Lander's delight, it was to head a new Department of Harpers Ferry and Cumberland, which meant he would be in charge of setting to rights a 120-mile stretch of the B&O Railroad that had been disrupted for months. On October 15, 1861, he headed back to northern Virginia.

Virginia, near Leesburg: October 1861

Albert Bierstadt and Emanuel Leutze had an unprecedented opportunity to document the war. By special permission of General Scott, they went along with Lander on his expedition into the Virginia countryside where

31 Lander married the popular British actress Jean Margaret Davenport in San Francisco in October 1860.

32 John Hay, diary entry for October 10, 1861, *Inside Lincoln's White House: The Complete Civil War Diary of John Hay*, ed. Michael Burlingame and John R. Turner Ettinger (Southern Illinois University, 1999), 24–25; Ecelbarger, *Frederick W. Lander*, 131–32.

both Union and Confederate soldiers were massing. Leutze proved a far more stalwart sketching companion in difficult conditions than Worthington Whittredge had been on Bierstadt's Alpine trek. Although he was fifteen years Bierstadt's senior, Leutze was an adventurer at heart, which was a good thing since the two painters had heard intermittent musket fire as they skirted the banks of the Potomac River.

An uneasy truce was starting to fray, and they witnessed groups of five to ten soldiers exchanging fire. Lander drew the artists' attention to the 7th Michigan Infantry Regiment, which had formerly been under his

Bierstadt Brothers stereograph, Camp of 49th PA Regiment, Divine Services, 1861.

command. Although he criticized them as dirty and drunken – and the regiment's officers once plotted to kill him over an insult to their hygiene – they were good marksmen.[33] Bierstadt sketched and photographed the regiment.

The two artists returned to Washington on October 20, in the nick of time as it turned out. The following day, the Union suffered a defeat at Ball's Bluff, near Leesburg, where poor planning and timid leadership led to chaos and a terrible loss of life. Receiving ever more urgent communications about the deteriorating situation, General Lander was sent across the Potomac at nearby Edwards Ferry with some units from his demoralized brigade. On October 22 he was shot through the leg while

33 Ecelbarger, *Frederick W. Lander*, 130.

directing skirmishes and had to retreat to Poolesville, Maryland, for medical care, swearing violently all the way.

Lander became increasingly enraged as he heard more details about mismanagement of Union forces during the Battle of Ball's Bluff. He was particularly furious about the decimation of the 20th Massachusetts Volunteer Infantry, of which two hundred men had been killed and many more wounded. One of the wounded was a young officer in the regiment who had graduated Phi Beta Kappa from Harvard the previous spring: the future Supreme Court justice Oliver Wendell Holmes Jr., son of the physician who introduced Bierstadt to his stereoscope. The 20th Massachusetts Volunteers had performed bravely – so bravely that a Confederate officer was heard to remark that "fewer of the Massachusetts officers would have been killed had they not been too proud to surrender." This comment inspired Lander to write a poem called "Ball's Bluff" in honor of his fellow sons of Massachusetts, harking back to their fathers who had fought for freedom against the British, and even to the ancient Greeks who had sacrificed themselves at Thermopylæ fighting the Persian invaders:

> *Aye, deem us proud, for we are more*
> *Than proud of all our mighty dead;*
> *Proud of the bleak and rock-bound shore*
> *A crowned oppressor cannot tread.*
>
> *Proud of each rock, and wood, and glen;*
> *Of every river, lake and plain;*
> *Proud of the calm and earnest men*
> *Who claim the right and the will to reign.*
>
> *Proud of the men who gave us birth,*
> *Who battled with the stormy wave*
> *To sweep the red man from the earth,*
> *And build their homes upon their grave.*
>
> *Proud of the holy summer morn*
> *They traced in blood upon its sod;*
> *The rights of freemen yet unborn;*
> *Proud of their language and their God.*
>
> *Proud that beneath our proudest dome*
> *And round the cottage-cradled hearth*

There is a welcome and a home
For every stricken race on earth.

Proud that yon slowly sinking sun
Saw drowning lips grow white in prayer,
O'er such brief acts of duty done,
As honor gathers from despair.

Pride – 'tis our watchword, "Clear the boats,"
"Holmes, Putnam, Bartlett, Peirson – Here"
And while this crazy wherry floats
"Let's save our wounded," cries Revere.

Old State, – some souls are rudely sped –
This record for thy Twentieth Corps, –
Imprisoned, wounded, dying, dead,
It only asks, – "Has Sparta more?"

Lander did a poor job of masking his disapproval of how the Battle of Ball's Bluff had been fought and his particular disdain for General McClellan, who was popular with the troops but consistently outmaneuvered by Confederate generals. McClellan retaliated against Lander by canceling his pet project, the Department of Harpers Ferry and Cumberland.

Ignoring his doctor's prescription of bed rest, Lander commanded a division of the Army of the Potomac during the winter, with significant success, but he kept reinjuring his leg. As an unseasonably warm December gave way to a shockingly cold January, he contracted a persistent chill. Despite his failing health, he agitated for more action until the end. "I am never so sick as when I cannot move," he wrote in a cable on February 19.[34] Frederick Lander died at Camp Chase on March 2, 1862, of pneumonia or an infection that resulted from his bullet wound. Twenty thousand people attended the funeral in his honor in Washington, D.C., and he was finally laid to rest in Salem, Massachusetts.

New York: 1862–63

Albert Bierstadt was at work on two separate paintings that were related to Lander when news of the general's death reached New York. The first, titled *Guerrilla Warfare: Picket Duty in Virginia*, was well under way. It was

34 Ecelbarger, *Frederick W. Lander,* 260.

Albert Bierstadt, *Guerrilla Warfare: Picket Duty in Virginia*, 1862.

a result of the artist's autumn foray into northern Virginia, where he had observed sharpshooters trained by Lander at Camp Benton. The scene suggests the artist as a direct observer of warfare as it happened, rather than the re-creator of historical events (as was the case with Leutze's *Washington Crossing the Delaware*). The painting does not show a particularly dramatic moment nor does it focus on an important personage (as did West's *The Death of General Wolfe*). Instead, it shows a skirmish between an anonymous little group of infantrymen and their even more obscure distant targets, a moment in a war that was still going on. Bierstadt embedded this human drama in the rolling Virginia landscape, which dominates the figures. He used the painting as his submission piece for the Century Association in New York; it was accepted, and he became a member of the prestigious men's club later in 1862.

Guerrilla Warfare was dwarfed by another canvas in Bierstadt's studio that was still very much in the planning stage. At six feet high and ten feet across, it was almost ten times the size of *Guerrilla Warfare* and the largest painting that Bierstadt had attempted to date. He conceived it as the "great picture" that would establish his reputation and confirm his status as the preeminent painter of the American West. The studio was littered with the flotsam and jetsam of his trip through the territories – stereoscopes and curious Indian-made objects, as well as countless sketches

of everything from mountain ranges to bears devouring their prey.

Bierstadt had been meditating on how he would bring all the myriad details he had collected on his journey into a single image that provided a taste of what he had seen and also an idea of the boundless opportunity in the American West. The New World landscape had become a powerful metaphor for the potential of the young republic, but the Civil War shattered the utopian image, blighting man and his habitat alike. In the West, however, Bierstadt found a place where America's promise could be revived.

The news of Lander's death gave him a jolt, and he focused on the memory of the Shoshone encampment on the banks of the Green River, where the surveying party had stayed on July 3, 1859. He transferred this scene to the base of one of the tallest mountains they had seen, which was generally known as the "Saber Tooth" but Bierstadt began to call it "Lander's Peak." He converted the Green River into a lake fed by mountain runoff. He also erased any sign of the surveying party, as if the viewer had stumbled onto a pristine scene of the West as it was before the white man's arrival.

The painting is thus far more than a documentary snapshot of Bierstadt's experience on his trip; it fuses a realistic attention to detail with a sublime idealization of the landscape to give viewers the impression of witnessing a distant, exotic event along with a visionary sense of the possibilities in that land. It was a winning formula that inspired a revival of patriotic pride in a bitterly divided and suffering nation – a formula that Bierstadt would repeat in a number of highly successful western pictures in the ensuing decades.

It was not however Bierstadt's vision that this landscape should be preserved in its virgin state. The artist, like Frederick Lander, frankly believed that these natural wonders were resources for settlers who would turn a rude wilderness into a civilized paradise and a credit to the United States. In the spirit of "manifest destiny," the painting was a visual argument that America's future lay in the exploration – and exploitation – of the West.

In the spring of 1863, *The Rocky Mountains, Lander's Peak* was exhibited in Boston. Bypassing the usual practice of debuting major new works at the National Academy of Design's annual show, Bierstadt opted for a private venue, where large crowds paid twenty-five cents apiece to see his painting.[35] But the artist was not there to enjoy his own triumph; he was already embarked on a journey that would take him all the way to the Pacific Ocean in pursuit of ever-grander vistas in the unexplored territo-

35 The painting would eventually be sold for the unheard-of sum of $25,000 after the artist reportedly rejected an offer of $10,000.

ries of America. He remained in the West while the fighting raged at Gettysburg and President Lincoln spoke his famous lines vowing that the United States, four score and seven years into its history, would not abandon its commitment to a democratic union of states in the New World.

Bierstadt's painting did its part in the war effort, even if the artist himself was absent. On April 4, 1864, *The Rocky Mountains, Lander's Peak* was exhibited along with Leutze's *Washington Crossing the Delaware* at the New York Metropolitan Fair, which was part of the Sanitary Fairs program organized to raise funds for the Union Army hospitals. For a country still in the throes of a brutal civil war, Leutze's heroic view of the past and Bierstadt's hopeful vision of the future would have been a potent combination, together declaring that the grand experiment that was the United States had not been a mistake.

Difficult challenges lay ahead – President Lincoln, who attended the opening of the fair, had only a year to live before John Wilkes Booth assassinated him.[36] But even this traumatic event could not shake the conviction that a free and democratic America was destined to play a unique role in the world. Indeed, the United States would fulfill that destiny in the twentieth century by intervening not once but twice to save Europe, and then the globe, from tyranny.

36 In an odd coincidence, the father of Lincoln's assassin was named Junius Brutus Booth in honor of the ancient Roman family that produced an assassin of Julius Cæsar as well as the founding hero of Rome.

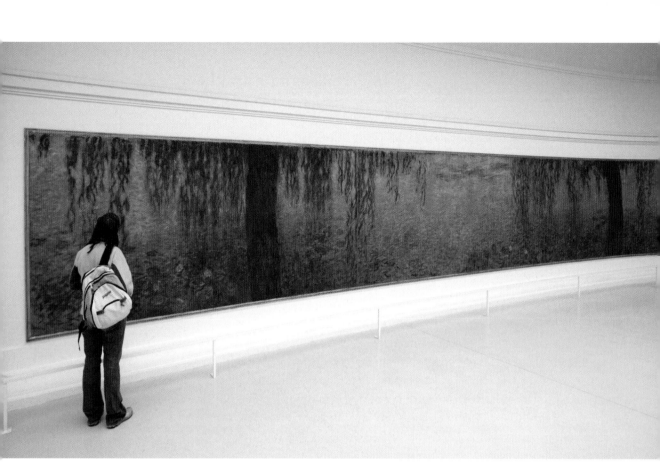

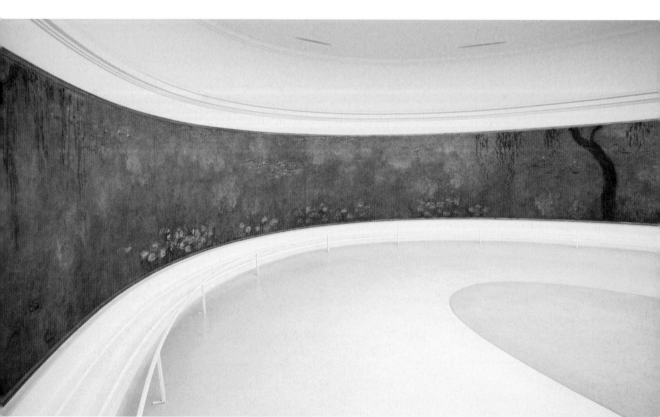

Claude Monet, *Nymphéas* (*Grandes Décorations*), 1917–22.

Art and Victory

Monet's Water Lilies and the French Third Republic

> *I am about to finish two decorative panels that I wish to sign on the day of Victory, and I approach you with the request to offer them to the State through your mediation. It is not much, but it is the only manner that I can take part in the Victory. I wish these two panels to be placed in the Musée des Arts Décoratifs and would be happy if they are chosen by you. I admire you and embrace you with all my heart.[1]*
>
> CLAUDE MONET
> Letter to Georges Clemenceau,
> November 12, 1918

Giverny: November 18, 1918

Georges Clemenceau was the busiest man in Europe. As prime minister of France, he had only just signed an armistice – on the eleventh hour of the eleventh day of the eleventh month – to terminate "the war to end all wars." Now he needed to deal with the cruel devastation visited upon France by the new horrors of heavy artillery, air bombardment and chemical weapons.

In the four-plus grim years since the Germans under Kaiser Wilhelm II had ignited a pan-European conflict, a disproportionate amount of the fighting had been done on French territory. Over one million French soldiers were killed and more than four million wounded. Clemenceau, aptly nicknamed "the Tiger," spearheaded the effort to get American help against the Germans long before he became prime minister in November 1917. He also took it upon himself to rally French public morale and frequently visited troops on the front lines; during the last year of the war he averaged one day a week in the trenches. With his big white moustache and an old felt hat on his bald head, he was quite a distinctive figure as he made the rounds without apparent care for his own safety.

When peace was finally declared, Clemenceau's ministers wanted

1 Gregor Dallas, *At the Heart of a Tiger: Clemenceau and His World, 1841–1929* (Carroll & Graf, 1993), 556.

Dans l'Oise. — M. Clemenceau, Président du Conseil français, causant avec un soldat.

Prime Minister Georges Clemenceau visiting with a soldier, Oise, France, 1917–18.

him to go immediately to the provinces of Alsace and Lorraine on the German border and lay claim to them personally in the name of France. But the premier had something else on his schedule: he was going to attend a belated birthday party.

Claude Monet's seventy-eighth birthday was on November 14. He didn't mind waiting a few days to celebrate with his "dear and great friend," although he was eager to show Clemenceau the project that was consuming his attention. When news of the armistice had broken, the painter wrote to the prime minister straight away offering two canvases to the nation as his way of participating in the great victory.

Clemenceau was equally eager to see both Monet and his new paintings. On November 18, he traveled to Monet's house at Giverny, forty-five miles northwest of Paris, in the same open car he had used to visit soldiers on the front. It was a joyous reunion.

Even on the threshold of winter, Giverny was a magical spot. Monet had spent decades refining the property inside and out to suit his aesthetic taste and exacting horticultural standards. The extensive gardens were largely dormant, but the weeping willows were still lovely, and the careful placement of plants and architectural features around the water elements was more apparent without the luxuriant foliage of summer. One thing that looked distinctly unlovely, however, was the big shed in the northwest corner of the property.

Monet had decided he needed an unusually spacious studio for a

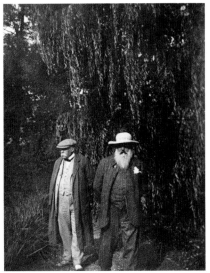

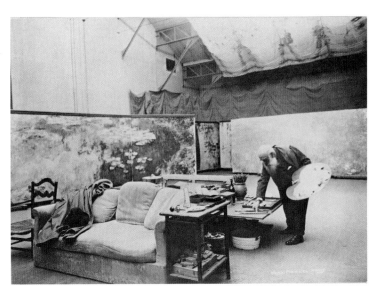

Georges Clemenceau and Claude Monet at Giverny, 1921.

Henri Manuel, Claude Monet in his studio at Giverny, c. 1917.

new series of paintings depicting his gardens that he started during the war. His previous works had been done for the most part on a standard, domestic scale, but now he was going much bigger. Some of his canvases were almost twenty feet long – partly because his failing eyesight made it difficult for him to paint in small detail, but even more because he had a grand vision in mind. These outsized canvases were a challenge to move and Monet had received offers of help to put them in safe storage during the war, but he declined. Earlier in his life, in 1870, he had gone abroad to wait out the Franco-Prussian War; this time he decided to stay put in Giverny and continue working, even while the fighting raged very near his home. "If the savages come," he declared, "they will take me here among my gardens and my paintings."[2]

Although Monet had been working on these paintings for several years when Clemenceau visited the shed, some of them were obviously still unfinished. The prime minister walked from canvas to canvas in silence, studying each one intently. Parts of them seemed weighted and brooding, while other areas were luminous and reflective. The lighting effects ranged from the clarity of sunrise to the gloom of dusk. But the overarching impression was of tranquil peace. Man and his works were banished, as light and shadow, land and water blended into each other. A lifetime of observing and analyzing nature was in evidence.

2 Monet letter to Clemenceau, September 1, 1914, in *Monet by Himself,* ed. Richard Kendall (Little, Brown, 1990), 252.

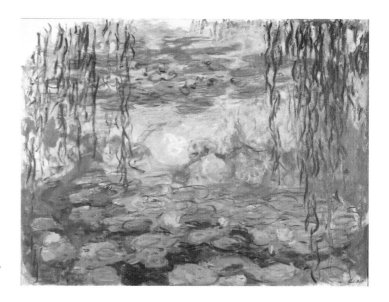

Claude Monet, *Water Lilies*,
1916–19.

Finally, Clemenceau gave his assessment: "I see what you are doing. It is nothing less than the natural cycle as plants are born, thrive with the aid of the sun, which also burns them, and then wither and die, only to be born again."[3]

"As always, you understand," Monet said with relief. All his career, he had resented the judgment that his paintings were mere studies of different optical effects on landscapes. Very few people had been able to grasp the significance of his subjects or appreciate the agonizing labor it had taken to capture them. "I am not sure it is right yet," Monet continued. "I have so many paintings under way but I can't seem to get any of them finished. The weather changes constantly, causing me heartbreak. I don't know if they will ever satisfy me."[4]

"Whatever you do, don't lose courage; you are almost there," Clemenceau said quickly. He knew that Monet had destroyed a number of canvases when he despaired of them. "You are creating a veritable oasis of calm and meditation for a nation that badly needs a refuge."

They walked back to the main house, where by tradition lunch began promptly at 11:30. Monet rose very early in the morning, so this was the main meal of the day. He loved hearty food, and they would have enjoyed local gamecock and champagne in a dining room with chairs and walls painted a glowing yellow, adorned with colorful Japanese prints. Even the dessert was brightly colored – a green pistachio cake called *vert-vert*, which was the artist's favorite.

3 Georges Clemenceau, *Claude Monet: Les Nymphéas* (Plon, 1928), 133.

4 Monet letter to Gaston Bernheim-Jeune, August 3, 1918, in *Monet by Himself*, 251.

When he left Giverny that day, Clemenceau had not selected the "one or two" canvases that Monet had mentioned in his letter, because he had no intention of choosing. Never one to think small, he was already convinced that the whole enormous cycle by the greatest living French painter was the proper tribute to the battered but triumphant Third Republic. The poet André Masson would declare the resulting installation at the Orangerie in Paris the Sistine Chapel of Impressionism.

June 28, 1868

The dining room in Monet's house at Giverny.

It was all too much to bear. Six months shy of his twenty-eighth birthday, Claude Monet walked to the banks of the Seine and jumped into the river with the aim of drowning himself. Although he had met some success as an artist, his troubles just kept piling up.

During his childhood in the seaside town of Le Havre in Normandy, he had spent as much time as possible walking on the cliffs and beaches, studying the effects of sunlight on water and drawing the sailboats. He avoided school whenever he could, and when forced to go he would draw insulting caricatures of his teachers. His parents never approved of his determination to be an artist, and kept trying to get him to focus on the family's prosperous grocery business. After his mother died when Claude was sixteen, he finally escaped the "prison" of formal education and went to live with a wealthy and childless aunt who encouraged him to study art in Paris.

Monet's aunt envisioned a traditional training that followed rules established in the Académie des Beaux-Arts (formerly the Académie Royale, where generations of artists including Jacques-Louis David had studied before the revolution) and focused on the annual Salon de Paris, an exhibition of paintings selected as worthy by the academicians. In the 1860s, the jurors for the Salon were trying mightily to resist the radical innovations of new painters such as Édouard Manet and Gustave Courbet by refusing to exhibit their works. When the jurors turned down two-thirds of the paintings submitted for the 1863 Salon, Napoleon III called for the rejected works to be displayed in a second exhibition, which was called the Salon des Refusés.

The painting that drew the most attention at this Salon was Manet's *Déjeuner sur l'herbe* (The Luncheon on the Grass). The artist took aim at the mythological paintings by Titian and Poussin in which female nudes were presented as idealized goddesses or muses, and instead he portrayed

a well-known contemporary woman, the model Victorine Meurant, casually dining alfresco without clothes and with two men who happened to be the artist's brother and brother-in-law. It caused such an uproar among the critics and the public alike that a Salon des Refusés was not attempted again, although an interest in exhibiting new painters outside the traditional parameters had taken root.

Édouard Manet, *Luncheon on the Grass*, 1863.

In response to the derision heaped upon it, the influential critic and novelist Émile Zola wrote an impassioned defense of Manet's painting. He pointed out the hypocrisy of those who claimed to be shocked by Victorine's nudity but did not object to the many traditional depictions of nudes on display in the permanent collections at the Louvre:

> This nude woman has scandalized the public, who see only her in the canvas. My God! What indecency: a woman without the slightest covering between two clothed men! That has never been seen. And this belief is a gross error, for in the Louvre there are more than fifty paintings in which are found mixes of persons clothed and nude. But no one goes to the Louvre to be scandalized. The crowd has kept itself moreover from judging *The Luncheon on the Grass* like a veritable work of art should be judged; they see in it only some people who are having a picnic, finishing bathing, and they believed that the artist had placed an obscene intent in the disposition of the subject, while the artist had simply sought to obtain vibrant oppositions and a straightforward audience.[5]

5 Émile Zola on Édouard Manet's *Le Déjeuner sur l'herbe*, posted at *The Imagist*, http://www.theimagist.com/node/4391.

Zola's pen was powerful and may have garnered more attention for Manet's work than inclusion in the Salon de Paris could have won. The balance was shifting in the art world, so that eventually there would be a significant number of artists who preferred to work outside the constraints of the Académie and rely on the popular press for publicity. It was to this group that the young Monet gravitated – especially since the academicians rejected many of his early works as well.

One such painting shows four young, fashionably dressed women in a garden, with such naturalistic lighting effects that the scene seems to be captured from life. Monet claimed he had painted it outside, employing a system of ropes and pulleys that raised and lowered the canvas, which was more than eight feet tall, in and out of a trench he had dug in the ground.[6] He was certainly an advocate of painting *en plein air*, a practice that enabled an artist to record his impressions of nature directly onto his canvas.[7] But in this case Monet's paintbrush could not have been simply a conduit through which his subject passed from his eye to the canvas, for it turns out that this scene could not have happened outside Monet's imagination. Three of the women in *Femmes au jardin* (Women in the Garden) are painted after the same model, Camille Doncieux.

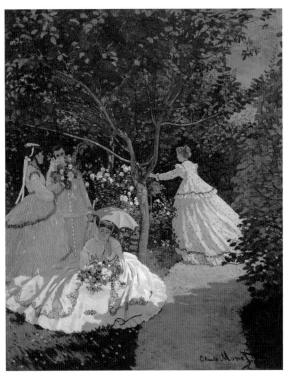

Claude Monet, *Women in the Garden*, 1866–67.

Femmes au jardin is in fact a highly artful invention portraying Camille in different costumes and moods. Zola wrote favorably about the painting, and Monet's close friend Frédéric Bazille bought it for a large sum (as a way of giving the perennially impoverished painter some financial assistance), but the official Salon rejected it.

Compounding this disappointment, Monet's parents reacted in horror when they learned that Camille was his mistress as well as his muse. He pretended for a period to give her up and hid the fact that she had given birth to his son in August 1867, not long after *Femmes au jardin* was completed. When his family discovered the existence of his child and his ongoing relationship with Camille the following spring, they disowned him. Even his aunt withdrew her support and kicked him out of her house. He had no money to pay for a hotel. In a fit of self-pity, he went to the riverbank and hurled himself in. Fortunately, reason and the

6 Paul Hayes Tucker, *Monet: Art and Life* (Yale, 1995), 31.

7 *Plein air* painting had been facilitated by the invention of the portable paint tube in 1841, which also freed painters from the necessity of grinding pigments and mixing them with oil by hand.

instinct of self-preservation kicked in, and, as he wrote the next day to Bazille, "no harm was done."[8]

35 boulevard des Capucines: April 15, 1874

The former studio of the photographer Nadar was located in one of the new sections of Paris that were built for Napoleon III under the supervision of Baron Georges-Eugène Haussmann.[9] Elegant, wide boulevards cut through the tangled medieval fabric of the city, creating modern Paris but demolishing a great deal of the past in the process. The studio at 35 boulevard des Capucines was a world away from the venerable halls of the Louvre, where the Salon de Paris took place.

François-Joseph Heim, *Charles X Presenting the Prizes at the 1824 Salon*, 1827.

8 Monet letter to Frédéric Bazille, June 9, 1869, in *Monet by Himself*, 26.

9 Born Gaspard-Félix Tournachon in 1820, Nadar was originally a cartoonist who became a pioneering photographer, specializing in artificial lighting effects and the so-called "serial photographs" that suggested motion when viewed in rapid sequence. Like the painters he befriended, Nadar was on the cutting edge of culture in Paris in the 1870s.

A group of young artists – including Monet, Edgar Degas and Pierre-Auguste Renoir among others – were fed up with the established academy system and its hostility to their work. Even when one of their paintings was accepted, it would be crammed into one of the galleries at the Louvre in a position where it could hardly be seen. According to academic tradition, historical and religious subjects were given pride of place at eye level, while the landscapes and contemporary scenes favored by a new generation of artists were put high above them, out of direct view.

Monet and his friends decided to take matters into their own hands. They formed a group called the Société Anonyme des Artistes, Peintres, Sculpteurs, Graveurs, etc., and designed their own exhibition in Nadar's

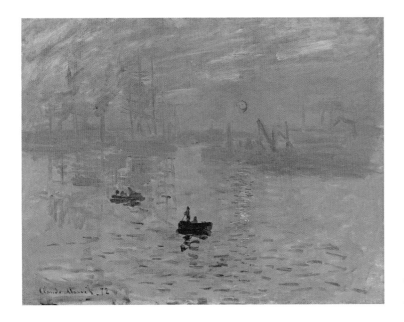

Claude Monet, *Impression, Sunrise*, 1872.

studio, placing their works at the prime viewing height and leaving open wall space around them. (Degas recommended no less than thirty centimeters between paintings.)[10]

Among the 165 paintings shown at the Société Anonyme's exhibition in 1874, one canvas was singled out as representative of the whole. It was a picture that Monet had painted in his native Le Havre, choosing the scene of boats on the water that had fascinated him as a boy. The artist captured the moment of dawn when the sun first comes over the horizon in a fiery ball of orange and illuminates the harbor. As the son of a grocer and ship chandler who got up early to bring supplies to the maritime crews, Monet would have been familiar with this time of day, and he knew the harbor would already be busy. But rather than focus on details of the vessels and the water's surface, as traditional seascapes did, he tried to convey the atmospheric effects of this moment, in which the early light penetrates the haze of mist and smoke and reflects off the water. His use of rough, clearly visible brushstrokes imparted the sketch-like quality of recording a scene directly from life.[11] Monet realized that he could not accurately call his painting a "view of Le Havre," so instead he called it *Impression, soleil levant*, or "Impression, Sunrise."

The artistic establishment of Paris was outraged. Important paintings were supposed to depict weighty subjects, not random, fleeting moments. One critic, Louis Leroy, described a visit to the exhibition in

10 Martha Ward, "Impressionist Installations and Private Exhibitions," *Art Bulletin* 73:4 (December 1991), 600.

11 This technique showed the influence of Joseph Mallord William Turner's landscapes, which Monet had studied while he was waiting out the Franco-Prussian War in London. There he befriended the American painter James McNeil Whistler, who was also influenced by Turner.

the company of an academic painter who was wholly unprepared for what he saw: "The rash man had come without suspecting anything; he thought he would see the kind of painting one sees everywhere, good and bad, rather bad than good, but not hostile to good manners, devotion to form, and respect for the masters."[12] By the time they arrived at *Impression, Sunrise*, Leroy's painter friend was agitated with dismay. "*Impression* – I was certain of it," he muttered. "I was just telling myself that, since I was impressed, there had to be some impression in it ... and what freedom, what ease of workmanship! Wallpaper in its embryonic state is more finished than that seascape!"[13] Leroy titled his review "The Exhibition of the Impressionists," seizing on the title of Monet's painting with the intent of dismissing them all as less artistically accomplished than mass-produced wallpaper.

Monet and his friends came to regard the complete discomfiture of traditional critics and artists as a badge of honor. They had not yet chosen a name for the new style they were experimenting with, but most of them eventually embraced what was supposed to be insulting. Their third exhibition, held in 1877, was advertised as a show of "Impressionists."

Galerie Durand-Ruel, Paris: May 1895

Recent developments in the art world had caught the interest of Georges Clemenceau, a well-known doctor and politician in Paris. He met a number of artists in the Impressionist movement at the Café Guerbois in the Montmartre district, where they often gathered. Édouard Manet painted Clemenceau's portrait in 1879, and Auguste Rodin sculpted him in both clay and bronze. Clemenceau became increasingly close to Monet, and he was an early visitor to an exhibition of the painter's works that opened in May 1895 at the Paris gallery of the dealer Paul Durand-Ruel. The politician expected to be favorably impressed, but he was not prepared for the overwhelming effect of Monet's Rouen Cathedral series, which he described as "nothing short of an artistic revolution" and a "profound celebration of France."[14]

Clemenceau was almost the same age as Monet, and both were raised in northwestern France, but they had followed very different paths. The son of an atheist radical, Clemenceau was attracted to politics even while studying medicine in Paris in the 1860s. He became profoundly devoted to the French Republic, trying to serve it any way he could, and he viewed French art through a patriotic lens.

12 Louis Leroy, "L'exposition des impressionistes," *Le Charivari*, April 25, 1874, translated in Linda Nochlin, *Impressionism and Post-Impressionism, 1874–1904: Sources and Documents* (Prentice-Hall, 1979), 10.

13 Leroy, "L'exposition des impressionistes," as translated in Nochlin, 13.

14 Georges Clemenceau, "Révolution de Cathédrales," *La Justice*, May 20, 1895, 1, http://gallica.bnf.fr/ark:/12148/bpt6k823773n.

The establishment of a stable republican government in France after the revolution of 1789 was anything but straightforward. There was Napoleon's imperial reign, followed by a restored monarchy with constitutional limits, then a popular uprising in 1830 that installed a former member of the Jacobin Club as a "Citizen King," then an insurrection against his increasingly autocratic rule in the great revolutionary year of 1848, which ushered in the Second Republic. But this government proved even less durable than the first French attempt at democracy, ending in 1852 when its president, Louis Napoleon Bonaparte, made himself Emperor Napoleon III.

Clemenceau viewed this development with horror, and along with his father he worked resolutely to discredit the imperial regime. In 1861 he started a political journal with some friends and was soon arrested after calling for a commemoration of the 1848 Revolution on its anniversary. He landed in the new Mazas prison, where he was held for more than seventy days in one of the notorious isolation cells. Upon his release, he resumed his political publishing activity and again drew official censorship, so he left the country after completing his medical studies in 1865.

His destination was the United States, which was then in the final throes of the Civil War. President Lincoln had been assassinated earlier that year, and the last surrender of Confederate forces was not far away. As Reconstruction began, Clemenceau saw rampant corruption and violence; he personally witnessed the lynching of former slaves in Florida. Still, he remained confident that the American experiment in democracy would right itself through "an indescribable faculty for adaptation to circumstances, for accepting the lessons of experience, for rapidly changing direction." In the United States, he predicted, "Mistakes will certainly be made, but means will always be found for rectifying them. There will be long flounderings in the void of incomplete, tentative solutions, but these people will always end by seeing where justice and truth lie."[15]

While he was in America, Clemenceau taught horseback riding and French to young ladies at a Connecticut finishing school. One of his students was Mary Plummer, whom he married in 1869. He returned with her to France that year.

Clemenceau was just in time to see Napoleon III be manipulated by Otto von Bismarck into declaring war on Prussia. The ensuing Franco-Prussian War was a humiliating disaster for France, with Napoleon taken prisoner in September 1870 and Paris capitulating the following year. France then inaugurated the Third Republic, originally intended to be a transitional government during the crisis of war.

Édouard Manet, *Georges Clemenceau*, 1879.

15 *Le Temps*, as quoted in J. Hampden Jackson, *Clemenceau and the Third Republic* (Collier Books, 1962), 20–21.

In the months when Paris was under threat both from the Prussians and from endemic political instability, Clemenceau assumed his first official government role as mayor of Montmartre. As such, he was involved with an attempt to establish Paris as an independent democracy, called the Paris Commune. This effort was bloodily suppressed by the French army in May 1871, but not before Clemenceau barely escaped violent death at the hands of an angry mob. As the Third Republic took on a more settled form, Clemenceau was elected to the Chamber of Deputies, France's reorganized legislature, in 1876. He would remain a deputy until his unwillingness to compromise and his abrasive bluntness cost him his seat in 1893.

Now separated from his American wife and out of politics, Clemenceau poured his energy into journalism. He had founded a newspaper called *La Justice* in 1880, for which he at first functioned exclusively as publisher, but now he began writing daily articles on topics ranging from capital punishment and the plight of the poor, to cultural subjects including contemporary painting. Naturally he was eager to review an exhibition of new works by his friend Monet in 1895, at the Galerie Durand-Ruel in Paris.

Around this time, the traditional arrangement of an artist working directly for a patron was giving way to independent creation by artists, who then relied on a third party to market their works to collectors. Thus was born the concept of the dealer who facilitated the sale and vouched for the value of the object in question. Indeed, Paul Durand-Ruel had carefully fostered media anticipation of Monet's latest project.

The dealer had first met Monet along with his fellow painter Camille Pissarro when they were all staying in London during the Franco-Prussian War, and he quickly became a champion of the emerging style that would become known as Impressionism. In 1876, Durand-Ruel organized their second group exhibition in Paris at his own gallery, which was consequently nicknamed the "insane asylum." He also offered groundbreaking single-artist shows, publicized widely in the popular press and promoted to wealthy potential patrons in the financial industry. Durand-Ruel went on to purchase some 1,500 canvases by Renoir, 400 by Degas, and more than 1,000 by Monet, to sell in his galleries in New York, London and Brussels. Eventually he would make a considerable profit dealing in Impressionist art, but for many years it was an uncertain proposition. Had he died in the 1880s, Durand-Ruel later remarked, he would have been "insolvent amongst undiscovered treasures."[16]

The exhibitions showcasing Monet at the Galerie Durand-Ruel

16 "Durand-Ruel et Cie," 2006, http://www.durand-ruel.fr/english/historique.html.

were doubly unusual in that they featured not only a single artist but also a very limited number of subjects. His early triple study of Camille (*Femmes au jardin*) was only the beginning of Monet's fascination for painting the same thing over and over again from multiple angles, at different times of day, and in various atmospheric conditions. His aim was to convey how the eye can continually see familiar subjects anew. He could have as many as a dozen canvases in progress at the same time and switch between them as the light – or his mood – shifted.

Discussion of these pictures focused mostly on optical effects. The painter Paul Cézanne, for example, famously called Monet "only an eye, but my God what an eye!" Cézanne admired Monet, but this was backhanded praise, since he was characterizing the older artist as a neutral instrument through which visual impressions were transmitted onto canvas. This type of assessment almost completely missed – or ignored – how Monet's carefully selected subjects revealed the natural bounty and beauty of France and the resourcefulness of its people.

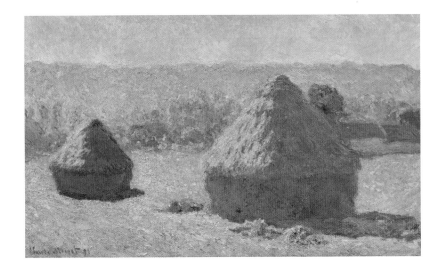

Claude Monet, *Grain Stacks, End of Summer, Morning*, 1891.

Early in the 1890s, for example, Monet produced a series of paintings that depict grain stacks in the fields near his home. These were not simple piles of organic matter, but ingenious architectonic structures that kept the harvest safe and dry through the winter. From the grain stacks he proceeded to a series featuring the poplar trees along the river Epte. Poplars were a ubiquitous sight in the French countryside. Many thousands had been planted in the wake of the French Revolution, when the

Claude Monet, *Poplars on the Epte*, 1891.

Rouen Cathedral.

17 Monet letter to Paul Durand-Ruel, March 9, 1892, in Paul Hayes Tucker, *Monet in the '90s: The Series Paintings* (Yale, 1989), 167.

tree was regarded as an emblem of liberty because its name derives from the Latin word *populus*, "the people." A fast-growing tree, it provided both a wind barrier for cultivated fields and a ready supply of lumber. When a line of poplars was going to be auctioned off while he was still painting them, Monet arranged to purchase them jointly with a lumber merchant on the condition that they wouldn't be harvested before he finished. The geometric grain stacks and the parallel poplars both have an abstract visual appeal, but these subjects were also important natural symbols of the country Monet loved.

Monet's next series focused on the manmade rather than the organic, but Rouen Cathedral too was profoundly French. Although architecture in the classical style had superseded the ornate Gothic style of the Middle Ages, the soaring vaults and towers of medieval cathedrals were still a defining feature of northern France. They had been a target for antimonarchist fury during the revolution, when the Catholic Church was outlawed; Chartres Cathedral escaped demolition only because the authorities realized that clearing away all the rubble would be more trouble than it was worth. But in Monet's time, there was a renewed appreciation for the achievements of medieval architecture as a manifestation of French creative excellence.

The great Gothic cathedrals generally took decades or even centuries to complete, but even in this context the cathedral of Rouen had an unusually long building period. It was under almost continuous construction from the twelfth century until 1876, when a modern cast-iron central tower was completed to replace a spire that had been destroyed by fire. Scholarly appraisal of the cathedral was mixed. On the one hand, the signatures of so many generations of architects and craftsmen made it one of the least pure in architectural terms; but on the other, they made Rouen Cathedral the most organically French, reflecting century upon century of the nation's history.

Monet had become consumed with exploring the lacelike interlocking masonry forms of the cathedral's exterior and studying how its various features appeared to recede or project according to the time of day or the weather. Recording this complex subject on canvas required intense observation and meticulous attention to detail, along with a talent for drawing. Far from being a simple transmission of what he saw into paint, Monet's effort to portray the ever-changing aspect of Rouen Cathedral was a titanic struggle. "What I have tackled," he wrote to Durand-Ruel in March 1892, "is enormously difficult but at the same time of really great interest. Unfortunately, the weather is deteriorating"[17]

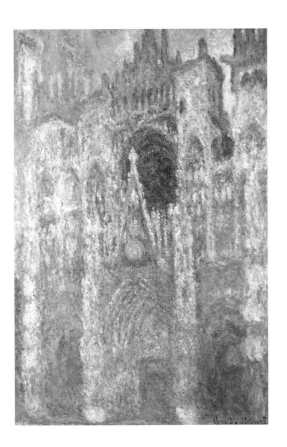
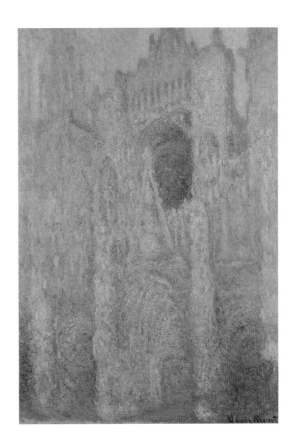
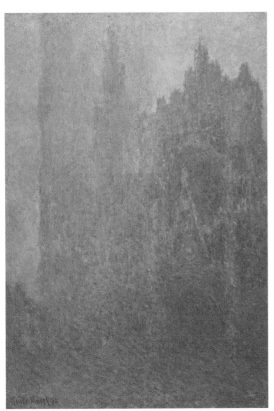
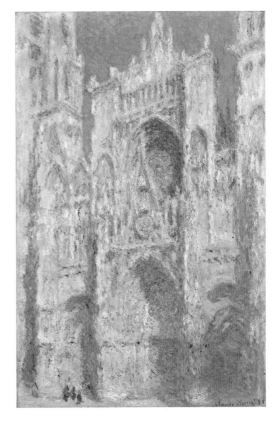

Claude Monet, four examples of *Rouen Cathedral*, c. 1893.

To Durand-Ruel's dismay, Monet did not work quickly; he spent months laboring over his canvases. The exhibition of the Rouen Cathedral series had to be postponed until 1895, when the artist finally believed he had something worth displaying. Twenty images of the cathedral were the centerpiece of a show that opened at the Galerie Durand-Ruel on May 10, and they attracted the most attention, although not all of it was favorable. Some critics believed that Monet's very personal interpretation of the monument, with his heavy application of paint in loose brush-strokes, did not treat it with proper respect as a representation of France.

Clemenceau had the opposite reaction. He grasped that Monet had not broken the tradition linking French painters with French national-ism, but rather had brought it into the modern age by fusing a historical subject with a new technique, thus revitalizing the tradition. "It is a rev-olution of the cathedral," he declared. "By bringing together passion and science, you have taken your place in the long history of landscape stretching back to Poussin and even the ancient Greek painters. You have taken that old pile of stones in Rouen and made them live again; you have made them eternal!"

Standing back to take in the twenty cathedral canvases together, Clemenceau had an idea: "If Félix Faure has an ounce of sense he will buy all of these. He has to understand he isn't just one man anymore – he's the president of the republic, and these paintings, which are a more profound celebration of France than I have seen in years, should be in the care of the nation."[18]

January 13, 1898

Émile Zola was not only influential as an art critic, he was also widely acclaimed as France's preeminent writer of fiction, renowned for his nat-uralistic portrayal of contemporary life in Paris. Not shying away from the harsh realities of French society during the Third Republic, he addressed such unsavory subjects as prostitution, alcoholism and labor unrest. He generally did so in his novels, particularly in the massive Rougon-Macquart cycle, which ran to more than twenty books. But in 1898, a real-life scandal that had dominated the headlines a few years earlier re-emerged and riveted his attention.

An espionage ring was uncovered in 1894, and a young army officer was accused of selling military secrets to the Germans, including new weapon designs. A handwritten document seemed to be a clear indica-

18 Faure did not take Clemenceau's advice. Clemenceau, "Révolution de Cathédrales."

tion of the officer's guilt, and a closed court-martial in December 1894 quickly resolved the case. The following January – a few months before Monet's exhibition opened at the Galerie Durand-Ruel – the culprit was submitted to a formal expulsion from the French army, in which his medals and rank were torn off and his sword broken. He was then paraded in front of the assembled officers to be mocked and even spat on.

Amid the taunts and jeers, the word "traitor" could frequently be heard, as could the word "Jew." The convicted man, Alfred Dreyfus, was viewed as doubly perfidious, and it was not clear which label carried the most opprobrium. Dreyfus was shipped off to Devil's Island, the notorious penal colony that had been established by Napoleon III off the coast of French Guiana, where the mortality rate was so high that the prison was known as the "dry guillotine."

With only his family protesting his innocence, that might have been the end of Dreyfus, but the lack of reliable evidence against him remained troubling to some observers, as did the growing impression that he had been scapegoated because he was a Jew. Eventually it was revealed that Dreyfus could not have had opportunity to deal with the Germans. Another candidate emerged whose handwriting turned out to be a closer match to the incriminating document than Dreyfus's script. A case that had once seemed so open-and-shut now began to look like a set-up.

And so the "Dreyfus affair" was back in the headlines in *fin de siècle* Paris, dividing French society between traditionalists who believed the whole thing was a plot to undermine military culture, and progressives who saw it as a shameful manifestation of anti-Semitism masked by the intense anti-German sentiment that was still prevalent in the decades after the Franco-Prussian War. Clemenceau and his friends, including Zola, were among the most vociferous critics of the military and the administration of President Félix Faure, which had overseen the trial.

"*J'ACCUSE*" screamed the headline of Clemenceau's new paper, *L'Aurore*, on January 13, 1898. Zola had written a public letter to President Faure detailing the abuses of justice in the Dreyfus affair and warning the president that the scandal threatened to engulf his administration. Zola acknowledged that his action was in violation of the law – that he could be accused of libel – but he willingly accepted the risk. "My fiery protest is the cry of my very soul," he wrote. He could not remain silent.[19]

The government moved quickly against Zola. He was convicted of libel and fled to England. But he had brilliantly distilled all the concerns and misgivings over the Dreyfus affair into one resonant phrase: *J'accuse*. It had an effect, and the case began to fall apart piece by piece. Dreyfus

Henri Meyer, *The Degradation of Alfred Dreyfus*, 1895.

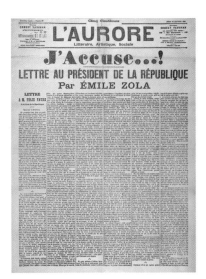

L'Aurore, January 13, 1898.

19 Émile Zola, "I Accuse!" Letter to the President of the Republic, January 13, 1898, http://www.marxists.org/archive/zola/1898/jaccuse.htm.

was brought back to France in 1899 for another trial, in which he was convicted "with extenuating circumstances," but soon pardoned. With the emergence of new evidence, he was exonerated altogether in 1906.

The drawn-out affair was deeply divisive and disruptive, not only in politics but in the art world as well. Some artists, including Renoir and Degas, sided with the traditionalists. The normally apolitical Monet, on the other hand, firmly agreed with Clemenceau and Zola that Dreyfus was innocent, and he signed a petition of protest in *L'Aurore* the week after Zola's letter appeared. For him, the entire wretched business undermined the profound nationalism that inspired much of his recent work, and he looked around for new subjects. He also started to avoid Paris. Monet went to London three times beginning in autumn 1899 to paint the famous fog; later he traveled to Spain and to Italy. But most importantly, he poured attention into his idyllic home and garden outside the capital.

Giverny

The small town on the rail line that ran northwest of Paris was not a particularly fashionable spot, but Monet fell in love with the place. He first rented a simple rectangular farmhouse with a pleasant garden on a couple of acres there in 1883, and then began turning the property into a horticultural paradise together with the woman who would become his second wife.

His first wife, Camille, had died in 1879 from a wasting sickness (probably uterine cancer), made all the more cruel by the knowledge that her replacement was already established in her own house more than a year before she passed away. Alice Hoschedé was then the wife of a former patron of Monet's who had gone bankrupt and fled abroad to escape his debts. Monet took in his abandoned family, and his relationship with Alice became something of a scandal. The couple finally married in 1892 after Alice's husband died.

By that time, the great popularity of Monet's paintings in the United States had given them the financial means to buy the Giverny property, to which they soon added a second plot across the train tracks. Monet personally designed architectural features in the garden and selected rare plant specimens. Eventually he would employ six full-time gardeners to carry out his detailed instructions on tasks such as planting peonies and training clematis. His plants were carefully placed for both aesthetic

Monet's house and upper garden, spring.

Water lily pond with Japanese footbridge in Monet's garden, Giverny.

and horticultural reasons, but then mostly allowed to grow naturally.

Monet's garden was a novel combination of traditional French design with ideas from the Far East. The artist never traveled to Japan, but he was an avid collector of the Japanese prints that were pouring onto the European market after that country opened up to the West in the 1850s. These images presented a different way of looking at the natural world, which Monet integrated into the design for his own garden. Visitors would come through the house and out into a Western-style formal garden with regular beds organized on a grid. They would proceed down the central *grande allée* through a series of vine-covered arches and then cross the train tracks to a garden that was distinctly Japanese in character. Dominated by water, the design was a play of light and reflection.

Suzuki Harunobu, *Two Women Gathering Lotus Blossoms*, 1765.

Monet had dug a pond fed by a brook that crossed the lower property, and he became increasingly interested in aquatic plants, which were something of a novelty at the time. There was a native strain of water lily with small and delicate white flowers on the Seine, and he had studied them closely for his earlier series of paintings of the river. He knew from imported woodcut prints that there were much larger and more colorful water lilies in Japan, but they would not be hardy enough to weather northern France's winters.

Another possibility was presented to him at the Exposition Universelle of 1889. The exposition was an enormous world's fair staged in

Paris to mark the centennial of the French Revolution. Its most famous – or infamous – exhibit was the Eiffel Tower, designed to show off the sophistication of French engineering and the new capacity to build cast-iron structures that dramatically altered the Parisian skyline. Monet helped to arrange a special exhibition of his own work along with that of Rodin in Paris to coincide with the Exposition Universelle, knowing that large crowds of tourists would be flocking to the city and many of them would no doubt be interested in modern art.

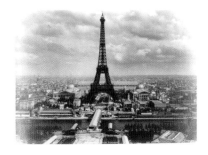

Exposition Universelle with the Eiffel Tower, 1889.

What Monet did not anticipate was discovering a remarkable and quite useful innovation by a pioneering French botanist when he visited the exposition. Joseph Bory Latour-Marliac had been working for decades to develop a hybrid water lily that would thrive in France, and his plants won a top prize. Monet started placing orders with Latour-Marliac once he finished building the pond for his water garden in 1894. His first order included lotus flowers, but apparently he had little success with them, so he focused on the water lilies.[20]

The pond in the lower garden in Giverny grew larger over the years and more crowded with lilies, surrounded lushly by other plantings such as iris, bamboo and Japanese cherry trees. Monet added an elegant curved wooden footbridge in 1895, modeling it on Japanese examples but painting it green rather than the traditional red. The water garden met with some resistance from locals who were concerned about the diversion of water from the river Epte and suspected that the exotic plants might be toxic.[21] But Monet was unfazed, and the pond with its unique fusion of East and West, natural and artful quickly became his favorite subject to paint. One of his gardeners had the job of rising at the crack of dawn to go out on the lily pond and wipe away any accumulated soot from passing trains, so the flowers would be pristine when the painter began his work.

The paintings of Monet's garden enjoyed broad critical success and were immensely popular with collectors, including some Japanese aristocrats. Once an *enfant terrible* who challenged the very foundations of art, Monet, then nearing sixty, was becoming an old master, respected and wealthy.

Meanwhile, artists from another generation were forming a new avant-garde and grabbing headlines, both good and bad. The Spanish painter Pablo Picasso outraged the art world in 1907 when he exhibited *Les Demoiselles d'Avignon*, a picture of naked prostitutes so shocking in both content and style that it made Manet's *Déjeuner sur l'herbe* appear prim by comparison.

20 Monet placed three orders with Latour-Marliac, which are still preserved in the company's archives: a large order in 1894 and two smaller ones in 1904 and 1908. From the company website at http://www.latour-marliac.com, follow links to "Histoire" and "Ce que Monet a commandé."

21 Tucker, *Monet in the '90s*, 256.

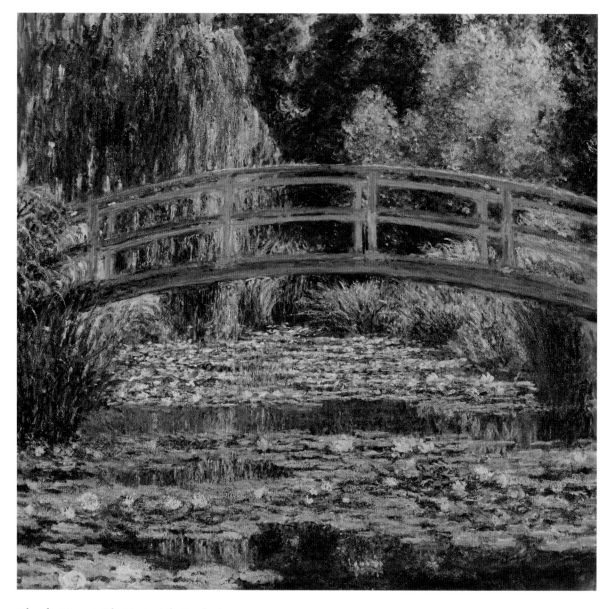

Claude Monet, *The Water Lily Pond*, 1899.

While the artistic landscape was shifting around him, Monet suf-
fered personal trials that nearly made him stop painting. His marriage to
Alice was happy, but her health declined after a trip to Venice in 1908.
She died three years later. Monet was devastated. He was entering his
seventies alone, and his eyesight was failing, which seemed the death
knell for his career as a painter. He went into a deep depression.

His friend Clemenceau pestered Monet to keep working. "Do you
remember the old Rembrandt in the Louvre, furrowed, ravaged beneath

the cloth that hides his denuded head," he wrote the artist. "He clasps himself to his palette, resolved to stand firm up to the last through terrible trials. There is the example."[22]

Clemenceau was by now rather portly and suffering from diabetes, and it may have seemed his best days were behind him as well. But the Tiger kept making his voice heard. After returning to politics as a senator in 1902, he was appointed interior minister in 1906, and prime minister later that year. He had a tumultuous tenure, spending most of his time battling labor unions, which had learned the power of the strike. Clemenceau was even more concerned, however, about the looming possibility of a major European war. "We must do nothing to provoke it, but we must be ready to wage it," he wrote in 1908.[23] His diplomatic priority was, accordingly, to bolster France's alliances. Remembering the lessons of 1870, the prime minister repeatedly warned that no matter what the German diplomats might say, their intentions were aggressively imperial and a threat to the freedoms the French had so painfully established over the preceding century.

Clemenceau couldn't resist bickering with his rivals, and the infighting undermined his own government. He resigned in July 1909, but continued to press his case for national vigilance. He traveled abroad to give lectures about the imperative to preserve democracy. Through his position on the Senate army commission, and then through a newspaper he started in 1913 called *L'Homme libre*, he urged his countrymen to build up their defenses against the menace he saw on the horizon.

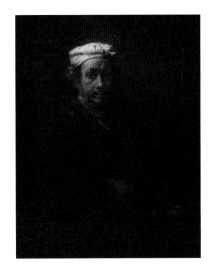

Rembrandt, *Self-Portrait of the Artist at His Easel*, 1660.

June 28, 1914

Monet was at home in Giverny on the June day when Archduke Franz Ferdinand of Austria was assassinated in Sarajevo by the "shot heard round the world." For the moment, the artist had no idea what had happened. On June 29 he wrote to Durand-Ruel that he was hard at work, getting up every morning at four and painting diligently until evening.[24] But these quiet days were numbered. The spark set off at Sarajevo rapidly ignited a world war.

France withstood the first withering German onslaught in the summer of 1914, but the months of fighting turned into years as the armies on both sides dug into their trenches. These artificial ditches gave the troops some protection from the dramatically more lethal new military technology that was developed and deployed in this war: motorized

22 Steven Z. Levine, *Monet, Narcissus, and Self-Reflection: The Modernist Myth of the Self* (University of Chicago, 1994), 277–78.

23 Jackson, *Clemenceau and the Third Republic*, 105.

24 Monet letter to Paul Durand-Ruel, June 29, 1914, in *Monet by Himself*, 247.

vehicles such as airplanes and tanks, increasingly efficient machine guns that magnified the effect of each weapon a hundredfold, and devastating chemical weapons such as chlorine and mustard gas. But the trenches were wretched places full of vermin, disease and a sickening stench. They were also inherently defensive, so it was very difficult to make any meaningful progress in trench warfare, even as casualties soared to astounding numbers.

The trains that ran through Monet's property carried soldiers and materiel to the front, and the fighting was so nearby that he could hear and even smell it. He sent much of the family's prized vegetable crops from the garden to the local hospital, where the wounded were being treated. Monet's son Michel enlisted and spent what the painter referred to as "three terrible weeks" on the front lines at Verdun in 1916.[25]

The Battle of Verdun dragged on for ten months, during which the Germans failed to "bleed the French white," in part because they were distracted by the British offensive at the Somme starting in July. The Battle of the Somme achieved prodigious slaughter on both sides but no victory, and it was finally called off as inconclusive in November. A mood of resignation set in – a sense that the best the French could hope for was a stalemate that would end the carnage.

Even after the United States entered the war in April 1917 – at least partly in response to Clemenceau's direct appeals – the situation for France was dire. But when President Raymond Poincaré asked Clemenceau to become prime minister for the second time on November 17, 1917, the Tiger did not hesitate. Ever since the war began, he had kept urging the French people to give all they could toward victory, and he would do the same. Poincaré had no personal incentive to call upon an old political rival who had been fiercely criticizing his leadership, but these were desperate times. "Now that everything seems to be lost, he alone is capable of saving everything," the president wrote of Clemenceau.[26]

The day that Clemenceau presented his credentials to become prime minister at the Chamber of Deputies he seemed a man possessed – pacing about the room like a wild animal and terrifying the assembled company, who knew they had no choice but to follow him. Clemenceau harangued them about the necessity of putting all thoughts out of their heads save for winning the war. Asked what his policy would be, he barked his manifesto: "My policy is victory!" He went on:

> Home politics? I wage war. Foreign politics? I wage war. Russia betrays us? I continue to wage war. We will fight before Paris; we

25 Monet letter to Gustave Geffroy, September 11, 1916, in *Monet by Himself*, 250.

26 Jackson, *Clemenceau and the Third Republic*, 124.

will fight behind Paris; we will fight, if necessary, to the Pyrenees. I will continue until the very last quarter of an hour, for the last quarter of an hour will be ours.[27]

The new prime minister had no patience for defeatism. Infuriated by calls for a negotiated settlement with the Germans, he had some prominent politicians, including a former prime minister, tried on charges of treason. Clemenceau's uncompromising resolve to defeat the Germans made a profound impression on a British official who was in Paris as the minister of munitions (a new position dedicated to making sure the modern firearms had sufficient ammunition). Winston Churchill, then forty-two, was fascinated by Clemenceau and occasionally accompanied him on his frequent trips to the front lines.[28]

Upon becoming prime minister, Clemenceau's top priority was preparing France to withstand an offensive in the spring of 1918, when, as was no secret, the Germans planned to end the war as victors with overwhelming force. The onslaught was brutal but the Allies held, and by June they were preparing a counteroffensive. In the end, Clemenceau's almost frenzied rallying and re-rallying of his nation paid off. The Germans, demoralized by the sudden resurgence of the Allies, lost their nerve in October 1918 and sued for peace.

The Tiger was victorious. But a large swath of France – the so-called "Zone Rouge," covering more than 450 square miles in the northeastern part of the country – would be uninhabitable for a generation, littered as it was with unexploded munitions, not to mention human and animal carcasses.

Once the armistice was declared, Clemenceau embarked on the herculean task of negotiating the final settlement between the great powers. He entered the process keenly aware that victory, as sweet as it was, could be fleeting. Determined to deny Germany an opportunity to emerge with the potential for future aggression, he devised a plan to redraw the map of Europe with a buffer state between Germany and France.

Clemenceau tried to get all his allies behind his plan, but the American president had other ideas. Woodrow Wilson came to Versailles intent not on disarming Germany, but on removing the incentive for aggression by improving the global condition through an emphasis on diplomacy and the promotion of democracy. However well intended his proposals may have been, they did little to address Clemenceau's immediate concern, which was securing France and preventing Germany from trying again to dominate Europe. As Churchill put it, Wilson's idealistic

Georges Clemenceau and Woodrow Wilson at Versailles, 1919.

27 Quoted by the Associated Press, "Simplicity Marks Last Rites for Clemenceau," *Southeast Missourian*, November 25, 1929 (search by article title on Google).

28 Churchill records that while his understanding of French was imperfect, the prime minister's message was clear. Winston S. Churchill, *Great Contemporaries*, (1932; Norton, 1991), 198.

initiatives such as the League of Nations were "a mere garnish" on the real work that Clemenceau wanted to do.[29]

Given these widely disparate priorities, it was no surprise that the resulting Treaty of Versailles championed by the American president turned out to be a disappointment for Clemenceau and for France. The prime minister had successfully argued for financial reparations from Germany, but his territorial demands had been judged too harsh and were watered down. And although Wilson signed the treaty, the United States Congress refused to ratify it and was thus unlikely to enforce its terms with any vigor.

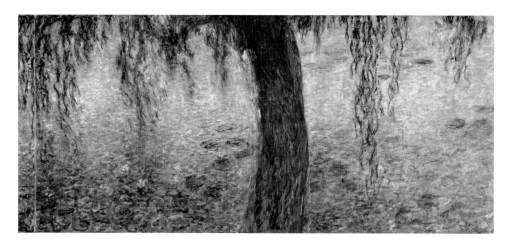

Claude Monet, *Weeping Willow* (detail from the *Grandes Décorations*).

Worried that France was still in a precarious position, Clemenceau decided to allow his name to be put forward in January 1920 for the presidency, a position elected in the Chamber of Deputies. But he declined to promote his own candidacy, and he was up against the combined forces of those who feared he would make the presidency a virtual dictatorship and those who thought he had ceded too much to the Americans and the British during the negotiations. He was voted down and immediately retired from government – this time for good.

While Clemenceau had been tenaciously leading France to military victory, Monet was immersed in a creative project that became closely tied to the national struggle. For a decade, especially since Alice's death, he had painted almost no other subject than water lilies; his fascination with the pond turned into a fixation. He painted on an unprecedented

29 Jackson, *Clemenceau and the Third Republic*, 137.

scale, on canvases that were six feet high and nearly twenty feet wide, in accordance with his monumental concept. There were dark and melancholy passages, dominated by the weeping willow that Monet had made into a new and central feature of his water-lily paintings, but other parts were light and serene.

When Clemenceau first saw these huge compositions in progress at Giverny a week after the war ended, he understood that they were not merely records of what Monet's cataract-clouded eyes perceived; they told a story of trial and regeneration. For both Clemenceau and Monet, these paintings were a monument to the nation's resolve. The artist proposed to donate two large panels to the state in honor of France's victory in the war. The Tiger had a bigger plan.

Musée de l'Orangerie, Paris

Monet's water-lily paintings were not an unqualified critical success, perhaps because his portrayal of unfettered nature was out of step with the newly fashionable style of the Cubists, who imposed a severe intellectual order on nature. Although Monet was greatly respected, even revered in the twentieth century, he had difficulty selling his late paintings. About nine months after Clemenceau was rejected for the presidency, and at the former prime minister's constant urging, Monet decided to solve the problem by expanding his offer of paintings to the nation: instead of two canvases, he would give twelve, thereby ensuring that these works became part of the national patrimony.

The terms of the bequest gave the artist the final say in how his paintings would be displayed. After rejecting several proposals, Monet accepted two oval rooms in the Orangerie, a modest building in the Tuileries Garden near the Louvre. It had seen various uses since its construction in 1852, ranging from an annex for the Musée de Luxembourg, to housing for soldiers on leave from the war. It offered sufficient internal space and flexibility of design to allow for the contiguous installation of large canvases that totaled 298.5 feet in length.

Monet signed the contract for the gift in 1922. A condition of the deal was that the state would purchase *Femmes au jardin*, with its triple portrait of Camille, for a large sum, and so this previously rejected work also joined the national collection.[30] The water-lily paintings – known both as the *Grandes Décorations* and as the *Nymphéas* cycle – were not immediately transferred to Paris. Monet had finally agreed to have cata-

30 *Femmes au jardin* is now displayed in the Musée d'Orsay.

Clemenceau and Monet on the
Japanese footbridge, 1821.

ract surgery in 1923, at Clemenceau's insistence, and the procedure
improved his vision so dramatically that he continued to work on the
canvases until his death from lung cancer on December 5, 1926.

He had left instructions that his funeral be simple, and it was; but it
was also well attended. Clemenceau ripped the black drape from the
coffin, declaring "No! No black for Monet!" and replaced it with a bril-
liant floral textile.[31] The Tiger wept bitterly as his old friend was interred
in the churchyard at Giverny.[32]

After Monet's death, Clemenceau felt increasingly isolated from his
countrymen and spent most of his time alone. He kept insisting that the
Germans remained a threat, but his warning seemed almost laughable
given the dire straits of the German economy during the 1920s and the
ineffectual government at Weimar. The French very much wanted to
forget the horrors of the recent war, and it seemed self-evident that no
one would ever risk consuming the world with such a conflict again.
Clemenceau emphatically disagreed. He toured the United States in an
unsuccessful attempt to get Americans to see that Germany had not trans-
formed into a pacifist state. At home, he was called an "old dotard" for his
efforts, even as the Third Republic drifted further into dysfunction.[33]

Once again, Clemenceau turned to writing for comfort. In 1928 he
published *Claude Monet: Les Nymphéas*, a book-length meditation on the
water-lily cycle that had opened to the public the previous year but
attracted little notice. Drawing on his personal recollections of the artist
as well as a trove of correspondence, Clemenceau tried to explain the
paintings to the public, insisting on their surpassing beauty and
excellence.

Clemenceau also meditated on the legacy of classical Athens in an
extended essay on Demosthenes, the orator who struggled to alert his
fellow citizens to the encroaching menace from Philip of Macedon
before he conquered Athens in 322 BC, ending its democracy once and
for all. For Clemenceau, the situation of Athens in Demosthenes' time
was closely analogous to the contemporary situation of France, where
the public seemed willfully oblivious to gathering dangers. "Ah, your
attention quickens?" he asked his countrymen in the essay:

> Yes, it is indeed the untiring orator [Demosthenes] whose image I
> evoke, the man who was preëminently the good soldier of the
> fatherland. He aspired to lift you to the height of his own energetic
> soul, of his own will – an inspiration that, had it been realized,
> would have placed you in the forefront of human history. Born for

31 Henry Vidal, "L'Enterrement d'un
peintre," *Le Figaro*, December 9, 1926.

32 "Clemenceau Weeps at Funeral,"
Milwaukee Sentinel, December 28,
1926 (search by article title on
Google).

33 Jackson, *Clemenceau and the Third
Republic*, 160.

great achievements, you were able merely to conceive and to attempt them – not to realize them. I want to consult the sorrowful catalogue of your grandeurs and your humiliations in order to draw therefrom the lesson they may hold for those whom the fatalities of descent have led after you into the higher paths of human idealism. May I, in the *Champs-Élysées*, awaken your remorse? Can the lives of others really teach us how to discipline our own?[34]

Like Demosthenes, Clemenceau would not be recognized as prescient until after his lifetime. He died in Paris on November 24, 1929. Per his instructions, he was interred next to his father and his grave was marked by a piece of marble he had brought back from a trip to Greece, which was carved by a contemporary sculptor with a figure of Athena. He also requested to be buried with a few of the flowers he had picked during his visits to the soldiers in the trenches and carefully saved.[35]

Both the Tiger and Monet's *Grandes Décorations* passed into a period of relative neglect in the following decades. Few visitors came to the Musée de l'Orangerie, where rain dripped in through leaky skylights that would be blocked by the unfortunate addition of a second story in 1960. The French people wanted to suppress any thought of the events that Monet's paintings commemorated. But France could not shut out history or wall off the world, and Adolf Hitler's Third Reich presented a far more existential threat to the Third Republic than Kaiser Wilhelm had. Clemenceau's prediction that another conflict would engulf Europe – and the world – proved terrifyingly correct. The third French attempt at a republic would end in this grim ordeal, and yet another effort would have to be launched when it was over. But after many years, the paintings that Monet had created in the context of the war that was supposed to end all wars would receive their due acclaim, and be properly understood as a symbol of national healing and the renewal of the French Republic.

34 Georges Clemenceau, *Demosthenes,* trans. Charles Miner Thompson (Houghton Mifflin, 1926), 3.

35 "The Cannon of the Armistice in Salute to Great Statesman," *Jefferson City Post-Tribune,* November 29, 1929, 5, http://www.newspapers.com/newspage/19716366/.

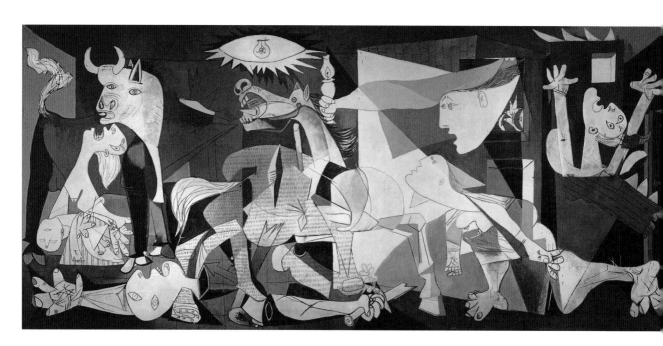

Pablo Picasso, *Guernica*, 1937.

Trial by Fire

Picasso's *Guernica* and the Threat of Fascism

> *At 2 am today when I visited the town the whole of it was a horrible sight, flaming from end to end. The reflection of the flames could be seen in the clouds of smoke above the mountains from 10 miles away. Throughout the night houses were falling until the streets became long heaps of red impenetrable debris.*
>
> GEORGE STEER, "The Tragedy of Guernica"
>
> *The Times* (London), April 27, 1937

Guernica, Biscay: April 26, 1937

It was a Monday afternoon – market day – so the streets of Guernica were crowded with people who had come into town to buy and sell. Suddenly, church bells rang out, sounding an alarm that sent people running for any shelter they could find.

Aircraft had appeared on the horizon. They were not those of the Spanish air force, then under the command of General Francisco Franco; they were the cream of Adolf Hitler's burgeoning Luftwaffe, including Heinkel fighters and Junkers bombers. For exactly three hours and fifteen minutes, the planes flew back and forth over the town, dropping thousands of tons of bombs in precise patterns. The first attack set off a stampede, as the townspeople who could not reach some kind of shelter ran out into the countryside, along with herds of sheep, only to be mowed down by gunfire from the aircraft above. Then the planes dropped heavier bombs that could penetrate the shelters.[1]

When the Luftwaffe bombers finally disappeared a little before eight in the evening, they left a ghastly scene of devastation. Some sixteen hundred people were dead and many more wounded. Throughout the night, damaged houses continued to collapse and fires raged in the street. Seventy percent of the town was in ruins, while parts that would have seemed the logical targets for an attack – including army barracks and a munitions factory outside town – were untouched.

[1] Local authorities had built air-raid shelters after Franco's forces bombed nearby Durango a few weeks earlier.

255

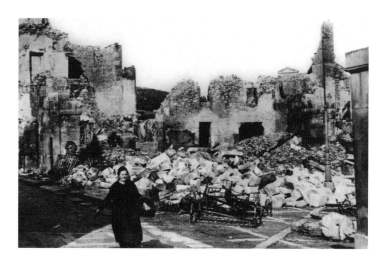

Ruins after the bombing
of Guernica, 1937.

Most of the traffic on the main road outside town consisted of ref-
ugees fleeing westward to Bilbao. One of the few cars going in the oppo-
sition direction carried journalists from the international press, including
the veteran reporter George Steer from *The Times* of London. Steer was,
in the words of Evelyn Waugh, "a very gay South African dwarf [who
was] never without a black eye." He was accustomed to gunfire, having
gotten married in the middle of a war zone while reporting on the Ital-
ian invasion of Ethiopia in 1936.[2] But even Steer was shocked by what he
saw in Guernica when his party arrived around two in the morning.

The reporter described "a horrible site, flaming from end to end.
The reflection of the flames could be seen in the clouds of smoke above
the mountains ten miles away." Steer was doubly appalled because he
judged the raid on Guernica to have been not military in nature. Instead,
it was a deliberate attack on civilians, "unparalleled in military history,"
he wrote. "The object of the bombardment was seemingly the demoral-
ization of the civil population and the destruction of the cradle of the
Basque race."[3]

By the time of the attack on Guernica, the Spanish Civil War had
been going on for about nine months, following some years of unrest. A
republic had been instituted in 1931, after Primo de Rivera's moderate
dictatorship was brought down and King Alfonso XIII permitted the
elections that sent him into exile. But the Spanish Second Republic was
highly unstable as liberal and socialist forces contended with the tradi-
tional power centers of church, aristocracy and military. The Popular
Front victory in the elections of 1936 veered the country sharply left-

2 Nicholas Rankin, *Telegram from
Guernica: The Extraordinary Life of
George Steer, War Correspondent* (Faber
& Faber, 2003), 11.

3 George Steer, "The Tragedy of
Guernica," *The Times* (London), April
27, 1937.

ward, stirring up resentment and alarm among traditionalists and resulting in a revolt by a group of army officers under General Franco's leadership.

Franco was able to unite a range of opposition groups, from monarchists to the fascist Falange, into one Nationalist front. While the Republicans (also called Loyalists) got military assistance from the Soviet Union, the Nationalists received aid from Fascist Italy and Nazi Germany – despite the nonintervention agreement that all three powers had signed along with twenty-seven other nations. Some of Hitler's advisers recommended staying out of the conflict in Spain, but the Führer sensed a double opportunity: he could attract another ally while sending the technologically advanced military force he had been developing on a practice run. He provided Franco with his elite Condor Legion of fighters and bombers, which would be accountable to the general alone. From Franco's perspective, it would be the perfect tool to bring the Basque region to heel.

The Basque people, living on both sides of the Pyrenees, had a stronger allegiance to each other than to Spain or France. One of the oldest ethnic groups in Europe, they were well established as a people when the Romans arrived in the Iberian Peninsula during the first century BC. They retained their unique language and distinct culture through five centuries of Roman occupation, through the migrations and incursions of Visigoths and Franks and Moors, and through the flux of kingdoms and lordships in the Middle Ages. When the Basque provinces south of the Pyrenees fell gradually under the sway of Castile and finally under the control of a unified Spanish crown in 1512, each king would traditionally swear an oath to respect the liberties and local laws of the Basque people. The oath was made under a particular tree in Guernica, which was also where a Basque representative assembly would meet for centuries.

The Basques in Spain were mostly left to themselves until the nineteenth century, when their customary rights were abolished in the wake of the Carlist Wars (involving a dispute over royal succession) and the monarchy tried to assimilate them fully into the Spanish nation – an effort that stirred up considerable tension. During the brief republican period of the 1930s, the Basque provinces enjoyed autonomy, and most of them supported the Loyalists in the civil war. Franco distrusted anything that deviated from the dominant Spanish national identity, however, and he viewed the Basques with special hostility, so he unleashed the Condor Legion on their historic capital.

Guernica never stood a chance.

La Coruña, Galicia: January 10, 1895

The little girl grew steadily weaker, her breathing increasingly labored. Scientists were on the verge of discovering the cause of the disease that was killing her, and soon there would be a vaccine to render diphtheria nonexistent in most industrialized nations. But that was no comfort to Conchita, who could barely inhale through her painfully swollen throat. Children were particularly susceptible to this bacterial infection, which was known as the "strangling angel."[4]

Her family prayed for a miracle, begging God to spare this bright, jolly creature who just days ago had been chasing pigeons across the sunny piazza outside their home. Her siblings, Lola and Pablo, were distraught. They did not understand what had happened to their sister.

Pablo was thirteen years old and small of stature, with piercing eyes and prominent ears under a mop of unruly black hair. He was confident, even aggressive, but he had a tender heart. It was unbearable for him to watch Conchita gasp for every breath, unable even to swallow.

The boy already considered himself an artist, and he felt a natural affinity with the divine Creator. Surely God would hear him now if he cried out loud enough? Kneeling at Conchita's bedside, he clenched his hands together and prayed: "Please God, let her live. I will do anything you want." He searched his mind desperately for something, anything that would prove how much this meant to him. "If you do, I will give up my art. I will never paint again."[5]

The moment the prayer crossed his lips, Pablo froze in fear. But he was unsure what he feared more: his sister's death or a miraculous cure, which would oblige him to fulfill an oath that now seemed a fate worse than death for him.

He did not need to make the effort. Conchita died not long afterward and Pablo's grief was compounded by an agony of guilt. He kept torturing himself over his rash vow and his fear of trying to keep his end of the bargain. He blamed God for letting his sister die, then he blamed God for allowing him to make the pledge, and finally he wondered if God even existed.

From early childhood there had never been any doubt that Pablo would be an artist. His mother proudly recalled that his first word was not "Mama" but rather *piz*, slang for *lápiz*, or pencil. His father was an art teacher and a curator in Málaga, Andalucia, before moving his family across the country so he could take a job teaching at the art institute in La Coruña, on the northwest coast of Spain. José Ruiz Blasco carefully

4 Roger W. Byard, MD, "Diphtheria: 'The strangling angel' of children," *Journal of Forensic and Legal Medicine* 20:2 (February 2013), 65–68.

5 See, e.g., Michael FitzGerald, *Picasso: The Artist's Studio* (Yale, 2001), 71.

fostered his son's precocious talent, encouraging him to draw and then to paint.

Don José had fixed ideas about how art should be taught, based on the methods of the academies that were established across Europe in the seventeenth and eighteenth centuries – including the Académie Royale in Paris, the Real Academia de Bellas Artes de San Fernando (Royal Academy of Fine Arts of Saint Ferdinand) in Madrid, and the Royal Academy of Arts in London. Pablo's father believed that young students should begin by drawing from life models, and then spend years diligently studying and copying the masters, both ancient and modern. Pablo easily excelled at these tasks. For life models, he used his younger sisters, local townsfolk, even birds on his windowsill. Don José also taught his son about Spain's proud history of artistic greatness, first from prints and books. When they visited Madrid's Museo del Prado in 1895, after Conchita's death, Pablo had the opportunity to study paintings by the Spanish masters in person.

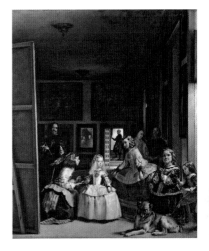

Diego Velázquez, *Las Meninas*, 1656.

At the Prado, he could see the greatest work of Diego Velázquez, court painter to King Philip IV in the seventeenth century. Known as *Las Meninas* (The Handmaidens), it was really a portrait of Philip's five-year-old daughter Margarita with her retinue. Velázquez himself, resplendent in a velvet doublet, appears on the left-hand side of the canvas in the act of painting. He is not painting the princess, who has her back to him, but her father and mother, who would be standing in the position of the viewer and can be dimly seen in a mirror on the back wall. The complex picture turns out to be not only about the royal family, but also about the courtier-artist who portrays them for posterity.

Pablo also studied the equally renowned Francisco de Goya, whose work inspired nineteenth-century masters including Édouard Manet and Claude Monet. Goya had witnessed Napoleon's invasion of Spain in 1808, which he documented first in a series of etchings titled "The Horrors of War," then in the monumental *The Third of May, 1808*, painted in 1814 after the French had been defeated.

Francisco de Goya, *The Third of May, 1808*, 1814.

On May 2, 1808, there had been a popular uprising against the French in Madrid. The following day, hundreds of Spanish civilians were rounded up and summarily executed with the intent of terrifying the populace into submission. This brutality ended up having the opposite effect, in no small part because the victims showed remarkable fortitude in the face of the calculated cruelty of the French.

Goya's painting depicts huddled targets kneeling in the blood of those who have gone before them and facing the firing squad. The little

group includes a tonsured priest clutching a rosary, as well as the great central figure, brightly lit by a lantern, who throws his arms out in a gesture of martyrdom. The machine-like French storm troopers show no mercy, but this anonymous patriot's brave moment of defiance turned into an immortal representation of all the innocents who died that night.

To Pablo, these great paintings offered not just instruction but also a challenge. As he began to exhibit and sell his own work, he grew tired of copying others. He was already meditating on how he might surpass the achievements of even Velázquez and Goya.

In September 1895, Pablo's father took a new job at La Lonja, the art academy in Barcelona, and Pablo was soon accepted there as a student. The bustling metropolis was a dramatic and welcome change from the provincial towns where he had grown up. Two years later, his father sent him to the top art school in the country, the Real Academia de San Fernando in Madrid, where he could study works of the Spanish masters at his leisure. But after only a year, Pablo felt he had exhausted what the academy could teach him, so he returned to Barcelona.

There he fell in with a new avant-garde community. On the eve of the new century, poets and journalists as well as artists all across Europe were rejecting the constraints of tradition and exploring novel ways to understand and visualize the world. Pablo Ruiz Picasso positioned himself at the center of this gathering creative storm, and in 1900 he moved to Paris, the capital of the art world.[6]

Pablo Picasso, *The Acrobat and the Young Harlequin*, 1905.

Paris: 1907

Picasso's precocious talent paid off in his new home, where he achieved some early success through his association with the powerful and visionary dealer Amboise Vollard, who also represented Vincent van Gogh, Paul Cézanne and Paul Gauguin. Vollard had an acute eye for the "Post-Impressionists" who built on the work of artists such as Renoir and Monet but went in different and highly idiosyncratic directions. Picasso's brooding, insecure images from his "Blue Period" (1901–04) sold well, as did those from the warmer and more lyrical "Rose Period" (1904–06), when he became fascinated with circus performers and began to feature them in his paintings.

In 1907, however, Picasso took a new and, to many, confounding turn when he cultivated an ever more extreme abstraction. In concert

6 Around this time he dropped his father's patronym, Ruiz, and would henceforth use only his mother's, Picasso.

Pablo Picasso, *Les Demoiselles d'Avignon*, 1907.

with his fellow artist Georges Braque, Picasso conceived an entirely new way of painting that broke subjects down into geometric shapes and then reassembled them imaginatively, in a style that came to be known as Cubism. The results were fascinating but frustrating images that teased viewers into trying to decipher the declared – but frequently undecipherable – subjects.

Picasso's seminal work from this period was *Les Demoiselles d'Avignon*, which he began during a flurry of activity in 1907 but did not exhibit until 1916. Harking back to classical French and Spanish examples, he took the female nude as his theme, but instead of featuring goddesses he portrayed five prostitutes from his favorite brothel in Barcelona (named after Avinyó Street, where it was located). The painting was most obviously a radical new approach to the traditional nude, but it could also be read as a grotesque parody of Velázquez's *Las Meninas*.[7]

The deliberately provocative subject was made even more so by Picasso's style. Instead of idealizing the women's bodies, he attacked them, thickening and flattening them and topping them with faces based

7 Picasso remained fascinated by Velázquez's masterpiece throughout his career, and in 1957 he produced a suite of fifty-eight variations on *Las Meninas*.

on the African masks he had studied in the Musée d'Ethnographie du Trocadéro, the first anthropological museum in Paris. The result was crude, overtly sexual, even primitive – and disconcerting to an audience preconditioned to find something very different in an image of female nudes with a still life, an element that Picasso carefully placed in the foreground of the image.

Before it was publicly exhibited, the picture had already proved incendiary. Georges Braque, for example, said it made him feel "as if someone was drinking gasoline and spitting fire."[8] When the painting finally made its public debut on July 16, 1916, the general response was outrage.

Exhibitions of new works were resuming in Paris after a hiatus; most artists and dealers had packed up and left the country at the outbreak of World War I, but many had since returned. (Picasso had remained in Paris, while Monet continued to paint at Giverny.) The influential novelist and art critic André Salmon organized a show titled "L'Art Moderne en France," including works by Picasso's fierce rival Henri Matisse, among others. Salmon persuaded Picasso to display his large canvas of female nudes and even convinced him to rename it "The Young Women of Avignon" rather than "The Brothel of Avignon," its original title, in an attempt to diminish the shock value.

It was a futile effort. Some viewers were reduced to tears. Matisse called the painting a "hoax" and predicted it might drive Picasso to suicide. Gertrude Stein pronounced it a "veritable cataclysm." *Les Demoiselles d'Avignon* would remain unsold in Picasso's studio for years, but it had served its purpose in declaring the painter's powerful new fusion of a traditional theme with a radically modern style.

Les Deux Magots, Paris: January 1936

The café called Les Deux Magots had become the preferred meeting place for left-leaning artists and intellectuals in Paris. With the two affable Chinese figurines (*magots*) keeping watch over its mahogany tables and banquettes covered in dark red leather, it was a congenial place to gather – and conveniently located in the bustling 6th Arrondissement, just across the plaza from the medieval abbey church of Saint-Germain-des-Prés. Every day, Jean-Paul Sartre and Simone de Beauvoir would appear at their especially reserved tables to sip absinthe and discuss radical politics.

Picasso was also a regular visitor. Perpetually rumpled, in unmatched layers of sweaters with his keys chained to his belt and his money pinned

8 Picasso biography at http://www. biography.com/people/pablo-picasso-9440021?page=3.

into his pocket, he was an intense, sometimes angry presence, a man who had defined himself through rebellion but was now grappling with the realities of middle age.

It should have been a golden period for Picasso. He was married to a beautiful ballerina, Olga Khokhlova, whom he had met while designing sets in Rome for Serge Diaghilev's Ballets Russes in 1917.[9] He had achieved financial security and was moving in elevated social circles. He was widely acknowledged as one of the greatest living painters, but he constantly worried that his success was undermining his talent. After developing the principles of Cubist abstraction for a period, he had shifted to a more representational, even classical style in the wake of World War I, though Cubist elements continued to appear in his work. Then he began to incorporate ideas from the members of the Surrealist avant-garde who attached themselves to him. Even so, he feared that he would never again know the savage creative frenzy that had produce *Les Demoiselles d'Avignon*. Meanwhile, his marriage to Olga had become strained, and it ruptured in 1935 when she learned that his young mistress was pregnant (although they remained legally married until Olga's death in 1955 because Picasso was unwilling to split his property with her as required by French law).

Sitting at Les Deux Magots with the poet Paul Éluard, the artist would have had much to discuss with him. Éluard had his own personal scandal – his wife, Gala, having left him for Salvador Dalí in 1929. They were distracted, however, by a young woman sitting alone nearby.

She was undeniably beautiful, with her pale skin and green eyes beneath elegantly arched dark eyebrows, but that was not what attracted their attention. She was fixated on her right hand, spread out on the table beside a pair of black gloves embroidered with pink roses. Over and over again she stabbed a penknife between her fingers into the heavy wood. Occasionally she missed, and blood seeped into her gloves.

"I know her," Éluard said. "That's the photographer Dora Maar. In fact, you know her too – I introduced you at the screening of Renoir's new film."[10] Fascinated, Picasso asked Éluard to introduce them again. He spoke to her in French; she responded in Spanish. She knew who he was. When they left the café, Picasso asked for her bloody gloves, and she gave them to him.

Dora Maar, born Henriette Theodora Marković to a Croatian father and a French mother, had spent much of her early life in Buenos Aires before returning to Paris to study painting. As it turned out, she found more success in photography.

9 Based in Paris, the Ballets Russes company (1909–29) brought cutting-edge music as well as innovative set and costume design to the ballet genre. Participants also included Henri Matisse, Igor Stravinsky and George Balanchine.

10 Jean Renoir, son of the Impressionist painter Pierre-Auguste Renoir, had recently completed *Le Crime de Monsieur Lange*, a socialist panegyric to a downtrodden worker who murdered his tyrannical employer.

Dora Maar, *Untitled* (boy with mismatched shoes), 1933.

Portrait of Dora Maar, 1930.

Photographic technology had come a long way in the seventy-five years since Albert Bierstadt loaded up a donkey with bulky equipment and headed to the American West. Cameras had grown smaller until they could be easily hand-held, and film now came in a convenient roll, courtesy of Kodak. Dora favored the dual-lens Rolleiflex Standard, a compact, lightweight German camera that she could carry with her through the streets of Paris. There she applied her genius for capturing intriguing scenes, such as a young boy with mismatched shoes leaning against a derelict building – perhaps just a random moment, or a more profound meditation on the passage of time. As she explored the Surrealist limits of photography, her work attracted the attention of the American artist Man Ray, who photographed her in 1936.

Some months later, Maar and Picasso encountered each other again in the South of France. They returned to Paris as a couple. Dora was then thirty years old, and unlike Picasso's previous paramours, her key attraction was not her physical desirability or a docile nature, but rather her fierce creative intelligence. Within the context of their relationship, she would struggle to maintain her own artistic identity while fulfilling her self-appointed role as Picasso's muse.

The two artists moved into separate apartments about a block apart, and Picasso, on Maar's recommendation, rented an attic studio nearby. Aside from being technically an attic, it had nothing in common with the

legendary bohemian garrets of Montmartre. Picasso's "attic studio" was the top floor of a grand building that had once been the Parisian home of the dukes of Savoy.

After the revolution, the Hôtel de Savoie had served as the setting for "Le Chef-d'œuvre inconnu" (The Unknown Masterpiece), a short story written in 1831 by Honoré de Balzac. This work of historical fiction tells the tale of a young Nicolas Poussin visiting the studio of another painter, Frans Pourbus the Younger.[11] A third artist named Frenhofer comes along, and their visit to the studio gets Poussin and his favorite model embroiled in a tragic inversion of the Pygmalion myth. Frenhofer has been working in secret for a decade on his masterpiece,

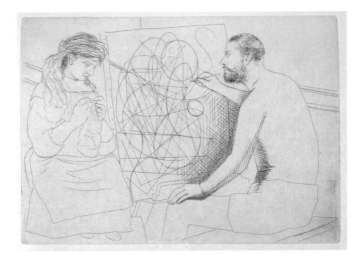

Pablo Picasso, Frenhofer at work on his "Unknown Masterpiece," 1931.

but upon realizing he has failed in his quest to capture perfect beauty he goes mad and destroys his painting before killing himself.

Picasso knew this story intimately, since his dealer, Amboise Vollard, had asked him to provide illustrations for a special centenary edition of "Le Chef-d'œuvre inconnu." The painter felt an affinity with the creative struggle described by Balzac, particularly the pursuit of a new code of beauty that others viewed as the work of madness. Here Picasso saw a parallel to his own creation of *Les Demoiselles d'Avignon*.

The attic of the Hôtel de Savoie was, as Balzac described it, an enormous room flooded with light. Picasso loved it, and he quickly packed it with an eclectic clutter of finds from the junk-heap, African artifacts, magazines, chocolate bars, ancient bronzes, half-finished canvases and

11 Pourbus had worked alongside Peter Paul Rubens at the ducal court of Mantua before being appointed court painter to the French king Henry IV and Marie de' Medici in 1609. Around the time that Pourbus died in 1621, Marie commissioned Rubens to paint the grand cycle celebrating her achievements for the Luxembourg Palace.

various dogs.[12] It made him feel, he said, as if he were on a ship with everything he needed around him.[13]

Picasso also believed the space was haunted by Balzac and by the history of the storied building, both real and imagined. "You see that?" he would ask visitors, pointing to a heavy old iron hook protruding from the ceiling. "After Ravaillac stabbed Henry IV, they brought him here – they hung him from that hook and tortured him for days and days. They thought he was a villain – a regicide. But I think he was fighting for freedom."[14]

Paris: April 28, 1937

News was beginning to travel at remarkable speeds. George Steer's account of the attack on Guernica on April 26, written the following day, did not have to be carried on ships or horse-drawn conveyances over a period of many days or weeks. Instead, it was rapidly sent to London by telegraph, then translated and splashed across the front of all the major newspapers around the world, accompanied by grim black-and-white photographs.

Picasso got the news from *L'Humanité*, the daily newspaper of the French Communist Party. The bombing of Guernica was only the most spectacular – and well-reported – of the atrocities that were becoming routine in the Spanish Civil War. Picasso's sympathies were firmly with the Republicans; he and Dora Maar were both fiercely antifascist.

A few months earlier, in January, the Spanish Republic had commissioned Picasso to paint a large mural for the Spanish pavilion at the International Exposition of Art and Technology in Modern Life. It was scheduled to open on May 27 in the area adjacent to the Eiffel Tower – the same place where Monet had visited the Universal Exposition in 1889. By the end of April, Picasso had made little progress beyond a few sketches for an image of "The Artist in His Studio," which had its roots in Velázquez's self-portrait in *Las Meninas*. But when he read the newspaper report about Guernica, his concerns about the carnage in his homeland came to the fore. He had his subject.

Picasso executed some forty-five formal studies for his representation of the bombing, each carefully labeled with its date of creation, as well as a number of preparatory drawings. His first sketch, dated May 1, shows two traditional symbols of Spain, the horse and the bull, illuminated by a woman with a lamp leaning out of a window. While many

Picasso's studio in Paris, 1944.

12 Jean Cocteau, as quoted in Russell Martin, *Picasso's War: The Destruction of Guernica, and the Masterpiece That Changed the World* (Plume, 2003), 80.

13 Brassaï, *Conversations with Picasso*, trans. Jane Marie Todd (University of Chicago, 1999), 53.

14 Kim Willsher, "Picasso's Paris Studio Where He Painted *Guernica* at Centre of Bitter Tussle," *Guardian*, August 8, 2013.

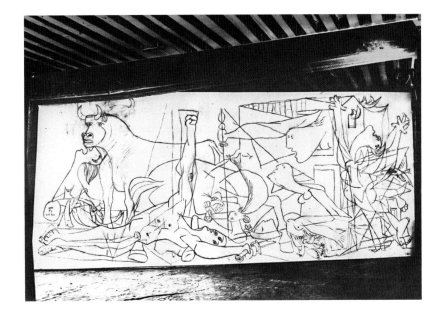

Dora Maar, Picasso's preparatory study for *Guernica*, 1937.

details would change over the coming weeks, these basic elements would remain in the final composition.

By May 11, Picasso was ready to work on the massive canvas, eleven and a half feet high and almost twenty-six feet wide. He had settled on a palette of black, white and gray – like the newspaper photos of smoking rubble and terrified refugees. But his imagery was far from documentary. He had in mind a grander theme, in which the bombing of Guernica would symbolize the larger threat of militaristic tyranny. Stung by accusations that he was secretly a Franco sympathizer, the artist declared:

> The Spanish struggle is the fight of reaction against the people, against freedom. My whole life as an artist has been nothing more than a continuous struggle against reaction and the death of art.... In the panel on which I am working and which I will call *Guernica*, and in all my recent works of art, I clearly express my abhorrence of the military caste which has sunk Spain in an ocean of pain and death.[15]

Picasso usually insisted that he eschewed symbolism, that his paintings and sculptures were what he said they were and any further meaning was in the imagination of the observer. But for *Guernica* he frankly explored the world of allegory, drawing on a series of canonical models from the

15 As quoted in Ronald Penrose, *Picasso: His Life and Work*, 3rd ed. (University of California, 1981), 315.

history of European art and transforming them into a modern icon.

The artist's sources began with the pediments of Greek temples, with their triangular compositions and mythological figures. As a young man under his father's tutelage, he had studied plaster casts of the Elgin Marbles, and now he may have been making a direct challenge to the Parthenon's east pediment, depicting the birth of Athena.[16] The idealized figures that Phidias created, including Selene's elegant horse, were generally understood to embody the perfection of Athenian classicism. Picasso employed many of the same elements, such as the interlocking female forms and the horsehead, but he turned the message upside down. The figures are broken and frantic. The horse twists and screams. Serenity is replaced with violence, beauty with distortion. This is not the birth of democracy; it is the death.

Picasso owed a greater debt to Peter Paul Rubens, who had painted his *Consequences of War* almost exactly three hundred years earlier in response to the artist's personal experiences during the Thirty Years' War. From this work, Picasso borrowed the powerful image of a mother

Peter Paul Rubens, *The Consequences of War*, 1637.

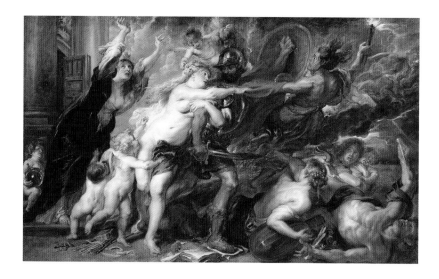

mourning over her dead child, as well as the broader theme of the senseless horrors wrought by a pan-European conflict.

The creation of *Guernica* was a work of performance art in its own right, for which the Hôtel de Savoie served as the stage set and Dora Maar as the chronicler. Normally she would have had to wait for a specific invitation to Picasso's studio, but during this project she was a con-

16 Eugene B. Cantelupe, "Picasso's *Guernica*," *Art Journal* 31:1 (Autumn 1971), 18–19.

stant presence. Day by day she photographed the master in the act of painting, or brooding over his composition, or even confronting the viewer. In this production, the painter was as much a work of art as the painting itself. Just as Picasso was engaged in creating the quintessential image of protest against oppression, so Maar was engaged in creating the quintessential image of the artist at work.

By June 4, the composition was largely complete. Joining the original horse and bull were six humans in various stages of dismay, panic and death, including a central male figure lying on his back in defeat, his sword broken. A bare lightbulb at the top represents a single, stark source of illumination, echoing the lantern in Goya's *Third of May*. While the individual elements of the composition are clearly recognizable, their proportions are fantastic and the pictorial space is flattened. Forms are fractured and abstracted in the Cubist manner, emphasizing the violence being played out across the canvas.

The International Exposition of Art and Technology had already opened when Picasso completed the *Guernica*. Two mammoth temples faced off on opposing sides of the central plaza near the Eiffel Tower, one glorifying Nazi Germany and the other Soviet Russia. The considerably smaller Spanish pavilion was late for the opening, as the beleaguered Republicans struggled to finish the work. But finish they did. "It seems almost impossible in the struggle that we are conducting, that the Spanish Republic has been able to construct this building," remarked the Spanish author Max Aub. "There is in it, as in everything of ours, something of a miracle."[17]

On June 10, Picasso accompanied his mural to the exposition grounds and oversaw its installation just inside the entrance of the pavilion. Alongside the painting was a powerful tribute written by Paul Éluard, who had been a frequent visitor to the attic studio during its production:

> *Men for whom this treasure was extolled*
> *Men for whom this treasure was spoiled*
> *Real men for whom despair*
> *Feeds the devouring fire of hope*
> *Let us open together the last bud of the future*
> *Pariahs*

Dora Maar, Picasso painting *Guernica*, 1937.

Henri Baranger, International Exposition of Art and Technology in Modern Life, Paris, 1937.

17 As quoted in Gijs van Hensbergen, *Guernica: The Biography of a Twentieth-Century Icon* (Bloomsbury USA, 2004), 71.

The Spanish Pavilion with Picasso's *Guernica*, 1937.

Death earth and the vileness of our enemies
Have the monotonous colour of our night
The day will be ours.[18]

Despite Picasso's focus on the brutal destructiveness of the attack on the Basque town, Éluard found hope in the painting. He titled his poem *La Victoire de Guernica*, confident that the forces of freedom would ultimately triumph.

Max Aub anticipated that some viewers would object to the painting's style or political message, or both, but he vigorously defended Picasso's creative vision:

It is possible that this art be accused of being too abstract or difficult for a pavilion like ours which seeks to be above all, and before everything else, popular manifestation. This is not the moment to justify

18 Translation in Van Hensbergen, *Guernica*, 80.

ourselves, but I am certain that with a little good will, everybody will perceive the rage, the desperation, and the terrible protest that this canvas signifies.... To those who protest saying that things are not thus, one must answer asking if they do not have two eyes to see the terrible reality of Spain. If the picture by Picasso has any defect it is that it is too real, too terribly real, too atrociously true.[19]

Aub also correctly predicted that *Guernica* would be "spoken of for a long time": it has sparked a great deal of comment ever since, in forms ranging from academic analysis to poetry and film.

While it was still on display in Paris, for example, the painting engendered a public spat between two prominent British art experts. One was Anthony Blunt, then serving as surveyor of the queen's pictures (and also, it would later emerge, as a spy for the Soviet Union); the other was Herbert Read, a curator at the Victoria and Albert Museum and editor of *The Burlington Magazine*, a prestigious monthly devoted to art. In a letter to *The Spectator* published on October 8, 1937, Blunt claimed to be an admirer of Picasso but harshly criticized the mural as an overly complex and self-referential muddle of "abstruse circumlocutions." According to Blunt, the artist had completely missed the significance of the Spanish Civil War. "There is something pathetic in the sight of a talented artist struggling to cope with a problem entirely outside his powers," he sniped.[20] In the next week's issue of *The Spectator*, Read retorted in defense of Picasso that the painting in fact expressed "the close cooperation and mutual understanding between the artist and the democratic government of his country." *Guernica*, he observed, had garnered "the respect and wonder which all great works of art inspire."[21]

Madrid: October 25, 1981

Picasso's masterpiece continued to be an object of considerable interest, and after the exposition in Paris it went on an extended world tour designed to draw attention to the plight of the Spanish and to raise money for refugees. The painting arrived in Great Britain on September 30, 1938 – only a few hours after Neville Chamberlain signed the Munich Agreement acknowledging Germany's annexation of the Sudetenland, the mostly German-speaking territories of Czechoslovakia. The prime minister would return home shortly thereafter, agreement in hand, and confidently announce that he had achieved "peace in our time."

19 As quoted in Van Hensbergen, *Guernica*, 71.

20 Anthony Blunt, "Picasso Unfrocked," *Spectator*, October 8, 1937.

21 Herbert Read, "Picasso Unfrocked," Letter to the Editor, *Spectator*, October 15, 1937.

Less than a year later, the United Kingdom and France declared war on Nazi Germany. Another year after that, London seemed like another Guernica under the Blitz, a sustained bombing campaign that began on September 7, 1940, and continued for fifty-seven consecutive nights, taking forty thousand lives. By the time World War II ended, the staggering death toll, along with the unprecedented horrors of the Holocaust and the shock of the first atomic weapons, made the First World War pale in comparison.

Meanwhile, Spain retreated from the headlines. General Franco decisively won the civil war in 1939 with the support of Germany and Italy. He dissolved the parliament and made himself dictator for life, a brutal reign initially characterized by the torture and execution of his political opponents. But he kept Spain out of World War II, so the Allies essentially left him alone.

Picasso remained in Paris during the war, and he never seemed to tire of taunting the German officers who would visit his studio. One of them offered him additional firewood to heat the large, drafty space. "A Spaniard is never cold," Picasso retorted. Another officer, seeing a drawing for *Guernica*, asked him, "Did you do this?" "No, you did," was the caustic response. In spite of such provocations, Picasso survived the occupation with his person and his œuvre mostly intact.

The same was not true of his relationship with Dora Maar. It had always been volatile, but for Picasso the end came naturally when his ever-wandering eye was captured by a much younger woman, an art student named Françoise Gilot. In April 1944 he bought Dora a house in the idyllic Provençal town of Ménerbes and gave her some significant drawings and paintings as parting gifts, but these were little consolation to her. She had a nervous breakdown and abandoned photography altogether, turning to painting and poetry instead. Dora lived in deep seclusion until her death in 1997 at age ninety-one – still, more than half a century after they had parted, best known as Picasso's lover.

Undeniably the most famous artist on the planet, Picasso continued to paint and draw with unflagging energy. He never returned to Spain after a visit there in 1934. Franco's baleful presence in his homeland was a perpetual source of irritation to the artist, who officially joined the Communist Party in 1944. In his ferocious opposition to fascism and his personal affinity for left-wing politics, he could not – or would not – see that Soviet communism presented just as grave a threat to the freedom he claimed to champion.

Guernica toured the globe until the constant travel was found to be

damaging the canvas. Although the painting technically belonged to the defunct Spanish Republic that had commissioned it, Picasso arranged an extended loan to the Museum of Modern Art in New York, where it was displayed from 1956 to 1981 along with some of the preparatory sketches and Dora Maar's photographs of the creative process. During this period, the painting metamorphosed from a protest against fascist oppression to a generalized symbol of antiwar dissent. Vietnam sit-ins routinely took place in its gallery, and on February 28, 1974, the painting was attacked by a protestor who wrote "KILL LIES ALL" across it with red spray paint (which was subsequently removed).

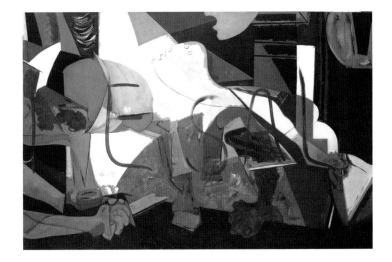

Felix Gmelin, *Kill Lies All after Pablo Picasso* (1937) *& Tony Sha-frazi* (1974), 1996. The attack on Picasso's masterpiece inspired a contemporary artist in turn to explore the theme of "revolution-ary destruction."

Franco made an effort in the late 1960s to bring the painting to Spain, but Picasso was adamant that this would not happen until Franco was no longer there and the republic was re-established. The artist made these conditions explicit in his will, so *Guernica* could not legally travel to Franco's Spain even after Picasso's death in 1973. The general died two years later, and his appointed successor, Prince Juan Carlos (the grand-son of Alfonso XIII, who had abdicated in 1931), initiated a transition to a parliamentary monarchy of which he would be the titular head. The Spanish government soon requested that *Guernica* be brought to Spain, which had been Picasso's wish once political liberties were restored. But his heirs were dubious that this condition had been met, while MoMA, for its part, was understandably resistant to relinquishing what was now generally accounted one of the greatest paintings of the twentieth century.

Eventually, all sides came to terms. With great ceremony, *Guernica* finally traveled to Madrid to be displayed at the Prado, as the artist had specified in his will.[22] The exhibit opened for public viewing on October 25, 1981, the centenary of Picasso's birth. Over a million people visited his masterpiece during the first year of its residence in Spain.

In 1982, the newly democratic Spain joined the North Atlantic Treaty Organization as part of the effort that would ultimately defeat the Soviet Union in one of the greatest victories of freedom over tyranny in history. No one knows what Pablo Picasso would have made of this development. It is true that he remained a card-carrying Communist to the end of his life. He allowed his celebrity to be exploited by the Soviets, and he accepted the "Stalin Peace Prize" in 1950 and the "International Lenin Peace Prize" in 1962. Like many other artists and intellectuals of his generation, Picasso abhorred the oppression and violence he saw close to home, and so he attached his name to an ideology that claimed to be a champion of the oppressed and a force for international peace. Communism was for him a distant ideal rather than a daily reality, and he chose to ignore the oppression and slaughter being perpetrated under its shadow.

After Soviet communism had joined Nazi fascism on the ash heap of history, however, an exhibition celebrating *Guernica* would be held in a reunified and free Berlin in 2007. Picasso might have appreciated the significance of this event – for while most of his art was not political, his finest work drew its inspiration from a fight against tyranny.

22 Although Picasso had wanted *Guernica* to share gallery space with works of Velázquez and Goya, it was actually displayed in an annex to the Prado. In 1992, due to space constraints, it was moved to the new gallery of modern art, the Reina Sofía (Queen Sofia Art Center), a short distance from the Prado. Meanwhile, Basque separatists continue to argue that the painting should by rights be displayed in the city of Guernica.

Conclusion

The Apprenticeship of Liberty

That nothing is more prodigal of wonders than the art of being free is a truth that cannot be repeated too often. But nothing is harder than the apprenticeship of liberty. This is not true of despotism. Despotism often presents itself as the remedy for all ills suffered in the past. It is the upholder of justice, the champion of the oppressed, and the founder of order. Nations are lulled to sleep by the temporary prosperity to which it gives rise, and when they awake, they are miserable. Liberty, in contrast, is usually born in stormy times. It struggles to establish itself amid civil discord, and its benefits can only be appreciated when it is old.

ALEXIS DE TOCQUEVILLE,
Democracy in America

Alexis Charles Henri Clérel de Tocqueville arrived in America already an accomplished student of human nature, and of politics. Born in 1805 to an aristocratic family in Normandy, he had the right to the title of Count, which he chose not to use. Both his parents had been jailed by Robespierre during the Terror, but thanks to his precipitous fall from power they retained both their property and their heads. The young Alexis received a thorough education that emphasized the legacy of classical antiquity, and he traveled extensively through Europe before making his journey to the United States in 1831.

The ostensible purpose of this trip was an official study of the American penal system, though Tocqueville's real interest was not in detention but in freedom. He understood the seismic effects of the American and French revolutions, and had witnessed the convulsions of postrevolutionary French politics: Napoleon's rise and fall, the Restoration monarchy, and then the July Revolution that brought the so-called "citizen king" Louis Philippe to the throne in 1830, the year before Tocqueville came to America. While the United States was consolidating its democratic institutions, France seemed far away from realizing the

revolutionary ideals of 1789. Tocqueville's goal was to find the secret to successful democracy in America.

He traveled tirelessly the length and breadth of the union, which then encompassed two dozen states. Determined to spend as much time as possible in the countryside, he journeyed to the nation's northern and western boundaries. He slept in his clothes, ate whatever was available, almost drowned in a river in Michigan, and conversed with everyone he could—from the inmates of Eastern State Penitentiary in Philadelphia to the president of the United States, Andrew Jackson. In the southern states he saw the cruelty of the slave system firsthand. It was not lost on him that a country formally dedicated to the protection of individual liberties could still brutally oppress both the indigenous people of the continent and those forcibly imported from Africa.

But despite this jarring inconsistency, Tocqueville was optimistic about what he found. In the American people he identified a deep commitment to the democratic experiment, as well as the potential to surpass the free polities of classical antiquity. He identified two basic principles that defined the American system:

> 1. The majority can err on some points, but on the whole it is always right and there is no moral power superior to it; and 2. Every individual, private person, society, township or nation, is the sole legitimate judge of its own interests, and so long as it does not damage the interests of anybody else, nobody has the right to interfere.[1]

Tocqueville returned to France in 1832 and wrote his magisterial *Democracy in America* during what he called a "grip of religious terror" over what had been achieved, and what was still to be accomplished.[2] His careful observations of the United States became a treatise on the nature and scope of democracy in the modern age. Tocqueville discerned in America some of the same factors that had propelled earlier democracies to the heights of human achievement: equality under the law, profound religious faith, the combination of an effective executive with an equally effective legislature, and strong local participation in government. His hope was that the results of these principles in the New World would inspire European patriots to implement them at home.

As princelings and potentates were tumbled from their thrones in the revolutions of 1848, it may have seemed that the moment was at hand when all men would embrace liberty. But reactionary forces were also at work, and democracy was not the default alternative to the status

1 As quoted in Hugh Brogan, *Alexis de Tocqueville: A Life* (Yale, 2007), 185.

2 Alexis de Tocqueville, *Democracy in America*, trans. Arthur Goldhammer (Library of America, 2004), 6.

quo. Tocqueville was bitterly disappointed to see Louis Napoleon, after becoming the first president of the French Second Republic, declare himself Emperor Napoleon III a few years later.

Napoleon III was still firmly in power when Tocqueville died of tuberculosis in 1859, and the vision of an unstoppable spread of democracy appeared to be in tatters. But the cycle would turn again, as the young Georges Clemenceau was about to embark on the political career that would be so instrumental in preserving the Third Republic through World War I.

As it turned out, Tocqueville was correct in seeing the birth and growth of the United States as evidence that the battle for freedom could still be won. But this achievement, being a human one, would never be perfect. The fight would never be over. The key to a viable democracy over the long term would lie in sustaining the national will to preserve it, rather than deciding, in indolence or exhaustion, that surrendering to despotism was easier.

One thing that Tocqueville did not predict was a flowering of cultural brilliance in America that would rival the achievements of Europe. He expected the aesthetic productions of the New World to be distinguished in quantity rather than quality, and to be mostly of a domestic nature, such as the white houses of New England and the small paintings that adorned them. The refined quality of a Raphael, he opined, was not part of the American character. While he was impressed by the monumental buildings under construction in the nation's capital, he considered them the exception.[3]

A ten-year-old boy living in one of those simple white houses that Tocqueville described would prove him wrong. Frederick Lander may well have agreed that the arts of the United States were rudimentary when the Frenchman made his visit in 1831. Perhaps nettled by the cultural condescension of Europeans, he wanted to demonstrate that the backwardness of American culture was not a permanent state. He believed that Americans' capacity for excellence was equal to their determination to defend their freedom—a proposition which remains every bit as true today as it was when Lander chose Albert Bierstadt to be the official artist on his Honey Lake Road expedition, thus laying the foundation of a uniquely American contribution to the catalogue of great art inspired by democracy.

Despite the dramatic success of the United States and the multiplication of our democratic allies around the globe, the struggle for liberty goes

3 Tocqueville, *Democracy in America*, 532–37.

on some 2,500 years after Pericles proclaimed the glories of Athenian democracy and commissioned Phidias to design a monument to that achievement. Over time, the threats to democracy have increased in virulence—in the course of the last century we saw the emergence of two ideologies, fascism and communism, that were not content to attack individual countries that happened to be democracies, but were determined to destroy the very concept of individual liberty.

At enormous cost, both of those existential threats were defeated, and the end of history was declared. Some observers (again) suggested that the global spread of freedom was practically inevitable. All too soon, however, new threats emerged. New, or newly emboldened, enemies of liberal democracy are today determined to eradicate it. Meanwhile, people who have long enjoyed freedom may be inclined to take it for granted, or to regard the effort to defend it as altogether too taxing—or too risky.

And so the cycle turns again in the twenty-first century. How much easier *David's Sling* would have been to write if freedom were the default setting for governance, and if human beings had the sense and the will to guard their achievement of liberty as a prize above all others. But as the many disappointments and setbacks chronicled in these pages attest, the opposite case might be easier to argue. Will liberty always be a rare thing in history, rather than a trend of history? And will liberty, where it does prevail, continue to nurture the kind of cultural excellence for which the Athenians set an enduring standard?

As this book illustrates, however, free systems can spring up in the most unlikely of places, and the inspiring force of freedom can result in creative achievements of the highest order. It may be impossible to predict where and when the next chapter of this story will emerge, but history gives us reason to be confident that once again another hand will reach out to grasp David's sling.

Suggestions for Further Reading

Classical Athens and the Parthenon

The writing of history was born in classical Greece, and the pioneering works of Herodotus and Thucydides are available in excellent modern editions; for this study I used *The Landmark Herodotus: The Histories*, ed. Robert B. Strassler, trans. Andrea L. Purvis (Pantheon, 2007); and *The Landmark Thucydides: A Comprehensive Guide to the Peloponnesian War*, ed. Robert B. Strassler, trans. Richard Crawley (Free Press, 1996). Additional information on the Greek historians can be found in Stephen Usher, *The Historians of Greece and Rome* (1969; Bristol Classical Press, 1997); and Mary P. Nichols, *Thucydides and the Pursuit of Freedom* (Cornell, 2015).

An enormous amount of ink has been spilled concerning Pericles in the 2,400-plus years since his lifetime, although he left almost no first-hand written legacy. The only surviving contemporary inscription that includes his full name is the one recording his sponsorship of Aeschylus's tragedies in 472 BC. Thucydides provided a contemporary's view of Pericles' leadership in Athens, but the fullest portrait of his character was composed by the Roman historian Plutarch some five hundred years later. There are many translations; for this book I used the seminal sixteenth-century translation by John Dryden as revised by Arthur Hugh Clough in 1864, reproduced in Stephen V. Tracy, *Pericles: A Sourcebook and Reader* (University of California, 2009). Additional background and bibliography can be found in Vincent Azoulay, *Pericles of Athens*, trans. Janet Lloyd (Princeton, 2014); A. R. Burn, *Pericles and Athens* (Macmillan, 1949); Donald Kagan, *Pericles of Athens and the Birth of Democracy* (Free Press, 1990); and Anthony J. Podlecki, *Perikles and His Circle* (Routledge, 1998).

For more on the development of Athenian democracy, see Aristotle, *The Politics and the Constitution of Athens*, ed. Stephen Everson (Cambridge, 1996); W. G. Forrest, *The Emergence of Greek Democracy, 800–400 BC* (McGraw-Hill, 1966); S. Sara Monoson, *Plato's Democratic Entanglements: Athenian Politics and the Practice of Philosophy* (Princeton, 2000); G. R. Stanton, *Athenian Politics c. 800–500 BC: A Sourcebook* (Routledge, 1990); and Dean Hammer, ed., *A Companion to Greek Democracy and the Roman Republic* (Wiley, 2014). On the Peloponnesian War, see Victor Davis Hanson, *A War Like No Other: How the Athenians and Spartans Fought the Peloponnesian*

War (Random House, 2006). Also useful is Josiah Ober, *The Rise and Fall of Classical Greece* (Princeton, 2015).

For the Parthenon and the other projects on the Acropolis, see Mary Beard's excellent *The Parthenon* (Harvard, 2003); Vincent J. Bruno, ed., *The Parthenon* (Norton, 1974); Jeffery M. Hurwit, *The Athenian Acropolis: History, Mythology, and Archaeology from the Neolithic Era to the Present* (Cambridge, 2000); Hurwit, *The Acropolis in the Age of Pericles*, abridged ed. (Cambridge, 2004); Michael B. Cosmopoulos, *The Parthenon and Its Sculptures* (Cambridge, 2004); Ian Jenkins, *The Parthenon Sculptures* (Harvard, 2008); and Jenifer Neils, *The Parthenon Frieze* (Cambridge, 2001). Joan Breton Connelly proposes a new interpretation of the Parthenon frieze in *The Parthenon Enigma: A New Understanding of the West's Most Iconic Building and the People Who Made It* (Knopf, 2014).

The Roman Republic and Its Legacy

The practice of writing history flowered in ancient Rome, giving us two excellent sources for Lucius Junius Brutus: Livy's magisterial *Ab urbe condita libri*, composed in the early first century AD; and Dio Cassius, *Historia Romana*, from about a hundred years later. For this study I used Livy, *History of Rome*, vol. 1, trans. B. O. Foster (Loeb Classical Library, 1919); and Dio Cassius, *Roman History*, vol. 1, trans. Earnest Cary (Loeb Classical Library, 1914). Also helpful are Mary Jaeger, *Livy's Written Rome* (University of Michigan, 1997, 2009); Gary B. Miles, *Livy: Reconstructing Early Rome* (Cornell, 1995); and Steven Usher, *The Historians of Greece and Rome* (1969; Bristol Classical Press, 1997). For Marcus Junius Brutus, we have Plutarch's biography in the *Parallel Lives*, vol. 6, trans. Bernadotte Perrin (Loeb Classical Library, 1918).

Modern histories of the early Roman Republic include Michael Grant, *The History of Rome* (Scribner's, 1978); Klaus Bringmann, *A History of the Roman Republic* (Polity, 2007); and Anthony Everitt, *The Rise of Rome: The Making of the World's Greatest Empire* (Random House, 2012). For the political structure of the republic, see Andrew Lintott, *The Constitution of the Roman Republic* (Oxford, 2003); and Dean Hammer, ed., *A Companion to Greek Democracy and the Roman Republic* (Wiley, 2014).

The bibliography on Roman republican portraiture is remarkably thin and mostly confined to chapters in broader surveys, notably Nancy H. Ramage and Andrew Ramage, *Roman Art: Romulus to Constantine* (Prentice Hall, 2004); and Donald Emrys Strong, Jocelyn M. C. Toynbee

and Roger Ling, *Roman Art* (Yale, 1995). There is a useful introductory essay in Ludwig Goldscheider, *Roman Portraits* (Oxford, 1940).

For the culture of Renaissance Rome around the time of the recovery of the bronze *Brutus*, see David R. Coffin, *The Villa in the Life of Renaissance Rome* (Princeton, 1979); Peter Partner, *Renaissance Rome, 1500–1559: A Portrait of a Society* (University of California, 1976); and Ingrid D. Rowland, *The Culture of the High Renaissance: Ancients and Moderns in Sixteenth-Century Rome* (Cambridge, 1998). Ulisse Aldrovandi's memoirs, *Memoria della Vita di Ulisse Aldrovandi* (1774), are unfortunately not available in translation. For the legacy of Lucius Junius Brutus during the French Revolution, see Robert L. Herbert, *David, Voltaire, 'Brutus' and the French Revolution: An Essay in Art and Politics* (Viking, 1973).

Venice and St. Mark's Basilica

Everyone who writes on the history and culture of Venice or the Byzantine Empire stands on the shoulders of the great John Julius Norwich; here I relied on *A History of Venice* (Knopf, 1982); *A Short History of Byzantium* (Knopf, 1997); and *Paradise of Cities: Venice in the Nineteenth Century* (Doubleday, 2003). Also useful for the evolution of the Venetian political system are Frederic C. Lane, *Venice: A Maritime Republic* (Johns Hopkins, 1973); and John Jeffries Martin and Dennis Romano, eds., *Venice Reconsidered: The History and Civilization of an Italian City-State, 1297–1797* (Johns Hopkins, 2000).

For Venice's economic development, see Roger Crowley, *City of Fortune: How Venice Ruled the Seas* (Random House, 2012); and Jane Gleeson-White, *Double Entry: How the Merchants of Venice Created Modern Finance* (Norton, 2012). A view of Venice within the wider European economy can be found in Robert S. Lopez, *The Commercial Revolution of the Middle Ages, 950–1350* (Cambridge, 1976).

For St. Mark's Basilica and its decoration, see Otto Demus, *The Mosaic Decoration of San Marco Venice*, ed. Herbert L. Kessler (University of Chicago, 1988); Charles Freeman, *The Horses of St. Mark's: A Story of Triumph in Byzantium, Paris and Venice* (Overlook Press, 2010); Dial Parrott, *The Genius of Venice: Piazza San Marco and the Making of the Republic* (Rizzoli, 2013); and Henry Maguire and Robert S. Nelson, eds., *San Marco, Byzantium, and the Myths of Venice* (Dumbarton Oaks, 2010). Useful material on St. Mark's can be found in Patricia Fortini Brown, *Venice and Antiquity: The Venetian Sense of the Past* (Yale, 1997); Deborah Howard,

The Architectural History of Venice, rev. ed. (Yale, 2002); and David Rosand, *Myths of Venice: The Figuration of a State* (University of North Carolina, 2001).

The fascinating Enrico Dandolo gets a well-documented biography in Thomas F. Madden, *Enrico Dandolo and the Rise of Venice* (Johns Hopkins, 2003). We are fortunate to have contemporary accounts of the Fourth Crusade in Joinville and Villehardouin, *Chronicles of the Crusades*, trans. Caroline Smith (Penguin, 2008); and Niketas Choniates, *O City of Byzantium: Annals of Niketas Choniates*, trans. Harry J. Magoulias (Wayne State University, 1984). See also David M. Perry, *Sacred Plunder: Venice and the Aftermath of the Fourth Crusade* (Penn State, 2015); and Jonathan Phillips, *The Fourth Crusade and the Sack of Constantinople* (Viking, 2004). For the Napoleonic appropriation of the horses, see Cecil Gould, *Trophy of Conquest: The Musée Napoléon and the Creation of the Louvre* (Faber & Faber, 1965); and Louis Antoine Fauvelet de Bourrienne, *Memoirs of Napoleon Bonaparte*, ed. R. W. Phipps (1891, 2008), vol. 1.

Michelangelo and Renaissance Florence

Many poems and letters by Michelangelo are available in English translation; reliable editions include *The Complete Poems and Selected Letters of Michelangelo*, trans. Creighton Gilbert and ed. Robert N. Liscott (Princeton, 1980); and *The Complete Poems of Michelangelo*, trans. John Frederick Nims (University of Chicago, 1998). Michelangelo also benefited from two highly sympathetic contemporary biographers with whom he worked closely and who produced detailed portraits of him. Giorgio Vasari's "Life of Michelangelo" first appeared in the 1550 edition of his *Lives of the Most Excellent Painters, Sculptors and Architects*, and was significantly revised and expanded for the 1568 edition with Michelangelo's direct participation; for this study I used *Lives of the Artists (Volume I)*, trans. George Bull (Penguin, 1987). In addition, Michelangelo's pupil Ascanio Condivi wrote his *Life of Michelangelo* in 1553; for this study I used the translation by Alice Sedgwick Wohl, edited by Hellmut Wohl, 2nd ed. (Penn State, 1999). The far more salacious account of Michelangelo's life written by the "Anonimo Magliabechiano" around 1540 has not been translated.

The modern bibliography on Michelangelo is vast, but following Charles de Tolnay's brilliant *The Art and Thought of Michelangelo*, trans. Nan Buranelli (Pantheon, 1964), scholars have generally avoided a political interpretation of his work, instead focusing on the artist's personal

or spiritual motivations. This is the approach taken, for example, by Charles Seymour in *Michelangelo's David: A Search for Identity* (Norton, 1967). Studies that were particularly useful for this book are Paul Barolsky, *Michelangelo's Nose: A Myth and Its Maker* (Penn State, 1990); Martin Gayford, *Michelangelo: His Epic Life* (Penguin UK, 2013); Michael Hirst, *Michelangelo: The Achievement of Fame, 1475–1534* (Yale, 2012); John Spike, *Young Michelangelo: The Path to the Sistine – A Biography* (Vendome Press, 2010); and William E. Wallace, *Michelangelo: The Artist, the Man, and His Times* (Cambridge, 2010). There are recent popular histories of varying quality on Michelangelo and his early works, including Anton Gill, *Il Gigante: Michelangelo, Florence, and the 'David,' 1492–1504* (St. Martin's Press, 2004); Jonathan Jones, *Lost Battles: Leonardo, Michelangelo, and the Artistic Duel That Defined the Renaissance* (Knopf Doubleday, 2012); and Ross King, *Michelangelo and the Pope's Ceiling* (2003; Bloomsbury USA, 2014).

We have two crucial Renaissance sources for the history of Florence: Francesco Guicciardini, *The History of Italy,* trans. Sidney Alexander (Princeton, 1984); and Niccolò Machiavelli, *History of Florence and of the Affairs of Italy,* trans. Christian E. Detmold (1882), available as ebook, or online from the Liberty Fund. Also pertinent is Machiavelli's *Discourses on Livy,* trans. Harvey C. Mansfield (University of Chicago, 1996). Valuable modern contributions include Christopher Hibbert, *The House of Medici: Its Rise and Fall* (William Morrow, 1975); and Gene Brucker, *Florence: The Golden Age, 1138–1737* (1984; University of California, 1998). Key figures in Florentine history have been given excellent biographies, including Daniel Weinstein, *Savonarola: The Rise and Fall of a Renaissance Prophet* (Yale, 2011); Miles J. Unger, *Machiavelli: A Biography* (Simon & Schuster, 2011); and Unger, *Magnifico: The Brilliant Life and Violent Times of Lorenzo de' Medici* (Simon & Schuster, 2008). For the rise (and fall) of free communes in medieval Italy, see Daniel Waley and Trevor Dean, *The Italian City-Republics,* 4th ed. (Routledge, 2010). On Florence's commercial economy, Richard A. Goldthwaite, *The Economy of Renaissance Florence* (Johns Hopkins, 2009) is exhaustive but accessible.

Rembrandt and the Dutch Golden Age

The seventeenth-century Dutch Republic is best represented by the fascinating work of Simon Schama, *The Embarrassment of Riches: An Interpretation of Dutch Culture in the Golden Age* (University of California, 1988). Also valuable is Jonathan I. Israel, *The Dutch Republic: Its Rise, Greatness,*

and Fall, 1477–1806 (Oxford, 1995). Histories of the formation of modern financial markets include Niall Ferguson, *The Ascent of Money: A Financial History of the World* (Penguin, 2008); and William N. Goetzmann and K. Geert Rouwenhorst, *The Origins of Value: The Financial Innovations That Created Modern Capital Markets* (Oxford, 2005). For the Dutch East India Company, see Stephen R. Brown, *Merchant Kings: When Companies Ruled the World, 1600–1900* (Thomas Dunne, 2010); and Antony Wild, *The East India Company: Trade and Conquest from 1600* (Lyons Press, 2000). The iconography of Marie de' Medici is covered in Philip Mansel and Torsten Riotte, eds., *Monarchy and Exile: The Politics of Legitimacy from Marie de Médicis to Wilhelm II* (Palgrave Macmillan, 2011); and Ronald Forsyth Millen and Robert Erich Wolf, *Heroic Deeds and Mystic Figures: A New Reading of Rubens' Life of Maria de' Medici* (Princeton, 1989).

Despite his immense popularity today, Rembrandt van Rijn is a somewhat enigmatic figure, having left behind him a minuscule documentary record (in contrast with Michelangelo). We have brief biographies by his contemporaries Joachim von Sandrart, Filippo Baldinucci and Arnold Houbraken – none of them particularly complimentary – published in *Lives of Rembrandt*, ed. Charles Ford (Pallas Athene, 2007). Christopher White, *Rembrandt* (Thames & Hudson, 1984) provides an accessible overview. Modern scholarship has been largely preoccupied with the raging debate over the attribution of the artist's traditional œuvre in light of judgments by the Rembrandt Research Project, a subject covered in some detail in the exhibition catalogue *Rembrandt / Not Rembrandt in the Metropolitan Museum of Art: Aspects of Connoisseurship*, 2 vols. (1995); and in Ernst van de Wetering, *Rembrandt: The Painter at Work* (University of California, 2000). Svetlana Alpers, *Rembrandt's Enterprise: The Studio and the Market* (University of Chicago, 1988) illuminates the economics of Rembrandt's career. The artist's self-portraits are examined in Christopher White and Quentin Buvelot, eds., *Rembrandt by Himself* (National Gallery London / Yale, 1999). Simon Schama, *Rembrandt's Eyes* (Knopf, 1999) is an effort to make up for the paucity of documentary evidence on the artist through a biographical interpretation of his paintings. Hendrik Willem van Loon's highly imaginative *The Life and Times of Rembrandt* (1930; Kessinger Publishing, 2004) traces the artist's life through the eyes of a fictional descendant of the author.

For Rembrandt and Italy, see Harry Berger Jr., *Fictions of the Pose: Rembrandt against the Italian Renaissance* (Stanford, 2000); and Kenneth Clark, *Rembrandt and the Italian Renaissance* (New York University, 1966). Studies of *The Night Watch* include Harry Berger Jr., *Manhood, Marriage,*

Mischief: Rembrandt's 'Night Watch' and Other Dutch Group Portraits (Fordham, 2007); and Ton Koot, *Rembrandt's Night Watch: A Fascinating Story* (1949; Meulenhoff International, 1969); but the most comprehensive treatment remains Egbert Haverkamp-Begemann, *Rembrandt: 'The Nightwatch'* (Princeton, 1983).

Jacques-Louis David and Revolutionary France

A wealth of primary documents survives from the French Revolution, giving us insight into what the principal actors thought and what they might have said to each other in their interactions. These documents include personal correspondence, transcripts of speeches, political pamphlets, datebooks, and sketches. Many of the critical papers can be found in English translation in Laura Mason and Tracey Rizzo, eds., *The French Revolution: A Document Collection* (Houghton Mifflin, 1999). Other documents are available online.

The French Revolution was so bloody and divisive that it took decades to gain some perspective on the event. The process began with Alexis de Tocqueville, *The Old Regime and the French Revolution* (1856). Simon Schama provides a useful overview in *Citizens: A Chronicle of the French Revolution* (Knopf, 1989). Peter McPhee, *Robespierre: A Revolutionary Life* (Yale, 2012) is a dispassionate portrait of a controversial figure. Clifford D. Conner, *Jean Paul Marat: Scientist and Revolutionary* (Humanities Press, 1997) examines the many activities of the Friend of the People. By far the most imaginative portrayal of the period is found in Hilary Mantel's novel *A Place of Greater Safety* (1993).

Jacques-Louis David has been a tough nut for modern scholars to crack, particularly in terms of his politics. Simon Lee, *David* (Phaidon, 1999) is a standard treatment of his life and works, while Robert L. Herbert, *David, Voltaire, 'Brutus' and the French Revolution: An Essay in Art and Politics* (Viking, 1973), and Warren Roberts, *Jacques-Louis David, Revolutionary Artist: Art, Politics, and the French Revolution* (University of North Carolina, 1989) have useful information on this critical phase of David's life. For *The Last Breath of Marat*, Tom Gretton presents many of the major sources in "Marat, *L'Ami du peuple*, David: Love and Discipline in the Summer of '93," in *David's 'The Death of Marat,'* ed. William Vaughan and Helen Weston (Cambridge, 1999). T. J. Clark identifies the work as a radical step toward modernism in "Painting in the Year 2," chap. 1 of *Farewell to an Idea: Episodes from a History of Modernism* (Yale, 1999).

The Elgin Marbles and Great Britain

The development of the British constitutional monarchy is traced in Vernon Bogdanor, *The Monarchy and the Constitution* (Clarendon, 1996); and of course in Winston Churchill, *A History of the English-Speaking Peoples*, vol. 3, *The Age of Revolution* (1957), and vol. 4, *The Great Democracies* (1958). For the British fascination with the democratic legacy of the classical past during this period, see Bruce Redford, *Dilettanti: The Antic and the Antique in Eighteenth-Century England* (J. Paul Getty Museum, 2008); and Frank M. Turner, *The Greek Heritage in Victorian Britain* (Yale, 1981).

Robert Bruce, Lord Elgin receives thorough treatment in William St. Clair, *Lord Elgin and the Marbles: The Controversial History of the Parthenon Sculptures,* 3rd ed. (Oxford, 1998). An engaging portrayal of Elgin's wife is offered in Susan Nagel, *Mistress of the Elgin Marbles: A Biography of Mary Nisbet, Countess of Elgin* (William Morrow, 2004), which relies heavily on her letters and journals. Other important resources are Benjamin Robert Haydon, *Lectures on Painting and Design* (1846); *The Autobiography and Memoirs of Benjamin Robert Haydon*, ed. Tom Taylor (Harcourt, Brace & Co., 1926), 2 vols.; and Paul O'Keeffe, *A Genius for Failure: The Life of Benjamin Robert Haydon* (Random House, 2009).

For Sir William Hamilton's antiquarian activities, see Ian Jenkins and Kim Sloan, *Vases and Volcanoes: Sir William Hamilton and His Collection* (British Museum Press, 1996). Hamilton, his wife and Lord Nelson all appear in Susan Sontag's novel *The Volcano Lover* (1993). A useful depiction of the Ottoman court that the Elgins encountered can be found in Philip Mansel, *Constantinople: City of the World's Desire, 1453–1924* (John Murray, 1995). *London: World City, 1800–1840*, ed. Celina Fox (Yale, 1992) provides background on the city that received the Elgin Marbles.

The works of Byron, Hazlitt, Keats, Shelley and Wordsworth discussed in this chapter are widely available in modern editions. The impact of the Elgin Marbles on British literary culture is outlined in Stephen A. Larrabee, *English Bards and Grecian Marbles: The Relationship between Sculpture and Poetry Especially in the Romantic Period* (Columbia, 1943); and Grant F. Scott, "Beautiful Ruins: The Elgin Marbles Sonnet in Its Historical and Generic Contexts," *The Keats-Shelley Journal* 39 (1990). For Lord Byron and Greece, see Stephen Minta, *On a Voiceless Shore: Byron and Greece* (Henry Holt & Co., 1998); and David Roessel, *In Byron's Shadow: Modern Greece in the English and American Imagination* (Oxford, 2002). For the Greek War of Independence in this connection, see Gonda

Van Steen, *Liberating Hellenism from the Ottoman Empire: Comte de Marcellus and the Last of the Classics* (Palgrave Macmillan, 2010).

The Elgin Marbles are still among the most controversial objects on the planet, a status that points to the ongoing power of the Parthenon as the preeminent symbol of the classical tradition. The debate in Parliament over the purchase of the marbles was published in 1816 and is available online. Their installation in the British Museum is discussed in Christopher Whitehead, *Museums and the Construction of Disciplines: Art and Archaeology in Nineteenth-Century Britain* (Bloomsbury USA, 2013). For Joseph Duveen, see *Duveen: A Life in Art* (Knopf, 2004). For discussion of the marbles' legal status, see James Cuno, *Who Owns Antiquity? Museums and the Battle over Our Ancient Heritage* (Princeton, 2008); Christopher Hitchens, *The Parthenon Marbles: The Case for Reunification* (Verso, 2008); and Fiona Rose-Greenland, "The Parthenon Marbles and British National Identity," *openDemocracy*, October 25, 2013.

Albert Bierstadt and the United States

Among the useful recent additions to the bibliography on the United States in the nineteenth century are: Daniel Walker Howe, *What Hath God Wrought: The Transformation of America, 1815–1848* (Oxford, 2009); David M. Potter, *Impending Crisis: America before the Civil War, 1848–1861* (HarperCollins, 2011); Brenda Wineapple, *Ecstatic Nation: Confidence, Crisis, and Compromise, 1848–1877* (Harper, 2013); and Gordon S. Wood, *Empire of Liberty: A History of the Early Republic, 1789–1815* (Oxford, 2009). For the role of ancient democracy in the American experiment, see Carl J. Richard, *Greeks and Romans Bearing Gifts: How the Ancients Inspired the Founding Fathers* (Rowman & Littlefield, 2008).

Rinker Buck, *On the Oregon Trail: A New American Journey* (Simon & Schuster, 2015) traces the experience of the brave souls who set out in prairie schooners westward from St. Joseph, Missouri, by attempting to recreate their journey. For Chief Washakie, see Grace Raymond Hebard, *Washakie: Chief of the Shoshones* (University of Nebraska, 1930, 1995).

We are extremely fortunate to have the detailed diary of Abraham Lincoln's close aide John Hay, published as *Inside Lincoln's White House: The Complete Civil War Diary of John Hay*, ed. Michael Burlingame and John R. Turner Ettinger (Southern Illinois University, 1999). For Virginia during the Civil War, see James I. Robinson Jr., *Civil War Virginia: Battleground for a Nation* (University of Virginia, 1993). Eleanor Harvey Jones's

exhibition catalogue for *The Civil War and American Art* (Metropolitan Museum of Art, 2012) is also useful.

The life of Frederick Lander is well documented in Gary L. Ecelbarger, *Frederick W. Lander: The Great Natural American Soldier* (Louisiana State University, 2000); Alan Fraser Houston and Jourdan Moore Houston, "The 1859 Lander Expedition Revisited: 'Worthy Relics' Tell New Tales of a Wind River Wagon Road," *Montana: The Magazine of Western History* 49:2 (Summer 1999); Joy Leland, ed., *Frederick West Lander: A Biographical Sketch* (Desert Research Institute, 1993); and Jermy Benton Wight, *Frederick W. Lander and the Lander Trail* (Star Valley Llama, 1993).

A number of Albert Bierstadt's letters from the 1859 expedition were immediately published, including one in the *New Bedford Mercury*, June 15, 1859, and another in *Harper's Weekly*, August 13, 1859 (with illustrations by the artist). The key text for Bierstadt remains Nancy K. Anderson and Linda S. Ferber, *Albert Bierstadt: Art and Enterprise* (Hudson Hills Press, 1991), which includes primary documents. Also useful are Gordon Hendricks, *Albert Bierstadt: Painter of the American West* (Crescent, 1988); and Gerald L. Carr, *Bierstadt's West* (Gerald Peters Gallery, 2011). For the development of landscape painting in America, see the exhibition catalogue *American Paradise: The World of the Hudson River School* (Metropolitan Museum of Art, 1988). Patricia Trenton and Peter H. Hassrick, *The Rocky Mountains: A Vision for Artists in the Nineteenth Century* (University of Oklahoma, 1983) examines a range of responses to a novel artistic subject. The role of photography in the exploration of the West is thoroughly treated in Peter E. Palmquist and Thomas R. Kailbourn, *Pioneer Photographers and the Far West: A Biographical Dictionary, 1840–1865* (Stanford, 2000).

For Worthington Whittredge, see *The Autobiography of Worthington Whittredge, 1820–1910*, ed. John I. H. Baur (Brooklyn Museum Press, 1942). For Emanuel Leutze, see John K. Howat, "Washington Crossing the Delaware," *The Metropolitan Museum of Art Bulletin* 26:7 (March 1968); and Jochen Wierich, *Grand Themes: Emanuel Leutze, 'Washington Crossing the Delaware,' and American History Painting* (Penn State, 2012). Oliver Wendell Holmes published two important essays on the stereoscope in the *Atlantic Monthly*: "The Stereoscope and the Stereograph," June 1859; and "Sun-Painting and Sun-Sculpture," July 1861. See also George E. Hamilton, *Oliver Wendell Holmes – His Pioneer Stereoscope and the Later Industry* (Newcomen Society in North America, 1949), to which I am indebted for the quotation on the jacket back.

Monet's France

For the history of the French Third Republic, see Jean-Marie Mayeur and Madeleine Rebérioux, *The Third Republic from Its Origins to the Great War, 1871–1914* (Cambridge, 1984). For World War I, see John Keegan, *The First World War* (Knopf, 1999); Margaret MacMillan, *Paris 1919: Six Months That Changed the World* (Random House, 2002); and Barbara W. Tuchman's classic *The Guns of August: The Outbreak of World War I* (Random House, 1962). Georges Clemenceau is certainly due for a new biography; existing studies include Gregor Dallas, *At the Heart of a Tiger: Clemenceau and His World, 1841–1929* (Carroll & Graf, 1993); and J. Hampden Jackson, *Clemenceau and the Third Republic* (1946; Collier Books, 1962). Two important texts for this study are, unfortunately, available only in French: Georges Clemenceau, *Claude Monet: Les Nymphéas* (Plon, 1928); and Alexandre Duval-Stalla, *Claude Monet – Georges Clemenceau: une histoire, deux caractères* (Gallimard, 2010). The nexus of art and politics represented by the Dreyfus affair is examined in Philip Nord, "The New Painting and the Dreyfus Affair," *Intellectuals and the Dreyfus Affair*, special issue of *Historical Reflections/Réflexions Historiques* 24:1 (Spring 1998).

The bibliography on nineteenth-century French painting is vast. Good introductions include Francis Frascina et al., *Modernity and Modernism: French Painting in the Nineteenth Century* (Yale, 1993); Robert L. Herbert, *Impressionism: Art, Leisure, and Parisian Society* (Yale, 1988); and James H. Rubin, *How to Read Impressionism: Ways of Looking* (Harry N. Abrams, 2013). For Paul Durand-Ruel and the rise of the modern art dealer, see Flavie Durand-Ruel and Paul-Louis Durand-Ruel, *Paul Durand-Ruel: Memoirs of the First Impressionist Art Dealer, 1831–1922* (Flammarion, 2014); and Sylvie Patry, ed., *Inventing Impressionism: Paul Durand-Ruel and the Modern Art Market* (National Gallery London, 2015).

Claude Monet likewise has an enormous bibliography, but the key scholarship placing him in the long tradition of nationalistic French artists is by Paul Hayes Tucker (to whom I owe both my introduction to Monet and my first museum job), including *Monet in the '90s: The Series Paintings* (Yale, 1989); *Monet: Life and Art* (Yale, 1995); and *Monet in the Twentieth Century* (Yale, 1999). See also Richard Kendall, ed., *Monet by Himself* (Little, Brown & Co., 1990), a useful compilation of primary documents in translation; Steven Z. Levine, *Monet, Narcissus, and Self-Reflection: The Modernist Myth of the Self* (University of Chicago, 1994); and Daniel Wildenstein, *Monet, or the Triumph of Impressionism* (Taschen, 2010). For Monet's work at Giverny, see the exhibition catalogue *Monet's*

Years at Giverny: Beyond Impressionism (Metropolitan Museum of Art, 1978); Benedict Leca, ed., *Monet in Giverny: Landscapes of Reflection* (Cincinnati Art Museum, 2012); Derek Fell, *The Magic of Monet's Garden: His Planting Plans and Color Harmonies* (Firefly Books, 2007); and Michel Hoog, *The Nymphéas of Claude Monet at the Musée de l'Orangerie*, trans. Jean-Marie Clarke (Réunion des musées nationaux, 1987).

Picasso and Spain

The breakdown of the Spanish Republic is well documented in Antony Beevor, *The Battle for Spain: The Spanish Civil War 1936–1939* (Penguin, 2006); Paul Preston, *The Spanish Civil War: Reaction, Revolution, and Revenge*, rev. ed. (Norton, 2007); and Richard Rhodes, *Hell and Good Company: The Spanish Civil War and the World It Made* (Simon & Schuster, 2015). The relationship between the conflict and art is explored in Robin Adèle Greeley, *Surrealism and the Spanish Civil War* (Yale, 2006). George Steer's firsthand account of the bombing of Guernica is treated in Nicholas Rankin, *Telegram from Guernica: The Extraordinary Life of George Steer, War Correspondent* (Faber & Faber, 2003). For Paris in the lead-up to World War II, see Dan Franck, *Bohemian Paris: Picasso, Modigliani, Matisse, and the Birth of Modern Art* (Grove Press, 2001); James D. Herbert, *Paris 1937: Worlds on Exhibition* (Cornell, 1998); and William Wiser, *The Twilight Years: Paris in the 1930s* (Carroll & Graf, 2000).

Pablo Picasso's larger-than-life personality and his prodigious creative output have resulted in a similarly outsized bibliography. John Richardson provides a thorough overview of the artist's career in *A Life of Picasso*, three volumes of which have been published: *The Prodigy, 1881–1906* (1991; Knopf, 2007); *The Cubist Rebel, 1907–1916* (1996; Knopf, 2007); and *The Triumphant Years, 1917–1932* (Knopf, 2007); the fourth and final volume will cover the period of *Guernica*'s creation. Existing scholarship on Picasso's masterwork includes Rudolf Arnheim, *The Genesis of a Painting: Picasso's 'Guernica'* (University of California, 1980, 2006); Jutta Held, "How Do the Political Effects of Pictures Come About? The Case of Picasso's *Guernica*," *Oxford Art Journal* 11:1 (1988); Werner Hofmann, "Picasso's *Guernica* in Its Historical Context," *Artibus et Historiae* 7 (1983); Gijs van Hensbergen's extremely useful *Guernica: The Biography of a Twentieth-Century Icon* (Bloomsbury USA, 2004); Alain Serres, *And Picasso Painted 'Guernica'* (Allen & Unwin, 2010); and Rachel Wischnitzer, "Picasso's *Guernica*: A Matter of Metaphor," *Artibus et His-*

toriae 12 (1985). Dore Ashton, ed., *Picasso on Art: A Selection of Views* (1972; Da Capo Press, 1988) is a fascinating compendium of the artist's frequently contradictory statements, including his interview with Jerome Seckler at the end of World War II and his comments on *Guernica*. Firsthand portraits of the artist by his contemporaries are in Paul Éluard, *Pablo Picasso*, trans. Joseph T. Shipley (Philosophical Library, 1947); and Brassaï, *Conversations with Picasso*, trans. Jane Marie Todd (University of Chicago, 1999).

Picasso's colorful personal life has received extensive treatment, for example, in Jean-Paul Crespelle, *Picasso and His Women* (Hodder & Stoughton, 1969); and Françoise Gilot and Carlton Lake, *Life with Picasso* (1964; Nabu Press, 2011). For his relationship with Dora Maar, see Anne Baldassari, *Picasso: Life with Dora Maar: Love and War 1935–1945* (Flammarion, 2006); Mary Ann Caws, *Picasso's Weeping Woman: The Life and Art of Dora Maar* (Bulfinch Press, 2000); and James Lord, *Picasso and Dora: A Personal Memoir* (Farrar Straus & Giroux, 1993).

Conclusion

There are a number of editions of Tocqueville's reflections on the United States; for this study I used Alexis de Tocqueville, *Democracy in America*, trans. Arthur Goldhammer (Library of America, 2004). See also Hugh Brogan, *Alexis de Tocqueville: A Life* ((Yale, 2007); and Alexis de Tocqueville, *Letters from America*, ed. and trans. Frederick Brown (Yale, 2010).

Acknowledgments

This book has its roots in decades of studying and teaching art history, but the idea came quite suddenly one day in the autumn of 2010. My old pedestrian commute to the Rumsfeld Foundation offices took me down 15th Street in Washington, D.C., past the *Washington Post* building with the news scrolling by on a red LED display. It made for an interesting mental juxtaposition with my ruminations on a colleague's project, which posits that Michelangelo's so-called *Rebellious Slave* and *Dying Slave*, now in the Louvre, had been given to Francis I by Roberto Strozzi as part of an effort to persuade the French king to help save the Florentine Republic from the resurgent Medici in the late 1520s.[1] The entreaty failed, and the participation of these sculptures in the political turmoil of their day was eventually forgotten after they joined the French royal collection; but the slaves had once been, in their own way, warriors for freedom. This line of thought led to Michelangelo's more famous *David* and how it was similarly recontextualized as a Medici emblem and then as an icon of idealized male beauty. How many viewers knew that the statue was originally commissioned by the Florentine Republic? Then I wondered how many other artworks had similarly obscured origins in free systems of government. Little did I know where these seemingly idle musings would lead, or foresee that the *Dying Slave* would wind up making an appearance in a chapter on the French Revolution.

The development of these ideas into a book has benefited from the input of many other colleagues and dear friends. My original companions were my family, starting with my parents, Anne and Gene Gardner, and my brother, Eugene, with whom I made my first visit to Europe in 1974. The first work of art I remember seeing is *The Night Watch*. Subsequent trips to Greece, England, Italy and beyond brought us into contact with many of the objects under consideration here, notably the Parthenon, the Elgin Marbles, St. Mark's Basilica and Michelangelo's *David*, so that by the time I started writing this book they were old friends. As our family has expanded it has been a joy to share more adventures with my husband, George, and our children, Gardner and Gowen, as well as my indefatigable sister-in-law, Bernadette, and cherished nieces: Caroline, Victoria, Abigail and Grace.

From my earliest days as an art historian I was immensely fortunate

1 Maria Ruvoldt, "Michelangelo's *Slaves* and the Gift of Liberty," *Renaissance Quarterly* 65 (2012), 1029–59.

in the trio of advisers who guided my steps: Michael Mahoney of Trinity College, Samuel Y. Edgerton, Jr. of Williams College, and Malcolm J. Campbell of the University of Pennsylvania. All three of these institutions and their staffs have remained valued sources of guidance and support for many years after graduation – particularly in the art history departments and also at the Trinity College Rome Campus, the Clark Art Institute, Penn's University Museum, Penn's Fisher Fine Arts Library, and the Penn–Bryn Mawr College summer program in Florence.

I am also grateful for the fellowship of so many professors, mentors, colleagues, students and friends who have shared portions of this journey with me, notably Brian T. Allen and Steven Horsch, Linda and Ronald Anderson, Simi Kaplin Baer, Mary Beard, Michela Capasso, Bunny Coates, George G. H. Coates, Carol and Paul Collins, Jodi Cranston, Maria diPasquale, Howard Downey, John Duffy, Erick Woods-Erickson, Doug Feith, Kathy and Law Fotterall, David Goder, Alden Gordon, Daryle and Jimmy Hanlon, James Hargrove, Lothar Haselberger, Renata Holod, Elsbeth and Marco Keller, Ann Kuttner, Ken Lapatin, Samantha Leahy, Michael and Barbara Ledeen, Catriona MacLeod, Betsy Brubaker McGill, Stewart Manger, Anita and Rick Perry, Livio Pestelli, Herman Pirchner, Patricia Reilly and David Creagan, Liz and Larry Richardson, Betsey Ann Robinson, Allen Roth, Chip Roy, Maria Ruvoldt, Jon Seydl, Dor Shapira, Sandy and Nort Sloan, Carolyn and Ignat Solzhenitsyn, Paul Tucker, and Mari and George Will.

This book would not exist without the generous early support of the Earhart Foundation, under the able leadership of Ingrid Gregg and Montgomery Brown. Thanks are also due to the Commonwealth Foundation and the Foundation for Defense of Democracies for believing that an art historian had a meaningful contribution to make to the important work both institutions do to promote liberty in the modern world. I am grateful to the contributors and community of Redstate. com for providing a sounding board as well as a treasured source of comradeship.

The bulk of *David's Sling* was written at idyllic Andalusia on the Delaware River in Pennsylvania, some twenty miles south of where General George Washington made his bold crossing that frigid Christmas night in 1776. It was an endless source of inspiration to look out upon the historic Biddle estate – a nineteenth-century, New World interpretation of the Parthenon, providing architectural evidence of the visceral connection felt by the founders of the United States to the birth of democracy in classical Athens. Many thanks to Kristen and Jamie Biddle

and all the community of Andalusia for welcoming me, and to Richard Snowden and Fred Holzerman for thinking it was a good idea in the first place.

My transition from academic to commercial publishing has been deftly managed by the capable and creative group at Javelin, D.C., led by Keith Urbahn and Matt Latimer. The learned and patient Roger Kimball and his team at Encounter Books, who also bravely accepted a jackalope project without a traditional identity – or readership – have been a joy to work with, as has my exemplary editor, Carol Staswick. Michael Sobolik provided invaluable assistance with both substance and the Herculean task of tracking down the photo permissions.

A short explanatory autobiographical note: I do not know what possessed Donald Rumsfeld to conclude one day in May 2007 that an art historian ("of all things") was the right person to help organize his memoir documenting some six decades of service to our country. But I am grateful that he fulfilled his historic role as "the storm in the calm" and presented me with the challenge and opportunity to apply the training of a historian to a living subject, whose story encompasses events from the attack on Pearl Harbor to the attacks of September 11, 2001 and beyond.

After four years studying the formation of American national security and foreign policy under Mr. Rumsfeld's watchful eye, I started being asked questions about current events, and answering them. This development led to perhaps the most unexpected twist in a life full of surprises when I joined the staff of Senator Ted Cruz of Texas as an adviser for national security policy in March 2013. And despite the delays to my publication schedule caused by Mr. Cruz's remarkable enthusiasm for his job, waking up every morning with the directive to "fight for freedom" has greatly enriched this book.

All these professional shenanigans would not be possible without the love, support and inspiration of my wonderful family, to whom this book is dedicated with – it bears repeating – all my love. There simply are no words to thank them for their steadfast belief in and enthusiasm for this project and its author.

Andalusia, Pennsylvania
September 2015

Illustration Credits

CHAPTER 1

The Parthenon, Athens, Greece. Photo © Mark Fiennes / Bridgeman Images.

Bust of Greek general and politician Pericles (marble), Roman copy of Greek original from the Acropolis, Athens. Greek Civilization, 5th century BC / De Agostini Picture Library / G. Nimatallah / Bridgeman Images.

Attic black-figure olpe depicting Athena confronting Poseidon, 6th century BC (pottery), Amasis Painter (fl. c.560–515 BC) / Louvre, Paris, France / Peter Willi / Bridgeman Images.

Dionisov teatar u Akropolju. Photo © Славен Косановић (Slaven Kosanovic), December 11, 2007. Available under Creative Commons Attribution–Share Alike 3.0 Unported license at https://commons.wikimedia.org/wiki/File:Dionisov_teatar_u_Akropolju.jpg.

Statuette of Athena Promachos, 50 BC–25 AD, bronze, H 20.6 cm (8.5 in) / The J. Paul Getty Museum, Villa Collection, Malibu, California / Gift of Barbara Lawrence Fleischman.

Reconstruction of the Acropolis, Athens, 5th century BC (color litho) / Italian School / Private Collection / De Agostini Picture Library / Bridgeman Images.

Parthenon plan, Argento. Accessed November 4, 2015, https://commons.wikimedia.org/wiki/File:Parthenon-top-view.svg.

Reconstruction of the east pediment of the Parthenon according to drawing by K. Schwerzek (New Acropolis Museum). Photo © Tilemahos Efthimiadis. June 27, 2009. Available under Creative Commons Attribution–Share Alike 2.0 Generic license at https://www.flickr.com/photos/64379474@N00/3668047128.

East pediment KLM Parthenon BM. Photo © Marie-Lan Nguyen. August 1, 2007. British Museum. Available under Creative Commons Attribution 2.5 Generic license at https://commons.wikimedia.org/wiki/File:East_pediment_KLM_Parthenon_BM.jpg.

Slab from the Parthenon frieze depicting Centaur and Lapith / Werner Forman Archive / Bridgeman Images.

Riders Preparing to Form a Procession, from the far west slab of the north frieze, 477–432 BC (marble) / British Museum / Bridgeman Images.

Phidias Showing the Frieze in the Parthenon to Friends, 1868 (oil on canvas), Lawrence Alma-Tadema (1836–1912). Birmingham City Museums. © DeA Picture Library / Art Resource, NY.

Visit to the Studio of Phidias (oil on canvas, 122 × 66 cm), Hector Le Roux (1829–1900). Inv. CM108. Photo: René-Gabriel Ojéda. Musée Bonnat. © RMN–Grand Palais / Art Resource, NY.

The Kritios Boy, c.480 BC, Greek (marble) / Acropolis Museum, Athens, Greece / Ancient Art and Architecture Collection Ltd. / Bridgeman Images.

CHAPTER 2

Bronze bust portraying Lucius Junius Brutus, known as the Capitoline Brutus / De Agostini Picture Library / G. Nimatallah / Bridgeman Images.

Panoramic view of the archaeological site with the theatre at the Temple of Apollo (photo), Greek / Delphi, Phokis, Greece / Bridgeman Images.

Marble bust of a man, mid 1st century AD. Roman, Julio-Claudian period. Marble, H. 14 ⅜ in (36.5 cm). Rogers Fund, 1912 (12.233). The Metropolitan Museum of Art. © The Metropolitan Museum of Art / Art Resource, NY.

EID MAR, the Ides of March, on a denarius of Marcus Junius Brutus. Roman. c.43–42 BC. CM 1855,0512.40. British Museum. © The Trustees of the British Museum / Art Resource, NY.

Marcus Junius Brutus, marble bust. Photo: Carlo Brogi. Accessed November 4, 2015, https://commons.wikimedia.org/wiki/File:Brogi,_Carlo_(1850-1925)_-_n._16585_-_Roma_-_Museo_Capitolino_-_Marco_Giunio_Bruto,_busto_in_marmo..jpg.

View of the Capitoline Hill before Michelangelo's Restoration, 16th century (brown ink & pen, brown wash, over red chalk, 28.2 × 42.5 cm), Anonymous, Italian School. INV11028. Photo:

Jean-Gilles Berizzi. Musée du Louvre. © RMNGrand Palais / Art Resource, NY.

View of the Capitoline Hill (Campidoglio) / Scala / Art Resource, NY.

Campidoglio (Capitol Hill) in Rome, 1568 (engraving), Étienne Dupérac (1525–1605). Accessed November 4, 2015, https://commons.wikimedia.org/wiki/File:CampidoglioEng.jpg.

Aerial view of the Piazza del Campidoglio, designed by Michelangelo Buonarroti (1475–1564), completed 17th century, with the Palazzo Senatorio, Palazzo del Museo Capitolino, Palazzo dei Conservatori and surrounding area (photo) / Campidoglio, Rome, Italy / Alinari / Bridgeman Images.

Cardinal Rudolfo Pio, Bishop of Faenza (c.1500–64), 1528, Francesco de Rossi Salviati Cecchino (1510–63) / Kunsthistorisches Museum, Vienna, Austria / Bridgeman Images.

Capitoline Brutus, Roman, 4th–3rd century BC (bronze) / Musei Capitolini, Rome, Italy / Ghigo Roli / Bridgeman Images.

Départ de Rome du troisième Convoi des Statues et Monuments des Arts. . ., 1978, print by Jean-Jérôme Baugean. British Museum. © The Trustees of the British Museum.

CHAPTER 3

Venice—St. Mark's Basilica. Photo © Nino Barbieri. November 2004. Available under Creative Commons Attribution–Share Alike 2.5 Generic license at https://commons.wikimedia.org/wiki/File:Venice_-_St._Marc%27s_Basilica_01.jpg.

Original Horses inside Basilica San Marco. Photo © Tteske. October 30, 2008. Available under Creative Commons Attribution 3.0 Unported license at https://commons.wikimedia.org/wiki/File:Horses_of_Basilica_San_Marco.jpg.

Image of Venice (engraving), attributed to Bolognino Zaltieri, 1565, from *Civitates Orbis Terrarum*, vol. 1, first Latin ed. 1572.

The Arrival of the Body of Saint Mark in Venice, Byzantine mosaic / San Marco / Cameraphoto Arte, Venice / Art Resource, NY.

Plan of San Marco, from James Fergusson, *The Illustrated Handbook of Architecture*, 1855, via Wikimedia Commons.

The Betrothal of the Venetian Doge to the Adriatic Sea, c.1729–30 (oil on canvas), Canaletto (Giovanni Antonio Canal) (1697–1768) / Pushkin Museum, Moscow, Russia / Bridgeman Images.

Interior view of the nave (mosaic), Veneto-Byzantine School / San Marco, Venice, Italy / Alinari / Bridgeman Images.

The Conquest of Constantinople in 1204 by the Crusaders, Domenico Tintoretto (1560–1635) / Palazzo Ducale, Venice, Italy / Erich Lessing / Art Resource, NY.

Effigy to John VIII Palaeologus (1392–1448), Byzantine emperor, 1438, medal by Pisanello (c.1395–c.1455), bronze, diameter 10.2 cm / De Agostini Picture Library / Bridgeman Images.

The Tetrarchs. Photo © Nino Barbieri. November 2004. Available under Creative Commons Attribution–Share Alike 3.0 Unported license at https://commons.wikimedia.org/wiki/File:Venice_%E2%80%93_The_Tetrarchs_03.jpg.

Horse statues on St Mark's Basilica, Venice. Photo © Gary Houston. May 24, 2005. Available under the Creative Commons CC0 1.0 Universal Public Domain Dedication at https://commons.wikimedia.org/wiki/File:Basilica-di-San-Marco-horses-2005 0524-031.jpg.

Pala d'Oro, entire view, 976 AD, remade in 1342–1345 (gold, enamel and gems, 212 × 334 cm), Giampaolo Boninsegna (fl.1342) / Cameraphoto Arte, Venice / Art Resource, NY.

Enamel on the Pala'Oro, detail, Byzantine, 12th–14th century (gold, cloisonné enamel and precious stones) / Cameraphoto Arte, Venice / Art Resource, NY.

The Apotheosis of Venice (oil on canvas), Paolo Veronese (Caliari) (1528–88) / Palazzo Ducale, Venice, Italy / Cameraphoto Arte Venezia / Bridgeman Images.

Entrée Triomphale des Monuments des Sciences et Arts en France, 1802 (engraving), Abraham Girardet, after Pierre-Gabriel Berthault [public domain], via Wikimedia Commons.

CHAPTER 4

David, 1501–04 (marble), Michelangelo Buonarroti (1475–1564) / Galleria dell'Accademia, Florence, Italy / Bridgeman Images.

Gold florin, with fleur-de-lys (obverse), and John the Baptist (reverse), Florentine, 1252, Italian School (13th century) / Museo Nazionale del Bargello, Florence, Italy / Bridgeman Images.

View of the Duomo and Palazzo Vecchio (photo) / Florence, Tuscany, Italy / Bridgeman Images.

Plan of the Duomo (Santa Maria del Fiore), Florence, from Dehio & von Bezold, *Die kirchliche Baukunst des Abendlandes*, vol. 5 (Stuttgart, 1901) / Foto Marburg / Art Resource, NY.

General view of the Brancacci Chapel, 15th-century frescoes by Masaccio, Masolino and Filippino Lippi / Santa Maria del Carmine, Florence, Italy / Bridgeman Images.

Adam and Eve banished from Paradise, c.1427 (fresco) (post-restoration), Masaccio (Tommaso) (1401–28) / Brancacci Chapel, Santa Maria del Carmine, Florence, Italy / Bridgeman Images.

The Tribute Money, c.1426 (fresco), Masaccio (Tommaso) (1401–28) / Brancacci Chapel, Santa Maria del Carmine, Florence, Italy / Bridgeman Images.

Palazzo Medici-Riccardi, begun in 1444 (photo), Michelozzo di Bartolommeo (1396–1472) / Florence, Tuscany, Italy / Bridgeman Images.

Portrait bust of Lorenzo de' Medici, probably after a model by Andrea del Verrocchio and Orsini Benintendi (painted terracotta), Italian School / Palazzo Medici-Riccardi, Florence, Italy / Bridgeman Images.

Battle of the Centaurs (marble), Michelangelo Buonarroti (1475–1564) / Casa Buonarroti, Florence, Italy / Bridgeman Images.

Michelangelo's Pietà in St Peter's Basilica (photo) / Godong / UIG / Bridgeman Images.

David, 1408 (marble), Donatello (c.1386–1466) / Museo Nazionale del Bargello, Florence, Italy / Bridgeman Images.

David, c.1440 (bronze), Donatello (c.1386–1466) / Museo Nazionale del Bargello, Florence, Italy / Bridgeman Images.

David, detail of the head, 1504 (marble), Michelangelo Buonarroti (1475–1564) / Galleria dell'Accademia, Florence, Italy / Bridgeman Images.

Study for David (pen & ink on paper), Michelangelo Buonarroti (1475–1564) / Louvre, Paris, France / Bridgeman Images.

Fountain with the Dioscuri, Piazza del Quirinale (photo) / Bridgeman Images.

David, detail, 1501–04 (marble), Michelangelo Buonarroti (1475–1564) / De Agostini Picture Library / G. Nimatallah / Bridgeman Images.

Exterior of the Palazzo Vecchio, designed by Arnolfo di Cambio, 1298–1302 (photo) / Piazza della Signoria, Florence, Italy / Alinari / Bridgeman Images.

Project for the Tomb of Pope Julius II (drawing), Michelangelo Buonarroti (1475–1564) / Gabinetto dei Disegni e delle Stampe / Scala / Art Resource, NY.

Tomb of Pope Julius II (1453–1513) (marble), Michelangelo Buonarroti (1475–1564) / San Pietro in Vincoli, Rome, Italy / Bridgeman Images.

Drawing of fortifications for Florence, Michelangelo Buonarroti (1475–1564) / Casa Buonarroti, Florence, Italy / De Agostini Picture Library / Bridgeman Images.

CHAPTER 5

The Night Watch, 1643, Rembrandt van Rijn / Rijksmuseum, Amsterdam, The Netherlands.

Kloveniersdoelen, 1627 / Rijksmuseum, Amsterdam, The Netherlands.

The Procession of Marie de' Medici through Amsterdam, 1638 (engraving), Salomon Savery, after Jan Martsen the Younger (c.1609–c.1647), from Caspar Barlaeus, *Medicea Hospes* / Private Collection / Bridgeman Images.

The Siege of Leiden, 1574, Frans Hogenberg [public domain], via Wikimedia Commons.

The Anatomy Lesson of Dr. Nicolaes Tulp, 1632 (oil on canvas), Rembrandt Harmensz. van Rijn (1606–69) / Mauritshuis, The Hague, The Netherlands / Bridgeman Images.

Lucas van Uffel (d. 1637), c. 1621–27, by Anthony van Dyck (1599–1641), oil on canvas, 49 × 39 ⅝ in. (124.5 × 100.6 cm). Bequest of Benjamin Altman, 1913 (14.40.619). The Metropolitan Museum of Art. © The Metropolitan Museum of Art / Art Resource, NY.

Portrait of Baldassare Castiglione (1478–1529), before 1516 (oil on canvas), Raphael (Raffaello Sanzio of Urbino) (1483–1520) / Louvre, Paris, France / Bridgeman Images.

Captain Bicker's Company Waiting to Greet Marie de' Medici, 1638–40, Joachim von Sandrart / Rijksmuseum, Amsterdam, The Netherlands.

Baldassare Castiglione, author of *Il Cortegiano*, 1639 (pen & ink), Rembrandt Harmensz van Rijn (1606–1669), Inv 8859, Graphische Sammlung Albertina / Erich Lessing / Art Resource, NY.

Portrait of a Man, c.1512 (oil on canvas), Titian (Tiziano Vecellio) (c.1488–1576) / National Gallery, London / Bridgeman Images.

Self-Portrait at the Age of 34, 1640 (oil on canvas, 102 × 80 cm), Rembrandt Harmensz van Rijn (1606–1669). Bought 1861 (NG672). © National Gallery, London / Art Resource, NY.

Galerie Médicis, Richelieu Wing, Palais du Louvre. Photo: Matt Biddulph (Flickr) [CC BY-SA 2.0 (http://creativecommons.org/licenses/by-sa/2.0)], via Wikimedia Commons.

The Majority of Louis XIII (1601–43) 20th October 1614, 1621–25 (oil on canvas), Peter Paul Rubens (1577–1640) / Louvre, Paris, France / Bridgeman Images.

The Meagre Company, 1637, Frans Hals / Rijksmuseum, Amsterdam, The Netherlands.

Estancia del Sello (Stanza della Segnatura), 1508–11, frescoes by Raphael, Photo © 0r0r. Available under the Creative Commons Attribution–Share Alike 3.0 Unported license at https://commons.wikimedia.org/wiki/File:1_Estancia_del_Sello_(Vista_general_I).jpg.

The School of Athens, 1550 (engraving), Giorgio Ghisi (1520–1582), after Raphael Urbino (1484–1520), purchased with support of Stichting Lucas van Leyden 1964 / Museum Boijmans Van Beuningen, Rotterdam, The Netherlands.

The Night Watch, detail, 1643, Rembrandt van Rijn / Rijksmuseum, Amsterdam, The Netherlands.

Watercolor copy of Rembrandt's Night Watch, c.1665 / Rijksmuseum, Amsterdam, The Netherlands.

Self-Portrait as an Old Man, c.1664 (oil on canvas), Rembrandt Harmensz. van Rijn (1606–69) / Galleria degli Uffizi, Florence, Italy / Bridgeman Images.

CHAPTER 6

The Death of Marat, 1793 (oil on canvas), Jacques Louis David (1748–1825) / Musées Royaux des Beaux-Arts de Belgique, Brussels, Belgium / Bridgeman Images.

Queen Marie Antoinette on the way to her execution, 1793 (litho), Jacques Louis David (1748–1825) / Private Collection / Bridgeman Images.

Exhibition in the Salon of the Louvre in 1787, Pietro Antonio Martini (1738–1797) / Hamburger Kunsthalle / Foto Marburg / Art Resource, NY.

The Death of Socrates, 1787 (oil on canvas), Jacques Louis David (1748–1825) / Metropolitan Museum of Art, New York / Bridgeman Images.

Marie-Antoinette and Her Children, 1787 (oil on canvas), Elisabeth Louise Vigée-Lebrun (1755–1842) / Château de Versailles, France / Bridgeman Images.

Lictors Bearing to Brutus the Bodies of His Sons, 1789 (oil on canvas), Jacques Louis David (1748–1825) / Louvre, Paris, France / Bridgeman Images.

Head of Marat, 1793 (pen & ink on paper), Jacques Louis David (1748–1825) / Château de Versailles, France / Bridgeman Images.

Dying Slave (marble), Michelangelo Buonarroti (1475–1564) / Louvre, Paris, France / Bridgeman Images.

Unfinished portrait of General Bonaparte, c.1797–98 (oil on canvas), Jacques Louis David (1748–1825) / Louvre, Paris, France / Bridgeman Images.

CHAPTER 7

British Museum: Elgin Marbles. Photo © stuartpilbrow. February 19, 2009. Available under Creative Commons Attribution–Share Alike 2.0 Generic license at https://www.flickr.com/photos/stuartpilbrow/3337344207/.

Portrait of Richard Payne Knight (1750–1824), c.1793–94 (oil on canvas), Sir Thomas Lawrence (1769–1830) / Whitworth Art Gallery, The University of Manchester, UK / Bridgeman Images.

Thomas Bruce, 7th Earl of Elgin, 1787 (engraving), George Perfect Harding, after Anton Graff (1736–1813) (b/w photo) / Private Collection / Bridgeman Images.

The Destruction of the Parthenon in 1687, from Francesco Fanelli, *Atene Attica*, 1707. Artillery History, https://artilleryhistory.wordpress.com/tag/francesco-morosini.

Mary Nisbet, Countess of Elgin, c.1804 (oil on canvas), François Pascal Simon Gerard, Baron (1770–1837). © Scottish National Gallery, Edinburgh / Bridgeman Images.

Lady Hamilton as a Bacchante, c.1790 (oil on canvas), Elisabeth Louise Vigée-Lebrun (1755–1842). © Walker Art Gallery, National Museums Liverpool / Bridgeman Images.

Sultan Selim III, c.1803–04 (oil on canvas), Konstantin Kapidagli (18th–19th century) / Topkapi Palace Museum, Istanbul, Turkey / Bridgeman Images.

The Parthenon, 1801 (watercolor), Sir William Gell (1777–1836), English archaeologist / British Museum / Art Resource, NY.

Selene's Horse, 1809, Benjamin Robert Haydon. © The Trustees of the British Museum.

Portrait of Lord Byron (1788–1824) (oil on canvas), Thomas Phillips (1770–1845) / Private Collection / Bridgeman Images.

John Keats, 1816, by Benjamin Robert Haydon, pen & ink, 2 ¾ × 8 in. (70 × 203 mm). Purchased 1945, Primary Collection, NPG 3250. © National Portrait Gallery, London.

The Temporary Elgin Room, c.1819 (oil on canvas), Archibald Archer (1820–1902). British Museum. © The Trustees of the British Museum / Art Resource, NY.

Copper scrapers used for cleaning the Elgin Marbles. © The Trustees of the British Museum.

The Parthenon Sculptures. British Museum. © The Trustees of the British Museum.

UK – London – Bloomsbury – British Museum: Elgin Marbles – Horsemen of the North Frieze. Photo © Wally Gobetz, 2006. Available under Attribution-Noncommercial-NoDerivs 2.0 license at https://www.flickr.com/photos/wallyg/302422841.

UK – London – Bloomsbury: British Museum – Elgin Marbles – Southeast metope. Photo © Wally Gobetz, 2006. Available under Attribution-Noncommercial-NoDerivs 2.0 license at https://www.flickr.com/photos/wallyg/302426890.

CHAPTER 8

Rocky Mountains, Lander's Peak, 1862, Albert Bierstadt (1830–1902) / Metropolitan Museum of Art, New York / Bridgeman Images.

Washington Crossing the Delaware, 1851 (post-cleaning), Emanuel Gottlieb Leutze (1816–1868), oil on canvas, 149 × 255 in. (378.5 × 647.7 cm). Gift of John Stewart Kennedy, 1897 (97.34). The Metropolitan Museum of Art. © The Metropolitan Museum of Art / Art Resource, NY.

Frederick West Lander, 1821–1862 (steel engraving), J. C. Buttre (after photoprint by Matthew Brady). Library of Congress Prints and Photographs Online Catalog. http://www.loc.gov/pictures/item/2003655492/.

The Death of General Wolfe (1727–59), c.1771 (oil on panel), Benjamin West (1738–1820) / Private Collection / Phillips, Fine Art Auctioneers, New York / Bridgeman Images.

Bust of Benjamin Franklin, 1779 (marble), Jean-Antoine Houdon (1741–1828) / Philadelphia Museum of Art, Pennsylvania, purchased with a generous grant from The Barra Foundation, Inc., matched by contributions from the Henry P. McIlhenny Fund in memory of Frances P. McIlhenny, the Walter E. Stait Fund, the Fiske Kimball Fund, et al. / Bridgeman Images.

Albert Bierstadt, c.1865 (photo), Napoleon Sarony. Accessed October 26, 2015, https://commons.wikimedia.org/wiki/File:Bierstadt.jpg.

The Athenæum Picture Gallery, 1855, Boston Athenæum, anonymous. Accessed October 26, 2015, https://commons.wikimedia.org/wiki/File:BostonAthenaeum2_BeaconSt_1855.png.

Lake Lucerne, 1858, Albert Bierstadt, oil on canvas, 182.9 × 304.8 cm (72 × 120 in.). Gift of Richard M. Scaife and Margaret R. Battle, in Honor of the 50th Anniversary of the National Gallery of Art / National Gallery of Art, Washington, D.C.

The Holmes stereoscope, with the inventions and improvements added by Joseph L. Bates, advertisement. Center for the History of Medicine: OnView. Accessed October 26, 2015, http://collections.countway.harvard.edu/onview/items/show/6277.

Ludgate Hill, stereoscopic view (photo), English photographer (19th century) / Private Collection / © Look and Learn / Peter Jackson Collection / Bridgeman Images.

Pony Express poster advertising for young riders. Accessed October 26, 2015, https://commons.wikimedia.org/wiki/File:Pony_ExpressAdvert.jpg

A Pike's Peaker (wood engraving), anonymous, *Harper's Weekly*, 1859. Library of Congress Prints and Photographs Online Catalog. http://www.loc.gov/pictures/item/2007681454/.

Chief Washakie (c.1804–1900) (b/w photo), American photographer (19th century) / Private Collection / Peter Newark American Pictures / Bridgeman Images.

Surveyor's Wagon in the Rockies, c.1859 (oil on paper mounted on masonite), Albert Bierstadt (1830–1902) / Saint Louis Art Museum, Missouri / Gift of J. Lionberger Davis / Bridgeman Images.

Camp of 49th PA Reg't, Divine services, 1861 (stereograph), Bierstadt Brothers. Library of Congress Prints and Photographs Online Catalog. http://www.loc.gov/item/2015649035/.

Guerilla Warfare: Picket Duty in Virginia, 1862 (oil on canvas), Albert Bierstadt / The Century Association.

Young female admires the Water Lily Nymphéas paintings (photo) / Musée de L'Orangerie, Paris, France / Bridgeman Images.

Water Lily Nymphéas series (photo) / Musée de L'Orangerie, Paris, France / Bridgeman Images.

French Prime Minister Georges Clemenceau chatting to a soldier, Oise, France, World War I, 1917–1918 (b/w photo), French photographer (20th century) / Private Collection / © Look and Learn / Elgar Collection / Bridgeman Images.

Georges Clemenceau and Claude Monet (b/w photo), French photographer / Private Collection / Roger-Viollet, Paris / Bridgeman Images.

Claude Monet in his Studio at Giverny (b/w photo), Henri Manuel (1874–1947) / Private Collection / Roger-Viollet, Paris / Bridgeman Images.

Waterlilies, 1916–19 (oil on canvas), Claude Monet (1840–1926) / Musée Marmottan Monet, Paris, France / Bridgeman Images.

Monet's Dining Room / Ariane Cauderlier / giverny-photo.com.

Déjeuner sur l'Herbe, 1863 (oil on canvas), Edouard Manet (1832–83) / Musée d'Orsay, Paris, France / Bridgeman Images.

Women in the Garden, 1866 (oil on canvas), Claude Monet (1840–1926) / Musée d'Orsay, Paris, France / Bridgeman Images.

Charles X presenting awards to the artists at the end of the exhibition of 1824, François Joseph Heim (1787–1865) / Louvre, Paris, France / Peter Willi / Bridgeman Images.

Impression: Sunrise, 1872 (oil on canvas), Claude Monet (1840–1926) / Musée Marmottan Monet, Paris, France / Bridgeman Images.

Portrait of Georges Clemenceau (1841–1929), 1879 (oil on canvas), Edouard Manet (1832–83) / Musée d'Orsay, Paris, France / Bridgeman Images.

Grainstacks at the end of the Summer, Morning effect, 1891 (oil on canvas), Claude Monet (1840–1926) / Musée d'Orsay, Paris, France / Bridgeman Images.

Poplars on the Banks of the Epte, Autumn, 1891 (oil on canvas), Claude Monet (1840–1926) / Private Collection / Bridgeman Images.

Postcard depicting the façade of Rouen Cathedral (b/w photo), French photographer (20th century) / Private Collection / © Look and Learn / Elgar Collection / Bridgeman Images.

1. Rouen Cathedral, Blue Harmony, Morning Sunlight, 1894 (oil on canvas), Claude Monet (1840–1926) / Musée d'Orsay, Paris, France / Bridgeman Images.

2. Rouen Cathedral, 1891, Claude Monet (1840–1926) / Private Collection / Photo © Christie's Images / Bridgeman Images.

3. Rouen Cathedral, Foggy Weather, 1894 (oil on canvas), Claude Monet (1840–1926) / Private Collection / Bridgeman Images.

4. Rouen Cathedral, West Façade, Sunlight, 1894 (oil on canvas), Claude Monet (1840–1926) / National Gallery of Art, Washington, D.C. / Bridgeman Images.

Traitor: Degradation of Alfred Dreyfus (1859–1935), cover of *Le Petit Journal*, January 13, 1895, Henri Meyer (1844–1899), France, 19th century / De Agostini Picture Library / G. Dagli Orti / Bridgeman Images.

Front page of the newspaper *L'Aurore*, January 13, 1898, with the open letter by Zola about the Dreyfus affair (photo), Encyclopædia Britannica Online. Accessed October 26, 2015, http://www.britannica.com/topic/Jaccuse/images-videos/Front-page-of-the-newspaper-LAurore-January-13-1898-with/159796.

Giverny-2. Photo © shogunangel. June 4, 2011. Available under Creative Commons Attribution-NonCommercial-NoDerivs 2.0 Generic license at https://www.flickr.com/photos/shogunangel/5799716764/.

Giverny-10. Photo © shogunangel. June 4, 2011. Available under Creative Commons Attribution-NonCommercial-NoDerivs 2.0 Generic license at https://www.flickr.com/photos/shogunangel/5799182587/.

Japan: Two women gathering lotus blossoms, 1765, Suzuki Harunobu (1724–1770) / Pictures from History / Bridgeman Images.

Exposition universelle de 1889 (Paris, France), 1889 (photographic print), anonymous. Library of Congress Prints and Photographs Online Catalog. https://www.loc.gov/item/2002723525/.

The Japanese Footbridge and the Water Lily Pool, Giverny, 1899 (oil on canvas), Claude Monet (1840–1926) / Philadelphia Museum of Art, Pennsylvania / The Mr. and Mrs. Carroll S. Tyson, Jr. Collection, 1963 / Bridgeman Images.

Portrait of the artist with easel, 1660, Rembrandt Harmenszoon van Rijn (1606–69) / Musée du Louvre Paris / Gianni Dagli Orti / Art Resource, NY.

Lord Balfour, Georges Clemenceau and Woodrow Wilson arriving at the Château de Versailles (France) for the Paris Peace Conference, January 1919, Anonymous (20th century) / Adoc-photos / Art Resource, NY.

Waterlilies: Morning with Weeping Willows, detail of the right section, 1915–26 (oil on canvas), Claude Monet (1840–1926) / Musée de l'Orangerie, Paris, France / Bridgeman Images.

Georges Clemenceau, Claude Monet and Alice Butler on the Japanese Bridge in Monet's garden, Giverny, 1921 (b/w photo), French photographer (20th century) / Musée Marmottan Monet, Paris, France / Bridgeman Images.

CHAPTER 10

Guernica, 1937 (oil on canvas), Pablo Picasso (1881–1973) / Museo Nacional Centro de Arte Reina Sofia, Madrid, Spain / Bridgeman Images. © 2015 Estate of Pablo Picasso / Artists Rights Society (ARS), New York.

Spanish Civil War : the ruins after the German bombing of Guernica (Spain) in 1937, Anonymous (20th century) / Adoc-photos / Art Resource, NY.

Las Meninas or The Family of Philip IV, c.1656 (oil on canvas), Diego Rodriguez de Silva y Velázquez (1599–1660) / Prado, Madrid, Spain / Bridgeman Images.

Execution of the Defenders of Madrid, 3rd May, 1808, 1814 (oil on canvas), Francisco Jose de Goya y Lucientes (1746–1828) / Prado, Madrid, Spain / Bridgeman Images.

Acrobat and Young Harlequin, 1905 (oil on canvas), Pablo Picasso (1881–1973) / The Barnes Foundation, Philadelphia, Pennsylvania / Bridgeman Images. © 2015 Estate of Pablo Picasso / Artists Rights Society (ARS), New York.

Les Demoiselles d'Avignon, 1907 (oil on canvas), Pablo Picasso (1881–1973) / Museum of Modern Art, New York / Bridgeman Images. © 2015 Estate of Pablo Picasso / Artists Rights Society (ARS), New York.

Untitled (Boy with mismatched shoes), 1933, Dora Maar (1907–1997) © ARS, NY (gelatin silver print, 26.9 × 26.6 cm). AM1987-

489. Photo: Jacques Faujour. Musée National d'Art Moderne. © CNAC / MNAM / Dist. RMN–Grand Palais / Art Resource, NY.

Portrait of Dora Maar, ¾ profile. 1930. 18.4 × 11.9 cm. MP1998-147. Repro-photo: Franck Raux. Musée Picasso, Paris, France. © RMN–Grand Palais / Art Resource, NY. © 2015 Estate of Pablo Picasso / Artists Rights Society (ARS), New York.

Frenhofer at work on his "Unknown Masterpiece," illustration from "Le Chef-d'Oeuvre Inconnu" by Honoré de Balzac (1799–1850) (engraving), Pablo Picasso (1881–1973) / Private Collection / The Stapleton Collection / Bridgeman Images. © 2015 Estate of Pablo Picasso / Artists Rights Society (ARS), New York.

The Afghan greyhound Kazbeck in the studio whose window opens on the roofs of Paris, the Grands-Augustins studio, 1944 (silver print). MP1986.29. Photo: Franck Raux. © RMN–Grand Palais / Art Resource, NY.

View of the preparatory study of the painting "Guernica" by Pablo Picasso in his studio, rue des Grands-Augustins, Paris, illustration from *Verve* no.1, December 1937 (b/w photo), Dora Maar (1907–97) / Private Collection / Archives Charmet / Bridgeman Images. © 2015 Artists Rights Society (ARS), New York / ADAGP, Paris.

The Consequences of War, 1637–38 (oil on canvas), Peter Paul Rubens (1577–1640) / Palazzo Pitti, Florence, Italy / Bridgeman Images.

Pablo Picasso painting "Guernica," 1937 (b/w photo), Dora Maar (1907–97) / Private Collection / Archives Charmet / Bridgeman Images. © 2015 Artists Rights Society (ARS), New York / ADAGP, Paris.

The Eiffel Tower, the German and Russian pavilions during the International Exhibition of Arts and Techniques (Exposition internationale des arts et techniques), Paris, 1937 (photo), Henri Baranger (b. 1924) © Baranger–RMN. EAT638N. © Ministère de la Culture / Médiathèque du Patrimoine, Dist. RMN–Grand Palais / Art Resource, NY.

Spanish Pavilion, World's Fair, Paris, 1937. KLL13542NNR0. © Ministère de la Culture / Médiathèque du Patrimoine, Dist. RMN–Grand Palais / Art Resource, NY.

Kill Lies All After Pablo Picasso (1937) & Tony Shafrazi (1974), 1996 (oil on canvas), Felix Gmelin. © Felix Gmelin, 1996 / Saatchi Gallery, London.

Index

A Note on the Type

DAVID'S SLING *has been set in Monotype Dante, conceived and drawn in 1954 by Giovanni Mardersteig, the scholar-printer of Verona. The punches for the original foundry versions of the type were engraved by the Parisian punchcutter Charles Malin in two text sizes and one display size: a more complete range of sizes was later made widely available for Monotype composing machines under Stanley Morison's direction, and further weights were added when the types were digitized in 1993. Derived from Mardersteig's deep knowledge of Renaissance type forms, the design of Dante is exceptional for its readability and for the balance between its roman and italic faces. In no way an "everyday" type, Dante shows to best advantage in more formal pages in which types of similar derivation – like Bembo, Jenson, or Centaur – may not quite be suitable by virtue of their individual quirks. The display type is DF Rialto, a modern interpretation of Renaissance calligraphic hands, designed by Giovanni di Faccio & Lui Karner.*

DESIGN & COMPOSITION BY CARL W. SCARBROUGH
MAPS BY KATHERINE MESSENGER